Break the Frame

Break the Frame

Conversations with Women Filmmakers

Kevin Smokler

OXFORD
UNIVERSITY PRESS

Oxford University Press is a department of the University of Oxford.
It furthers the University's objective of excellence in research, scholarship,
and education by publishing worldwide. Oxford is a registered trade mark of
Oxford University Press in the UK and certain other countries.

Published in the United States of America by Oxford University Press
198 Madison Avenue, New York, NY 10016, United States of America.

© Kevin Smokler 2025

All rights reserved. No part of this publication may be reproduced, stored in a retrieval system,
transmitted, used for text and data mining, or used for training artificial intelligence, in any form or
by any means, without the prior permission in writing of Oxford University Press, or as expressly
permitted by law, by license or under terms agreed with the appropriate reprographics rights
organization. Inquiries concerning reproduction outside the scope of the above should be sent
to the Rights Department, Oxford University Press, at the address above.

You must not circulate this work in any other form
and you must impose this same condition on any acquirer

Library of Congress Cataloging-in-Publication Data
Names: Smokler, Kevin, author.
Title: Break the frame : conversations with women filmmakers / Kevin Smokler.
Description: New York, NY : Oxford University Press, [2025]
Identifiers: LCCN 2024049577 | ISBN 9780197619766 (hardback) | ISBN 9780197620977
Subjects: LCSH: Women motion picture producers and directors—United States—Interviews. |
Women in the motion picture industry—United States.
Classification: LCC PN1995.9.W6 S637 2025 |
DDC 791.4302/309252—dc23/eng/20250117
LC record available at https://lccn.loc.gov/2024049577

DOI: 10.1093/oso/9780197619766.001.0001

Printed by Sheridan Books, Inc., United States of America

To the women who have shown me how.
And why.

Contents

Acknowledgments	ix
INTRODUCTION: BIGGER AND LOUDER THAN SILENCE	1
SECTION 1: TRAILBLAZERS	9
Amy Heckerling	11
Julie Dash	21
Patricia Cardoso	31
Cheryl Dunye	39
Barbara Kopple	49
SECTION 2: SAGES	59
Mimi Leder	61
Jamie Babbit	71
Jessica Yu	81
Tamra Davis	91
Aline Brosh McKenna	101
Debra Granik	111
SECTION 3: DOCUMENTARIANS	121
Chris Hegedus	123
Dawn Porter	133
Tiffany Shlain	143
dream hampton	153

viii Contents

SECTION 4: DIRECTING IN PARTNERSHIP 163

Shari Springer Berman (with Robert Pulcini) 165

Julie Cohen and Betsy West 175

Anna Boden (with Ryan Fleck) 185

E. Chai Vasarhelyi (with Jimmy Chin) 195

SECTION 5: THE FEMALE FUTURE 205

Felicia Pride 207

Jessica Sharzer 217

Tanya Saracho 227

Alice Wu 237

Erin Lee Carr 247

EPILOGUE: A PRACTICAL GUIDE 257

Acknowledgments

SOUND SPEED
CAMERA SPEED
SLATE

Beautiful gratitude to all of the filmmakers in this book and their teams who worked with us and gave so generously of their time during one of the hardest times in the modern history of filmmaking. It is my honor to tell your story and spend time with your work.

Break the Frame would not exist without the experience and wisdom of Executive Producer Rochelle Roberts, talent booker, co-pilot, and consigliere whom I am lucky to work with and even luckier to know.

Thank you to my friend Alan Black, who suggested an Executive Producer for this project right when I needed to hear that most.

My dear agent Nicki Richesin at Dunow, Carlson & Lerner took a chance on a book praising the work of women authored by a man. I hope I have done right by your trust.

Norm Hirschy is the editor we should all want. Thank you for your guidance.

At Oxford University Press, *Break the Frame* completed production and publicity due to the acumen and steady hands of Zara Cannon-Mohammed, Rajeswari Srinivasan, and Emma Paolini. Thank you for your care and time.

The idea for this book was born from a long summer night conversation with comedian and screenwriter Erin Judge who concluded by saying "maybe we can stop pretending women don't direct movies now."

Shout, sister, shout.

My dream list of directors to interview was aided immeasurably by Kyle Buchanan's October 2015 Vulture article "100 Women Directors Hollywood Should Be Hiring." The catalyst for this project came from a panel I was asked to moderate saluting two legendary women directors of comedy films from the 1980s. Thank you to Lance Fensterman, Mike Armstrong, and Chris D'Lando of ReedPop Exhibitions for the chance to do so.

Introductions to several directors in this book were made by Michelle Upton of the National Geographic Channel, Marsha Miro, Jessica Sharzer, Saul Austerlitz, Susan Ito, and Chris Colin. Thank you for your generosity and trust.

Break the Frame exists in a world created by pioneering work in the struggle for gender equality in movie and television directing. The leadership and vision of Melissa Silverstein, founder and publisher of Women and Hollywood, Geena Davis, Founder and Chair of The Geena Davis Institute and its CEO and President Madeline Di Nonno, and Stacy L. Smith, founder of the USC Annenberg Inclusion Initiative, created the very conversation in which this book plays a small role. Thank you for showing us a new way forward.

I am fortunate beyond measure to have friends who are also writers, who do this thing better than me, whose work and companionship is essential to my own creative education. To Holly Payne, Clive Thompson, Bob Kolker, Mo Ryan, Erin Keane, Sarah D. Bunting, Oscar Villalon, Susan Orlean, Linda Holmes, Stephen Thompson, Avery Trufelman, Lauren Marie

x Acknowledgments

Fleming, Tod Goldberg, Adam Mansbach, Mary Ladd, Helen Zaltzman, A.J. Jacobs, Dani Shapiro, Kathleen Rooney, Rebecca Black, Susan Ito, Saul Austerlitz, Faith Adiele, Annie Zaleski, Mark Sarvas, Mo Daviau, Laura Stanfill, Taffy Brodesser-Akner, Danyel Smith, Matt Wardlaw, Dan Charnas, Mark Blankenship, Will Schwalbe, Jennifer Senior, Jane Friedman, Dominic Lin, Nancy Nichols and Lili Loofbourow, thank you for being the lanterns on the ragged road.

Early on, I shared the proposal for this book with feminist thinkers I admire. Veronica Arreola, Cinnamon Cooper, Kate Harding, and Wendy McClure are the reason *Break the Frame* (which was called something far less interesting back then) became real. Only the mistakes have been mine.

The other half of my professional life is making documentary films. My co-director/co-producer Christopher Boone and our cinematographer Sherri Kauk were both patient and supportive when some days I had to be an author and others, a filmmaking teammate. Thank you.

The good people of Philz Coffee, Russian Hill branch in San Francisco—Teri, Andy, Bo, Lluvia, Sav, Bella, and Arlo—have provided a clean, well-lighted place to work on this project each weekday morning for many years now. Thank you for being the best start to the work day for myself and so many others.

As someone who grew up with only brothers and almost all male cousins, I have been blessed throughout my life by my friendships with women. Emily Siegel, Dinan Messiqua, Kristi McClamroch, Melissa Chipman, Tara Anderson, Carla Borsoi, Jennifer Jongsma, Meghan Wilhelm, Jo Brief, Elizabeth Bridges, and Jennifer Haig Cooreman, for all the miles and decades, thank you for being your grand and glorious selves.

To my parents, Drs. Carol and Irv Smokler thank you for the role model of what equality looks like and can be.

To my brothers Matthew and Daniel Smokler, my sister-in-law Erin Leib Smokler, our niece Tair and nephews Shalev and Nadiv. Thank you for believing in me and that crazy thing Uncle Kevin has chosen to do with his life.

To my brother and sister-in-law Mike Hebert and Kat Marrow, everyone in the car and to the library!

Most of all, I thank my wife Cariwyl Hebert who both supported this effort and believed it should always strive for better. Our life together is the model of equality I most treasure. Our love is what I had been waiting for.

DID WE GET IT?
THAT'S A WRAP

Introduction: Bigger and Louder Than Silence

The room held about one hundred people, but double that many lined up. I wasn't surprised, just scared. Or maybe intimidated. Like when you feel called to do something that must be done right, in service of those you admire and those who admire them too.

Late Saturday afternoon at New York Comic Con is not a prime slot. Most of the big announcements of upcoming summer movies or new television series have already happened, and anyone with a long ride home has their mind on leaving. But after the doors swung open, the room filled almost immediately with fans and filmmakers in training. They were here to give thanks to and learn from two directors[1] who broke new ground for women filmmakers nearly forty years before and, between them, had made at least four movies that will outlive our grandchildren, launched the careers of actors who are now world-famous celebrities, and won enough awards to fill that room to capacity all over again.

My job was to moderate, which in this case meant to ask questions that led to stories about great movies from even greater careers and then encourage the audience to do the same. An unanswered question hung in the air like a curse.

The first hand up during Q&A belonged to a charismatic film student in the sixth row. She asked her heroes what could be done about the little progress women directors seem to have made between their time in film school in the 1970s and hers. Director number one, nine movies and thirty five years into a career, said she had nothing to add to the discussion of a senseless problem that won't go away. Director number two, fourteen movies and forty years into a career, reminded every young filmmaker in the room that, despite this curse, each of them could make a difference via the stories they tell and the talent and crews they hired to tell them.

Silence. No hands raised. With twenty minutes left in Q&A, my job as moderator was to say, "Next question please."

"If I may," I began instead.

We are here as fans of these two legends. Everything that happens here at Comic Con is for and because of us, the fans. That is our power. That means when we see the words "directed by" any female director, we buy a ticket for that movie, and we don't ask questions, because that director's name on that movie is good enough for us. And then after we've seen it, we tell our friends immediately how great that movie was.

We keep getting lied to that not enough people want to see movies directed by women. We have the power to prove them wrong.

The room may have applauded at that moment because I had suggested an alternative to giving up. Or to shut me up because no one had come to this event to hear the moderator.

2 Introduction

The two star directors of the afternoon, who have sat on hundreds of panels about women and movie directing, looked at the dozen hands now raised, smiled, and nodded as if to say, "Let us continue."

It was not my place to speak in that moment. I opened my mouth because, in that terrible silence, the biggest thing in that room seven years ago wasn't the movies the two directors had made that will live forever or the audience that had come to thank them or the work that audience will make in the future. It was a wrong that has no reason to exist. In that terrible silence, I wanted the movies gifted to us by Amy Heckerling and Julie Dash, by Chloé Zhao and Jessica Yu, by Patricia Cardoso and Barbara Kopple and Dawn Porter and Erin Lee Carr, movies directed by women that have shaped me and my work and made my life extraordinary, to be bigger and louder than all of it.

This book came from that afternoon. If hundreds had shown up at an off hour during New York Comic Con to honor of these two directors, weren't there more women directors deserving of such flowers? Dozens with a filmography showing us their growth as artists? As human beings? And wouldn't that mean there was something called "a Mary Harron movie" with a signature style and themes, just as clear as the phrase "a Wes Anderson movie"?

To find out meant speaking with but mostly listening to women film directors across genre, race, age and methods: about all of the their movies not just the ones most of us know about, about the other filmmakers that inspired them, about how they ran sets and companies and how they trained, mentored, and believed in the generation of directors coming up. Because, as I learned right away, of course the director of *I Shot Andy Warhol*, *The Notorious Bettie Page*, and the Netflix series *Alias Grace* has created "a Mary Harron movie." We are just long overdue in praising and studying it.

<p style="text-align:center">***</p>

In the twenty-first century alone, women have triumphed at directing every size, genre, and style of motion picture. *Shrek* was directed by a woman. So was half of the *Kung Fu Panda* franchise. So were *Barbie* and *Wonder Woman* but also *Deep Impact*, *American Psycho*, *Captain Marvel*, *Billy Madison*, and *American Splendor*, movies that might not seem to have been directed by a woman, but what does that even mean? *Bridesmaids* was directed by a man. *Point Break* was directed by a woman.

The directors in this book have won Oscars (*Free Solo*), made actors like Jennifer Lawrence and Ryan Gosling household names, and had their movies added to the Library of Congress's National Film Registry (*Real Women Have Curves*), the highest honor America can give a motion picture. On television, directors in this book have helmed the pilots to *Only Murders in the Building* and priceless episodes of *The West Wing*, *The Leftovers,* and *Succession.* As showrunners and executive producers, they've been responsible for your favorite episodes and seasons of *Crazy Ex-Girlfriend* and *American Horror Story.*

At the same time, women directed only 12 percent of the American films made in 2023, down from a twenty-first-century peak of 15 percent in 2020. From 2007 to now, men have outnumbered women in the director's chair nearly ten to one. "These figures are not merely data points on a chart," said Dr. Stacey L. Smith, founder of the USC Annenberg Inclusion Initiative, a global think tank studying issues of inequality in the entertainment industry. "They represent real, talented women working to have sustainable careers in an industry that will not hire them into jobs they are qualified to hold solely because of their identity."[2]

Hollywood's fossil progress on women directors is a systemic problem we won't solve here. And make no mistake, it is a systematic problem. In 2017, a year-long investigation by the Equal Employment Opportunity Commission (a federal agency created via the 1964 Civil Rights Act) found every major Hollywood studio systematically discriminated against hiring female filmmakers. The current president of the Directors Guild of America is only the second woman to hold the office since the organization's founding in 1936. It took the Oscars eighty-two years to award the Best Director trophy to a woman, Kathryn Bigelow for directing 2009's Best Picture winner, *The Hurt Locker*. Since then, two women have won the Best Director Oscar, Chloé Zhao for the 2020 Best Picture winner *Nomadland* and Jane Campion for 2021's *The Power of the Dog*. This is all happening at roughly the same moment when the graduating classes of America's top film schools are fifty-fifty male/female.

"It's taken many, many years, for 100-year old institutions to create and disrupt a process in order to incorporate a diversity inclusion lens," said Madeline Di Nonno, PRESIDENT and CEO of the Geena Davis Institute on Gender in Media, when I interviewed her in 2023. "And then once that's in place, now, how do they become organizationally ready? ... A tremendous amount of infrastructure, organization road mapping had to be put in place in order to manifest these changes."

That's how big the problem is. Which makes the success—awards, multi-million-dollar studio contracts, and enough great movies to make you dizzy with happiness—of the directors I spoke to all the more sweet. The need then for us to be knowledgeable and loud about their work and their success is not an option but an urgency.

A word about that urgency: Upon Chloé Zhao's winning the Best Director Oscar in 2020 for *Nomadland*, I had no fewer than seven conversations where articulate, filmgoing friends marveled at Ms. Zhao's impressive win as a first-time director. *Nomadland* was, in fact, Ms. Zhao's third film, and it was the dozen awards and nominations for her first two (plus the admiration of *Nomadland* star/producer Frances McDormand) that made *Nomadland* happen at all. We may not be as familiar with the five documentaries E. Chai Vasarhelyi made before she won an Oscar for directing *Free Solo* with her husband Jimmy Chin in 2017. Doesn't mean they don't exist. And I really had to talk myself down when a dear friend, and one of the biggest advocates of movies directed by women I know, messaged me after multiple viewings of *Barbie* to say, wasn't it great that Greta Gerwig "finally made the big time as a director." At which point I reminded him that Greta Gerwig had already received three Oscar nominations for her debut film *Lady Bird* (2017), and if that doesn't count as "making the big time" (as it most certainly had for Quentin Tarantino and *Pulp Fiction* twenty-five years before), I don't know what does.

No one is expected to have watched as many movies directed by women as the person under contract for a book about women directors. It is also human nature to believe that an artist's career began the moment we first became aware of them. But something more insidious is happening here than who has or has not done their homework. Without meaning to, even admirers of women directors are seeing their work as miracles, accidents, and exceptions. Misogyny and patriarchy has so conditioned us to believe great cinema comes from male genius that female genius behind the camera doesn't feel like the inevitable result of talent, hard work, and growth. It feels like a unicorn.

"The most annoying thing to come of this past truly good year is the narrative that I 'came out of nowhere,'" wrote *Wild* author Cheryl Strayed in a 2012 Facebook post, the year her bestselling memoir was purchased by Reese Witherspoon for film adaptation.[3] Picking up

4 Introduction

on Strayed's sentiment, feminist cultural critics indicted the phrase "came out of nowhere" as condescension impersonating a compliment. A successful male artist will have a lavishly reported backstory meant to inspire the rest of us. The tale of a young Steven Spielberg sneaking onto the Universal Studios lot (aka the last thirty minutes of *The Fabelmans*) or a young Kevin Smith selling his comic book collection to finance *Clerks* will become Hollywood legend. A newly successful female artist will "come out of nowhere," like a ghost.

No wonder we have a hard time imagining women directors with a fully realized filmography and career. In order to see how Christopher Nolan laid tracks for *The Dark Knight* and *Inception* with *Memento* and *Insomnia* (because the man has always been fascinated with loneliness and skewed realities as subjects) you have see his movies as parts of a whole not a series of one-offs. But how can you do this with women directors if their newest creation feels unconnected to anything they made before it? If we don't know their work as a series of evolving intentions, it will feel like a series of flukes. A fluke "came out of nowhere."

The critic Lili Loofbourow put this best in her 2018 modern classic of an essay "The Male Glance," which remains one of the *Virginia Quarterly Review*'s most read pieces six years after publication. "The Male Glance," writes Loofburrow, is our collective trivializing of creative work by women. We glance at it, declare it special interest product for one gender and move on. By trivializing the art, we trivialize the female artist by viewing her output as "chance, accident, and the passive construction of female artistry—not "How did you create?" but "How were you struck?"

"We are capable of more," concludes Loofbourow, but "The next step is harder. . . . We have remained endlessly receptive to the slightest sign of male genius. (The convention of not classifying White male cis straight texts in exactly those terms has paradoxically made them glance-resistant.) Our starting assumption, to correct for our smug inattention throughout history, ought to be that there is likely quite a bit more to the female text than we initially see."[4]

That next step is up to all of us: Watch as many movies as we can by as many women directors as we can and rave about our favorites to as many people as we can. It is entirely within our grasp and our divine power, even if that seems to place the burden of sexism on all of us to change our behavior rather than the sexist entertainment industry to change its own.

The entertainment industry is already changing, whether or not it wants to. Organizations like the Geena Davis Institute and the USC Annenberg Inclusion Initiative have decades of data on who directs movies and television and how that changes what we see in movies and television. Male actors and directors demanding equal pay for their female colleagues is becoming routine instead of rare. Programs established by Meryl Streep, Margot Robbie, Ryan Reynolds, and Blake Lively have the explicit mission to support and mentor women filmmakers and screenwriters. Labs led by directors Ava DuVernay, Lena Waithe, and Tanya Saracho are doing the same for young women filmmakers and filmmakers of color. Their efforts exist in a galaxy of funds, institutes, and nonprofits all aimed at opening doors for the next Tamra Davis and not just the next David O. Russell. UCLA's decade-old biannual Hollywood Diversity Report has been concluding for pretty much its entire existence that diversity—in hiring and in content—is better for Hollywood's bottom line than the old ways of doing business. Anyone, then, who does not hire women directors should be willing to stand before their board of directors and stockholders and admit they chose stupid business decisions over smart ones.

Most importantly, ordinary people like you and me who love movies are over it. Over talented women directors working twice as hard for half as much, over award nominations and best movies of the year/decade/century lists resembling fraternity pledge classes, over being lied to about how we the movie-loving public don't seem to want movies directed by women when we could stand on one foot and name fifteen examples to the contrary. Collective roars like the seemingly annual hashtag #oscarssomale are the digital vocalization of how over it we are.

Is it a wrong choice then to center the conversations in this book on success rather than struggle? The institutional bigotry faced by women directors cannot be ignored, and I didn't try. That bigotry has kneecapped career advancement and killed movies we will never benefit from seeing. While remaining honest about that loss, I tried to pay as much attention to work these artists *still* gave us. Women directing movies today have climbed through a cracked glass ceiling, avoided a glass cliff, and freed themselves from directors' jail. The idea of a "glass cliff" comes from a 2005 study by British sociologists which concluded that women are often given opportunities when economic or corporate conditions are bad so that failure at a rigged game can be blamed on them.[5] "Director's jail" is a movie version of going over the glass cliff where a female director's bomb will be viewed as a felony worthy of a decade of exile and a male director with a similar failure will be given a misdemeanor, time served, and a sack of money for their next project.[6]

The directors in this book are champions, not victims. I chose to focus on their triumphs. If the motto of the Geena Davis Institute is "If she can see it, she can be it," what I hope I am saying by looking at the bounty of great work by women directors is "If we know it, we can glow it."

I selected filmmakers for this book who have at least one film or television series a reasonably avid consumer would have heard of or seen. While I'm pleased to report that there are enough female directors doing great work to fill twenty books like this one, I saw my job here as not to unearth talent but to show it hiding in plain sight. I also considered it important that, if I'm suggesting we all become experts on movies directed by women, those movies must be ones we can watch. Therefore I kept my questions for the filmmakers to movies and television one could find easily on streaming services or disc.

I chose the interview format because I saw my job much as I did as the moderator at the 2016 New York Comic Con, to ask the best questions and to listen so that, in answering, the directors here are speaking directly to you, the reader. Since this project overlapped nearly perfectly with the COVID-19 pandemic, I could only conduct interviews over the telephone and Zoom. The demands of filmmaking meant I was largely catching directors when they could squeeze me in—in preproduction or on publicity campaigns for a new project, sometimes putting the final touches in late postproduction. One director came out of an all-night editing session, wheeled in by an equally zonked assistant, and conducted our interview over a mug of coffee and on no sleep.

If your favorite director isn't here, it isn't because I ignored her. It's because she could not take time away from her work to speak with me. I had a dream list of at least double the number of filmmakers in the final manuscript and I see it as a positive sign that everyone on that list was in some way busy making work we will be enjoying soon enough.

We live in a cultural moment where directing for television is as prestigious as directing for the movies and documentary, as feature film or limited series, seems to be everywhere. I've therefore also spoken to directors who work primarily in TV or who have had crucial

6 Introduction

moments of their career appear on the small screen. I've also paid special attention to directors who work primarily in nonfiction, as documentaries are both a different filmmaking style and a different filmmaking business. At the front of each interview, I've included a list of the movies and television shows discussed in that interview as well as the actors whose career breakthroughs came by working with that director. Open to any chapter and you'll know immediately what this woman made happen, even if her name isn't familiar to you right away.

For easy binging, I've put each director's filmography in reverse chronological order. The years in parenthesis next to their television credits indicates the years that director worked on that series.

To keep this book at a readable size, I had to limit interviews to American directors. I welcome the opportunity for a sequel, written by me or someone else, of women directors from other countries because that's a book that needs to exist—like, yesterday. For a project about women directors, I have taken that to mean any director who self-identifies as female.

Watching a director's complete work, insisting you do the same or choosing this topic at all, might seem like I'm all about the Auteur Theory, the mid-twentieth-century critical notion that a film comes from the singular artistic vision of the director, much like a novel or a painting. And while I feel like "a Sofia Coppola movie" has its signature style and themes just as "a Francis Coppola movie" does, overall I find auteurism a bunch of patriarchal nonsense. It justifies the delusion that movie directing means ordering a group of subordinates around until they act as handmaidens to your genius. And anyone who has spent twenty minutes on a film set knows that moviemaking doesn't work this way at all. *Barbie* was directed by a woman and photographed by a man. *Black Panther* was directed by a man and photographed by a woman.

Nonetheless, when Sarah Polley, the writer-director of the 2022 film *Women Talking* decided that her movie, about women, told by women, and primarily filmed by women could run a different kind of workplace (a movie set is as much a workplace as an office or factory floor), the very idea was radical enough to land her on the cover of *Vanity Fair*. "Throw out the rulebook," Polley said, about creating a workplace of reasonable hours that left time for the actors and crew to see their families and have the services they needed to tell a painful story of sexual assault tearing apart a community. "People are different when they feel like someone gives a shit about how they're doing."[7]

These simple yet radical notions of moviemaking garnered Sarah Polley the best reviews of her directing career (a former actress, *Women Talking* was Polley's fourth film behind the camera) and an Oscar for Best Adapted Screenplay. "She set the bar," said producer and cast member Frances McDormand of Polley, giving voice to a hope cast forward in time: that this particularly female way of making movies is not a unicorn but the future.

We all have a hand in that future (We tried to interview Polley, who was not available). If we cannot make movies ourselves or control which ones do get made, we can throw our own support behind movies directed by women already here. We can go deep via a little research and a public library card on the back catalogs of women directors that impress us with one movie because, I promise, there are many more and they will continue to impress you. We can become the source for our friends and family of great movies, of all eras, styles, genres, and feeling, directed by women. "You have to see this" is often a better endorsement than a star's charisma, revolutionary special effects, awards, or millions of dollars in marketing.

Does this sound like a capitalist solution to the inherent evils of capitalism? Maybe so. But movies have always been a commercial product, and no director has a future without us the audience voting with our pocketbooks right now. Will we have to convince friends and loved ones that movies made by women aren't just for women? (Was the *Jurassic Park* franchise only for paleontologists?) Will we need to subscribe to some idiotic streaming service we've never heard of for seventy-two hours in order to see a movie directed by a woman that deserves our time and love? That'll probably happen too. The joy of discovering and sharing those movies overrides the little inconveniences almost immediately.

"We all know how to do it," said writer-director Joey Soloway (*Transparent*) in a 2015 *New Yorker* profile. "We fucking grew up doing it! It's dolls. How did men make us think we weren't good at this? It's dolls and feelings. And women are fighting to become directors? What the fuck happened?"[8]

What indeed? Movie making is an inherently collaborative art form because, unlike designing a dress or composing a song, you can't just storm off and finish the project yourself if you and your collaborators aren't getting along. And working together is inherently about listening, generosity, and human relationships, skills we demean as "female" but are a near-perfect overlap with skills we call "filmmaking." It's my pleasure, then, to point out that every director I spoke to was not only eager to praise her collaborators but also eager to tell me about three to five other filmmakers I absolutely had to know. The rewards of women directing movies, for them, for their colleagues, for their industry, and for us, the audience, appear endless.

I hope what you read here leads you to admire the great wealth of great movies already made by women and conveys the gratitude I still have in getting to study their work and spend time with them. I hope it compels you to do the same, to dream about what is possible and, from here forward, never settle for silence.

Notes

1. I was not able to reinterview both filmmakers for this book. Out of respect for their privacy, I have omitted their names.
2. USC Annenberg School for Communication and Journalism, "Was 2023 the Year of the Woman director? Survey Says . . . No," January 3, 2024, https://annenberg.usc.edu/news/research-and-impact/was-2023-year-woman-director-survey-says%E2%80%A6-no#:~:text=For%20women%2C%20there%20were%20no,of%20women%20helmers%20was%202.7%25.
3. Sarah Mendekik, "She Came Out of Nowhere," *Vela*, https://web.archive.org/web/20230202071952/https://velamag.com/she-came-out-of-nowhere/.
4. Lili Loofbourow, "The Male Glance," *Virginia Quarterly Review*, Spring 2018, https://www.vqronline.org/essays-articles/2018/03/male-glance.
5. Emily Stewart, "Why Struggling Companies Promote Women: The Glass Cliff, Explained," *Vox*, October 31, 2018, https://www.vox.com/2018/10/31/17960156/what-is-the-glass-cliff-women-ceos.
6. Joe Reid, "Why Do So Many Women Languish in 'Director Jail'?," *Decider*, February 27, 2018, https://decider.com/2018/02/27/women-in-director-jail/.

8 Introduction

7. David Canfield, "Sarah Polley's Radical Vision for *Women Talking*." *Vanity Fair*, Dec 2022 *Cover Story* https://www.vanityfair.com/hollywood/2022/12/awards-insider-women-talking-cover-sarah-polleys-radical-vision?srsltid=AfmBOop-JdWX-uMCpePZG4Oxp5iUqBKWhtalb1bNWsLmsevm7SIWkp-B

8. Ariel Levy, "Dolls and Feelings," *New Yorker*, December 6, 2015. https://www.newyorker.com/magazine/2015/12/14/dolls-and-feelings.

Section 1
Trailblazers

Amy Heckerling, Julie Dash, Patricia Cardoso, Cheryl Dunye and Barbara Kopple

The five interviews in Section 1, "Trailblazers," are women filmmakers who broke new ground in their genre: Barbara Kopple, the first women director to win the Best Documentary Oscar twice; Cheryl Dunye, the first Black lesbian to write and direct a feature film; Amy Heckerling, the creator of the modern teen movie; Patricia Cardoso, the first Latine woman to direct a movie inducted into the Library of Congress's National Film Registry; and Julie Dash, the first Black woman to direct a feature film in general release in America.

"Firsts" are complicated. Sometimes they can be proved (Dorothy Arzner, mentor to Francis Coppola, was the first woman to join the Directors Guild of America), but often they can't (the first romantic comedy? Define your terms. Jane Austen might have something to add here). When they can't, it's usually because we've gotten tripped up on vocabulary ("Is it a romcom if I cried more than laughed?"), which keep us at arms length from our purpose: honoring the women who cleared an impossible path and inspired the work of so many who came next.

The five directors here who come "first" could have been included in other sections of this book. Indeed, since all of them continue to make great work, I could have placed them (as well as, really, every director here) in our final section: "The Female Future." These five sit up front because they were most often spoken of as inspirations and mentors to the rest of the group. "An OG" is what Tanya Saracho called both Patricia Cardoso and Cheryl Dunye. "A legend," Jessica Sharzer noted of Amy Heckerling. These are the wise elders named and praised by their students, nieces, and daughters.

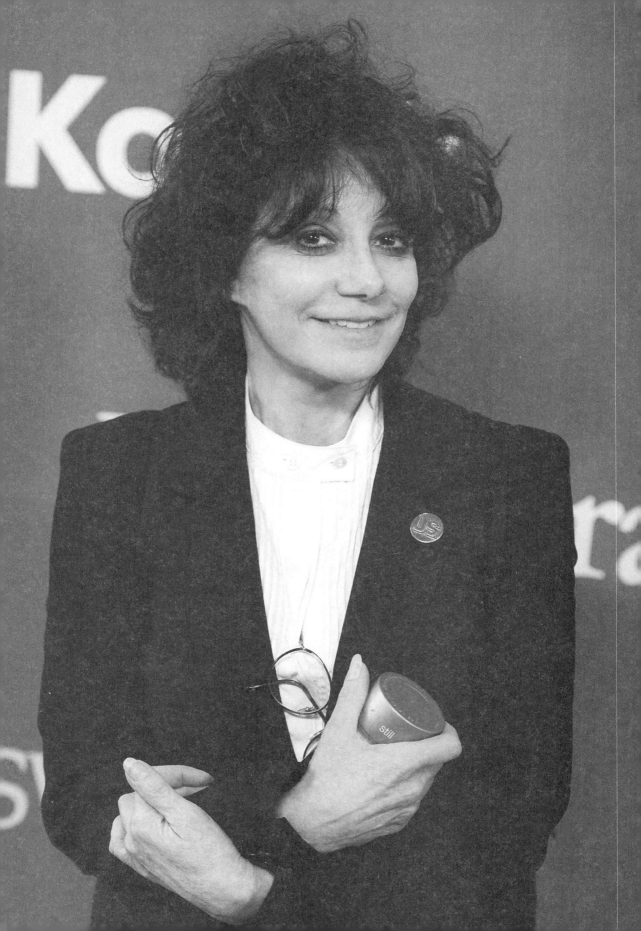

Amy Heckerling (b. 1954)

Films Mentioned
Vamps (2012)
I Could Never Be Your Woman (2007)
Loser (2000)
Clueless (1995)
Look Who's Talking (1989)
National Lampoon's European Vacation (1985)
Johnny Dangerously (1984)
Fast Times at Ridgemont High (1982)
Getting It over With (1977) (short)

Television Mentioned
Red Oaks (2015–2017)
Gossip Girl (2007–2012)

Actors Launched
Phoebe Cates
Stacey Dash
Donald Faison
Jennifer Jason Leigh
Brittany Murphy
Sean Penn
Paul Rudd
Alicia Silverstone
Forest Whitaker

Amy Heckerling is the only filmmaker I spoke to who directed the defining movie of a generation—twice. Her 1982 debut *Fast Times at Ridgemont High*, an ensemble film of six high school students growing up too fast in the San Fernando Valley In the early years of Ronald Reagan's America, kicked off the teen movie boom of the 1980s and became the cool senior in the cinematic high school that would later include *The Breakfast Club*, *Pretty in Pink*, and *Heathers*. *Fast Times* received induction into the Library of Congress's National Film Registry in 2005, alongside its classmates *The French Connection*, *Miracle on 34th Street*, and *Toy Story*. In 1995, Heckerling wrote and directed *Clueless*, which did for early millennials what *Fast Times* had done a decade before and is likely headed for that same National Film Registry any year now.

Had Ms. Heckerling perfected the modern teen movie alongside John Hughes, Cameron Crowe, and Savage Steve Holland well, as they say at the Passover Seder table, it would have been enough for us. But equally big is her eye for talent and ear for dialogue. The number of actors you know who owe their career breakthroughs (Sean Penn, Jennifer Jason Leigh, Alicia Silverstone, Paul Rudd), comebacks (John Travolta), or revaluations (Bruce Willis, Wallace Shawn, Ray Walston) to being cast in an Amy Heckerling movie could fill a jury box plus alternates. As a screenwriter, her accomplishments include the minor fact of adding the phrase "As if!" to the English language.

12 Break the Frame

Heckerling has directed nine feature films for as many television series and wrote the book for *Clueless, The Musical* (2018). A graduate of NYU and the American Film Institute, she's the winner of AFI's Franklin J. Schaffner Alumni Medal and the Crystal Award for Women in Film. Her screenplay for *Clueless* received a Writers Guild of America Award nomination in 1996.

Amy Heckerling spoke in 2015 and early 2020 from her home in New York City.

Kevin Smokler: I know you are a night person.[1] Has evening always been your most productive time?

Amy Heckerling: Oh, I don't know about productive, but yeah, I've always been a night person. So naturally school was a pain in the neck, but once you get to college, like after the first year, classes are not all nine in the morning. And then when I was able to control my schedule. It just seems like the chatter is less at night.

KS: I get that.

AH: I mean in my brain, you know?

KS: Did you start working at night in film school? Did you schedule your classes to begin at one in the afternoon or something like that?

AH: No, I had to work around what I needed to have to graduate, and also I had jobs at night because I was working a few different things while I was in school. You did what you could. I don't know if it's the best way to do things. Everybody's stuck in their own heads and it's just too much. What is it? "The world is too much with us"?

KS: What was the origin of the idea for "*Getting It Over With*?" [the adventures of a nineteen-year-old girl trying to lose her virginity the night before her twentieth birthday], and how did you decide that it was going to be your final project at AFI?

AH: The idea of being the last virgin that I knew of and I had this thing about schedules about that you have to do this by the time you're this old.... I thought that's how everybody's brain worked. I don't think it does. But it was sort of like instead of a romcom, an OCD-com where X amount of hours to find love, get it done, and that schedule must be adhered to or the world will come to an end in some way.

KS: From early on, a lot of your movies—*Fast Times at Ridgemont High, Clueless, Loser,* even *Vamps*—are about young people. The same is true for your television directing [*Gossip Girl, Red Oaks*].

AH: Yeah, well it's fun. You do stuff where people work in an office, they're all people that do that job. Or even when they're in college they're all people that are majoring in the similar thing. But high school is like all different types of people thrown together and getting romantically involved and figuring out who they are. There's so much going on that it's just so fun. It's a fun thing to play with.

KS: You've also worked a lot with young actors after they were no longer young actors. [Heckerling cast Alicia Silverstone in *Clueless* when Silverstone was in her late teens playing a high school student and again in *Vamps* when she was in her mid-thirties and playing a young professional.] It doesn't matter how old you are. You maintain an interest in young people grappling with the adult forces in their lives.

AH: Yeah, of course.

KS: I love that. I think a lot of us get older and suddenly think young people have nothing to teach us.

AH: Oh God. Young people always have something to teach you.

KS: *Fast Times at Ridgemont High* was not only your directorial debut but a breakout for so many of the actors—Sean Penn, Forest Whitaker, Jennifer Jason Leigh—in it too. What do you look for in casting a young person's role when the right actor for that role might be twenty-six years old or fourteen?

AH: There's usually not a perfect match between the character in my head and the right actor. In the best of all worlds, I find someone who brings something I hadn't thought of. But ultimately, I'm trying to find the right person for the project, not trying to show the town or the studio how smart I am by whom I chose. The studio usually has all sorts of suggestions. The right actor may come from there or it may have been someone you were thinking of but didn't see in the right context right away. So you don't always know if the right person is someone you bump into every day and fall in love with or did the elders in the community set it up for you?

KS: In *Clueless*, there's probably a good three or four actors who owe their careers to that movie. What is it like to see those actors bloom and get nominated for Oscars and things like that later in their careers after having a great part in one of your movies?

AH: I'm thrilled that some of them have been both nominated for and won Oscars: Jennifer Jason Leigh, Sean, Forest Whitaker, and Saoirse Ronan. Saoirse played Michelle Pfeiffer's daughter in *I Could Never Be Your Woman* [Ronan's debut film when, she was eleven, that Heckerling wrote and directed in 2007], so I will always think of her as a kid … Meryl Streep in a kid's body. I feel like mom back home watching them, cheering. I mean, even when I see Sean Penn playing like really crazy, evil characters, at some point or other they'll be like a hint of a smile and I see Spicoli. I mean to me he's always got that sweet person in him.

KS: *Clueless* takes place explicitly in Beverly Hills and the Valley. *Fast Times* was shot in the Valley and also in Santa Monica, but the story happens in a fictional place called Ridgemont. What was behind the choice to fictionalize *Fast Times*' locations while making plain those in *Clueless*?

AH: The characters in *Fast Times* are based on real high school students that Cameron [Crowe] wrote about in his book that was the basis for the movie. At the very least we had to make the movie its own thing to protect their privacy. To shoot in LA and not in San Diego, where the high school actually was, that decision was already made when I came on. To shoot on the lot, at the mall nearby, at the school nearby, that meant an executive could stumble out of bed and check on us. Which made sense. It was my first movie and Cameron's first movie. And *Fast Times* was the kind of small-budget film where nobody was being put up in a hotel and everyone drove themselves.

KS: Ridgemont seems like a small town and the Los Angeles of *Clueless* feels like a giant sprawling metropolis, like in the scene where the characters argue about who will drive who home from the party in the Valley …

AH: The directions argument in *Clueless* I'm afraid comes straight out of Jane Austen. There's a scene in *Emma* where they argue over who will leave with whom in which carriages. Reading it you know that even back then, driving home with someone was really about who gets private time with who, not just who is going in which direction but who gets to spend time alone with who. The trick is convincing that person that it was an intelligent solution. It's the same old story whether you're talking about a carriage or driving or an Uber.

KS: Where did the choice to begin and end *Fast Times* at the same mall come from?

AH: I was not at that time a mall expert. The theme of the movie was the characters were growing up too fast. They were all working people with jobs even though they were really still children. I liked the action all being in one place on a single boulevard or consolidated all in the same building under one roof where kids at different jobs would walk past and run into each other all wearing their uniforms from work.

That idea came from a movie that I loved called *Mean Streets* [Martin Scorsese's 1973 breakthrough film that also changed the career trajectories of stars Robert De Niro and Harvey Keitel]. After all the adventures and romance that happen in this one neighborhood, you see the neighborhood closing down, the lights going off in the buildings, the neighbors closing their shades. I wanted to do the same with the mall in *Fast Times*. We've gone on this journey, now we're saying goodbye. There's something deeply satisfying about that. The studio [Universal] had made *American Graffiti* about ten years before, which ended by telling you what happened to the characters. They wanted to know what happened to everyone and I thought, "Do we really need that?" We just saw a whole movie showing what happened to them. But they were insistent.

KS: *American Graffiti* was a period piece. *Fast Times* takes place entirely in the present.

AH: It's hard to say what will happen to the characters in the future because the future hasn't happened yet.

KS: Many of your movies pay real attention to these artificial ideas of time. Both *Clueless* and *Fast Times* are about a school year. *National Lampoon's European Vacation* is about a two-week vacation the Griswold family wins at the beginning of the movie. *Johnny Dangerously* is told in flashback so there's a time boundary grafted over the story.

AH: Well, *Johnny Dangerously* being told in flashbacks was something that was added on much later. It was more along the lines of straight gangster movies that start when you're a child and then you see how the neighborhood and the forces and the environment kind of turn somebody that's a good person into a gangster, the way that every character in those old Warner Brothers movies starts. And then when we tested the film, it wasn't getting the numbers that they wanted. And two of the executives said we had to sweeten it up. Oh, God. And so, one thing was that he should be this just cuddly guy and he's telling you the story as a sort of cautionary tale.

KS: I don't think anyone would watch *Johnny Dangerously* and confuse Michael Keaton playing the main character with a cold-blooded 1930s movie gangster like James Cagney.

AH: Even the shootouts and massacres are still played for comedy. But they were taken out because they said, "No, we can't have this. We can't have that." And I thought everybody would understand we're making fun of these things. I love those old gangster movies. So I thought I had hit upon something that I loved a lot and I thought that the writing was funny. And another thing was, after doing *Fast Times*, everybody was sort of trying to get me to do more "girls lose their virginity" movies. I felt like the movies that females were doing, they were allowed to do smaller films. They were allowed to do films with female themes, but it felt like, "I want to do what the boys do."

KS: I love how, in your work, you seem particularly drawn to characters who are forces of nature, where that character can walk down a hallway and pull the attention of the whole movie towards them. Jeff Spicoli is that kind of character. Johnny Dangerously is that kind of character. And it seems that kind of role in movies is typically given to men, except Cher Horowitz is that character too.

AH: Scarlett O'Hara might have not been taken seriously, but that's a pushy, self-centered female who is a force of nature who will do whatever it takes to keep her house and try to get somebody else's man. There are examples of them often not so likable. A lot of the Bette Davis characters are not people that you go, "Oh, I want to be friends with her."

KS: Exactly. But unlike those examples. Cher Horowitz manages to be charismatic, self-centered, and also admirable at the same time.

AH: Well, we got to take our hats off to Jane Austen for that because she created a character in a time when women were not so strong who was a very strong character and not perfect, but grows and never doubts her abilities and her strengths, the freedom to do things or get things done.

KS: Even though you didn't write *Fast Times at Ridgemont High*, it seems like there's a parallel between Jeff Spicoli and Cher Horowitz, an unshakable belief that things will turn out okay if you just have the right attitude or frame of mind.[2]

AH: Well in *Fast Times*, of course, the most successful character was Spicoli and Spicoli didn't even understand that people were mad at him. And that cracks me up. Also, a lot came from my daughter because my father was a very, very angry man. The slightest thing would make him start yelling. And I had this little toddler and he'd start yelling and she'd just start cracking up, and then he would look at her and they'd start laughing. And I was like, "How did she know that that would work?" That never would have occurred to me. And so it's kind of Spicoli-ish. So I thought these characters, they can't even understand somebody being mad at them, not even having the concept that the world may not be a great place. That the things you want are accessible. There will always be waves.

KS: Yep.

AH: And that you enjoy your friends. You get burgers. And that, that's enough to make you happy. I mean, how do people go through life like that? That's not where I live. And I don't get it, so it fascinates me. So that character or that kind of feeling came first. And then I thought, "Well, what's the story of a person like that? Where have I ever read of them or seen them in film?" I mean I've seen them in films obviously—characters that assume things will go great, are always thinking of the next thing they can do to manipulate the world into what they want. Like when my mother was reading *Gentlemen Prefer Blondes* [the 1925 novel by Anita Looslater adapted into a 1953 film starring Marylin Monroe and Jane Russell] and I pick it up and this female character assumes all men love her. And that was like, "Oh, so you can say, 'Oh, I kind of have a headache' " because the diamond they were bringing wasn't big enough? Or "Those curtains will make a great dress"? And then I remembered in college that I had read *Emma* [Jane Austen's 1816 novel and the last one published before the author's death the following summer] and I reread it and was like, "Fuck, this is great." But it also felt so like I had seen it a million times, too, because I remembered when I was a little kid and I watched *Gidget* [the 1965 sitcom about a surfing teenage girl that launched the career of Sally Field], actually the reruns when it was on in the afternoon. And at one point a goofy exchange student comes and Gidget does a makeover on her because she's so like out of it. And when she's made over, she becomes really popular and then she starts to like Gidget's boyfriend. And I mean here it was in this California teens TV show where Gidget thinks she can do everything and now it's, "Oh no. I created a monster." She can make everybody's lives better not knowing that she's screwing up her own life. And there it was. I mean I assumed that writers of TV shows have read classic books, or maybe it's just one of those things that always happens.

KS: So *Clueless* ends up being a little *Gidget*, a lot of *Emma*, and a little Jeff Spicoli?

AH: Yeah, but the first glimmer was like, "What's the deal with positivity?"

KS: My favorite example of that with Cher Horowitz is the look Alicia Silverstone gives the driving instructor when he says, "Well, let's see. You can't parallel park. You can't make left turns. You damaged personal property and you nearly killed someone. Offhand, I'd say you failed." And Cher is still nodding like, "Sure, sure, and now you're going to give me a compliment, right?"

AH: It's a bubble that won't burst.

KS: I didn't remember that scene because I've seen *Clueless* twenty-five times, even though I have, or because I have such a fantastic memory. I remember it because *Clueless* is one of the most quotable movies of all time.

AH: I think that should go to *Casablanca*, but thank you.

KS: I'm guessing that wasn't your aim when you wrote *Clueless*, saying to yourself, "I got to have three zingers in this scene and five in this one." So what it's like for you that one of your great creative legacies will not only be the movies that you made and the actors that you discovered, but simple phrases like "As if!"?

AH: I had an ex-husband once and he was a comedy writer and he'd think in terms of zingers and buttons and things like that. My brain doesn't work that way. But also so much of what I've done is based on my traits that are the opposite, that are insecure or feel stupid or don't know how people do things. And another thing was, in school I never knew like, "How are these people standing around at recess and they talk to each other?" How do they know how to do that?

So from a very early age I was writing down snippets of things people said because it confused me. Like how do they know to do that? Just interaction of people and conversing was a very ... I mean I always felt like kids should shut up, and then when it's time to talk you don't know what to say. I mean I panicked before meetings. But in any case, when I was writing, you know, you sort of work out the story and the characters and things that you remember from people that you like or personality traits or all those things to build all of that stuff. At the same time, as you may have guessed I have a New York accent.

KS: Yes.

AH: And I am from a different time period than the characters that I was writing about. But you know of course I had friends that were younger and that were actors and talked and they had a certain way of speaking. And I watched MTV all the time when they used to have videos and crap. And there were rap songs that had specific speech patterns and vocabulary and I just compiled my own dictionary. I don't know if I told you about that.

KS: You hadn't, no.

AH: Because when you're writing and somebody goes, "Oh wow. That's great," well, nobody just says "great." They say it specific to where they come from, how old they are, what their other friends are saying, what profession they're in, what school they go to. So there are five billion ways of saying something positive about something, but which one you choose becomes very important. And it tells you too much about who you are. I feel like there are certain words that are in certain films I did that no matter how old I am or what year it is, I'm kind of allowed to say them, you know? Like I got some sort of bus pass for it for whatever. But mostly that's the fun of it. Who says what kind of words?

KS: Your films are often rich in different characters of different ages and different backgrounds. So it's easy to have many characters that speak many different ways.

Because you make movies with large casts, you don't need the lead character to say everything that might interest you as the writer.

AH: Certain kinds of speech go with different people. One of the most fun things for me was in *Clueless*, the Christian character because I was able to incorporate speech patterns from old movies that I loved. And there was a little glimmer of The Rat Pack being in style in the nineties for a minute.

KS: When he arrives to pick Cher up for their date and you shoot him from the side and he's still wearing the hat and he spins on his heel and looks at Cher's dad and says, "Nice pile of bricks you got here, man." It's that whole character in eight words.

AH: The Christian character is somebody that is creating a persona because he was a creative guy but also hiding something. So he would make a whole other speech, a way of language for himself. He would have a whole other way of dressing from the others. And so I just put him into that world so that I could have fun with all the 1930s slang.

KS: It feels to me like the screenplay for *Clueless* finishes or carries on with something the *Look Who's Talking* movies started, movies where a woman is at the center.

AH: Just trying to weasel my way through the system. At a certain point in time in the days of old, if you were doing a comedy, you needed Bill Murray or the next group of Bill Murrays so that they can know that there's a reliable person that they know is funny no matter what, that they know that they can sell no matter what. There was no female like that. So in the case of *Look Who's Talking* I had an idea with this talking baby and the woman and their relationship. But I knew nobody was going to give me more than ten cents to make a female movie, and so I had to sort of get one of those guys, and I knew I couldn't because I was a woman and my last two movies—well, *European Vacation* I wasn't very proud of and *Johnny Dangerously* didn't make money. So I knew my stock was down, as they like to say, and if I was going to get to do my movie that was in my head I had to sort of trick everybody into thinking that I had one of those. So I figured, "Well, I could get one of them for a day doing the voice and the voice would be throughout the movie." And it would be like I had a Bruce Willis movie. So that was part of the weaseling your way through the maze, you know? How do I get a little drop of the cheese that all the boys get?

KS: What are the different sides of you that come out as an artist when writing versus directing?

AH: The writer in you wishes there was a better director. The director is saying, "Who the hell wrote this crap?" After *European Vacation* [Heckerling's third feature, from 1985], which is a great movie that everyone should rent and fall in love with, was not a great experience for me, I didn't want to work with people I didn't particularly get along with. That shifted my focus back to writing my own scripts.

KS: Who are your cinematic peers, influences, and disciples?

AH: As far as the ones that were active when I was growing up and I was a student, my big heroes are Mel Brooks, Martin Scorsese, and Woody Allen. New York filmmakers. In my own generation, Martin Brest [*Beverly Hills Cop*, *Scent of a Woman*], one of my best buddies and a brilliant filmmaker. Also Harold Ramis [*Caddyshack*, *Groundhog Day*], who had the humor and the heart and wanted comedy to say something too. As far as female filmmakers, I look at Joan Micklin Silver [director of the legendary romantic comedy *Crossing Delancy*] and Lina Wertmuller [the pioneering Italian director who received an honorary Oscar in 2019]. Filmmakers today? Judd Apatow, Seth Rogan, James Franco, all brilliant.

KS: Jud Apatow would probably call your work an influence of his.

AH: I know him. But his movies are purely his own and are wonderful.

KS: What's it like, directing for television on shows like *Gossip Girl* and *Red Oaks*, which were created by someone else?

AH: You know, it's kind of like doing a puzzle as opposed to creating a character and what's happened to them, and why you want to be doing that and coming from you and your own insecurities: okay, this character is this and that's that. Now they're going to do this, and what is that saying, so how do you want to be showing that to people? So how would you shoot it, but also what have they got for you to be shooting, and how could you use that, and what things would fit into the DNA of the show that would be cool but accomplishable? So it's like you're sitting, you're writing your book, or you're doing a crossword puzzle. They both use the brain but in different ways.

KS: Literally like a puzzle. An episode of TV has to fit into something bigger.

AH: I know, and sometimes they're not sure because you'll go, "Well, is he going to like her eventually?" And they go, "Oh, we don't know yet." I mean, what do I want, like a lingering close-up? Do I want to move in, or do I want to just like they answer the door and walk off? *Gossip Girl* was very ensemble-y, kind of crazy but I liked the fact that it had an old movie feel. At the time, shaky cam was very in style. Everybody wanted to show that they were so realistic that it was a documentary and for some reason on documentaries, you hire people that have very shaky hands that can't hold a camera. So then I see this TV show that has these beautiful shots of New York and of these young people and of elegance and fashion, and it felt more like it was coming from another place, another time period. And *Red Oaks* [an early Amazon Prime series about teenagers working at a New Jersey country club in the 1980s] people are going, "What is this streaming stuff? Is this going to be anything?" And Amazon, who knows who they are?

KS: It's where you order a vacuum cleaner and have it delivered to your house.

AH: Yeah, so, what—you get packages and also TV shows? Anyhow, they had Paul Reiser and Richard Kind and all these great young people. So that was fun. And also the producers were great.... If I said, "Can he say this? Can I have him do that, is it okay? How would you feel about blah, blah, blah?" they'd let me contribute more to what was going on in the story and what people said, so I liked that. That was very nice of them.

KS: There were many fewer women directing when you started than there are now. Change is happening way too slowly. But I also feel like some kind of dam is breaking, a break that you started.

AH: Oh, I don't know. I don't feel like I got anything done or did anything. You just have to trick the system constantly. I go in and talk to NYU kids sometime, and, yeah, I just keep pushing.

KS: Is it strange to you that you get asked to do these? That you are seen as a sort of a mentor and an elder statesman to these succeeding generations of filmmakers?

AH: Oh my God, if I started feeling like that it would be so weird. I don't even want to, like, allow that into my brain.

KS: Do you say the same thing every time or do you sort of let the students and their questions guide your answers?

AH: I find out what they want to include and what they want me to be talking about. And then as quickly as possible, I try to get the kids to talk.

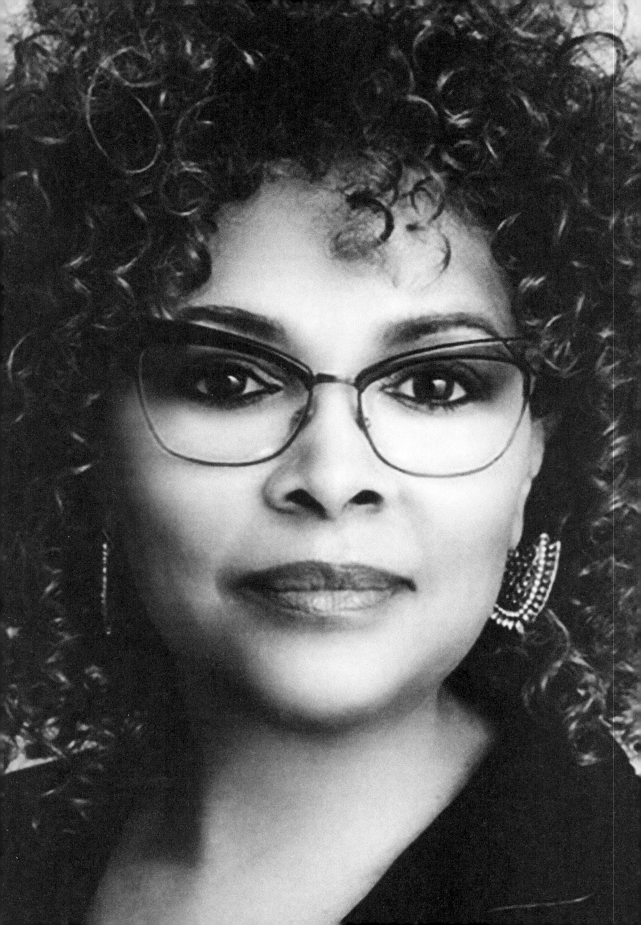

Julie Dash (b. 1952)

Films Mentioned
Funny Valentines (1999)
Daughters of the Dust (1991)

Television Mentioned
Women of the Movement (2022)
The Rosa Parks Story (2002)

Music Video Mentioned
Tracy Chapman, "Give Me One Reason" (1995)

The story of 1991's *Daughters of the Dust*, written and directed by New Yorker Julie Dash, may go down as one of the great redemption stories of modern cinema. Dash's first feature film told the story of the early twentieth century Peazant family on the day of their move from a coastal Carolina island to the mainland. It premiered at Sundance in 1991, was nominated for the Grand Jury Prize, and won top honors for Best Cinematography. Released in theaters the following winter (and considered the first widely distributed American film directed by a Black woman), critics called it awe-inspiring, a painting come to life, a masterpiece.

And then ...

Julie Dash could not make another movie. She clearly had the chops, relationships with talent, and stories to tell but could not get financing or studio buy-in for another chance. One studio labeled the movie a fluke despite two sold-out runs in New York. A talent agency told her she had no future.[3] In a 2007 interview, Dash put it gently and probably nicer than she had to: "Hollywood and mainstream television are still not quite open to what I have to offer."[4]

And then ...

Well, really "by then," because by then the world had begun to notice what the admirers of this movie and its visionary writer/director already knew. The Library of Congress added *Daughters of the Dust* to its National Film Registry in 2004. Younger Black directors like Ava DuVernay [*Selma, Origin*], Barry Jenkins [*Moonlight*], and Kasi Lemmons [*Eve's Bayou, Harriet*] talked about Dash as a pioneer who made their own careers possible. In 2016, as plans were already underway for a Blu-ray release of *Daughters* for its twenty-fifth anniversary, Beyoncé dropped her now legendary album *Lemonade*, complete with forty minutes of filmmaking to accompany the music. In the videos, her legions of fans discovered a striking influence from almost three decades ago, Dash's *Daughters of the Dust*. "This year's most original movie," wrote *New Yorker* film critic Richard Brody that November, "was made in 1991."[5]

Call it a comeback in terms of recognition, but certainly not in terms of output, because Dash had kept directing this whole time—television movies, music videos, short films for magazines like *Vogue*, and installations for museums. Most of all, the industry that didn't know what to do with an artist like Julie Dash and her deeply poetic and human style of filmmaking now has two generations of directors she inspired to contend with.

Dash was a member of the L.A. Rebellion, a pioneering generation of Black filmmaking graduates from UCLA in the 1970s. Currently an Endowed Professor of Art & Visual Culture

22 Break the Frame

at Spelman College, she's the recipient of a 2017 Women & Hollywood Trailblazer Award and a 2016 New York Film Critics Special Award. The filmmaking of Julie Dash has won and been nominated for awards from Sundance, the Directors Guild of America, and the NAACP Image Awards.

I spoke to Professor Dash from her editing suites in September 2023.

Kevin Smokler: I found a photo from the *Daughters of the Dust* shoot of you standing parallel to the camera. And on the camera is a piece of tape that says, "Let's get with it!"[6]

Julie Dash: Yes, we had a very young, lively AC [assistant cameraperson] who used to put little phrases on there. Like motivation! "Let's go!" "Let's get with it!"

KS: Did that phrase change each day of the shoot?

JD: Maybe not each day, but pretty often it would have something, you know, some punchy little witty statement or something. It was a grind. We needed this motivation every day to get up early, go out there, and face those little gnats that bite, flesh-eating. It was a very intense environment. Let's say that.

KS: I know you have visited the Sea Islands regularly in the thirty years since filming *Daughters of the Dust* there. But I'm wondering if you could if you have a predominant or a single sense memory from that shoot, a feeling, a smell, a touch, a taste, just something that always says that moment in your filmmaking career to you?

JD: Probably the smell of the ocean, the freshness of the ocean. Seafood, of course. Our favorite thing was to go to this little place called the Shrimp Shack, where they actually made shrimp burgers. Instead of hamburgers, they grind up and make little patties. And we would have shrimp burgers every day.

KS: The shoot began very early in the morning didn't it?

JD: Yes. like a 5:00 a.m. call. Yeah, we were out there. Sunrise.

KS: And that was to make use of the natural light?

JD: Absolutely. And it also became a kind of spiritual awakening. We'd get out there and would bring all of the equipment out because everything had to be hand carried into location. We weren't allowed to use trucks, nothing, only three-wheel vehicles like a wheelbarrow. And we'd be out there, and the sun was rising and people would just like take a five-minute break and just sit there and kind of meditate and feel good and be thankful for all things, including being able to be a filmmaker, to be able to work on a film company, to be able to work with such a wonderful cast and crew, because the cast and crew came from everywhere, from LA, New York, Atlanta. And it was kind of a spiritual thing in the mornings. And it was really lovely. I will never forget that, both the visuals of the sun rising and of the days planned, and you just kind of sit for a moment in silence and just let it all unfold! Let's see if it'll ever happen again. I can't say that I've experienced that on any other production. That feeling of wow, that feeling of wonder.

KS: There's something about the whole movie that's kind of imbued with that wonder, isn't there? In 2020, A. O. Scott, the former film critic of the *New York Times*, referred to the time since he first saw *Daughters* in the theater as "28 years of awe."[7]

JD: Wow. Okay. It was more than a production. It was an event. It was a be-in. We were *there*. There were some marriages that came about afterwards. One cameraperson, she married the cast member who played Daddy Mack [Cornell Royal] and they had a child and, yeah, a lot went on. A lot of relationships bloomed.

KS: So many of the people who worked on *Daughters of the Dust* carried the spirit and the magic of it into the rest of the rest of their careers. Not just you and [cinematographer] Arthur Jafa, of course, but Kerry James Marshall and Cheryl Lynn Bruce.[8]

JD: There was a lot of talent there. I feel blessed to have been able to have worked with them. People have passed away. Cora Lee Day [who played the family matriarch, Nana Peazant] passed away [in 1996], Kaycee Moore [who played daughter Viola Peazant, in 2021]. Also the man who played Daddy Mack, all of these people have passed. Hopefully it leaves something for their relatives, to be able to look at the film and see them and know they were really great.

KS: There's so many incredible faces in *Daughters of the Dust*. I can't separate my memories of seeing it from the opening shots of Cora Lee Day's hands and her incredible gaze. Watching *Daughters* again, and then watching *Funny Valentines* [a 1999 cable television film starring Alfre Woodard and Loretta Devine about the rekindling of a relationship between two cousins, based on a short story by playwright J. California Cooper], and watching *Ride to Freedom: The Rosa Parks Story* [a 2002 TV movie for CBS starring Angela Bassett], I get the sense you—particularly with actresses—really like to cast people whose appearance on screen is kind of timeless. These could be actors from the 1990s or from the 1920s.

JD: Well, I like to cast interesting faces that we normally don't see every day on television or in the movies, faces that have a story within the face itself. The eyes speak volumes. I love to cast against grain, against what's expected of me, because the faces themselves, they become characters themselves. They're not only faces that you see at the supermarket, they're faces of what our relatives really look like. They're not coming from the casting list that they send you—this person is available, that person is available. Yeah, they're very attractive. Yeah, that's what you think. I want to cast people with substance, faces that have resonance.

KS: The great C. C. H. Pounder[9] is a contemporary of Alfre Woodard's and yet plays her aunt in *Funny Valentines*. I've been watching Ms. Pounder on screen for thirty years now. I don't think I've ever seen her play someone's mother until you cast her in *Funny Valentines*, as Loretta Devine's mother.

JD: Right, they're probably all the same age! She knew how to do *exactly* what I was asking for. It's like, when you go to visit elderly sick women in the hospital, they always have their hospital wig ready for visitors. And they only put it on, you know, "Visitors! Gotta put the wig on!" But they do it so quickly that it's never, like, on straight. They want to get it on and it's kinda like a hat! And they didn't know what I was doing with that, but she knew, and she knew how to play that. She was laying there dying, but it's like, "Where's my wig?" That was, of course, an ad lib, "Where's my wig?" And it just works out so perfect. People who know, know; they recognize that situation, recognize their grandmother or auntie in that situation.

I did another film with a woman, an older woman, who had her house hat on. Don't ask me why, but I grew up seeing people, they would have their house hat. And it wasn't always a scarf like they do in other movies. You know, like "Let's tie a durag or a scarf." No! You got to have your Sunday hat, your house hat, your sleeping hat, your hat for when you're out in the yard.

When I did *Women of the Movement* [a 2022 ABC miniseries about the attempt by Mamie Till-Mobley to gain justice for the murder of her son Emmett Till], I said, "I want

24 Break the Frame

this character to wear a brown paper bag hat." And they would say, "Well, I've never heard of it." And I said, "Yeah, but I've seen it!" And they'd say, "Well, no, no one will know what it is" and it went back and forth and back and forth. And finally, I folded it myself and I have the character wearing a brown paper bag on her head outside, working in the yard. Because maybe her straw hat was damaged? I don't know. But people still wear brown paper bags on their head in the South. And I don't know how to explain it. They were saying, "Well, people ... they haven't seen it." Well people haven't seen it because they haven't seen it on film! And so I did it, and to the last minute, they were saying no, I couldn't do it. The producer would say, "No, you can't do it. Because people ... it'll confuse people." It's like, "But I've seen this!" Why isn't that good enough? That this happens. It's not like something that happens in California. So how could you have seen it? You're from LA! And so we did it, it worked out well. It's trying to be authentic without being phony authentic. Because the phony authentic is just throwing a scarf on someone's head because they did that seventy years ago in *Gone with the Wind*. But that's not real. That's not the way people tied their head up in the first place.

You have to understand that it's persistence of vision. In West Africa, where we came from, people would tie their head up in different ways. It meant different things. It might mean you're a maid, it might mean you're divorced, it might mean you're a widow. All the head ties had a different meaning. So it's not like we forgot that. I mean, people continue to tie their head up the same way. And it was never tied up the way it was in *Gone with the Wind* with Mammy; like pull that way and twist it. Nah.

KS: I've read that you had to defend many of the similar choices you made on the set of *Daughters of the Dust*, where people had a hard time believing that on this particular day at this particular time when the Peazant family is about to board boats and leave the island, that they would all be dressed as they are.[10]

JD: From people assigning meaning to different things I've seen in Hollywood. Of course, the Hollywood designers and everything, they're trying the best they can to just tell a story, and they just do whatever, but if it doesn't have meaning, if it doesn't have resonance, then it's just some s.i.c stuff, y'know? Why do things have to always be the same, as if there's a standardized way Black people dress and look? And, you know, even with *Daughters of the Dust* the white dresses were freaking some people out, because at the turn of the century, if you saw a Black person, they were working in the field, and it was an agrarian society and so therefore everyone has on field clothes. But not on a Sunday picnic! ... You have your Sunday-go-to outfits, and we made sure that all of their white dresses were at least ten to fifteen years *older* than the time period. So it's more like Gibson Girl dresses, the hand-me-downs. And also, I saw photographs of, pictures of people in white dresses at the Penn Center [an African American cultural and educational center on St. Helena Island, South Carolina, founded in 1862] before we started shooting. They had all these different kinds of hats, but we didn't have enough money for the hats that they wore to recreate those. But there was a lot there. And I think it's incumbent upon directors to seek out what's authentic to each region and not assume that every region is the same and everyone wore the same thing that you've seen before.

KS: Your costuming choices are so precise and important to the overall effect of the films you make. In *Daughters*, for example, that the character of Yellow Mary's companion [Trula Hoosier] is dressed in yellow, but Yellow Mary [Barbara-O] is not, says volumes about that relationship.

JD: Because Yellow Mary's name is Yellow Mary, but her companion is *really* yellow. So why are you calling her this?

KS: Mr. Sneads' [Tommy Redmond Hicks] suit is too tight and a bit too layered for a hot day.

JD: He represents, you know, the New Negro, the Philadelphia Negro, who is, you know, going to come down to the Sea Islands and photograph all these kind of like "primitive" Black people and perhaps go back up to Philadelphia or Boston and have a big exhibition, a show. When was the last time you saw a Black person with sunglasses on in a period film?

KS: I saw this same idea at work in *Women of the Movement* too. You have Gil Bellows and Timothy Dalton playing the attorneys in the episodes you directed, and they're both—even though this is a Mississippi courtroom—they're both dressed as if they're working in a courtroom in New York or in Boston. And you have the defendants dressed in the exact same clothes as the sheriff. Which suggests a ton without saying anything.

JD: And the jury! They all have khaki pants on. And yep, well, you know, that's the wonderful costumer who came up with that look, and that really tickled me that everyone had the same khaki pants from Sears and the same white T-shirt.

KS: Clothes are such a fundamental part of your work.

JD: In *Funny Valentines*, the [church] usher costumes had to be built. And that's because that's the way I remembered them growing up in New York City. They were, like, militaristic ... you got the braid, and you had those medals.

KS: This is still Professor Dash speaking?

JD: I don't know (*laughs*). But it is not like the ushers that you usually see in movies that depict something in the South. It's always someone just fanning and someone wearing a nurse's uniform, but it's much more layered. And has much more meaning, because whoever had the finest military uniform was the best usher group. So that's why I had 'em marching in competition, and people said, "Well, what are they doing?" They're competing! And I saw that growing up, they would have, you know, ushers marching and all of that. It was very competitive, and the ushers ran the church. It was not the preacher, like they usually show the choir and the preaching. No, the preacher? I grew up in the Baptist Church. It's the usher board that runs everything. Change that story around to show the power that the usher board had.

KS: The usher board was always women.

JD: Yes. Always women.

KS: You've said, "We have a lifetime of stories to tell about Black women." And I feel like all of your work is about the stories of Black women we haven't heard or seen yet.[11]

JD: Well, I appreciate you recognizing that because sometimes I get really disappointed when I see the same old story again. And if you notice, too, in *Funny Valentines*, I never let the choir sing, because if I see one more choir scene where people are rocking back and forth singing ... Y'know, it's like "What the hell?" There's so much more going on. Look at the usher board. The usher board has their own hand signals, like American Sign Language. What about that? Let's use that! Why are we always looking at the choir? I think–nothing wrong with the choir; I'm not a choir hater. But I think we've seen enough of the choir. Let's see what else goes on inside the church, the politics, the intergroup relationships. They're really profound, they're very interesting.

KS: And in *Ride to Freedom* we have never really seen something that focuses on Rosa Parks's marriage. Rosa Parks was not a widow or an old lady when the Montgomery Bus Boycott happened.

JD: And who knew that? I grew up thinking Rosa Parks was an older woman because you know the glasses and the little hair pulled back. She was forty! And so I decided that—I know the writer wasn't very happy—I wanted to focus on her as a woman, as a wife, but not as a mother. This is my take on it: If she had been a mother, I don't think it would have panned out that way. She was taken off the bus maybe three days before Christmas? And if she had children waiting at home. I don't know if it would have happened that way. But she did not, But she had working on the bus issue. She had been working on rape issues. She had all these—a wider concept of who her children were in the community. And she took action that way.

What a lot of people miss is, just before she got on the bus, she walked out of the department store and she saw them tracing a little girl's foot who was trying to buy shoes there. And I remember my mother telling me—we used to laugh, we didn't believe it—that they had to trace their foot. My mother grew up in the thirties, and they had to trace their foot on a brown paper bag and bring it to the store. And then measure the shoe for the foot. And you didn't get to try on shoes. And so she saw that on the way out. I inserted that little thing. And people say, "Oh, it's not important." It's *very* important. It's important to the whole zeitgeist of what's going on. She's seeing that, all of these things, and she just decided, "Nah, I'm not getting up." Not today.

KS: I'm actually from near Detroit, where Rosa Parks lived for the last thirty years or so of her life and was such a permanent fixture of life in the city. It just reminds me that notions of homeland are so important in your movies, where we are from and where our people are from.

JD: And who they are, and how they act, and react in and what's important to them, and who they love and who they nurture and support.

KS: I can't imagine Julie Dash making a movie where the place of it is not important.

JD: Probably not. And I'm also heavily influenced by the foreign films I watched in my formative years as a teenager—Japanese, Indian, everything. You felt like you were there, like you time-traveled, you experienced those familiar things. And I want to do that too. You know, it seemed to me like Black films always had to be so cool, so snappy. It didn't mean a lot to me, you know? I mean, I grew up in Queensbridge Projects in New York. It was just like a situation like *The Wire*. You could just look out the window and see a drug dealer. I had no interest in watching that or making a film about it. I want to make something *more*, something different.

KS: On the director's commentary of *Daughters*, you mentioned that the two big film influences of that movie for you were Akira Kurosawa and John Sayles,[12] particularly Sayles's 1987 book *Thinking in Pictures*. Can you tell me about that? Kurosawa is a generation older than you, and John Sayles is only a little bit older than you.

JD: John Sayles I remember especially. He always said, always have a scene in your pocket that you pull out and do it in case of emergency. "Let's do this thing!" That was so true. Working in the Sea Islands, because of the climate you never know what was going to happen. One minute, there'd be like a windstorm. And people say, "Oh, you can't shoot now." It's like, "No, let's use the wind scene and then go get the quilt!" And then there was another scene where the sea rolled back, and it looked really dangerous. But I know now

a tsunami was coming. The sea just simply rolled back, and it looked—it was wet sand, and it looked like we were on the face of the moon. And I reached in my pocket: "Let's do the scene with the photographer. With the little girl. Let's do that one!" It kind of drove the first AD [assistant director] crazy, but we couldn't do anything else. And we certainly weren't gonna sit there and wait, so let's do that. And then there was another scene, I mean, the sky turned magenta, and the wind was blowing. So I reached into my pocket and "Let's do the scene with the trolley car" [i.e., where a group of women teach themselves how to step off a trolley car without tripping over the hem of their dress]. I would have never known to have prepared for that, to do that if I had not read John Sayles, you know? So, yeah, I was very pleased.

KS: All of your work is so tactile and so sensual. That's the feeling I get from "Give Me One Reason" the 1995 Tracy Chapman video that you directed, where unlike most of her other videos, the colors are really saturated and deep. And it's the first time you sort of see a full body shot of Tracy Chapman in any of her videos. I know the album that song came from is called *A New Beginning*. Was the assignment to show Tracy Chapman as no one had seen her before?

JD: The only request she had was she wanted a blue velvet curtain behind her, and I was like, sure, we'll do that. And yes we convinced her to wear a dress, because I said, "I see her like, in a juke joint, one of the old ones, like Bessie Smith where someone grabbed the mic and says, 'Give me one reason to be here.'" So that was fun. But one thing that she had me cut out, she didn't agree with me on but what I thought it was pretty funny, was that, knowing she was a vegan, I had a huge, big roast beef, rare, on the counter where it was being sliced and making sandwiches. Because it's like, what if you're in this situation and you have your beer and your pig foot, all of these things that to you might find disgusting. But you still had to perform that night, and she's singing, "Give me one reason to be here." And I was having an actor cut into the roast beef and slamming it in between two slices of bread. And she said no.

The guy dancing off in the corner with the white belt on, off the beat? It's like, she's in this club performing, and it's like, "What have I got myself into? This is the worst place ever. Guy's dancing can't even hit the beat. He has on a white belt. Clearly, he's from another dimension. From you know, like the sixties." So it was fun.

KS: It's a blues number. And she had never done that before.

JD: Okay, yeah, she wasn't doing blues yet.

KS: May I ask you about *Lemonade*? Not the beverage but the album by Beyoncé?

JD: I love both!

KS: What are your favorite memories of that saga, of the connection being drawn between that record and *Daughters of the Dust*?

JD: It was a Sunday afternoon and my website manager called me to tell me that my website just crashed. And I was saying, "Okay, it crashed, we'll get into it tomorrow." And he said, "No! Your website crashed because of *Lemonade*!" And it was like "What?!" And it was so early on in the *Lemonade* saga that it was like private on HBO, something like that, you know. You just couldn't get into it. So I reached out to my sources and got a link! Got a link to *Lemonade* and I sat there for like forty minutes with my mouth open just watching it. This was another one where you feel that weeping sensation because of something so profound and they keep getting better and better. And you're just filled with *awe*. I was filled with awe and wonder and goodness. And then some people say, "Well, yeah, it's like

Daughters of the Dust." And I said, "What?!" I didn't even see it that way. I just saw it as being something that was remarkably like—you were talking about things being tangible and beautiful and just visceral in so many ways. So yeah, I saw some people in a tree, like *Daughters of the Dust*. But I don't *own* that. I mean, it's a tree! You know, anybody could be in a tree! I didn't really associate it with *Daughters of the Dust* at first. I just saw it as this operatic, Beyoncé's operatic performance that just left me in awe of her talent. So everybody reads things differently, but that's my *Lemonade* experience.

And then Cohen Media [the film's distributor], I think were getting ready to release it on Blu-ray DVD? I think they pushed up the date. "Let's release it now! *Lemonade* is out!" Then the newspaper was saying it brought *Daughters of the Dust* back to life to be released. But actually, we had been working on it for a year, because you just can't (*snap her fingers*) get it recolorized and everything. It was already in the works. But promotion-wise, that worked! I was very happy that people saw a connection, because her work—all of their work, the directors, because they were multiple directors on *Lemonade*—all of their work was so astonishing and amazing.

KS: Ava DuVernay has referred to you as both "my cinematic hero" and "the queen of it all."[13] Ava DuVernay is from a younger generation of filmmakers than you. Your career is, unfortunately, a case study in the kind of injustice of who gets access to proper resources to make movies and who doesn't. Is there a moment when this changed? Because you are experiencing a kind of late career, overdue recognition of your work right now.

JD: Yeah, because they weren't recognizing, I mean, anyone really. Cheryl Dunye, she was around for a very long time. We were all making films. When we're—I think about the film *Barbie*, that's so funny, and Greta Gerwig's success and it was just like, "Well, I'm glad it finally happened! But we weren't allowed to do our *Barbie*!" The male filmmakers were recognized more than us and given opportunities in film after film after film to make. But it seemed like we were just pushed to the back.

But actually, as it turns out, I was luckier than some filmmakers, like Ayoka Chenzira, whose film *now* is being recognized but it was just completely snuffed out at the time, just completely pushed to the side. And *Losing Ground*, of course, you know, Kathleen Collins's film.[14] We came up out of the muck and the mire, the muddy waters of history, and we said what we had to say; our voices were different, and I think our voices still are different. So you know, it is what it is. Not to be discouraged, or anything like that, because I still have things to say, to do.

I think my career was to make films that I wanted to make, the stories I wanted to tell and how I wanted to tell them, so I have not been able to make a huge film or even a second feature film, which is very odd. But I have been able to do quite a bit, you know, and there's some people who are, like, coming alongside me or behind me who have not had those same opportunities. . . . I have been asked to do some films, and I read the script, and it's like, "Well, no, that's not for me. You need to get someone else to do that." I might *watch* that film, but I am not the one to make it. I resent being asked to make films that provide an exposé about my community, culture, whatever, but sometimes those are the films that get made.

KS: You've said that so much of what goes into *Daughters of the Dust* is a sister of many of the great works of American Black female literature, Toni Morrison's work and Toni Cade Bambara's work, and, of course, that stretches all the way back to Zora Neale Hurston.[15] I feel like a lot of that is taking an elevated language and applying the lyricism and beauty

of that language not only to the Black female experience but that also creates an artistic tapestry so large that even though its focus is very specific, it says, if you pay attention, this is all of our stories as Americans.

JD: Yes, it is. It's an American story, absolutely. We would just hang around our dormitory rooms I remember in school and quote from Toni Morrison, *Sula*, and stuff like that. It was that words were so rich and filled with wonder of the future and all these different things. We would just, we would act out Toni Morrison's dialogue because I'd never heard words like that before.

KS: Who are your directing sisters, i.e., who are the directors you admire who are of your generation? And who are your directing daughters and nieces, the women directors who you admire, who come after you?

JD: Okay, that one's easy! The ones who came before me of course were Kathleen Collins's *Losing Ground* because her work was always so—the dialogue was so intelligent and meaningful and purposeful and all of that. And the ones that came along with me would be Ayoka Chenzira. And the ones that are my nieces: Ava DuVernay, Gina Prince-Bythewood . . . because I have so many great students, but I can't mention them all.

KS: You came up as a filmmaker at a very different time than your students. And now, as a professor, you spend a good amount of time around young people who want to make movies too. What do you tell them about the time they are coming up in as filmmakers?

JD: Well, I try to explain to them that Instagram and TikTok are *not* movies. And that they should reach out and try to tell stories about the wider world, not just navel gazing about "Me, me, me, me. Look at me. Look at my eyebrows. Look at how I'm slaying." There's so many stories to tell and expand upon. And I tell them, most of all, they have to be courageous. I always tell them that because they're so easily influenced by the outside world if they have an idea about doing a film and people say, "Oh, no, I'm not watching, nobody wants to see that. Why don't you do a film about this, that, and the other?" And they say, "Okay, I'll do it." No, you have to be courageous. And you have to tell the stories that you want to tell, the stories that are in your heart, that are just making your heart burst because they're dying to come out. I guess that means something that you're passionate about, you know, stories and ideas that just make your heart beat. Or stories, ideas that you think about, and it makes you weep, sometimes weep for joy, weep for shame, weep for whatever reason. Everything is not about sadness that you weep for. Weeping is cathartic, I think.

Patricia Cardoso (b. 1961)

Films Mentioned
Meddling Mom (2012)
Lies in Plain Sight (2010)
Real Women Have Curves (2002)

Television Mentioned
Tales of the City (2019)
Queen Sugar (2018–2022)

Actor Launched
America Ferrera

When everybody in your life knows how much you love movies, the hardest question you get is "Can you recommend me something?" Because "Have a seat while I prattle for fifteen minutes and make twenty-seven suggestions while pacing a hole in the living room floor" is not the answer whoever asked is looking for.

Movie lovers need go-tos, films that will please most anyone, are easy to find, and haven't been de facto recommended to death via winning nineteen Oscars or racking up a billion in the box office. My go-to, then, for over twenty years now, has been the coming-of-age modern classic *Real Women Have Curves* [2002], the movie debut of a seventeen-year-old theater kid from the San Fernando Valley named America Ferrara and the directorial debut of a former anthropologist from Bogotá, Colombia, named Patricia Cardoso. I've gifted enough DVDs of *Real Women*—sweet, funny, feels-like-it-was-made-yesterday *Real Women*—to have lost count somewhere around the movie's tenth birthday. It's been dozens since.

Real Women Have Curves would win the Audience Award for Dramas at the 2002 Sundance Film Festival, the first movie directed by a Latine woman to do so, be named by *Entertainment Weekly* as one of the decade's most influential films, and in December 2019, a month before its eighteenth birthday, become the first movie directed by a Latine woman to be added to the National Film Registry.[16] For its director, it would be the first and signature statement of her artistic and political priorities: celebrations of everyday magic and an unwavering faith in the abilities of women to enter new and frightening phases of their lives.

A Fulbright scholar and graduate of UCLA Film School [where she would win a student Academy Award], Patricia Cardoso was brought on to direct the adaptation of Josefina López's original stage play of *Real Women Have Curves* after the project had been greenlit by female executives at HBO. "It took a woman in a position of power to find value in this story," Lopez would recall many years later.[17]

Cardoso has since directed in both motion pictures and streaming television in both English and Spanish and taught at USC and her alma mater before becoming Distinguished Professor of Filmmaking in the Department of Theater, Film and Digital Production at the University of California, Riverside. She's also the recipient of the Smithsonian's Latino Recognition Award and of a Governor of California's Commendation and was, for five years, the Director of Sundance's Latin American Program.

I spoke to Patricia Cardoso in November 2023.

32 Break the Frame

Kevin Smokler: *Real Women Have Curves* was included as part of the inaugural exhibits in the Academy Museum of Motion Pictures when it opened in fall 2021. I also read that the Patricia Cardoso Papers now have a permanent home at this museum. I would love to hear from you about finding out that this was going to happen?

Patricia Cardoso: The process has lasted a few years. Maybe two or three years ago, I was approached by the curator, Sophia Serrano, and it was great to hear that the museum is reframing the way that they see movies. And fortunately, I had saved everything. I like to document. I'm always fascinated by the process of creating movies.... So I had saved all my papers. I had a ridiculous amount of materials in my garage; it took me a few months to find them because they were buried among other things!

Sophia, really, she did such a good job.... There was one wall that is dedicated to cinematography, another dedicated to production design, and in another one, casting and costumes. Of course, I'm very honored to be there, to be next door to *Citizen Kane*, which was very interesting because I've taught film directing for many, many years. But last year, I began teaching more film theory. So I got to revisit *Citizen Kane* for the first time last year, after twenty years of not seeing it.

The Academy Museum is trying to reframe "What is the impact of a movie?" I never imagined that *Real Women Have Curves* was going to have such big impact that I've traveled around the world with it.... It was made twenty years ago! And I keep being invited everywhere, and everywhere people keep telling me, you know, "This movie changed my life."

KS: I would love to ask you about the adaptation process of *Real Women Have Curves* because I did not realize that the original stage play by Josefina López was a workplace story that took place primarily in the dress factory where the characters worked. And so I'm curious, even though the play itself explored issues of body positivity and the relationship between mothers and daughters, the setting is that of a workplace and contains issues of immigration and a lot of things related to work that are not part of the movie. Tell me how you, in collaboration with Ms. López, decided to make *Real Women Have Curves* a coming-of-age story instead and to focus on the journey of Ana [America Ferrera] as a character.

PC: By the time I received the screenplay, HBO had decided both to make the movie and, with the adaptation Josefina had made with cowriter George LaVoo, to really open it up. So it was not only inside the factory but it had opened up to include more characters. And to me the story and the way I connected to it was a mother-daughter relationship. And it was a love story, but with a lot of pain. And that was kind of the essence, the emotional connection. It was very similar to my relationship with my mother. And I think that's why the movie is so good, because I could connect to it very emotionally, very deeply. When I was making it, I was not thinking, "Oh, this is a coming of age story." For me, it was a mother-daughter story.... And then, of course, opening up to not only having the women that work at the factory but having the father, the boyfriend, the grandfather, adding all these other characters, and the character of Los Angeles. That to me was really important when I was making the movie. I've lived in Los Angeles for like thirty years now and I love the city! I hated it with a passion in my first five years. Then I decided to like it. So I had to make a big effort. And I brainwashed myself, but then I found ways to like it. I wanted to show a Los Angeles that I had never seen on the screen before. It was the Los Angeles that I loved. So [for] me to open it up, that was also a very important part of the story, was that Los Angeles was a character.

KS: I'm so glad you mentioned that. Because when I talked to Tanya Saracho, we talked a lot about *Vida*, about how that television series of hers is part of this very distinguished

group of cinematic portraits of Latin American people in Los Angeles, which you can start almost arbitrarily with *El Norte* [1983] and the early films of Gregory Nava. If you start with *El Norte* and *Zoot Suit Riots* [1981], a little before that, and then you go to *Stand and Deliver* [1988] and then *Mi Vida Loca* [1993] and *My Family* [1995], then *Real Women Have Curves* [2002], and each one of those focuses on a slightly different geographic area of the city. Both *Vida* and *Real Women Have Curves* are present-day stories set in Boyle Heights, which makes *Real Women* feel to me a little like *Vida's* big sister. Have you ever thought of *Real Women Have Curves* having all of these younger and older siblings? Or is that just a theory I've sputtered out?

PC: Oh, yes, I do. And actually, the Academy did a series on their website where they had selected some of what they consider more distinguished movies that portray Los Angeles, and they did a one about *Real Women* and we went to the locations, and they interviewed me. I think it's a really important movie, in terms of our city, which, you know, it's a city that is traditionally not beautiful, that is conventionally just seen one way.

My background is in anthropology; I was an anthropologist before being a filmmaker. So even before making *Real Women Have Curves*, I just loved to go to East LA and walk the streets in all the different areas, and then see all these parts of my culture that I love, the little botanicas—the corner stores—all those things. And the murals on the walls. So when I got the job to direct *Real Women Have Curves*, it all had to be there.

It was also a very organic process. To me as a filmmaker, location scouting is a really important part of the process. And when I was location scouting, I even created new scenes, like, for example, this scene when Ana buys the condom in the pharmacy. I saw that pharmacy, and I thought it was so beautiful that I decided, "Okay, you know, I need to make a scene here!" Then, "What can I put here?" There was nothing that was already there.

KS: One of my favorite things about *Real Women Have Curves* is how it manages to take the best elements of theater and the best elements of cinema and have them work together. There are scenes that feel very theatrical, with the factory and the Garcia home being like little stages, and characters interacting and being blocked in an almost theatrical way. And yet the movie feels very tactile to me. I feel like the colors pop off the screen when the characters are sweating in the factory. You can feel the same heat in the room they do.

Can you talk a little bit about how you knew you were filming a play? Even though your job was to make a movie?

PC: I work in a very intuitive way. And oftentimes I don't realize what I've done until after I've done it. So I know my first love in storytelling has always been with images, telling the stories with images. So I was always like, "I want to make my movies and my television work as visual as possible. How do I tell this story with images?" I'm thinking of that with my storyboards. And with my cinematographers, I'm always doing that. But only recently have I come to understand in a sense the scenes that come from the theater, that come from that drama, there's so much depth to those scenes. So I think that I was not aware at the time, but I was gravitating towards that too.

KS: *Real Women Have Curves* revels in the beauty of the neighborhood and the characters' homes and physical surroundings. But I see it in so many of your films, in *Meddling Mom*, in *Lies in Plain Sight*, and especially in *Real Women Have Curves*, which underscores the theme that beauty is not one thing. Your work seems particularly interested in the beauty of everyday things.

PC: There is this tendency in life to pay attention to the big events and to the big things, but the beauty of life is in the daily life. [Novelist] García Márquez, who is my compatriot

34 Break the Frame

from Colombia, was a big influence for me growing up as a storyteller. When he won the Nobel Prize, he said something that I really related to. He was hoping that he received that award because of the poetry of the lentils that you cook every day in your kitchen. And that's what I really gravitate to, and because I think, like in life, what I've noticed is [it's] not as important to have what you want but to want what you have and to love what you have here, what you can control.

I feel that one of my missions in life is to expand the concept of beauty. I see and I do that in every project that I do. There is this concept that, you know, beauty is like *this*. It is so narrow, and then, with *Real Women*, it's like it is THIS! All of this is beautiful, and to have curves, you know, in that scene when they undress and then Pancha tells Rosali and Ana, and tells them, "No, look around! Look how beautiful we are!" And when I still see that scene, I get goosebumps and I have tears, because I feel that I accomplished what I wanted, that *they* felt beautiful and that we feel that *they're* beautiful, and we're all beautiful.

KS: The underwear scene in *Real Women Have Curves* you are describing [where the main characters, during a hot workday at the dress factory, take off their clothes, ostensibly to compare stretch marks and end up praising each other's beauty instead] is going to out-live all of us. People are going to be talking about it and remembering it and feeling seen by it one hundred years from now. If you could—and I know it was twenty years ago, so I don't expect you to have instant recall about it—could you just tell me about that day on set, what it was like for you to run the set and be the director in this scene that was so piv-otal to what the movie was about?

PC: Well, it was a huge challenge for me from the beginning, from when I read that script. I knew that that was going to be the most difficult scene, and because I had seen one version of the play before, even before I was directing the movie, and the way that it was portrayed in the play is like all the women had, like, this very large underwear that made them just funny, kind of in a burlesque way. And it was more like laughing at them than laughing with them. So I was very scared of this scene. Very, very scared. And I knew that because I wanted to show them with dignity and with respect and with beauty. And I knew that it was funny, but I wanted to laugh with them.

To reach that, I had to work very closely with a costume designer, with makeup, with hair, with the cinematographer, with a costume designer just to get to where you can have the actors choose and let them be themselves. I prepared so much. We did rehearsals, and during rehearsals, it was only the actresses—well, that cinematographer and the AD [assistant director] were male, but the actors and me and then during the rehearsals, eve-rything you know went really well. And then I tried to have a closed set, but you cannot really have a closed set because you need the sound person and you need the lighting. And we shot it over two days. And I actually asked the costume designer to let the actors choose any underwear they want, so that they feel good about it. And I actually bought myself really good underwear because I thought, "Well, maybe I'll need to get into my underwear...." But, fortunately, I didn't have to do it.

It was challenging, it was beautiful, it was difficult, too, because, at some point, America decided that she didn't want to take her pants off. And she was seventeen. She was truly one of the smartest people I've ever met. She was so smart and so articulate. And I would never force an actor to do something they don't want to do. She told me no. But she's already in the rehearsals. And she told me, "My character would never do that. I think it's enough if I just take my top off." And then I said, "Okay, give me a moment" because, you know, I knew that by the contract, she would have to do it, but I didn't want

to force it. First I questioned myself, you know, "Does she really need to take her pants off?" And I talked with my cinematographer and when my DP [director of photography] and my AD, and then I realized, "Well, she does need to." As I tried to talk with her and gave her all these reasons, and she was like "No, no." So I actually had Josefina brought to set. I had my assistant go and pick up Josefina, bring her to set, and talk to her. And she's still "No, no." And then finally I told her, "You know what? I need you to do it. I cannot give you a reason. You know I've given you all the reasons. I don't, cannot, add any more reasons. I need for you to find a way to do it. Just think about it, take ten minutes, come back to me." So she came back ten minutes after and she was really mad. And she told me "Okay, I'm gonna do it, but I'm only gonna do it for you." And for the rest of the day, she was so mad with me. She didn't say hi, she wouldn't talk. And then, well, she did a beautiful job. The next morning, she came running to me and she told me, "Oh, you know, you were right. I know why I had to do it. So can we please shoot it again? And I'll do it well." I'm sitting there like, "You did it perfectly. You don't need to re-do it!"

So, it was a challenge. It was fun, also, you know, in terms of the blocking, finding movement and everything. But you know, I was not aware that it was going to be such a huge scene in cinematic history.

KS: Ana is the person who makes everything else in the scene happen. The scene is not only beautiful and empowering, but the third dimension of that, it's uproariously funny. And the reason it's funny is the presence of the late, legendary Lupe Ontiveros [playing Carmen, Ana's mother]. She's the reason the scene is funny. You need her outraged reactions to what's happening. And I feel like this is a thing your movies do over and over again. You take an actress who has a distinguished career and yet has not maybe been recognized for the depth and breadth of their talents. And you cast them in a role that, even if the role isn't written to have a lot of big dramatic scenes, it's sort of that the role kind of points to all of the things that that performer can do. Your work often sees what Sônia Braga [Samantha's girlfriend Maria in *Sex and the City*, whom the *New York Times* ranked on their 2020 list of twenty-five greatest actors of the twenty-first century] or Lupe Ontiveros [who had been acting on film, television, and stage for twenty-five years before *Real Women Have Curves*] are capable of, while Hollywood sells them short.

PC: I have not thought about it so rationally, but, absolutely, there is intentionality. I'm just fascinated by humans, human life and experiences and the richness of how complex we are as humans, and I'm always wanting to explore that. And, of course, as Latinx people, we're always being, like, you know, framed like *this*, you know. And this is more like THIS. And then, you know, someone like Lupe, who is like, "Oh, my God, like, what an incredible actor!" But she played a hundred maids! So when you have the opportunity to give an actor the space and to nurture them ... I think I'm a very good nurturer. I'm very open. For me it's so important on set to create a safe space for the actors, so that they just can bloom in on their own and do that—go with their own talents and their own instincts.

KS: You're part of that sort of all-star team of directors that Ava DuVernay hired to staff *Queen Sugar* [for all seven seasons and eighty-eight episodes of the series, DuVernay only hired women directors]. You have said before that this opportunity really turned things around for you as a director of television.

PC: Yes.

KS: And you had also been attached to at least seven feature film projects immediately after *Real Women*? Do I have the timeline correct?

PC: In the story of my career, Ava DuVernay only came into my life in 2018. So that's like three and a half years ago. Right after *Real Women* and for a few years after, I was attached

36 Break the Frame

to direct a feature for Universal with Halle Berry and something for Disney with Anne Hathaway. But they never got made. Now, I understand why it didn't get made, but at the time, I thought it was all my fault, that I'd done something wrong.

First you go for interviews, to get a job—and I had to interview for HBO, for *Real Women*; it was not a product that I generated.... It's a whole process of how you present your vision and learning to articulate your vision. It took me a long time to understand that and to be able to connect to material, because at first, right after *Real Women*, I didn't like anything that I read: "Oh, I don't like … I don't like … " But then I realized anything that you give me, I can do a good job. Because *now*, I can find a way to connect; I can find a way to connect to anything. And then I have my own vision. So those seven projects were when I found my way to connect to things, and then I would come in and give my vision. But, of course, I really didn't have a chance of getting any of those jobs.

KS: I'm sure it wasn't intended this way, because no one can predict the future, but it's almost like those experiences and being able to articulate your vision as a filmmaker no matter what the story prepared you for this universe of streaming television. You have directed for so many different kinds of streaming television series and yet each one feels like a Patricia Cardoso project that is also part of a larger series. When you started working for streaming TV, tell me about that process of saying, "I understand I am part of a universe that exists already. But I'm also me and I bring my own priorities as an artist to this."

PC: Like everything in my life, everything takes a long time. At first I was scared of directing television because I thought, "How do you do television?"—where the world is already created and you're just one director. So I had shadowed on *Six Feet Under*, you know, this is like fifteen years ago, [with producer] Alan Poul for directing. And when I got to set and I saw the collaboration that he had with the writer, I thought, "Oh my God, I found my place in the world!" Because I'm very collaborative. And then I saw when I did this shadowing, and I also shadowed another series, and I realized that the collaboration I've had with cinematographers before, which were my partners, was similar to what directors have in television with their writers. And I just—I like thriving collaborations.

Then I had the fortune that my first episode that I directed was with Ava DuVernay in *Queen Sugar*, where I was completely embraced, supported. And it was also the first time that I was not the exception, but I was the norm. To be the only woman director—usually before in my life and a lot of parts of my life, I've been the only woman, the only person of color, the only immigrant, the only Latinx person. So, with *Queen Sugar*, that gave me a lot of confidence because I was able to do it in a very—work with the images, with the cinematographers to make it look really beautiful, and to work with the actors too.

And then, you know, after that actually Alan Poul, he hired me to direct an episode of *Tales of the City*. And again, he completely gave me—you know, he and the showrunner— they completely gave me the space to just go and do. I worked with Laura Linney and Elliot Page, and an amazing cinematographer. And yeah to me it's like candy, you know, it's just like I'm in heaven when I'm on set and I can collaborate that way.

KS: How did your professional relationship with Alan Poul begin?

PC: Just shadowing, because Rodrigo Garcia [who directed Glenn Close in her 2011 Oscar-nominated performance in *Albert Nobbs* and was the showrunner on the HBO series *In Treatment*], who had directed for *Six Feet Under*—and we've been friends for a very long time, you know, colleagues and friends—so I had asked him when I was thinking, "I want to direct television, but I want to see how it is," I told him, "Can I visit you on set and just see how it is?" He told me, "Well, I'm not directing something now, but I can ask

Alan Poul." So he arranged for that. So that's how I met him, and then I never saw him again. And suddenly he gave me my second job after Ava DuVernay. He gave me my second job.

KS: So much of your work is about women entering a new phase of life. I'm curious as to what your attraction is to that kind of story. Your work is almost never about people who are kind of okay with where they are and things being relatively unchanged.

PC: My first thought is, I love change. I just love when I try and change. My husband, he doesn't like change and I'm like "Change! Let's go! Let's move! Let's do!" And even now that I'm completely grown up, I feel that I'm coming of age with different things, you know, like having a career in academia, having a career in film. So that's the first thing that comes to mind, but I guess I have to think about that more. But even with the character of Sônia Braga in *Meddling Mom*, it is a kind of a coming of age for her because even though her character is sixty years old, she's transitioning to have a love interest after being a widow for many years. You know, it's changing her life. For Rosie Perez in *Lies in Plain Sight*, you know, of course, it's very dark, but it's also a coming of age where she takes control over her life, her husband that she loves, and her relationship where she wakes up to what it was there and she had not seen.

KS: I'm not gonna ask you to engage in false modesty, but I see so many movies that came after *Real Women Have Curves* as the kind of little sisters and younger cousins of that movie. I think Dee Reess' *Pariah* is a direct descendant of *Real Women Have Curves*, as is Greta Gerwig's *Ladybird*. As the filmmaker behind *Real Women Have Curves*, and obviously, so many other talented people were involved in the making of that film, its descendants are everywhere. And I'm curious as to when you see those descendants running around and becoming fully fledged artists and filmmakers in their own right, what is that like for you?

PC: Well, you know, I'm very happy that I've had that impact. Because I know the movie has had such a big impact in so many different ways. I'm very happy. But sometimes I'm jealous too. "Oh, my God, like these other filmmakers. They're having this huge career and they're making a living and I can barely pay my rent for shaking open a world that will never happen again."

KS: What kind of set do you run as a director? What kind of classroom do you run as a professor?

PC: I think they're very similar. I like to have a joyful set. And I like to have partnership with my collaborators, both the creators, the actors, the cinematographer, the sound designer, the production designer, the students. I always see them as equal to me, and I like to give them the space to grow. I try to have really good communication.

And, I like to challenge myself; I like to take risks. I have this metaphor that when I'm making a movie, I'm very good at finding and identifying talent and finding good ingredients, and it's like a test tube, and I put everything together with the actors, the screenplay, the production design, the location and then I just shake it and boom! I don't know what's gonna come out! I'm not one of those directors that *know* exactly what I want: this, this, this, this. I love the experimentation process. And in my classes, I'm continuously experimenting, sometimes with better results than when I was on a film with sharing, you know, sometimes better results than other ones. But I love that part of the process.

Cheryl Dunye (b. 1966)

Films Mentioned
The Owls (2010)
My Baby's Daddy (2004)
Stranger Inside (2001)
The Watermelon Woman (1996)
The Early Films of Cheryl Dunye (1994)

Television Mentioned
Lovecraft Country (2020)
Queen Sugar (2017–2019)

Actor Launched
Yolanda Ross

According to Cheryl Dunye, the tenth anniversary for her debut-now-classic-film *The Watermelon Woman* (1996) came and went and nobody cared. But soon after the twentieth, a print of the film was acquired by the Museum of Modern Art in New York. By its twenty-fifth anniversary, *The Watermelon Woman*, which had begun its life in the crosshairs of conservative congressman for receiving NEA funding as a story about lesbian representation in popular culture and young gay women looking for love, was being added to the Library of Congress's National Film Registry. Its fellow 2021 honorees included *Return of the Jedi* and *The Lord of the Rings: The Fellowship of the Ring*. In 2023, the first American feature film to be writen and directed by a Black lesbian became part of the Criterion Collection.

Ideas of identity, representation, and seizing the means of narrative are key to *The Watermelon Woman*, a seemingly autobiographical tale of "Cheryl" (played by Dunye herself) working as a young filmmaker and dating in 1990s Philadelphia. I say "seeming" because, while some scenes are taken from real life, the main character's passion project is a documentary about an underappreciated actress named Fae Richards from classical Hollywood, forced to play stereotypical roles available to Black performers and credited on screen only as "The Watermelon Woman." Fae Richards and her career are fictional, works of Dunye's screenwriting acumen. They were also our first feature-length example of a style and themes that would define Dunye's thirty-five-year career: movies that seem both documented and scripted about how women and people of color see each other, and how they use the means of narrative available to everyone else to define and change how they are seen.

Cheryl Dunye's 2001 film *Stranger Inside*, about mothers and daughters in prison, and 2010's *The Owls*, about a reunion of a group of old friends and lovers and a violent secret between them, are great examples of her skill directing groups of actors instead of stories primarily told from her point of view. This kind of versatility shows up again in her more recent work as the holder of one of the most prestigious résumés in both modern television directing (*Dear White People*, *The Chi*, *Bridgerton*, and *The Umbrella Academy*, to name only a few) and film academia (Dunye has taught at UCLA, Pomona, San Francisco State, and the Art Institute of Chicago, to again name only a few).

40 Break the Frame

Raised in Philadelphia and a graduate of Temple University and Rutgers's MFA program, Dunye's directing has been nominated for Independent Spirit Awards and NAACP Image Awards and has been honored by the Guggenheim Foundation, the Rockefeller Foundation and the Whitney Museum of Art. In 2023, she received the Brudner Prize from Yale University, given to a "scholar, artist, or activist whose work has made significant contributions for lesbian, gay, bisexual and transgender and sexual minority communities."

I spoke to Cheryl Dunye from the Oakland offices of her company, Jingletown Films, in May 2023.

Kevin Smokler: May we start with the term "Dunyementary" [a melding of documentary, fiction, autobiography, and myth], which you use to describe your work and the inspirations for it?

Cheryl Dunye: Well, let's go back into the wayback machine to talk about the Dunyementary. Audre Lorde's *Zami* [a 1982 novel that pioneered a literary genre known as "biomythography," where a nonfiction biography or memoir is constructed through fact, historical parallels, and myth], intersectionality, fed on all those wonderful, prolific writers and scholars and poets who are really trying to find a way to communicate artistically and creatively about differing parts of themselves.... Once you pull that back, you're looking at creating a myth of yourself, right? Taking that to heart and using that in my own work began with turning that lens on myself, in my world to create a body of work.

It started with a short film that I made at Temple University for a BFA thesis project where I was struggling to figure out what to make. I had gone to a women's music festival. I guess this is the late eighties. And the poet Sapphire [author of the 1996 novel *Push*, adapted for the 2009 Oscar-winning film *Precious*] was onstage reading a poem called "Wild Thing." I was [so] just blown away that I begged her to find a moment where I could record it again. I said, "I'm a student." I have a super-ridiculous VHS camera. And, of course, I didn't have any equipment other than just the camera, so it was dark but the audio was really good. So then I was like, "Well, what am I going to do to make this my own? What am I going to do to make a story out of this?" I decided to fill it up with my own images. So you, you hear Sapphire reading, but you see cutouts of newspapers, photos from my family and friends.

Everybody loved it. That opened the door for me to be offered a full ride to Rutgers University for my MFA program. The short works that you see [collected as six films under the title *The Early Works of Cheryl Dunye*], that's what I did. I kicked them out easily when I had the tools, the agency, and knew what the content was going to be. So *Janine*, then *She Don't Fade*, and then *An Untitled Portrait*, *Mother Love Me*. And then ending with *The Potluck and the Passion*. Those were the works that kind of really came from that lightning that was in me, that focus on, as I would say, the Dunyementary. And then that's what led into labeling it and building more work on it, which culminates in *The Watermelon Woman*.

KS: This technique, of your addressing the camera, of the story going forward and backward in time, shows up again in *The Owls*, which is fifteen years after *The Watermelon Woman*. But it has a whole other level in *The Owls*, which is ultimately a movie about a crime, and so this way of telling the story also forces us in the audience to ask who is telling the truth?

CD: Right. I think this technique of the Dunyementary comes back in *The Owls* around the mode of production, reinserting myself into the new digital world. I had just returned

from the Netherlands. I had to step out after I made *My Baby's Daddy*, which is totally the opposite of the mode of production I had began with. I felt that I had compromised and I was reflecting during that time about the big compromises in my heart and life changes from making *My Baby's Daddy* with Miramax.

By the time I got back to it, you know, itching and scratching and realizing that the world had changed, I had changed as a person and grown. Nostalgia was starting to kick in, and, you know, where are we now in this midlife moment? I'm reading Highsmith [Patricia Highsmith, an American mid-century novelist known for her psychological thrillers, most notably *The Talented Mr. Ripley* and *The Price of Salt*, now considered a classic of American lesbian literature]—that was a big one for me, and being a professor.

It was the perfect moment to intellectually play with what I had started with before. We formed The Owl—the collective—to do it. And it was made in that vein with characters from the past. I wanted to see if I could have lesbians who were icons from early queer cinema meet in one room as well as put my own form on top of it. So that's where that came from. And I didn't have any money either. But it was surprising that that film went that wide and far—it premiered at the Berlin Film Festival. So I was quite excited that it had a world that people remember. So thank you for bringing that up.

KS: Absolutely. Is *The Owls* a movie that only a mature director could make? Because so much of it is about the mistakes one makes as a young person coming back to haunt you.

CD: It's also about a time of return. You remember different things and you put yourself in different places.... I'm really talking about this abstraction, this uncertainty about memory. So that was the intellectual part of cinema behind it. And then it became, like, well, how do I promote it? How do I put this out there? What do people want to see at this point where you have *The L Word* [the pioneering 2004–2009 Showtime series and the first on American television to feature an entirely lesbian and bisexual female cast]? You have lesbian culture becoming more popular.... This is gonna be a fun way to bring them all into one timeline.

KS: Do you feel as though the techniques of Dunyementary seem incredibly prescient now, TikTok and YouTube before TikTok and YouTube? When this current form of filmic entertainment came along, did you have any feelings of what Sister Rosetta Tharpe said about rock and roll, you know? "Oh, yeah, that? That's just the blues. I've been doing that for twenty-five years."

CD: I mean, I'm alive, I'm not dead. I'm still making work. You get called a groundbreaking filmmaker, the one who did it first, and it puts you so out of it. On the opposite side of that, I still have to go through the same rigorous process of interviews and introductions with executives and producers when I want to get the job or something like that. I mean it sounds like I'm groundbreaking, but if I was a groundbreaking dude or somebody who had a bigger, you know, imprint on the film world, would you be making me do all these things?

So that's the Dunyementary too, where you have to think about where I've been on the totem pole of cinema. Part of my passion, part of the Dunyementary, is to build these characters in the world. And we do have more of them. But it took many years after *The Watermelon Woman*—[such as] Dee Rees's *Pariah* [the writer/director's 2011 debut film about the coming out of a seventeen-year-old Black lesbian which inducted into the National Film Registry in 2022]. And then we have stuff that happened with Lena Waithe [creator of the Showtime series *The Chi* and screenwriter and producer of 2019's *Queen &*

42 Break the Frame

Slim] and others. But we still don't have a world where queer women of color characters are just the other character or the main character, or as out and proud and as a complicated person. So that project is still active. And I think that all those pieces that you're talking about was really about trying to put those narratives at the center of storytelling.

The other bent for me is to explore playing with form, the way we remember the way that we tell stories. The real of the real. My life is not a Marvel movie. My life is not *Succession*. My life has a variety of experiences that are just not those things. So I want to see stories like that, given those plays with narrative too so they can figure out the way they're best told, right? For me, playing with narrativity, playing with form, is something that I must put in my work, or I haven't made work, I'm just reproducing what else is out there. I'm just AI. When I'm not doing that, that's where the struggle happens. I need to disconnect, keep that "I" going. So my work is mine.

KS: You've done a lot of work since *The Watermelon Woman*. Do you feel like, artistically speaking, there are parts of making that movie that have come along with you and other parts you have left behind?

CD: I have thought about it a little bit and I think the Dunyementary, documentary social project around identity politics and queering a narrative and critiquing at the same time and being entertaining, is there, and also having the courage or the fearlessness to pull out an identity to poke at, because they've been poked at me my whole life. Having that political side in my work is something that I continue to do. I can't not do that, I can't not see the world through that lens and have the struggle or defiance or sorrow, or elation to really have those sort of characters in it.

KS: *The Watermelon Woman*'s main character is a movie lover and obviously you are too. What has that struggle been like for you personally and as a filmmaker, to be someone who clearly loves movies, loves making movies, and yet the structure we have around making movies is unfair?

CD: Hmm … I guess my desire to constantly, you know, be in character in the world, to see that character exist in the world, to see someone you know, that person who's at the center of cinema, is something that I can't let go. I will always be creating that voice in the cocktail party of my head, to exist, to have an opinion. And I don't think there's enough opinions out there that are varied. And I think that having characters like the Watermelon Woman or Cheryl in *The Watermelon Woman*, who are the voice of the other experience, the other way to express themselves, is so essential, in thinking about expansive, you know, thinking outside of the box of Hollywood, thinking about other narratives in other parts of the world. That's the other side of me, always seeking to know what's happening in French cinema, what's happening in cinema in Japan or Korean cinema, British folk, Black British folk, looking for those different voices and different ways of telling a story. Cinema is expansive and I need to be expansive. And I need to be that type of citizen in the world, an ambassador of cinema and storytelling, to feel whole even though I'm telling a very specific story about a queer woman of color in the United States.

KS: *The Watermelon Woman* becomes famous, then infamous, undeservedly if you ask me, and then renowned as a classic. I am sure there were moments over that fairly long history of the film where you not only felt chosen as a filmmaker but also felt like the one that was let in the door, and many of your sort of talented peers were not. Is this accurate and if so, during this long arc, who were the other filmmakers where you wanted to say, "Hey, look over here at these filmmakers too"?

CD: I can only answer some parts of that. Let's see. So nobody really celebrated my work initially. I mean, of course, it won in Berlin [the Teddy Award given to films with LBGTQ themes at the 1996 Berlin International Film Festival], but it was very hard to find a distributor.... Even the new kind of new queer distributors that were out there in those days didn't want *The Watermelon Woman* either. Even Miramax, who had done *Go Fish* [a 1994 lesbian romantic comedy about a group of friends in Chicago], which is a very similar piece, didn't want it. So it was quite interesting to see how I pushed it by asking my academic friends—because I was going out with an academic at the time—"Can I come and speak in your class?" and that's really how I started getting around those circuit folks who knew and just going to show up and make my way doing lectures that way or applying for grants. It was all my own self-promotion for years and years and years, until the point where I'm able to piece together some income from having to hit I don't know, how many lectures a month to make ends meet, let alone finding places that'll screen the work.

For the tenth anniversary of *The Watermelon Woman*, nobody cared. I think maybe one or two people wrote about it. I didn't want that to happen at the twentieth anniversary. So I celebrated it myself, and we created a storm of it ourselves. The academics, of course, people who are seeking their identity and find me pre-internet, early days of internet, they were the ones who pushed it, or doing the readings and listening to professors, etc. But Hollywood, never.... Now I think it's the young folks who are sharing it with more conventional audiences than it has been in the past.

I think that's really what put it into this legacy moment.... But it's still not a thing that folks know, even queer folks know and queer folks of color know. It'll have its moment and when it does for the world to know, and for me to experience a world as that filmmaker that people have relaunched and embraced and become a part of that iconic cinema.

So the feelings around not having achieved that and seeing folks like myself who go there easily and younger folks who are, you know, coming up, using that and not, you know, me ever kind of being pulled along that way. It's hard. It definitely is hard sometimes. But I think, I'm sort of past that and realize that what I want to do is have a voice and continue to be able to make that work until I can't make it any more and then move on to doing something else. I think there's other things I want to do like a Jingletown production, or, you know, going back to even a studio art practice and making a different form media that exists in the world, not just as a feature. But I still have a couple of features to do. I'm working on those right now.

KS: *The Watermelon Woman* is very much looking inwardly at yourself, and *Stranger Inside*, the next movie you made, is very much looking outward at themes you were interested in exploring as a filmmaker.

CD: That's one aspect of *Stranger Inside*. It was me and looking at my social responsibility in the world, things that I'm interested in politically. That goes way, way back to being an artist filmmaker in Philadelphia in my early twenties, very much involved in ACT UP [AIDS Coalition to Unleash Power, an international political organizing group with the aim of ending the AIDS pandemic and improving the lives of those who suffer from the disease] and very much in Philadelphia as well as doing protesting and marching and activist work as an anarchist, lesbian, feminist separatist—a way to explain myself (*laughs*).

So there was a defiance about representation and social justice issues in all my stuff. So having my eye on the Angela Davis [feminist political activist and scholar and an early advocate for the abolishment of prisons], the Assata Shakur [political activist

44 Break the Frame

who escaped prison in 1979 and is currently wanted by the FBI], the political icons of the struggle were things that I read, or the people taking the struggle to the future, like Octavia Butler [the late, pioneering Afrofuturist author and the first science fiction writer to win a MacArthur Award] ... seeing the result of it or seeing the past of it, which I did not live, but I can still carry on through my work. That's where the wanting to do something about women in prison came from, as well as looking at myself as a subject in that light. At that moment that I was doing *Stranger Inside*. I had just had my kid Simone, who's now twenty-five. And my partner at the time, Alex, who actually produced *The Watermelon Woman*, just had Gabe. We had two kids. Gabe is White and Simone is mixed race. And I was pushing the stroller and people were looking at me. I was like, "Why are people looking at me?" And lo and behold, a White woman walks up to me and says, "You know, do you have any time to care for other people?" And it was like, Oh my goodness, is she thinking that I'm some sort of nanny or whatever? And so I was looking at myself through a different lens of what others are othering me as, so it goes along with the same project. And then another genre that I love, which was women in prison films, I mean, who doesn't as a queer woman? (*laughs*).

KS: Could you talk about the screenwriting workshop that gave birth to *Stranger Inside*. I know it was modeled on Rhodessa Jones's Medea Project: Theater for Incarcerated Women.[18]

CD: I worked with a directing coach [Joan Scheckel, who has coached the teams behind the movie *Little Miss Sunshine* and the television series *Transparent*, among many others] going deep, deep, deep, deep, deep into the characters I created to strip ourselves of our identities and have trust at the level of performance and the level of being a writer, taking off the writing hat, because I think there's an intellectual part of being. Being a director is about engaging with your cast. So we had to form a very different bond than the one that I wrote. So that work really forced the relationship [that] blossomed between Yolanda Ross and I and Davenia McFadden, to create a bond around stripping down who you are to get into the stories and the bodies that you have to be to do your work to show up in creating a strong narrative. As a director, you can't be in your mind. You have to be in your body. You have to be in your light in a different way, or your darkness depending on what the story is.

KS: Davenia McFadden is both the villain of *Stranger Inside* and a kind of second protagonist too.

CD: Right?! We went really hard and long with [producers] Jim McKay and Michael Stipe and the team to find the right person. And so once we kind of whittled it down, we did pairings, and I forgot who was in the room to be paired with others but that Davenia and [lead actress] Yolanda [Ross] were the best pairing to do those parts, though neither of them had any experience with basketball. Because that was a big thing [in the film], we had a coach come in to train the, but they did all their own stunts, which are not many in the film, and just a joy because they knew how to embody and they knew how to do that trust. We shot it on that campus, a former women's correctional facility that was closed, and ... it became this bond of a family. But she definitely went there and just played that character so well.

KS: I don't want to spend a ton of time talking about *My Baby's Daddy* [a 2004 comedy about three best friends who all find out they are going to be fathers at the same time] because I've read it was not a great experience for you as a filmmaker, but I gotta say,

knowing it was a movie made by you, I felt like the movie was ten times better than it could have been.

CD: It was playing the game—it was always with *My Baby's Daddy*, which was actually called *My Baby's Momma* when I first worked on it. It was seeing at least what Hollywood was like, and after being on the road for two years of looking for work. But you know, it was not wanting to be in Hollywood, wanting to be in Hollywood; not wanting that work, wanting that work. So once I did it, there was a lot of regret around it because there were a lot of compromises I had to make again. I couldn't do my talking head, I couldn't just translate it because it was not my text. In retrospect, there's some fun elements to it, working with Method Man [playing the narrator's trouble-making cousin] and playing with an-over-the-top farce was fun, and budget and having those tools. So it was a great way to really learn that sort of filmmaking on the job. So I'm blessed with that. And if I had much more command in personal politics going into that, I think it would have been a whole different world for me.

KS: My takeaway from *My Baby's Daddy* was that you've always had kind of a casting crystal ball. Anthony Anderson is the lead in that movie way before *Black-ish*. *Stranger Inside*, that's Yolanda Ross before *How to Get to Get Away with Murder* Yolanda Ross. I'm curious what it's like over the course of your career, seeing some actors really blossom and assume a bigger stage and profile for themselves and some not so much—accepting, of course, that once you've worked together, it's really not up to you.

CD: I'm looking for something that's raw, that's real. I'm looking for somebody that doesn't put on airs. I'm looking for authentic performances and behavior. People who are fearless and stripped down, who bring joy to the process and take joy away from it. Like that. And very few folks do that. Some people, they can't get that vulnerable.

I think people forget that you have to have that in yourself to be able to cross that doorway to make that work. And then you need everybody to be on the same page of trust to make that work. Trusting that you pick the right talent and you give them what they need is something that I think I'm able to sniff out, and I'm excited to bring that to—some of the intuition—to the things that I'm working on now. Even in casting in the small parts that I get to cast in episodic work as a director, you don't really get to cast the big lead. You give your input, and people are like, "Oh, my God, that's—we didn't even look at that person!"

KS: Your television directing résumé would be the envy of anyone working in your profession—*Lovecraft Country*, *The Chi*, *Y: The Last Man*, *Umbrella Academy*, and where this streak began, with directing and, later, producing for the series *Queen Sugar*. Is it fair to say that *Queen Sugar* kind of changed everything for you as a television director?

CD: Yes, I would say that Ava's project with *Queen Sugar* [for the entire seven-season, eighty-nine-episode run of the series, creator Ava DuVernay hired only women directors], that really broke it for me, putting me in that family. It's a political act to do that.

KS: Yes.

CD: And, I think, working with Misha [Misha Green, the series showrunner] on *Lovecraft* to deal with scale, and then I had all the tools that I needed to author that episode [Episode 5, titled "Strange Case"] the way that I wanted to, and show up the way they wanted. Misha reached out to me, and said, "Do you want to do this?" And I was like, *Hell yeah . . .* when I do get the call? I'm the right person in their mind, those things turn out to be the bomb. And I love that relationship with a producer or writer or show creator, that that happens. It's happening more and more.

46 Break the Frame

KS: What's it like being a Philadelphian who is now part of an Oakland filmmaking community, alongside the likes of Boots Riley [writer-director of *Sorry to Bother You*] and Ryan Coogler [writer/director of *Black Panther* and *Fruitvale Station*]?

CD: I realized a while ago, thinking, "Where do I want to live?" after I was finished with LA and kind of move on into the next iteration, that I needed to be in a Chocolate City. What's the closest Chocolate City but Oakland? So actively making my way over here, where I can feel that same sort of agency that I felt in Philly. That's important for me, and that's why I settled here. It feels real for me, like it has the same sort of parallel histories to Blackness and hope. Different timeline, but definitely.

KS: Who are your peers that you admire? What directors coming up do you have high hopes for?

CD: I've always been a fan of Julie Dash [writer/director of 1991's *Daughters of the Dust*, the first feature film directed by an African American woman to receive general release in the United States]. When I was trying to figure out how to do it and self-motivate and self-create, Julie is the mother of all in that realm.

Then there's a slew of young, young folks: Felicia Pride, somebody who's a little younger [than] me on the timeline and doing exactly what I am doing, you know, in a different realm, and continuing that sort of legacy of mixing Black queer woman's identity with storytelling, and then also doing social work, to create infrastructures for other young women who are queer, have that storytelling to live and exist within the concept of the commercialism of Hollywood. So I see that being like, whoa, boom! "Weren't we just talking through and that's what you just did … oh! Look at you now!" I love seeing that. So those are two backwards and forward moments and people that I really, really love in that. Thank, you know, the goddess here that this is really working out.

KS: You have done a ton of teaching, which meant you spent a lot of time around young people. My favorite advice you give to filmmakers just starting out is "You only live once and you have to do it now. Be a little extravagant and make some mistakes."[19] I get the sense that mentoring and being around young filmmakers is important to you.

CD: Yes, yep. This is so true, being around young filmmakers, handing them the brush and saying "go" and walking away and turning back and seeing what they've done and encouraging them. It's so important, giving them the right books or tools, being that little seed for them—your own source of knowledge, of passion, of life, of experience, of storytelling. Live a life that you have a story to tell. It's yours. Nobody can take that away from you, and you're the only one who can put it in the world, in any world that you decide to live in. So that brings me joy.

I'm not going to be around forever. Nobody is. But we can always pass the torch. And I think that I pass the torch on to, you know, a lot of folk through the work that I do and in the interactions I have with younger folks. And so it lives. *It lives.*

Barbara Kopple (b. 1946)

Films Mentioned
Desert One (2019)
Miss Sharon Jones! (2015)
Shut Up & Sing (2006)
American Dream (1990)
Harlan County USA (1976)

Television Mentioned
Running from Crazy (2013)
30 for 30: The House of Steinbrenner (2010)

Barbara Kopple made time to speak with me the week the Emmys gave her a Lifetime Achievement Award. She accepted that award by sharing the stage with a squad of comrades she had made movies with over her half-century-long career. In a moment designed to be all about her, Barbara Kopple made it all about everyone else who helped her get there.

That fact says everything and yet not nearly enough, because Barbara Kopple is, without question, the Mother Courage of American documentary filmmaking, its center of gravity and North Star. Pretty much every other documentary director in this book and even their peers whom I did not get to speak with, are Barbara Kopple's nieces and daughters.

Raised on a vegetable farm in Scarsdale, New York, Kopple began interning with the pioneering documentary sibling team Albert and David Maysles while a graduate student at the School of Visual Arts in New York City. Around the same time she created her production company Cabin Creek Films in 1972, coal miners walked off the job in Harlan County, Kentucky.

Kopple and her team would film in the mining communities of Harlan County during the yearlong strike and then spend four years completing their first documentary, *Harlan County USA*. The film would win the Best Documentary Oscar in 1976, when its director was only thirty. Her 1990 documentary, *American Dream*, about a strike at a Hormel meat-packing plant in southern Minnesota, would repeat the victory, making Kopple the only woman in Academy history to win the Best Documentary Oscar twice.

A Cabin Creek project will often be a story of the American worker. But the company has a filmography of celebrity biographies too, of actress Mariel Hemingway, singer Sharon Jones, and former New York Yankee owner George Steinbrenner. Uniting these two categories of film are forces deep in the American character, how we work together even when our interests diverge, how easy categories of class, gender, and privilege often fail us, how we contain multitudes.

In addition to her two Oscars and Lifetime Emmy, Kopple is the winner of the Maya Deren Independent Film and Video Artists Award from the American Film Institute, three DGA awards, three Sundance awards, the International Documentary Association's Career Achievement Award, and an honorary doctorate from American University.

I spoke to Barbara Kopple in October 2023.

50 Break the Frame

Kevin Smokler: In rewatching *Harlan County USA* for perhaps the fourteenth or fifteenth time, I also reread the original Roger Ebert review that made me tear up at the age of twelve and told me that I really needed to see this movie. And I had actually forgotten this line where the late great Mr. Ebert said, "Miss Kopple does not seem to have gone far looking for strong capable women in Harlan County. They were simply inescapable."[20]

Barbara Kopple: That's so true. The women of Harlan County were the ones who weren't afraid, who had watched their grandfathers and fathers and brothers go into the mine. And you would always say, "Have a safe day." Not a good day. And [strike leader] Lois Scott—who's the woman who took the gun out of her bra—was just so powerful. She just kept persisting. She put a woman's club together. She just did everything she possibly could to win the strike, and she was fearless, absolutely fearless, and she became my role model in life.

KS: In the same review, Mr. Ebert says that this begins as a portrait of a strike but concludes as a portrait of a community.[21] And the presence of women both in the strike and in this community kind of changes everything, doesn't it? I mean, the story that you told isn't the story without the women of Harlan County.

BK: Oh, yeah, it wouldn't have been the same story. The women really like to dig deep, and really poured their hearts out and became so fierce and so wonderful. And to some of them, that was the first time that they had ever done anything that was, you know, active like this and been on the picket lines and then hauled off to jail. And this totally changed the community. They were willing to give up everything. And they didn't have much, just for the right to have a union so that the people that work there, their brothers and fathers, their grandfathers, would have a safe place to work and get a decent wage, and most of them didn't have any indoor plumbing. I mean, it was tough going for them. And I didn't think that I would ever be able to go back to New York because I felt so much like I was part of the community and part of who they were and what they were about and was so smitten with how they changed me and how passionate they are. They changed me in a way that I would never be silent.

KS: I know you've been asked twenty versions of this question, so this probably sounds a little pre-chewed: How does a nice Jewish girl from Scarsdale earn the trust of a mining community in Brookside, Kentucky?

BK: Well, I think it started on the first day we were really there. It was a terrible rainstorm. And we were staying at this small motel at the top of the hill at the top of Pine Mountain. And there were no guardrails on either side. And going to the picket line at like, four in the morning or whatever time, five in the morning, a car skidded next to us. And we crawled out of the window of the car—everybody was fine—and walked to the picket line. And that's when they opened up to us at first when they thought, you know, we looked like a little bunch of hippies, particularly me. And then they just trusted us, and we stayed in their homes, and they fed and took care of us.

KS: I'm assuming when you guys showed up at the picket line that morning, you were soaked and muddy and probably sore from having carried your equipment all the way down that mountain.

BK: We were young and strong and vital and we didn't feel it then (*laughs*).

KS: If I may ask a little bit more about Ms. Scott, I am curious—I know because you really stayed in touch with her until her death in 2004. Is that correct?

BK: Yeah.

KS: How did your relationship with her change over time? Because I know she began as a subject but was also a role model, and then she was a close friend.

BK: Yes. And I think the most wonderful thing that happened to me was the showing of the film at the New York Film Festival, which is where the film had its premiere. Bringing the women from Harlan County to see the film, that was my next big challenge, to see if they would like it or if they cared about it, or I did something wrong, or I did something right. And they came to the New York Film Festival for the film's premiere, and Lois Scott had bought a dress. And it was like Minnie Pearl. She still had the price tag hanging from under her arm. And going onstage after it was over, and Hazel Dickens sang. We passed out song sheets in the program, and Hazel Dickens sang the last song and asked the audience to join in, and they did.[22] And then Lois Scott, who had just been made head of the Black Lung Association, and that's black lungs from the coal dust called pneumoconiosis, and she started trying to raise money. And there we were, at Alice Tully Hall [at Lincoln Center] and people are throwing five- and ten- and twenty-dollar bills on the stage. And I'm in a corner of the stage, just laughing, and Lois forgets that she's miked. And she says, "Barbara, you stop that laughing and stuff that money in your bra! We need it!" How could you not be in passion with this absolutely incredible woman?

KS: I know you maintained a friendship with her all the way until her death, and I am wondering if in key moments of your career how your friendship with Lois Scott impacted you.

BK: She was my role model. I wanted to always remember her and think about her and everything that I was doing in life, and still do.

KS: I know one of the things that you have talked about a lot with *Harlan County USA*, and that is very visible on screen, is the ever-present threat of violence that the men and women of this community live under during the strike. Perhaps the most important—I mean, there are many—but perhaps the most important moment in the movie is when [strikebreaker] Basil Collins and his thugs are turned back thanks to the defiance of Lois Scott and the women of Harlan County waving sticks at them and telling them to go away.

BK: Yes, they put a car across the road so they [the strikebreakers] couldn't get by. And that was a moment of greatness, I mean for them. They were so happy because they felt that, you know, they weren't at the picket line and that they couldn't shoot machine guns at us, with semiautomatic carbines, and we had them like right in the middle of the neighborhood and turned them back. And it was a stunning thing, everybody that's cheering and yelling and singing, and it was beautiful.

KS: I did not know that a rough cut of *Harlan County USA* was actually screened in the screening room of the legendary documentary film team of Chris Hegedus and D. A. Pennebaker. I know that was a long time ago, but I was wondering if you could just take me back to that moment, in any way memory serves.

BK: I remember it well. I think I was in fine cut of the film, *Harlan County USA*, and I didn't know whether it was good or not good, because I had lived in my head for so long and struggled to make it. I didn't get any funding, you know, for a long time. And so, Pennebaker, who I respect so much, and Chris, who I respect so much—I took a deep breath and I asked him if it was okay if we had a screening with other editors, like Charlotte Zwerin and Susan Steinberg and other people who I revered, [who] would look at it.... And they of course said yes.[23] And we did it. And I was so nervous. But people really liked that, so that made me feel very, very good. They were so generous and so wonderful to do that for me.

KS: And do you remember the moment of seeing so many of your heroes and mentors file into the room and sit down, about to watch your film?

BK: Yes, I was shaking in my boots! Not knowing what they would think or what they would say. And, you know, it's the sort of film that you've done on your own. And you've been in quarantine for so long making it that you just have no touch with reality. Except that you know, you *love* it and you love the experience of it.

KS: I know that many of these filmmakers present had also been part of the Maysles brothers' documentary ecosystem, and so had you as a young filmmaker. I was really delighted to hear you talk about how the Maysles brothers' working environment was really a fertile environment for young women filmmakers.[24]

BK: Yeah. Albert and David Maysles were incredible. They mostly only had women working there. And we would watch rough cuts of *Gimme Shelter* or *Grey Gardens*. I think *Salesman* was my first job, and my job was to do everything that nobody else wanted to do (*laughs*). And I did it with great spirit and glee. And Barbara Jarvis, who was working as an editor, would leave me work to do at night. So I would start to learn the editing, how to edit. It was incredible. Plus the Maysles—we would screen stuff and they would listen to everybody, what you had to say, and you just felt like you had a voice. It gave you incredible confidence. They were just extraordinary people, beautiful human beings. Albert would be fixated all the time on his camera, doing different tests to focus, and David would be on the phone wheeling and dealing.... It was so lively and so wonderful. It was really an extraordinary experience for me. The way that I got there was I decided to take a course in cinema verité at the New School and I was sitting next to a woman who was a receptionist at Maysles films named Angela. And she said, "You know, the Maysles brothers are looking for interns. Would you be interested?" And I said, "Are you kidding? I would love it!" And I never went back to the class again.

KS: What an extraordinary filmmaking education.

BK: You could talk to them about anything.

KS: I have a hard time reading the last line of Roger Ebert's review of *Harlan County USA* without tearing up, so if you'll forgive me because it refers to what is so special about your movie: "And most of all, there are the people in the film, those amazing people, so proud and self-reliant and brave."

BK: Yeah. Thanks for making me tear up. And I also think about Roger Ebert and, you know, what a sensational human being he was, and how he really took independent films very seriously and was one of the proponents that really looked deeply into everybody's work. I loved him. He was a wonderful person. Lots of times, he would interview me at Sundance.... We were just very, very good friends.

KS: One of the lessons that I think is so important from *Harlan County USA*, particularly now, is how we talk to people that are different from us. I feel like if anything will save America, it will be that. If this presumptuous claim of mine makes any sense, I'm wondering what lessons you learned about that from both filming *Harlan County USA* and *American Dream*?

BK: I don't know. I could think that, for me, we live in very serious times and people want to tell their story. And people want information, and they want to have a sense of truthfulness because leaders still lie to them. And if you can find incredible leaders in the field when you're making a film, there's hope for this country. And I don't know—I guess just hearing people's stories, hearing their dreams, watching them struggle for what they

Trailblazers 53

believe in and watching them change and grow as you know you're filming them over time. It's really a great communication because you're seeing it visually, and you're seeing it through them as people are getting stronger and stronger.

KS: I see this so much in all of your movies. I'm sure you have been called this before, that you are one of our most American of filmmakers, because so much of your work is not only about what it means to be an American, but what are our American values and ideals and how do we fall short of them and how do we live up to them?

BK: I guess I just really love this country and want to see it change in a way. And so I love going out into the field and meeting people and seeing people in different cultures and filming, whether it's celebrities or working people. There's nothing finer and nothing more extraordinary than being able to make these kinds of films. It's—I mean, people just open up to you and allow you in, and I just can't believe it. It's like a treasure for me.

KS: *American Dream* is a similar subject, a similar story but a very different movie from *Harlan County USA*. And I know the two are always spoken of in a pair, because they're both about labor strikes, and you won Oscars for both of them. But *American Dream* is very much about strategy. And unfortunately, it is also often about poor decisions, in a way that *Harlan County* is more clear, morally speaking, than *American Dream* is.

BK: Yeah, yeah. Well, there's people that have differing feelings about how one goes forward, not so much strategy, but you're dealing with United Food and Commercial Workers' Lewie Anderson, who had to organize all of the meat-packers, and who was very upset that Ray Rogers and Jim Guyette were doing this corporate campaign. And it was just destroying his, as you said, strategy of what he wanted to do. And they were asking for a lot of money, and many of the other plants couldn't get that kind of money. You're also dealing with [union local] P-9 people who were totally obsessed with winning and with Ray Rogers and also with Jim Guyette, and then another branch, which were not, and didn't want to lose their jobs, and have their families to support and felt like they were getting nowhere. As in Harlan County, their grandfathers worked in the packing plant and their fathers and their brothers and their husbands. So it was generations, just like in Harlan County.

KS: *American Dream* has a tough message for those of us who see ourselves as progressive or liberal, which is that moral clarity does not always equal strategic clarity. And being right does not always mean winning.

BK: Very true. I haven't seen *American Dream* in years because for some reason people don't ask to see it. So you're probably one of the few who've seen it in a long time. And also the filming of it was very difficult. There was absolutely no money. Of course, they decided to go on strike in the middle of a Minnesota winter, fifty below with the windchill factor. And we, of course, did not have the right clothes. And we would just pray that the battery wouldn't freeze in the camera so we could get in the car for ten minutes and warm up! It was a very tough shoot.

I remember my office called me. And they said, "Barbara, what are you gonna do? You have $250 left in the bank!" And I had just come in from filming. And I was trying to get warm. And I was pacing around the union hall saying, "Oh no! I don't know what to do!" But you know, do I have to go back and write, you know, up some treatments for a foundation who probably won't give me money anyway? And then they called again. And I wasn't going to take the call because I knew maybe it was really only $150 left. But I got on the call. And they said, "Bruce Springsteen just gave you a grant with $25,000."

54 Break the Frame

And I burst into tears, and everyone had to hear from my office on the phone because they had never heard me cry before. That was an amazing thing. Because we had, you know, been writing him letters and telling him, please, we'll take a small percentage of your concert, we'll do this, we'll do that. This is what we're doing. And he did it. He came across and he did it exactly when we needed it.

KS: Did you and Bruce Springsteen ever work together in the future? It seems like natural pairing to me.

BK: A little on *No Nukes* [a 1980 concert film of Musicians United for Safe Energy, a group protesting the use of nuclear power, coproduced by Ms. Kopple]. But we know each other.

KS: Did you ever have a moment filming *American Dream* where you said, well, at least for *Harlan County USA* the strike started in June and not the middle of the winter?

BK: Right. It didn't get quite as tough as in Austin, Minnesota, where it gets really cold and snows all the time! There's a big difference between the two.

KS: I know there was a fair amount of time between those two films. And I know you were not sitting around between them; you worked on several other people's films and had projects for television. I have to ask this question because, unfortunately, you have to ask it whenever you're doing interviews with women filmmakers. I hope that the length of time between *Harlan County USA* and *American Dream* was not "directors' jail."

BK: Oh, no. [I worked on] *No Nukes* through 1980–81. I was doing sound and I was doing other films.

KS: You did the sound for the first seventeen years of being a director. And you begin working in filmmaking as an editor. Do you advise young filmmakers to wear all the hats of the filmmaking process?

BK: I think so, because then nobody will ever tell you that you can't do something, because you know that you can. I think getting into the field and doing sound, you never miss anything. . . . You're hearing everything that's happening. So I think that it's very important in the storytelling.

KS: And you have fantastic ears. I'm not sure you would have made so many documentaries about music and musicians if you did not have fantastic ears.

BK: Well, I have ears that really wanted to hear what was going on! Each time I would do a film, I wouldn't want to miss a beat, I wouldn't want to miss anything that was happening.

KS: In seeing *Running from Crazy* [about the life of actress and activist Mariel Hemingway], *Shut Up & Sing* [about the music and politics of the country music band The Chicks], and *Miss Sharon Jones!* [about the late singer of the soul revivalist band Sharon Jones & the Dap Kings] all within a week's time, I realized that all of your biographical documentaries are in some way or another about fame, even if the person being featured is more famous or less famous. We ask famous people to both fit into a box and to surprise us. And your movies are always about the ideas that we have about these people are not enough, that they are more than they seem.

BK: Working with celebrities, they lead very exciting lives in front of the cameras or on red carpets or traveling around the world. But they also have the same quiet, intimate family moments that all of us have and all of us cherish. And it's these moments that interest me. It's the moments when celebrity fades away and you see the real man or woman behind the headlines. So they're real, they have their own problems, whether it's Mariel Hemingway talking about seven suicides in her family, and how to get healing and how to make sure that her kids are okay. I don't look at it as "I'm working with a celebrity!"

I'm just working with a human being who has the same pressures and the same challenges that all of us do.

KS: And in each of your documentaries about famous women, there is a moment where they all have to stand up and say, "This is who I am. This is what I believe in." That seems to be a theme that runs through them all.

BK: I think that it's important to portray the people that you film with dignity and be able to hear their own voice, be their own actions. And that goes for celebrities, as well as anybody else. I mean, as long as they're willing to let down their guard, I'm going to try to take the greatest care in telling this story the way that they see it.

KS: Intimacy is so important to your movies, isn't it? The quiet moments, the intimate moments.

BK: They're what's real! They're not playing to a camera; they're not playing to an audience. Just who they are as people. That's very, very powerful if you can get something like that.

KS: Your movies in the end are all about people. The bigness of the world kind of recedes, and you as a filmmaker and an artist like to be right up next to someone.

BK: And see the world through their eyes.

KS: I wanted to ask a couple of questions about *Desert One* if I could [*Desert One* is the story of Operation Eagle Claw, a failed attempt by the US military to end the 1980 Iranian hostage crisis]. First, most of your best-known films are photographed as things are happening. What then was your attraction to a story that was forty years done by the time you began filming?

BK: I wanted to tell this story because nobody had ever really heard it from the Americans' point of view and the Iranian point of view. And it was something that was so deep that these men had tucked inside of them. And all of them had made a promise that they weren't going to say anything about it, about the challenges and the horrors that they went through. And also when they were on the mission, there was absolute silence. You couldn't radio, anyone, you couldn't talk to anyone. These very strong Delta Force people, knowing that they might not ever come back and trying to get, you know, the Americans freed from the American embassy that were being held by the student revolutionaries. And to see these men cry and hold the most heartfelt story was—you didn't need to see it, you could just shut your eyes and you could feel it and hear where it was coming from.

KS: I was actually surprised to see and feel the emotional connections between *Desert One* and *Running from Crazy*, which are six years and several films apart in age. But both are about the weight of our own histories, that we are not just our mistakes but are more than our mistakes.

BK: Yes, absolutely. And these men saw eight of their own men die when a helicopter went into a C-130, and saw them burn up. And all these guys were so close and knowing that they would be going—and they went because their buddies were going, and they wanted to have their back and be part of what was happening.

And also, Jimmy Carter. It took me three months to be able to interview him, because it was the saddest thing he had ever gone through. The only way that I could maybe get an interview with him, but they doubted it, was to keep calling the Carter Center. And I was supposed to talk to this guy named Phil Wise, and Phil Wise would never call me back. So I decided to have a relationship with his voicemail. Because he would say, "Hi, this is Phil Wise and I'm not in right now." And so I would, you know, call and say, "Well, today we filmed this. And this person told us these stories and it was so chilling and moving,"

56 Break the Frame

and, you know, just kept doing it for weeks on end. And then finally I got a call, and the guy on the other end of the phone says, "Hi, this is Phil Wise." And I said, "I know! I'd know your voice anywhere at any time!" And he said, "We decided to let you film. You'll have twenty minutes. And it's on Valentine's Day, February 14." And I said, "Okay, we'll be there!" and then I went out and I got the best chocolates for President Carter. I had gone to South Sudan, and the women had made these beaded necklaces with hearts, And I got that for the First Lady. I brought her the necklace and I couldn't give it to them because they would take it off my twenty minutes. But President Carter was so open and really talked from his heart and talked about that, that this was one of the worst experiences of his life, almost as bad as losing his father, and that he had just wanted to negotiate and bring everybody back in one piece. It was quite a moving interview; this was in 2018–19 when he was, you know, quite elderly.

KS: Did you ever have a moment in leaving thirty-five messages for Phil Wise and trying get him on the phone where you said to yourself, "I'm a two-time Oscar winner! I'm in my seventies!"

BK: No (*laughs*). No, I did not.

KS: You are not a filmmaker that dwells much on their own success, are you?

BK: Definitely not. I just got a Lifetime Achievement Award from the Emmys. And I decided to bring up different people that I worked with over the course of my life. Because people say, "And I thank the team" and all of this, and I wanted everybody in the audience to know that you can't make these films alone—introduce them to the producers, the editors, everybody who had a part in doing a film with me and also what they're doing today, and who they are as people and what their hobbies are and things like that. So I like being able to do that; they so deserved it.

KS: Tell me about the choice to hire an all-women crew on *Desert One*.

BK: I knew that they were good. And I knew that we were all on the same wavelength. And that was what I wanted, because sometimes men have a harder time getting people to open up. That's why I wanted them. I learned early that if you're a guy, you're supposed to know all about sports, and you can't ask certain questions about boxing and things like that. But if you're a woman, you're not supposed to know about that, so they'll really try to help you understand what it's all about. And that makes for really good access and filming!

KS: Like on the George Steinbrenner film you directed for ESPN?

BK: Yes! I mean, we got into everything. I did the first interview ever with Hal Steinbrenner [the late George Steinbrenner's younger son and current owner of the New York Yankees, along with his three siblings]. And I got him to tell a really personal story. He was very shy and doesn't really like doing interviews. But I asked him about his relationship with his father, stepping into these shoes and how challenged he felt. And he told me a story, because he's a pilot, about taking his father up in a plane, and he said that that was the first time he ever had control over his father, George Steinbrenner, that George Steinbrenner was hanging on, white knuckled. He wanted to go down! Hal took him for a good ride and did circles and other things. And so for him that said a lot about who he was.

KS: Was that movie like making a biographical documentary about the president of Duke Power or Hormel Foods, one of the villains from *Harlan County USA* or *American Dream*?

BK: No, not at all. It's baseball. And everybody loves baseball and loves knowing what's happening there. And you don't often get a chance to go in the men's locker room, even

if they're taking showers and coming out. No it was more a film about the end of the Yankees, the old Yankees stadium, and the beginning of the new and also the beginning of not having George Steinbrenner there anymore.

KS: You've talked about how, no matter how far you get into your career, with each project, you feel like you're starting over every time.[25]

BK: Yes. That's always true. It's brand new, and you don't know where it's gonna go, where it's gonna lead you, and whatever research you do, you just have to let it out of your head and go with what's happening. And it always surprises you.

KS: Without that element of surprise, without, you know, to quote *Wicked*, without "closing your eyes and leaping," it's not fun.

BK: (*Chuckles*) I love not knowing what's around each corner. It's exciting. It's fun. It's, you know, making these kinds of films. It's messy. It's real life. It's tragic. And it's joy. It's all the different things that compile who we are as people and what life is all about.

KS: When you talk to young people who are at the beginning of their filmmaking careers and when you say to them things like you have to move towards the thing you're afraid of and embrace the uncertainty of it, do you see panic in their eyes? Do you see hopefulness?

BK: Oh, I see eagerness. And I see passion. And I don't see the fear. I see that they know that there are people who care about them and will help them in any way that they can to be successful.

Notes

1. Taffy Brodesser-Akner, "'Clueless' Was Amy Heckerling's Masterpiece. Is She Done with It? As If," *New York Times Magazine*, December 5, 2018.

2. Katie Rife, "*Clueless* Director Amy Heckerling on How a Pessimist Created One of Cinema's Great Optimists," *A.V. Club*, July 16, 2020, https://www.avclub.com/clueless-director-amy-heckerling-on-how-a-pessimist-cre-1844370931.

3. Cara Buckley, "Julie Dash Made a Movie. Then Hollywood Shut Her Out," *New York Times*, November 18, 2016, https://www.nytimes.com/2016/11/20/movies/julie-dash-daughters-of-the-dust.html.

4. "Julie Dash, "Making Movies That Matter: A Conversation with Julie Dash," *Black Camera* 22, no. 1 (2007): 4–12.

5. Richard Brody, "The Return of Julie Dash's Historic 'Daughters of the Dust,'" *New Yorker*, November 18, 2016, https://www.newyorker.com/culture/richard-brody/the-return-of-julie-dashs-historic-daughters-of-the-dust.

6. Craig D. Lindsey, "Julie Dash and the Ongoing Struggle of Black Women Filmmakers," *Indy Week*, September 7, 2011, https://indyweek.com/culture/screen/julie-dash-ongoing-struggle-black-women-filmmakers/.

7. A. O. Scott, "The Forerunners: Daughters of the Dust (1991)," *T Magazine*, April 13, 2020, https://www.nytimes.com/interactive/2020/04/13/t-magazine/daughters-of-the-dust.html.

8. Video Artist Arthur Jafa has exhibited at museums and galleries around the world and photographed and produced music videos for Solange and Jay Z. *Daughter*'s production designer, Kerry James Marshall, is a 1997 MacArthur Award recipient whose paintings are in permanent collections of dozens of museums. Cast member Cheryl Lynn Bruce is a fixture of the Chicago theater community as both a performer and director.

58 Break the Frame

9. Carol Christine Hilaria Pounder has been acting consistently in movies and television since 1979 and is a four-time Emmy nominee for her work on *The X-Files*, *The Shield*, *ER*, and *The No. 1 Ladies Detective Agency*.

10. Angelica Jade Bastien, "We Have a Lifetime of Stories to Tell: Julie Dash on 'Daughters of the Dust,'" Roger Ebert.com, March 27, 2017, https://www.rogerebert.com/interviews/we-have-a-lifetime-of-stories-to-tell-julie-dash-on-daughters-of-the-dust.

11. Bastien, "We Have a Lifetime."

12. One of the leading figures of the American independent film movement of the 1970s and 1980s, John Sayles has two films he wrote and directed—*Return of the Secaucus 7* (1980) and *Matewan* (1987)—in Library of Congress's National Film Registry.

13. "Ava DuVernay, Julie Dash & Euzhan Palcy | Academy Dialogues: Broadening the Aperture of Excellence," YouTube, October 20, 2020, 53:27, https://www.youtube.com/watch?v=pz-8LoMzLbc.

14. *Alma's Rainbow*, a 1993 coming-of-age story about Black womanhood written and directed by Ayoka Chinzera, was restored and released to theaters and streaming in 2022. The restoration was presented by Julie Dash. *Losing Ground*, a 1982 drama written and directed by Kathleen Collins, was not theatrically released in the filmmaker's lifetime. In 2020, it was added to the Library of Congress's National Film Registry.

15. Greg Tate, "Of Homegirl Goddesses and Geechee Women: The Africentric Cinema of Julie Dash," *Village Voice*, June 4, 1991, p. 79.

16. Joey Nofli, "15 Years Later, *Real Women Have Curves* Is Still a Cultural Revolution," *Entertainment Weekly*, October 18, 2017, https://ew.com/movies/2017/10/18/15-years-later-real-women-have-curves-is-still-a-cultural-revolution/.

17. Nofli, "15 Years Later."

18. Maria St. John and Cheryl Dunye, "Making Home / Making "Stranger": An Interview with Cheryl Dunye," *Feminist Studies* 30, no. 2 (2004): 325–338.

19. IUCinema, "Final Draft: Cheryl Dunye on Film," YouTube, April 18, 2018, 11:13, https://www.youtube.com/watch?v=it7Kra-Aw-g.

20. Roger Ebert, *Roger Ebert's Movie Home Companion 1987 Edition* (Kansas City: Andrews, McMeel & Parker, 1987), p. 242.

21. Ebert, *Movie Home Companion*, 242.

22. A pioneering bluegrass musician, the late Hazel Dickens appears in *Harlan County USA* and contributed three songs to the film's soundtrack. She was the first woman to receive the International Bluegrass Music Association's Merit Award.

23. The late Charlotte Zwerin edited pioneering documentaries such as *Salesman* and the Rolling Stones' *Gimme Shelter* documentary for the directing team of Albert and David Maysles. Susan Steinberg also worked on the editing team for *Gimme Shelter* and is an Emmy Award–winning producer of the PBS *American Masters* series.

24. Joseph Di Mattia, "Of Politics and Passion: Barbara Kopple's *American Dream*," *Documentary Magazine*, December 1, 1991, https://www.documentary.org/feature/politics-and-passion-barbara-kopples-american-dream.

25. Justin Anderson, "'Documentaries Can Open Windows': Barbara Kopple Talks Lifetime Achievement Emmy, Career Highlights," *Realscreen*, September 28, 2023, https://realscreen.com/2023/09/28/barbara-kopple-on-lifetime-achievement-emmy-and-the-importance-of-docs/.

Section 2
Sages

Mimi Leder, Jamie Babbit, Jessica Yu, Tamra Davis, Aline Brosh McKenna, and Debra Granik

The six filmmakers in Section 2 "Sages" are directors known for their staying power and influence over time: Mimi Leder, an action movie director (*The Peacemaker*, George Clooney's first starring movie role) who pioneered the use of Steadicams on workplace television dramas such as *ER* and *The West Wing* (resulting in the invention of the "walk-and-talk"); Jaime Babbit, a key director of the New Queer Cinema movement of the 1990s (*But I'm a Cheerleader*, which cemented Natasha Lyonne as a star) who also directed the pilot episode of *Only Murders in the Building*; Jessica Yu, who modeled seamless transitioning from documentary (the Oscar-winning *Breathing Lessons*) to fiction film and back again (the Awkwafina-starring *Quiz Lady*); Tamra Davis, who demonstrated the possibilities of music video directing (Hanson's *MMMBop*) launching a feature film career (Britney Spears's *Crossroads*); Aline Brosh McKenna, one of the few brand-name screenwriters of the modern era (*The Devil Wears Prada*), who became a TV showrunner (*Crazy Ex-Girlfriend*) and film director too (*Your Place or Mine*, starring Reese Witherspoon and Ashton Kutcher); and Debra Granik, whose films seem to inaugurate an actor's career (Vera Farmiga in Granik's debut *Down to the Bone*, Jennifer Lawrence in *Winter's Bone*, a pre–*JoJo Rabbit* Thomasin McKenzie in *Leave No Trace*) each time.

Our six sages have enough Oscars, Emmys, and film festival trophies to confuse us all trying to remember them. And yet their biggest accomplishment may be the future they showed was possible. Undoubtedly, all six had to find directing opportunities in television and music video in order to make a living and stay in the game, because their chosen industry was not always rolling out red carpets for their next film projects. Their tenacity however resulted in a bigger, richer vision of what a filmmaker does, an idea now so ordinary that we don't blink when we hear about this movie director making that music video and then taking on an opera before putting together some short films for this friend or that organization.

These artists diversified because they had to. But their diversified approach helped wash away artificial boundaries between power of director and size of project. Our understanding of directing is bigger and richer because our six sages showed us how it could be.

Mimi Leder (b. 1952)

Films Mentioned
On the Basis of Sex (2018)
Pay It Forward (2000)
Deep Impact (1998)
The Peacemaker (1997)

Television Mentioned
The Morning Show (2019–present)
The Leftovers (2014–2017)
The West Wing (2006)
ER (1994–2009)
China Beach (1988–1991)
L.A. Law (1987)

Mimi Leder's four films—about terrorism, the destruction of our planet, human generosity and kindness, and Ruth Bader Ginsburg—are all about how we humans are not the most important thing in our world and how destiny should and will call upon us to confront that. Perhaps it makes sense that when she got her start in television, this daughter of an independent filmmaker and classical pianist, a graduate of the first class of women at the American Film Institute, would soon be directing "prestige television" or "Peak TV" long before we had a name for it. The film directing of Mimi Leder has big on its mind. "Peak TV" does too. Of course her television directing, where her career began, would take arguably the most ubiquitous entertainment medium in human history and imagine it could be more.

An early hire to groundbreaking network TV dramas such as *ER* and *The West Wing*, Leder now (way too late but still) is given credit for such innovations as use of Steadicams to give workplace shows a feeling of speed and intensity. That pace on *ER* led to its executive producer, Steven Spielberg choosing Leder to direct his new studio DreamWorks's first movie, the international action thriller *The Peacemaker*, starring George Clooney and Nichole Kidman, and the company's equally grand comet-headed-to-earth action movie *Deep Impact*. It was Leder's third movie, the fable *Pay It Forward* that did not meet box office or critical expectations that landed her in "director's jail," a phenomenon where filmmakers can't get hired after directing a bomb. Unsurprisingly, women directors get longer sentences in director's jail than men.

And yet, in the nearly two decades between Leder's third film and her fourth, the RBG biopic *On the Basis of Sex*, television went from being a director's punishment for failing at movies to being what *The Ringer* called "a place of renewed prestige and creative freedom."[1] In the era of multiple-hundreds of scripted shows to fill several dozen channels and streaming services, TV directing can be as ambitious and daring as movies. And Leder, who has done both at the very peak of ambition, is a large reason why.

Over her career, Mimi Leder has received 12 Emmy nominations, winning one for directing and one for producing for her groundbreaking work on *ER*. Most recently, she earned nominations for both directing and producing on *The Morning Show*.

62 Break the Frame

She has also been honored with the prestigious Franklin J. Schaffner Award, celebrating the filmmaking achievements of an alumnus of AFI, and is a recipient of a Women in Film Crystal Award.

I spoke to Mimi Leder in June 2023.

Mimi Leder: Who are the other women in the (book) that you're interviewing?

Kevin Smokler: I'm so glad you asked that because we've been really fortunate—we spoke to Anna Boden, Sherry Springer Berman, Patricia Cardoso and Chris Hegedus, Cheryl Dunye, dream hampton, an incredible list of people I've admired my entire adult life as a movie lover. It's really been fun.

ML: My goodness, how wonderful. There used to be only a handful. When I was coming up, it was slim pickings, you know.

KS: Absolutely. May we start with your work on *The Morning Show*?

I feel like looking at your filmography, the work you did on *The Morning Show*, both directing and executive producing, is perhaps the completion of a circle. The idea of television looking more like film is not only something you made happen, but it's also a representation of your career as both a feature filmmaker and a television director.

ML: Ah, well, that's a lot of questions! When I approach a script or a story I want to tell, I don't look at it differently. I don't look at TV and film as different things, as different objects. I look at the story and how I want to tell it. And the big screen versus small screen, for me, only matters in terms of what the film ratio is: if you're going to see it on a big screen, if you're going to see it in a small box. And we never used to have to think about those things, and we would pick the 2:35 ratio versus the 2:1. And when I was shooting *On the Basis of Sex*, I was standing with my DP [director of photography], Michael Grady, in front of the Supreme Court Building and we kept looking at the framing going, "How is this going to fit in a 2:35 format? It's not. It's too tall! How people are going to see it?" Even though it was a film, you now know that people are going to see everything in a smaller image. And so for me, it's sometimes in the framing, but the storytelling is always the same.

I don't differentiate between television and film. I just look inside and try and find what the story is about. What am I trying to say with these images? With these words? That's why television is looking more like film every day. Because I think the world burst open and said, "What's the difference?" ... Film was the top dog, and then television became, "Hey, we can tell more stories in many different ways on television than we ever could in feature filmmaking!" Because feature filmmaking has changed quite substantially. What stories can we tell on film versus television? It's a really big question. And you know, everything changes, and will it ever go back to the way it was? It never will. But what can it be?

KS: Rewatching *The Morning Show* and then watching your movies in order, leading up to *The Morning Show*, I noticed how much of your work is about the smallness of human beings in the face of something huge, be it the whims of a network television audience or a comet hurtling towards Earth. How would you describe your attraction to stories where we as people are not in the driver's seat of our own lives?

ML: We can't control everything. We try, right? "This is how I want it to happen!" Well, that's not how it happens. You can control just so much. And then you have to let go and figure out if the universe is speaking to me, and it's not giving me the answer I want, well, how

can I get the answer I want? How can I find the bigness? How can I find the control? How can I find the answers to these big issues we can't control?

One of them was the comet [in Mimi Leder's second feature film, 1998's *Deep Impact*]. How do we control our lives if you're given a death sentence? If you are told in nine months the comet is going to hit and you are going to die. The world as we know it will no longer exist. Well, that's certainly out of your control, but you can control those nine months. You can control those feelings. And to me, that movie was really more about, What would you do if you had nine months to live? How would you live your life? It really wasn't about "a comet is coming to earth to destroy us!" It was more of, how do I find everything in my heart and soul that I want to do and express? Who haven't I told, "I love you"? What am I doing with my life? What is my purpose? So those are the questions I was answering, trying to answer and explore in that film.

With *On the Basis of Sex*, it's interesting you say things that are out of our control. Well, are the laws out of our control? Nowadays, they seem to be. Ruth Bader Ginsburg certainly took the law, with her brilliant mind, and changed 187 laws with this one case that we explored in *On the Basis of Sex*. So there ARE things you can control, there ARE things that you can grasp onto and change. There are those singular stories that affect the world. And yes, I'm interested in the world. But I'm interested more in our reaction to it and how to tell that story, how to tell a big story with big shots, big, wide shots. Then go into those tight close-ups to find the emotion, to find what is going on between the lines: What am I feeling? What do I want? And I think we're all sort of searching and asking those questions. And I think most characters in most stories are asking themselves those questions.

KS: I had not seen *Deep Impact* until researching for our conversation together. I found it deeply—pardon the pun—moving because I feel, particularly seen in the context of your other work, that so much of your work is about the human cost of large things. Your movies and TV work are not content with, sort of, institutions talking to one another or large phenomena being seen as self-contained abstractions. Instead, there's something deeply human about your work, because it is always telling us to not halt our attention at the large, inhuman thing happening. Do not stop and be content with "This story is about a deadly comet or a Supreme Court decision or a morning show television audience."

ML: Yeah, I hear you. Thank you. There's a human cost to everything, and I'm definitely fascinated with what that loss is. And one of the things that I was drawn to with *The Leftovers*—that Damon Lindelof, and Tom Perrotta created—and working on those stories about how 2 percent of the population disappears and nobody knows why, is how it deals with the emotions and the abandonment, and the feelings of loss and love with the people that are left behind.[2] That's the kind of story that really fascinates me.

I was gonna go back to *The Morning Show* because you asked me a question about that being a completion. What did you say?

KS: That your work on *The Morning Show*, a TV series that's a cinematic treatment about the making of television, is the completion of a circle in your career, which has been equal parts making movies and pioneering a kind of television that feels like moviemaking.

ML: I don't know if I will ever complete the circle, honestly. I think there's so many stories to tell. *The Morning Show* is a really fascinating story about the behind-the-scenes machinations of the people that you wake up with in the morning, and how flawed and fucked up they are, just like we are. They're no different, except they're extremely spoiled and very rich. But they're flawed, and they have real issues, real human problems—and then completely

64 Break the Frame

outlandish problems that, on the face of a lot of human suffering, don't mean a damn thing. It's been a fascinating series, exploring the #Me Too movement, exploring the autonomy of women, and exploring how they live in this ever-changing world as journalists.

Morning show journalists are not taken as seriously. And neither are women within the context of that world. They're always in search of power and control once again (*laughs*)!

KS: When my wife and I watched *The Morning Show* and saw your name in the credits, we said, "Oh, Mimi Leder! She's the perfect director for this show. Because *The Morning Show*'s principal characters exist in an America and a world, really, that a young lawyer named Ruth Bader Ginsburg created.

ML: (*Chuckle*) Yes, that's really great. Wow.

KS: It's a coincidence, of course, that *On the Basis of Sex* is the big project you were directing before *The Morning Show*, but, in my mind, I cannot separate the two.

ML: That's so interesting. Before I did *On the Basis of Sex*, I had dinner with Michael Ellenberg—who I worked with at HBO on *Luck*—and, anyway, he was beginning his own company, Media Res. He said to me, "I have this idea. I'm optioning this book, *Top of the Morning*, written by Brian Stelter, and it's about two hosts. Reese and Jen are involved, and I'd love you to develop it with us, and direct it, and exec produce it." And this is before it was written, before it was sold. And I love the inner workings of, I'm fascinated actually, with what goes on behind the scenes of anything. Especially television and films. . . . So that was before—nothing was written. I said, "Yes! I would love to do it!" And I've never signed on to anything that was not written.

And then I went off and directed *On the Basis of Sex*. And then I came back, and there was *The Morning Show*. It was really kind of fascinating how it all came together. One of the things I'm hopefully going to be directing soon is a story about my family. My father, Paul Leder, was an ultra-low-budget filmmaker starting in the 1960s to the 1990s who won the Santa Barbara Film Festival for the Best of the Fest in 1990. And he made movies for $300,000. They were B-movies, but they always had a message. I was brought up on these films. I was a crew member; I did every job one could do. With my sister, Geraldine, my brother Ruben, and my little niece, Stefanie, who's now a writer. Ruben, Stefanie and I wrote a script about my father and our family called "I Dismember Papa." It's about the family you make when you make a film, and making it with your family, your actual family. It's the whole behind the scenes of trying to tell a story; how you take risks and how you'll do anything to get that shot.

KS: That's so great. There are a number of pairs of brothers who direct films together but very few pairs of sisters or brother-and-sister combinations. I will say, in the course of my research, I did not realize that you are the first director I have interviewed who is both the parent of a director, the child of a director, and a director themselves.

ML: That is really true. Yes! Isn't that amazing? I learned so much from my father. He didn't have cranes. He didn't have all the fancy equipment. He just said, "How am I going to tell the story on this little shoestring budget?"

I went into mainstream and hopefully after Season 4 of *The Morning Show* I will be making my little indie film that is going to be the one closest to my heart. But my daughter, Hannah Leder, made a film called *The Planters* and with Alexandra Kotcheff, who's also the daughter of a filmmaker, Ted Kotcheff.[3] The two of them were like, "We're young filmmakers. No one's gonna want to give us money to make a film." They wrote a script.

They went to the desert. They co-directed it. They co-starred in it, they co-wrote it. They did all the costumes. They shot it; Hannah edited it. And they were the crew! And they made it and they won all these film festival awards. And it's on Apple TV+.

Yes! It's in our blood. It's in our DNA. And like my father, they didn't have any money. So they did it themselves.... And it was a real, *real* lesson in filmmaking. And I'm really proud of her.

KS: I think all of us who love movies love movies about the making of movies.

ML: Yes!

KS: I have a quick question for you about the opening scene of *On the Basis of Sex*, which I believe is now like a modern classic of opening scenes, because it accomplishes two things. One, you see a young Ruth Bader Ginsburg, on her first day at Harvard Law School, in a sea of men demonstrating the conditions of being a woman going to law school at that time. But the music underneath the scene has this marching band percussion to it and because she's wearing—because it's fall, with the beauty of the leaves turning colors in the sunlight and she's approaching this colonial building—this fabulous blue outfit. It feels like you're watching a movie about the making of an American icon. Shoot the scene the exact same way and its a young John Kennedy's first day at Harvard instead of Ruth Bader of Flatbush Brooklyn, and it still works.

ML: Well, it was really interesting. First of all ... the dress. Picking the perfect color blue was absolutely the most important detail. Revealing RBG in the sea of men of grays and blacks and browns. We wanted her skirt to sway in a certain way. The heft and the content of the material of the skirt was very important.

Isis Mussenden was our a brilliant costume designer. We had a lot of pictures of Madame Justice, and we were able to look at the times and styles, feel the quality of the materials. She designed all those costumes, and they were exquisite. The song is "Ten Thousand Men of Harvard." It's the Harvard song and we actually had the Harvard chorus rerecord it for us, too. And it was incredible to be a part of that experience.

Of course, we couldn't shoot at Harvard, because Harvard won't let you shoot at Harvard. We shot that at McGill University in Montreal. And our budget was low. And we didn't want to do a lot of visual effects. So I shot it in a very particular way with very few reverse shots. It was very important to show her eagerness, her passion as we all have when we are very young—and then see the passion that continued throughout her entire life, where it began, and where it continued, and then ended. It was a wonderful experience and fun to shoot that opening sequence and get it right. And Felicity Jones was absolutely tremendous.

KS: Also in that opening scene, other than in the most superficial way, you never say that the main character is out of place or doesn't belong. The feeling you get from the opening of *On the Basis of Sex* is that Ruth Bader absolutely belongs at Harvard Law School.

ML: Yes.

KS: You've said that crucial to the story of Justice Ginsburg is her marriage to Martin Ginsburg and how progressive it was for the 1950s and 1960s in America.[4] I feel like this is something I see, both in this movie and throughout your career as a filmmaker. You are always very vocal about the people who supported you coming up, [showrunners] Steven Bochco and Gregory Hoblit when you were a script supervisor on *L.A. Law*, and Steven Spielberg, who hired you to direct both *Deep Impact* and *The Peacemaker*, and the

66 Break the Frame

support that John Wells[5] and Damon Lindelof, all of these sorts of powerful figures in filmmaking, have given you.

There's something that feels very feminist about that to me, an acknowledgment of support and mentorship and that we all come after someone and come before the next generation. The opposite of this to this very patriarchal notion of "Oh, I'm a genius, and nobody helped me! I did it all myself!"

ML: I've had a lot of support and mainly from men, especially my husband, Gary Werntz. We've been married for thirty-seven years. He's a true feminist. He is a great supporter of my storytelling and has been a true partner. As was Marty to Ruth Bader Ginsburg. We had a lot of similarities in terms of she had a very long marriage, I have a very long marriage. We're very career minded. All I can say is, as a creative person—which my husband is a writer/actor—if anyone says they do it all themselves, it's ridiculous, a fantasy and bullshit.

Filmmaking is a collaboration. It takes a village to raise a family, to birth a baby. I compare filmmaking to birthing. It is hard, it is painful, and it's joyous. So I've been very fortunate. Only two women have ever really given me a job. And that is [former chairperson of Paramount Pictures] Sherry Lansing, who was a great supporter of mine with *Deep Impact*, and Gail Berman, former president of both Fox Entertainment and Paramount Pictures

It's been really interesting. I've given lots of women jobs. Coming up in TV, I would hire as many women as I could, and still do. In fact, most of our directors beside myself on *The Morning Show* are women . . . and yes, it takes a village.

KS: You've had a very long career in television. And I've read several times that hiring women is important to you.[6] I'm wondering if you have any success stories you'd like to point out, people you hired at the beginning of their career that went to do great things.

ML: I hired Lesli Linka Glatter on *ER*.[7] And Lesli is one of my dear friends now and became one of our great directors and a great human being.

KS: Current president of the DGA, right?

ML: Yes, she does it all.

As for my career, it's not over. It's really interesting at this age, I'm more in demand, and I'm offered more things than ever as I get older and as I get better. I feel like I'm in a way just at the beginning. Or kind of in the middle. I don't feel it's the end. The end will come (*laughs*).

KS: I mean, you were making something called "prestige TV" before we had that name for it.

ML: I would say that the first prestige television I did was called *China Beach*, and it would never be on a network today. And it was a really meaningful story about women in Vietnam, nurses in Vietnam, and the cost of war. It was all about relationships.

It was my third job. I had been directing in television for about a year, when [coshowrunner] John Sacret Young came calling and asked me to direct two episodes of *China Beach*. I directed them, and then he called me into his office, and he said, "Mimi, I want you to join the staff." And I said, "As what?" And he said, "As a director, producer. I want you to direct as many as you can and hire the staff and train all the directors and prep all the directors."

That's what Greg(ory) Hoblit did on *Hill Street Blues*, and he was my mentor. He's the one who gave me my break. He's the one who hired me [on the legal drama *L.A.*

Law in 1987], and I'm forever grateful for him. It was a meaningful time. It was a great time. Good stories.

KS: I watched all those shows growing up. I'm wondering if you recognized at the time, be it on shows like *L.A. Law*, created by Steven Bochco, which really revolutionized network television about the workplace, and later on *ER*, which pioneered the use of Steadicams and handheld cameras on television drama, that you were part of creating a new television language.

ML: I was just doing it. The *ER* pilot was about 25 percent Steadicam. And when I came along—I came along first episode as producer-director on the show—and changed it into 75 percent. But I had no idea that I was revolutionizing television. I was just telling stories, and what a great way to tell a story. It was, "Let's do these shots! Let's do six-minute shots! And let's connect everything!" We started doing these incredible one-ers [long shots in one take], and let's connect everything! It was a great, fascinating way to tell a story. Then as we were doing these shots and telling the story in this fast-paced, moving way, the scripts had to get longer and longer. We started out with fifty-three-page scripts. By the time I think we were done with the first season, we were doing eighty-page scripts because we were moving so quickly through the material.

I think when you're in the middle of it, at least for me, I was just having a great time telling these stories and really didn't think about the results or what it meant—until people started really talking about what it meant and how it felt to them.

KS: So do you find it flattering or silly or something else entirely that you are often given credit for creating the walk-and-talk that was brought to its zenith by Aaron Sorkin?[8]

ML: I think it's very flattering. I mean, why not? It's true. And then came *West Wing*, which articulated that whole style. I hired Tommy [Thomas] Schlamme, by the way, on *ER* and then gave him a second job on it.[9] And I remember him telling me one day, "When you gave me that second job, you know, it meant something to me." I was like, "I just love Tommy Schlamme and I want him to direct another episode because he's so good!" And what's interesting about episodic television is hiring these directors, you don't want someone to come reinvent the show, but you do want a director to give their point of view and make it better and grow it. Some episodic directors don't do that, and high-end directors do. I think great directors, strong directors come in and help grow the show.

KS: I have a question about your third film, *Pay It Forward*, because I read a lot of the reviews of *Pay It Forward*, and it seems like they categorically missed the point. I always saw that movie as a fable, and the reviews play it very straight.

ML: Yeah.

KS: So I'm wondering, you've said *Pay It Forward* landed you in "movie jail."[10] I totally believe movie jail is a real thing; I don't think this book would exist if it wasn't. I know that there's no actual place or nobody calls it that or anything. My question, then, is how you as a director whose talent has clearly been recognized by a lot of very powerful people, rightfully so, ends up in this place. I mean, is it one bad movie? Is it sexism?

ML: It's how one perceives that movie. So many people have come up to me in the years since saying how much they love that film. But yeah, the critics did not love it. And I went straight to movie jail. And I couldn't get a movie for years after that. The thing is about it, it was painful. It was something I came back from. I never stopped working after I made that film. I immediately went into television, continued in television. And I've directed,

I think, seven out of ten pilots that have gone to air. And so it's very interesting that I couldn't make a movie, but I could do television.

As television evolved, it was a great place to be. I would say it took a long time to get out of movie jail. Yeah, movie jail sucked. You know, and it was awful.

Do awards mean anything? Do nominations mean anything? I don't know. I look at it and I go, "Okay. You went to movie jail? You have two Emmys and twelve Emmy nominations. Do I measure my career by that?" And I hope not.

I would like to measure my career and the work I do with how it affected you. Did you feel something? I know that's so corny. Did it move you? Were you pissed off? Good! That's how I sort of want to gauge my success—not really through the awards, but through the ability to continue to tell stories in an interesting and unique way.

KS: I feel like a similar thing happened on *The Peacemaker* that happened on *Pay It Forward*, which was that movie was saddled with being both George Clooney's first major starring role and the new DreamWorks studio's first motion picture. And you had been chosen by Steven Spielberg to direct it. All of that tacked like a 50 percent expectation tax onto that movie before anyone saw it and that just felt really unfair to me. Unless it was the number one or two box-office hit of the year, someone was going to say, because of that expectation tax, that it was a disappointment.

ML: I'm sure they said to Steven, in quiet corners of the beginnings of DreamWorks, "You're hiring *who* to direct our first movie?!" And I even said, "Why are you hiring me? Why do you want me to direct your first movie? An action movie?" And he said, "Well, you know, you direct action every day on television."

In many ways, I think it was a very successful film. And I wish it had come out today. Our villain [was] played by Marcel Iures, this incredible Romanian actor. It was really challenging, you know, to try ... how would I say this? Creating a terrorist that was human, who was a human man, as he says, and the wrongs that had been done. It was the beginning of conversations like "Who are these terrorists? Where did they come from? Why do they want to destroy the world? Why is the world so painful? What did we do?"

Anyway, I really love the movie. It was a great experience, and I was so lucky to make it.

KS: Who are some of your peers, women directors of the same generation as you who are doing great work who you admire? And who are directors of a previous generation of filmmakers you could learn from and did learn from?

ML: In terms of female filmmakers, Lina Wertmüller blew my mind when I saw her films come on the scene. She inspired me to become a filmmaker, and so did Federico Fellini. And I know that's kind of, you go, "Federico Fellini and mainstream television? Or *The Morning Show*?" (*Laughs*) But he was my big inspiration, as was Hal Ashby. Hal Ashby told stories and made me want to be a filmmaker more than anything. Filmmakers like Fellini and Wertmüller, Spielberg, Hal Ashby. Points of view, unique voices. And I only aspire to be an ounce as good as they were.

I would say my contemporaries today would be—Kathryn Bigelow is one of the greats, and Paul Thomas Anderson is one of my big movie crushes. There's so many great ones.

In terms of my generation, it was Kathryn Bigelow, and me and Martha Coolidge and Amy Heckerling. I mean, there were just a few of us who were out there, and there's so many greats out there now.

KS: You and Amy Heckerling were AFI classmates?

ML: Correct. I went into AFI, I applied as a cinematographer because I wanted to shoot. I loved imagery, and I loved lighting. And I came in, I directed a little film, and they said, "Why are you coming in here as cinematography? You should be here as a director! You should be directing!" And I say, "Well, I don't want to direct, I want to be a cinematographer!" So as soon as I got in, of course, I wanted to be a director. But I was in there as a cinematography fellow, alongside Amy, and that was fun.

KS: May I ask one last question about *On the Basis of Sex?*

ML: Sure.

ML: *On the Basis of Sex* is your first movie that is set in the past and is also about a real person. I've heard you speak of it as a film that reflected the joy of feminism in the sixties and seventies.[11] And tonally, the movie has a great sweep and a real feeling of joy. It reminds me of an E. L. Doctorow novel, the glory of witnessing great Americans become great Americans. What is the unique challenge of making a movie that has this great feeling of joy, but it's also the nitty-gritty of a real person in their struggle to effect change?

ML: Daniel Stiepleman, her nephew, wrote the script. . . . Madame Justice had script approval. And so we wanted it to be as close to the truth, or inspired by the truth, of who she was. And it was really challenging to get that right. And her career was joyous. It was painful, and it was joyous. It was all the things that anyone who struggles to do something in this life experiences.

I lived through the seventies. I was raised to be a feminist. My father was a feminist. I remember that time of great joy and passion and so, it wasn't hard to find that. We just had to find it in a creative way with the script and keep it real. So it was really hard to get it right. And I think we did get it right.

When we had the screening with Madame Justice, I sat kitty-corner to her so I could see her watch the movie. And she laughed, and she smiled, and she cried throughout the whole thing. And that was my answer. Did I—did *we* tell the story right? Did we get it right? And her laughter, her tears, and her great big, beautiful smile and approval was everything I needed in order to say, "We got this film right."

It was a joyous experience. Joyous. It was incredible.

Jamie Babbit (b. 1970)

Films Mentioned
The Stand In (2020)
Addicted to Fresno (2015)
Breaking the Girls (2012)
Itty Bitty Titty Committee (2007)
The Quiet (2005)
But I'm a Cheerleader (1999)
Sleeping Beauties (1999) (short)

Television Mentioned
Only Murders in the Building (2021-Present)
Russian Doll (2019)
The Marvelous Mrs. Maisel (2018)
Silicon Valley (2016-2018)
Looking (2014-2015)

Actors Launched
Clea DuVall
Natasha Lyonne

If you've not seen *But I'm a Cheerleader*, the 1999 independent comedy that did much of the work of making a movie star out of Natasha Lyonne, really now, what are you waiting for? The directorial debut of Jamie Babbit, about a cheerleader mistakenly sent to a gay conversion center whose ridiculous program is succeeding with exactly zero of the teenagers in it, is now viewed as a comedy cult classic and has a place of honor in the modern queer film canon. To me, who would like to laugh more at the movies than he usually does, *Cheerleader* remains, after a dozen viewings, one of the funniest movies I have ever seen.

A theater kid from Shaker Heights, Ohio, Jamie Babbit attended Barnard College and took summer film classes at NYU. She developed her own projects while working entry-level jobs for directors Martin Scorsese, John Sayles, and David Fincher. Two of her early short films were accepted to Sundance, where she secured financing for *Cheerleader*.

Babbit's six feature films and television directing (including multiple episodes for *Gilmore Girls*, *The Marvelous Mrs. Maisel*, and the pilot of *Only Murders in the Building*) have been nominated for Emmys and Hugos and won prizes at Sundance and the SXSW Film Festival.

I spoke to Jamie Babbit while she was on location in London in January 2023.

Kevin Smokler: There's a real "There are no small parts" philosophy to your movies which I love. Legendary actors will sign on for a few minutes of screen time in a Jamie Babbit film. Cathy Moriarty [an Oscar nominee in Martin Scorsese's *Raging Bull*] as the antagonist in *But I'm a Cheerleader* or [eight-time Emmy nominee] Holland Taylor showing up for two scenes in *The Stand In*.

72 Break the Frame

Jamie Babbit: I've been very lucky to work with so many actors in my television career. So I have a lot of love and appreciation for them. And we ended up just really bonding when we work together on whatever it is. So whenever I'm doing my movies, I always email people that I've worked with before and just say, "Hey, I'd love to work with you." Like, "We had such a great time last time. Do you want to come and work on this other project?"

In the case of Holland Taylor, I had never worked with her. But I had certainly tried to work with her on other things. And so I was able to reach out to her directly and say, "Hey, remember me? I had offered you a million other things. Would you be interested in being in New York in two weeks to do this part where you can play me, basically, 'female director'?"

I think they have a good time working with me because I really love actors. So I'm always, like, "Let us play" when we're on set. And I think a lot of actors appreciate when you get takes where you're literally just playing and there's no stakes, and you can really explore and do different things.

KS: Long-term relationships with actors seem really important to you. That goes for actors who've been leads in your movies like Natasha Lyonne and Clea DuVall [the stars of *But I'm a Cheerleader*], but it also for actors who play the supporting characters in your projects. Shawn Ashmore [aka Iceman in the *X-Men* movies] has been in several of your films, as has the great Davenia McFadden.

JB: For sure. I think once you have worked with someone and you enjoy working with them, you just want to keep doing it. So I'm sure Molly Shannon [in the cast of 2020's *Addicted to Fresno*] will show up in my next film. People who I've worked with will just keep showing up because I just love them and I'm friends with them and I want to keep working with them. And I think as artists, mutual artists, director, actor, we want to put ourselves in an environment with people that we care about and like.

KS: Do you get a script and say, "Oh, there's the Davenia McFadden part" or "Oh, there's the Shawn Ashmore part?"

JB: Yes, yes, definitely. I'll read something and go, "Oh, this would be really good for Natasha, or Davenia could play that. Or Shawn could play that." When you work with an actor, it's really personal. And it's very intimate, and you're sharing your creativity together. So having someone that you can really play ball with and that is really willing to have fun and just be loose, and not only make a great scene but also have a good time making it— it's just a special thing.

KS: You have a knack for spotting an actor who has not been given the chance to be a movie star and then giving them that chance. And it's clear in your movies that this person was really a movie star all along. Like when you cast Judy Greer, who has played best friends for twenty years, as the lead in *Addicted to Fresno*. You watch that movie and say, "Why hasn't this happened sooner?"

JB: I think there are certain actors who are movie stars. And I can work with them in any capacity, whether it's a tiny little scene, and I can feel that they are just dancing with the camera. And Judy is definitely one of those actors. The one thing I needed for *Addicted to Fresno* was I needed a likable villain. And so I wanted her to play the villain because you can't hate Judy Greer. Also the thing that I like to do is what Natasha [Lyonne] once said to me: "You're the only director that's ever cast me to act. Because most people just cast me as myself."

*Slums of Beverly Hill*s [the actress's first starring role in 1998] was more Natasha. *But I'm a Cheerleade*r was truly nothing like Natasha. She's not from the Midwest. She was never a cheerleader. She's not an optimistic, happy-go-lucky, feminine lesbian. That's just not who she is. But she's an actor. And she's a star. And she's funny. And I can't teach someone how to be a star and I can't teach someone how to be funny. I can help, but I can't start from zero. You're either funny or you're not, and you're—either the camera loves you or the camera doesn't, and it doesn't have to do with looks. It actually just has to do with a certain God-given quality, and I have no idea where it comes from.

Directors are always looking for special actors, and they come in all shapes and sizes and races and male, female, trans. . . . My job is to find those people and put them in parts and let them act. Like Michael Cyril Creighton, who I had only worked with on a tiny part, but I was like, "This guy is a fucking star." So when we needed someone for Howard the cat guy in *Only Murders in the Building*, I thought of him right away.

KS: I think the mistake that people who finance movies have is this idea that charisma in person is the same thing as charisma on screen. But directors seem to understand this isn't always true. Does Judy Greer or Steve Buscemi in person scream "movie star?" No. Do they when we see them in movies? Absolutely.

JB: Yeah, that's true. My job is to look at a monitor all day. So all I'm doing is basically watching TV in a chair all day and seeing what pops. And there's so many actors that don't pop. And I ended up having to construct a lot of smoke and mirrors to get you not to notice that they don't pop. So when someone just comes on screen and has it, that makes my job so much easier.

KS: You were directing short films and working for David Fincher [*Fight Club*, *The Social Network*] while trying to put together financing for *But I'm a Cheerleader*.

JB: What's funny about David Fincher is when I showed him my short film [1999's *Sleeping Beauties*, about a woman who works as a makeup artist at a funeral home] that went to Sundance, he was like, "Oh, it doesn't work." And I was like, "It's not for you." And he was like, "It's just the tone isn't right." And I was like, "Yeah, I totally appreciate your opinion. But it's, once again, not for you." And so I actually think the thing that really benefited me from being in my early twenties was being in the Riot Grrrl early nineties, where there were so many female musicians who couldn't play very well, who were like, I don't care if I can't play my instrument, I'm going to be in this band anyway. And I don't care if you like it. This is my music. And I don't like mainstream music. So I don't care if mainstream people like my stuff or not.

When I ended up getting an F in *Entertainment Weekly* from Owen Gleiberman,[12] for example, I was like, "I don't like what Owen Gleiberman likes." So it sucks that he's like a mainstream critic and writes for a really important periodical that my mother gets in Ohio. And I got an F. Since *But I'm a Cheerleader*, I've never seen a movie get an F. So I clearly struck a chord with him. But I was like, "I don't like things you like, and I don't care." I'm in this young queer movement. I'm making a movie for my community. And there is literally not a single movie like this in my community. And my community needs this film and I don't care about your opinion.

I really kept going after that, and the *Itty Bitty Titty Committee* and *The Quiet* came after. And I was like, I'm just going to make movies for young women like myself, and eventually, those people will become critics and have power. And hopefully, I'll be vindicated in twenty years, but in the meantime, I'm just gonna keep making films.

KS: I think I've seen *But I'm a Cheerleader* eleven or twelve times. I may not have been the audience for that movie then or now but I have a great time every time. It's also funny in so many different ways. *But I'm a Cheerleader* is clearly a satire of gay conversion, but also has a fifties melodrama quality to it. And is clearly supposed to be sweet and hilarious at the same time. How did all of those things thread together and became this movie?

JB: I was really interested in a French movie called *Ma Vie en Rose* [1997], about a trans kid, and I loved the fantasy element of the production design. That was a huge part of the look of the movie. I also really liked Derek Jarman [pioneering British gay filmmaker of the 1970s and 1980s], and I liked *Edward Scissorhands*. That was a big inspiration. So I was like, how can I do a low-budget version of *Edward Scissorhands* and make the pink world of constructed feminine ideal into this Barbie Dream House kind of vibe? I knew I only had two cents to make the movie. If it's just kind of haphazardly put together, it will look cheap. So I thought I'll just be really organized about the color palette, and then it will give it a kind of more expensive feel. Also wanting to talk about like gender constructs, because one of the big things that was happening in my own personal life was that when I came out to my parents, who were very liberal, they were like, "You can't possibly be a lesbian, because you've always loved Barbies and you're terrible at sports." So I was confused for years, like how am I a lesbian when I am terrible at sports, and I'm not going to be good at sports. And I do love Barbie. And I was like, there's no movie where there's like a femme lesbian who saves a butch. And I wanted the movie to be funny. But I also wanted it to be like a romantic comedy, where the feminine lesbian uses her superpower, which is cheerleading, to save the butch instead of the butch saving the femme.

I was a huge fan of *Clueless*. And I was a huge fan of *Fast Times at Ridgemont High* and I definitely knew I wanted it to be funny. And I really wanted a swarthy lead and Clea DuVall who's just like every queer girl's dream girl. I was like, "I have James Dean at the height of James Dean." I am going to objectify the shit out of this girl. So I was excited to make her into a queer icon because she was just a girl I met at a coffee shop. But every lesbian in LA was like, this girl is smoking hot.

So yeah, all those things came together. And then I was nervous about Natasha because she was really wrong for the part. But I knew she was a star. And I knew that she was funny. And I really needed someone who had chemistry with Clea, and they were kind of falling into a very fast and loving friendship. So I thought, okay, they really want to work together. And Natasha is a star. She's funny. I'll just put a wig on her and teach her how to cheerlead. And we'll figure it out.

KS: The casting in that movie is a very special thing. There's a diversity and a multiracialness to the casting, which I really appreciate and was ahead of its time. Unfortunately, my DVD copy of *Itty Bitty Titty Committee* arrived from England an hour and a half ago, so I have not seen it yet but watching the trailer, I cannot tell you how much I appreciate a movie having a nineties punk soundtrack with a lead character who is not White.

JB: I think that's my upbringing. I was raised in a Black city, which is Cleveland, Ohio. My mom, she worked in politics in Cleveland, and she ran this rehab which was very multiracial. And my high school was like 60 percent Black and my elementary school was like 90 percent Black. So I was really shocked later in life, once I went to university in New York City, how not diverse that the rest of my life would be. I just thought, well, of course, every situation you go into, there's less White people than other types of people. But that was just not the case, once I left my hometown. I've worked really hard

to imagine, when I read scripts, all different types of people being in them. And I never imagined just a White world because it's never a world I grew up in.

KS: Similar to *But I'm a Cheerleader*, the world of the next several movies you made feels artificial on purpose. *The Quiet* looks to me like the whole thing is entombed in ice. The mansion in *Breaking the Girls* made my wife and I [say], "Oh, look. It's *Rebecca* but in color."

JB: That's hilarious, I love *Rebecca* [Alfred's Hitchcock's 1940 film that made the British director famous in America].

KS: This is a really roundabout way of saying that all of your movies, no matter how unreal they feel, provide a very real and honest place for female rage.

JB: It's funny that you should say that because I definitely had a lot of rage growing up … growing up as a girl in America, especially as a queer person, a liar. Because I think when you are a young queer person, you become a really good liar, that kind of rage that you brew inside, and the excitement for busting out and finding a place where you can be your authentic self. Especially for me, because I felt so trapped in female identity because, according to my mother, I was feminine and pretty and she would say, "I'll blow-dry your hair, and you'll wear a pink dress." And I did like those things. But I also was so ambitious and so hungry for so much more. So I had a lot of rage for these boxes that I felt like I was being put in. And I think *But I'm a Cheerleader* is certainly about a girl who doesn't know the box that she's in. It's important to me that she isn't lying about being gay, she really just didn't know. And then once it becomes clear to her, she has a lot of courage.

I think that's very true for me, too. When things have presented themselves, I've always taken it and then had a lot of courage at really leaning into it, whereas I really wanted the Clea character to be a coward. Like she actually knows who she is, but she's a coward at expressing it. And Natasha's character, Megan, doesn't know who she is. But when she finds out, she's got more courage than everybody. So that kind of inverse was really important to me. Women finding other women to help them see how they can break out of things is a theme that's been in a lot of my films, from *Addicted to Fresno*—certainly the sisters in the way their codependence kind of was crippling them but also empowering them—and *Breaking the Girls* is all about female rage and also leaning on other women and using other women to kind of see each other in a real way.

KS: If we start with *But I'm a Cheerleader*, where queerness is a central plot point, and two decades and five movies later, *Addicted to Fresno*, which I know it's not your most recent film, it's your second-to-most-recent film, queerness it's not even the most important thing that happens in that movie. The romance between Natasha Lyonne and Aubrey Plaza is a subplot in a movie that's really about siblings. Is that your priorities as an artist are changing, or the culture changing, or both?

JB: I think that queerness in some form will always be in my films just because it's how I live my life. And so it's such a part of my identity and my circle of friends.... But I also think I've lived a queer life for twenty-five years. So it's not the most exciting, new part of my identity. It's kind of old hat. I can pretty much guarantee I wouldn't do another coming-out film. It just feels too far away from my experience twenty-five years in to do that. But I certainly am interested in the different ways that queerness intersects in other stories for sure.

KS: You were nominated for an Emmy for directing *Silicon Valley*, which is both a satire of technology culture but also a satire of young men's inability to communicate with one

76 Break the Frame

another. Does that make *Silicon Valley* a very obvious show to have Jamie Babbit's directorial stamp on? Or is it a white tiger amongst orange ones?

JB: I had so much fun on that show. I hadn't watched it before I went into the interview, and there was this really lovely, funny weirdo who I interviewed with who sounded like *Beavis and Butthead*. And I had never watched *Beavis and Butthead*, but I had watched *Daria....* I never knew that Mike Judge was the voice of both Beavis and Butthead. I really had a friendship crush on him. He's so up my alley as a human. He is all about satire. We have a very similar comedic sensibility....But he's a science person who I think hangs out with a lot of other nerdy guys who do have a hard time communicating. And so he was making a satire about that. And I just really connected with his sense of humor.

I had a blast working on the show the first time and then just became a fan and then said, "I'm happy to join the show if you guys want me," and he was like, "We would love to have you." So then I ended up becoming an executive producer and directing a bunch of episodes.

It just ended up being like a little bit of a lovefest, but honestly, it was just a weird interconnectedness between my humor and Mike Judge's humor.

KS: You also directed three of the eight episodes of the first season of *Russian Doll*, starring Natasha Lyonne. What's it like directing an actor for television you've also directed in movies?

JB: I think my approach to actors is always the same. But I defer more to the writer in television because I have to. They're technically my boss in television. I think what could be harmful in television is that if you don't really take the writer in in a very close way through the rehearsal process, through the talking about the script, through the decisions that you're making about blocking, then they feel out of the loop, and they might mandate weird things that don't work. So I really try to hang tight with them and really bring them in.

I had worked with John Hoffman on a show called *Looking* [a 2014 HBO series, the network's first that centered on the lives of gay men], and we had such a blast. And so when he was working with Steve Martin on *Only Murders in the Building* [Hoffman and Martin created the show together; Jamie Babbit has directed the pilot and, as of this writing, six other episodes], he was like, "Hey, Jamie, would you be interested?" because he knew that we had a good working relationship. So I'm working with Steve Martin, who had obviously never done television.... He was really a joy to work with. But he really was confused about the difference between television and movies and the first day of shooting. He was like, "Why are there all these people here? Somehow, I thought it was only going to be like us and a couple people because it's television." And I was like, "No, Steve, it's exactly the same. It's just like, movies." And he was like, "All right, I don't even really think of it like that." I don't know why. So that was sort of a shock, where I realized, oh, wow, he really has never worked in TV. It really comes down to budget. Working on the third season of *The Marvelous Mrs. Maisel* was very different. It was a $25 million budget.

KS: A lot of giant synchronized dance numbers in that show.

JB: So it's a big-movie budget. But I'm working with Rachel Brosnahan, who's played this character for years. And so she really doesn't need much as far as character building. It's more navigating each scene and being a support system for her and being, you know, helping her guide through each scene but not really a deep dive into the character, which

when I was doing *Only Murders*, it was the pilot. So it was truly Steve getting to know the character for the first time, working with him on who is this character, this has-been actor? Does he want to still be an actor? Like, how much did we lean into that? Really, like world-building stuff.

KS: What was the essential Jamie Babbit-ness that you wanted to bring to that pilot?

JB: Edward Hopper loneliness about New York. That really struck me when I read the script, that these three characters find each other and their common interest in podcasts. They all live in the same building, but there's something about New York and living in these buildings that can be kind of lonely. So all the stuff where I'm going from window to window to window to window, all that stuff was not in the script and something that I just added and felt important in a *Rear Window*, Edward Hopper kind of way. The title sequence was something that I worked on with John, and incorporating a lot of the shots that I was doing where we were going from window to window to window, we decided to do that in the title sequence.

KS: Intimidating big buildings from a past age show up in a lot of your work, everything from the conversion house in *But I'm a Cheerleader* to the giant mansions of *Breaking the Girls* and *The Stand In* to the Arconia in *Only Murderers*. There's this architecture being like the patriarchy in bricks and mortar.

JB: The architectural home is a fun casting process as well. I do think 80 percent of movies is casting. So certainly in *The Stand In* [a 2020 comedy where Drew Barrymore plays a movie star who hides away in her Long Island mansion after a viral video ruins her career] that home became a huge character in the film.

Something about Drew Barrymore … feels very vintage, and it wasn't in the script. But it was just who Drew is like, just—she's just been in all of our worlds for so long as a classic movie star and her family being in the classic movie star category. So something about that house really spoke to something about Drew Barrymore that it felt very right.

For *But I'm a Cheerleader*, the house that I found for that was an insane amount of casting. I probably spent more time looking for that house than I did looking for the actors. I was looking at rehabs because I thought, "Oh, well, my mom runs a rehab and it was out of the house." So maybe I could find a rehab that would have what I'm looking for. And there was a rehab in Palmdale, outside of LA, and it had a terrible aesthetic. It was not right at all. And as I was driving back to the freeway, I drove by that Victorian house, and I was like, "That house is perfect." I pulled my car over and wrote a letter: "Hey, I'm a movie director. I love your house, please call me.", And this guy called and I was like "Please, God, can I shoot in your house?" And he said, "Well, we're about to move." And I said, "I'll hire your sons. The only thing I need them to do is to paint the house pink. We'll paint it back. But can I hire your house? And can I hire your sons to paint it?" And he was like, "Yeah, sure. We need money. That's fine." So the whole neighborhood was like, "What is happening? The house is painted pink?"

KS: Your career as a movie director begins with a movie that didn't make a pile of money, but it certainly launched at least two actors' careers, one of the big things the movie business asks a small independent film to do. And *But I'm a Cheerleader* was notoriously and wrongly given an NC-17 rating by the MPAA in a decision now widely viewed as homophobia [see the 2006 documentary *This Film Is Not Yet Rated* for the whole ugly story]. Also you had difficulty following up this movie despite being a hit on the film festival and art house circuit and twenty-five years later, a cult classic. Is the nonsense

78 Break the Frame

over the rating of *But I'm a Cheerleader* you had to deal with tied to the difficulty of following it up?

JB: They're not specifically tied to each other. But I think in the grand scheme of things, they're tied to each other, which is just misogyny and how difficult it was in the nineties to get any financier who was going to have to spend, you know, more millions of dollars, to put that in the hands of a young woman. It was just really tough. I mean right after *But I'm a Cheerleader*, I did get into a lot of studio rooms because I really wanted to direct a big studio movie. For example, I went into the room on *Legally Blonde*, which I would have loved to have directed. I prepared. I went in, I pitched. I just could not get a break. I actually had one guy ask me if I wore fake glasses after my pitch. He was like, "Oh, this young pretty girl is trying to wear glasses because she wants to get the job." This was the head of the studio.

KS: Ugh.

JB: I was like, "Fuck off. No."

It was the era of you go to Sundance and then Harvey Weinstein gives you a three-picture deal. Well, if you're me and you go to Sundance with *But I'm a Cheerleader*, you got an F from *Entertainment Weekly* and you have a predator who's trying to like . . . y'know? Anyway. Luckily, I was very into my own little weirdo film indie world. So I was just continuing to make movies in my own little world and then making TV as the moneymaker.

KS: Who are your female director heroes and mentors?

JB: Well, the director that really meant a lot to me when I first started getting into directing, and I actually went up to her and said, "I want to be a director". I think my voice was shaking so much. And she seemed kind of scared by me. It was [the legendary British writer/director] Sally Potter, and she directed a movie called *Orlando* [a 1992 adaptation of Virginia Woolf's novel and a career breakthrough for its star, Tilda Swinton] which really rocked my world in the nineties. And she had done a movie like *Itty Bitty Titty Committee* called *The Gold Diggers* [1983] before *Orlando*. That was an all-female crew, like feminist manifesto movie. So I was a really big fan of hers. And then, of course, just OG female director of all time—I've seen every one of her movies in order; I've seen all of her short films—Jane Campion [who after directing movies for nearly forty years, won a Best Director Oscar for 2021's *Power of the Dog*].

KS: What kind of set do you like to run?

JB: Open and flowing and improv allowed, multiple takes allowed. Let's do it always as scripted. And then let's fuck with it. Let's have freedom. Let's play with it. Let's make it our own. Let's do the dialogue. How would you say it? When I was in high school, I was an actor. And there's just something about really making a scene your own as an actor that it's always going to be better. And I'm going to look like an excellent director, if they put it in their own words. I talk to the actors while they're in the middle of the scenes constantly, like, "Hey, let's take it back. Okay, try it like this." I'll talk a lot so that I don't like cutting and then starting all over. I'd rather roll for like twenty minutes, and do like twenty takes at one time.

Sages 81

Jessica Yu (b. 1966)

Films Mentioned
Quiz Lady (2023)
Maria Bamford: Old Baby (2017)
ForEveryone.net (2016)
Misconception (2014)
The Guide (2013) (short)
Meet Mr. Toilet (2012)
Last Call at the Oasis (2011)
Ping Pong Playa (2007)
Protagonist (2007)
In the Realms of the Unreal (2004)
Breathing Lessons (1996) (short)
Sour Death Balls (1993) (short)

The documentary films of director Jessica Yu are about big ideas—global population growth, our dwindling water supply—and bigger dreamers like World Wide Web creator Tim Berners-Lee and the late Chicago artist Henry Darger, who wrote and illustrated a fifteen-thousand-page fantasy novel. Even her comedy work like 2007's *Ping Pong Playa* is about a Ping Pong player who learns the game as a trade-off for his big dream of playing in the NBA. *Quiz Lady* (2023) features Sandra Oh and Awkwafina as sisters and the comedic embodiment of what to do with big dreams, either chase them as a means of self-destruction (Oh) or avoid them as protection from being hurt (Awkwafina).

Maybe documentaries about ordinary people leading ordinary lives are your thing? If so, then reach out your arms and stand on your toes for the filmography of Jessica Yu. In her work, characters look beyond the horizon while striding away from home and do not turn around.

The middle child of a Silicon Valley (one of America's laboratories for big ideas/dreams) Chinese American family, Yu was a champion fencer in both high school and college and did grunt work on commercial sets in her early twenties. Her first short film, *Sour Death Balls*, was accepted into the prestigious Telluride Film Festival in 1993. Her third short, *Breathing Lessons*, won the Oscar for Short Documentary Subject in 1997, when Yu was just thirty.

Yu received both an Emmy and DGA nomination for directing on the limited dramatic series *Fosse/Vernon*, starring Sam Rockwell and Michelle Williams, and has been nominated three times for the Grand Jury Prize in documentary at Sundance.

I spoke to Jessica Yu in January and February 2022 and again in December 2023.

Kevin Smokler: Your documentaries are often about serious subjects, but your attraction to narrative filmmaking is often through comedy. Is there a contradiction between those two things?

Jessica Yu: Yeah, well, that's such a good question. Kind of a tricky one off the bat because I find that it's hard for me to analyze what I'm attracted to. It really is something that happens more organically. There are always ideas floating around, and it's the ones that are stuck in your head the next morning, I guess you could say. But I would say that it's

true that documentaries don't tend to be in the vein of humor very much. You can get to the truth more directly through comedy or humor than meeting it head-on sometimes. And I feel that in documentaries, it's different. You're actually exploring the real subject, meeting it head-on. You're filming something's happening in front of you in the moment and you get it or you don't get it.

With comedy, so many times, you want to shoot the rehearsal, because the rehearsal is where it's all fresh and happening. And then, as you do it over and over again, sometimes it evolves. Sometimes it doesn't. But there's a little bit more of a feeling of catching lightning in the bottle with comedy for me.

KS: If we draw an arc from your first short film, *Sour Death Balls* [a silent montage of people's faces as they eat very sour candy], to *Ping Pong Playa* to *Quiz Lady*—I don't want to use a word that's pejorative because I don't mean it that way, but—your sense of humor seems a little juvenile . . .

JY: (*Laughs*) Yeah, I know. I'm just not the most mature person, I guess. Maybe playful is part of it. Being on set, even if it's something that's very, very serious, I think that having a certain lightness—I guess it's kind of like serious play if you plan well.

KS: You have a dream project to make a documentary about *Mad* magazine, right?[13]

JY: I grew up on comic books, horror films, and *Mad* magazine. And I think that's a little bit unusual for Chinese American kids. My family was quite nontraditional that way.

My mother, she's very involved in the antiwar movement. And she used to take us down to this place where she would go and volunteer and send us to the comic book store down the street, where we would get *Mad* magazine. And I just remember reading it for the first time and feeling like, even if I didn't get all the jokes, that I was getting a glimpse into how the world really worked. There was a message behind whatever you were told by advertisements, by grown-ups, by the government. And so it made you feel like you were getting a different kind of education.

I think it was pretty much my first introduction to satire, the truth behind the joke. And so that's something that kind of stayed with me, and, I don't know, I think it feels, it's, it's something that has influenced my sensibility in ways that are probably so fundamental it's hard to parse them out. And I think a lot of people who grew up with *Mad* magazine feel the same way.

KS: *Ping Pong Playa* [about a twenty-five-year-old slacker who grows up by taking over teaching his mom's Ping Pong class and representing his family at a local tournament] was released in 2007. But to me, it has a very nineties sensibility, meaning it's about a character who lives in a very small world created out of their own imagination, and it's also wall-to-wall, danceable, hip-hop music. It reminds me a lot of Damon Wayans's and Chris Rock's early movies. How did the movie achieve this sensibility coming out after the 1990s, and long before the 1990s reboot we're currently living through?

JY: I think part of it is that the character himself, our protagonist, C-Dub, who was really just Jimmy Tsai, the star and cowriter and accountant for the production, that his alter ego is stuck in the nineties. That's when he was younger, and everything seemed possible. Maybe he'd still grow and be able to be in the NBA, which was, of course, not likely at all. We're all connected to certain times in the past. . . . That's kind of where a certain part of our longing or our heart is. And so I thought it was kind of funny that it was just a slight shift, maybe like a decade off, very recent nostalgia.

KS: You seem particularly drawn to people who kind of exist in their own reality and are motivated by their own big, crazy ideas. And in this way, there's a kind of sibling or cousin relationship between *Ping Pong Playa* and *Quiz Lady* [a comedy about two sisters repairing their relationship, damaged long ago]. Both movies have a one main character who is a big, crazy idea person, and both are also about being secretly really good at something that we don't value as a society being really good at [Awkwafina in *Quiz Lady,* whose superpower is knowing all the answers to her favorite TV game show].

JY: I do love an underdog movie. But I also am fascinated by this idea of having a superpower that no one else wants, you know, especially when we're in a society—and not just Asian American stereotypical culture—where we just value excellence. We value being a winner. And so there's that thing of like, well, you know, you've got a box of chocolates, but they're all the ones that you don't want.

I think it's also a way to kind of, again, skewer the "model minority" myth, turn a lot of that upside down. There's still, I think, so much more humor in the Asian American experience that hasn't quite been uncovered. And what I really love about *Quiz Lady* is that we're at a point where the fact that our characters are Asian American, is … a part of their identity, but the film doesn't have an obligation to string together an explanation of what that means, right? It'll come out to the characters in their own particular ways. When I started out, I think, when there was the occasional Asian American character or storyline, it felt like it had to be kind of a teaching moment. Or it was like the butt of a joke or something. So I think that it feels like a much better time now.

KS: I love movies like *Quiz Lady* that have their own internal logic and don't seem stuck on a schedule like "Well we've reached the 30 minute mark so now this has to happen!" Instead, *Quiz Lady* is a little bit of a road movie, a little bit of a sibling movie, and a little bit of a heist movie.

JY: What grounded everybody and all the conversations was that it's a relationship movie. So it was really important to try to ground that relationship and make us care about those characters, because then my theory was that if we do that, then we can go to all these crazy places, you know, you can totally stretch things more if you make the stakes for the sisters real enough.[14]

I think of comedies like *Little Miss Sunshine*, where you go in and you get so much more than you thought. I just love when you're sort of surprised by how much emotion you have for something because you've just been watching and enjoying it.

KS: All your funny movies seem to be saying, "Broad comedy doesn't mean stupid comedy."

JY: When I think of "broad," I like to think tonally of more "silly." I give credit to Sandra, who's saying that she wanted her character to be extremely inappropriate and self-serving in a way that was unapologetic. But you would believe in her, you would believe in her emotional life.

KS: Was she already part of the movie when you came on board?

JY: Awkwafina and Sandra Oh were already attached. So when I heard those two names together, I was pretty much sold. I do remember Sandra Oh, asking, "Well, you know, you've done a lot of drama"—she and I worked together before [on *Grey's Anatomy*]—and her asking me, "What makes you want to do a comedy now?" And this was coming out of, just starting to come out of, Covid. And I was like, this is a something that I want in my life. It's a space that I want to work with. I want to work with these wonderful people, but

84 Break the Frame

it just felt like that kind of project that could be a comfort film. And also, Asian American women playing sisters just felt really good to be able to bring personal things to it as well.

KS: The attraction and danger of completely living in your own world is a subject you return to often, be it in your comedies, or with Tim Berners-Lee, who was the subject of your Netflix film *ForEveryone.net*, the artist Henry Darger, or [sanitation activist-entrepreneur] Mr. Toilet?

JY: But it's an aspirational world, right? It's something where they imagine a different reality ... but those worlds are quite complete in a way. Yeah, I think that there's definitely some commonality there, people who live in some fear of their own imaginations. With Henry Darger, that certainly was the case. I really think that he was somebody who rejected the world that he had to physically move around in, in favor of the world that he could place himself and create for himself in his own apartment.

KS: What is your attraction to these kinds of stories?

JY: This is probably quite unconscious on my part. But now that you point it out, maybe there's some sort of innate sympathy for those kinds of dreamers.

KS: It echoes the experience of filmmaking which is a lot of time living in a world that you are building and that only you see.

JY: One fantasy I always have in making a film: I would love to be an untainted viewer of whatever it is that I'm in the middle of. I would love to be able to walk in, sit down, and be able to watch it without any knowledge of the story or the process. It's an impossible kind of fantasy. But thinking about that is helpful in trying to think of what is the journey you would want the viewer to have. How can you make it complete enough? Or how can you make it satisfying or intriguing or what, whatever it is you're going for? There's something in that that helps define the scope of what you're trying to do, right? You get lost in the weeds and you're thinking, "Oh, I got to put this in, I've got to put that in." And then it's really helpful to step back and think, "Okay, if you're somebody who doesn't know anything about the story or doesn't know anything about the subject, is this going to make sense? Are they going to care about this?"

Sometimes you're more successful than others. But that's certainly the challenge of working on something, especially in those moments of solitude, because it's hard to give yourself that fresh perspective, to extract your mind enough from the work ahead, to think about that.

KS: Both the protagonist of your short film *The Guide* [about a young biologist in Mozambique] and Gladys, one of the three principal characters in *Misconception* [a documentary about population growth], are inherently noble people. You would not apply the word "noble," at least offhand, to Henry Darger or to Tim Berners-Lee. Did you find it more difficult to tell a story of someone who is very obviously noble than someone who leads with how complicated they are?

JY: I would argue that a story about someone who's noble can be very complicated, because the world is complicated. And there's so many obstacles that come up.... How does someone who's pure of heart deal with corruption? How do they deal with betrayal? How do they deal with circumstances they can't control? How do they deal with making promises that they can't keep? So those are all things, those obstacles, that give dimension to somebody's good intention, the difference between good intention and effectiveness. That's kind of what the film *Protagonist* [from 2007, about four men on four very different life journeys] was about. Those were all men who started out with very noble intentions,

with very clear paths. And then, somehow, in that journey, they ended up doing the exact opposite of what they had set out to do. That's fascinating to me. It's a good example of how complicated goodness can be.

KS: *Protagonist* is very much a movie about maleness, and it is a subject you've come back to several times in your work. It's present in *Ping Pong Playa* and at least quietly in *The Guide*.

You have both brothers and sisters. You have daughters, but not sons. I am curious how maleness has become such a recurring theme in your work?

JY: If you're looking at what makes a protagonist interesting, it's helpful if they don't have total self-awareness. Certainly, in *Protagonist*, what we were discovering is that it's not that women were incapable of having an extremist experience, which I think is really what the film was also about.... But somehow the men seem to go full bore until they hit the wall, and dramatically hitting the wall ... that moment of, you know, sort of dark catharsis, is very, very powerful.

The other thing that we ended up talking a lot about, you know, with the people who were in that film was the importance of a manhood ritual.... In the absence of a rite of passage, if you have someone who is trying to find that threshold, or find that validation for themselves, interesting things happen.

KS: I'm sure you've been asked this a thousand times about *Protagonist*, but you are married to one of the four protagonists [author Mark Salzman].

JY: Yeah.

KS: Did that change the filmmaking process?

JY: Oh, yes. Mark, of course, he's told me his own stories many times. So Joe Loya, who was the ex-bank robber in the film? Long story, but I was friends with Joe and then Joe and Mark became friends. And so I had my list of questions. But I had Joe deliver the questions, and then I would give them the follow-up question, just so there was a layer of indirectness to it. So that Mark didn't feel like, "Oh, you've heard this one before."

KS: If we take your documentaries *Last Call at the Oasis* [about the global water crisis], *Misconception*, and even *Protagonist*, I'm going to draw this big, sweeping conclusion that they all contain this open-hearted idea that together, we share a common human destiny.[15]

JY: I think that is a very positive way of looking at that, because within those films, there are also moments where you get the sense of when we say common destiny, there's also the tragedy of the commons, where it's hard to maintain that perspective that everyone needs to participate in a certain way for the group to thrive. But I think what I've certainly been looking for in those films was some understanding of the scope of what we're facing as a whole and the responsibility as an individual, but also the sense of, is there actual hope of turning around something like our water crisis? And I think, personally, the idea that it might not be reversible, but manageable, that's something that I can understand. It's not the super cheerful conclusion that I would have liked to discover. But I feel like I was able to just see the contours of the issue enough to understand that managing it. That's a feat in and of itself. That is something that was within our grasp.

KS: For your documentary *In the Realms of the Unreal* on the artist Henry Darger, Darger knew and interacted with very few people, and I get the sense his legacy is very closely guarded [Darger died in 1973; his work was rediscovered in the 1990s]. How did you have enough access to his art and materials to make the movie?

JY: I was given great access to all written materials. The bigger question of access was just that he did not leave much of himself in terms of any photographic material or recollections

86 Break the Frame

among the people who knew him. So I had access to what was there. I think that what became clear is that the absence of the person in that more intimate sense had to become part of the story. Even though he lived there for a very long time, there was still the sense of everyone only getting a fleeting glimpse of him. And so that became something that was very tantalizing to me. And I think embracing that was something that helped me make the film make sense.

KS: You fill in a lot of those absences of Henry Darger himself with animation from his work.... And I feel like you were pioneering in the idea of using animation in documentaries even though it's very common nowadays for someone to just animate a sequence that they don't have footage or archival material for.

JY: I think with the Darger film, when I was looking at the written material, the visual material, and the fact that he even wrote some lyrics to battle songs, all the elements that could create an animated sequence, there was a way that he was trying to make that world as full and as vibrant and as alive as possible. And so it felt natural to put them together. But you're right. At the time, it was still somewhat controversial, because it is taking some liberty there. But I do really enjoy working with animators in the same way I like working with composers, because there's a skill set that I do not have, and being able to describe an element like that and having it come back and seeing how in most cases, it's even better than you had imagined. That, to me, is one of the most fun parts of collaborating.

KS: How did *Breathing Lessons* [about the late journalist Mark O'Brien, who could only breathe with the use of an iron lung] winning an Oscar change the trajectory of your career?

JY: The thing about making an independent documentary is that you just want to finish it ... and somehow make the story within your limited means. But then, if you win something like an Oscar, what it changes is that other people know what it is you do. And so it goes from you're pushing your own little engine up the hill to something where people say, "Oh, you know, you're a filmmaker." For me, I guess that felt like I gained a bit of professional identity from doing that, and your family stops asking, "What is it exactly that you do?" Does not mean that then I could fully support myself in any way. I mean, *Breathing Lessons* was pretty bare-bones operation. But it enabled me to start to imagine a path to do it.

KS: Afterward, did you have a dozen meetings that were of the variety of "I'm looking to do a feature film about a person with an iron lung"?

JY: Oh yeah, actually, I did for a while. There were some meetings. And at the time, too, I was so green, I think in even trying to understand what the meetings meant, and what people needed to see, to consider the idea of a fictionalized story about Mark and his life. But it was definitely an education. And you learn things like, if you can, try to schedule a lunch meeting, because at least you'll get lunch. Most of the time, it's just a water meeting. But yeah, there was some I just remember. There was one meeting in particular that kind of epitomized the difficulty in accepting this kind of subject matter as something considered to be entertainment.... Everybody really responded to the documentary and then, talking about the story fictionally, there was a pause, and then somebody said, "So ... the iron lung. Is there a chance that Mark could get better, you know, the chance he might walk?" And I just felt like ... "Did you actually watch the film? Or no, maybe you didn't." Oh, that's kind of the gap between what I do and what people consider to be something that could make some money.

KS: Were you part of the discussion when Mark's story was made into *The Sessions* [starring John Hawkes and Helen Hunt, which won the Audience Award at the 2012 Sundance Film Festival]?

JY: I wasn't when it was being made. And I think—I don't want to speak for the filmmaker or the producing team, but I think there was maybe some hesitation in inviting another voice in there. But honestly, I felt like it was Mark's story. It's not my story. I don't own it. I was approached when John Hawkes, who played Mark in the film, wanted to meet and to talk to me about my friendship with Mark and just that experience of working with him. I could immediately see that he was so tuned in to the character but also very open to hearing from people who knew Mark. And when I did go to see the film at Sundance, the moment John appeared on screen as Mark, like, from the moment I heard his voice, I cried through the whole thing. At the end, when the director came out, he very graciously said, "And we would like to thank a filmmaker whose film was helpful in the understanding of Mark's story" or something like that, and then all turned to me. And here I am just like completely sobbing in … one tiny Kleenex I had been relying on far too heavily. I was just—it was just a funny, disastrous moment. But I really was very impressed and heartened by what they did in that movie.

KS: I don't mean to make too much of this, but you've worked on a lot of TV shows with large casts and multiple storylines happening at the same time. And they're frequently organized around a big group of strangers that is thrown together by artificial circumstances, as, say medical students in *Grey's Anatomy* or work colleagues on *The Morning Show*. It seems to be connected to this idea that we see in a lot of your documentaries, that despite feeling very different from one another, we all kind of share a common destiny. We are all subject to forces larger than ourselves.

JY: I mean, it does seem like—don't you feel that there have just been more shows that have played with time lately? There aren't that many shows that stay in one time and place with one cast of characters anymore. Maybe it's just that the boundaries have been sort of expanded. And with the influence of streaming.

KS: Also we don't know when people are watching TV or how. Are they going to watch fifteen minutes of an hour-long episode? Are they going to watch nine hour-long episodes in a row? The audience can also fast-forward and rewind and watch episodes out of order. So maybe those storytelling risks are possible because the audience is not forced to march in a straight line.

JY: In streaming, because of binge watching, you can't have a ten-part series where every hour is the same rhythm as the previous hour. The story has to keep on surprising you. The basis upon which you attract people is variation. *American Crime* [a 2015–2017 ABC show where each season concerned a crime and a community's response to it] was an amazing show, so daring and for making such radical choices in the notion of POV [point of view]. I just found that so liberating…. You could have an entire scene that's played on one character if, say, it felt right to stay on Regina King in close-up, which is hard to argue against.

KS: Is the kind of set you like to run directing television different than the set you like to run directing documentaries?

JY: This is going to sound a little bit Pollyannaish, but I just want the possibility of some fun to exist on the set, even if we're shooting something quite serious. Part of that is just making sure that I'm prepped enough that I've done as much work as I can to make the day go smoothly. Also, that other people can do their jobs better if they know what it is that the

88 Break the Frame

director has in mind. The second thing I would say is just trying to keep the channels open, so people know that I welcome good and better ideas from anywhere.... I think that there's kind of the stereotype of the director being an authoritarian whose word is gospel. That notion would not work for me at all. I think that you can turn away a lot of good ideas, advice, the wisdom and the experience of your crew. And by and large, I've worked with fantastic crews, and you're never going to know everything. And so if you have more of a door-open policy where people know, "Hey, best idea wins; if you've got a good one, throw it in the pot," it just makes everybody feel like they're more appreciated and respected in the way that it should work on a set. I'm not very loud. My voice kind of disappears. So it's probably a quiet set. But I would much rather be open with communication.

On TV it's different relationship with the cast, often because they know the character better than you ever will if you're coming into a show that's like in its fifth season or something. It's different when you're doing a pilot, or it's different when you're working on a feature. That's the reality of that situation. You have to respect it and find a way to be a helpful storytelling partner.... But it's not like you're going to go in there and change everything about the story, because that is not the job.

KS: What directors in television would you say you've learned significantly from? And if that question is applicable to documentaries, that too?

JY: Oh, yeah. Well, so when I started out, you know, I was observing directors working on *The West Wing*. So that was Tommy Schlamme. I also observed John Wells a bit on—actually when he was directing on *ER*. And I remember one of the first directors I observed, he was an actor. And so the way that he communicated with the actors was very much in the language of acting, you know, of performance, though, I just remember being so lost in the terminology and the shorthand that they had with each other. And I remember thinking, "God, I don't know if I'll ever be able to talk to actors in that way."

Then I was on a panel with the late actress and director Adrienne Shelley [who wrote and directed the movie *Waitress* shortly before her murder in 2006]. And I remember talking to her about my concern over being able to communicate with actors. And then there was a little pause and she said, "Well, you know, you make documentaries. So you are, in your own way, directing people all the time. Actors are just people who just find the way to talk to them as people." And it just stuck with me because it gave me two things. One is there's not one way to talk to actors. And you need to find your own language and connect with them. And then the second thing was that it gave me some appreciation for the fact that I had some benefit from having worked in documentaries. And so, yeah, I just remember that that was a very insightful and kind thing that she said.

KS: I know sometimes you are directing both documentaries and TV concurrently. How does that work schedule-wise?

JY: I'd say the hardest thing, actually, for me, is scheduling, just in general, in this line of work, because you're always trying to see in the future and figure out what you'll be able to do and whether you should say yes to this thing. But there's this other thing on the horizon that if it came to pass, that would be amazing. So that part is tough. When I was starting to get into episodic directing, I would only do like a couple of episodes a year because I was more deeply embedded with my documentary projects, some of which would take several years to work on. And just once that train started moving, I was dedicated to that. Now, of course, there's just so much variety and quality in scripted material that I've been

very satisfied working in this space, but it's hard not to get excited about the right documentary subject matter when it pops up.

KS: I wanted to ask you about the project you did with comedian Maria Bamford. I'm always interested in when directors with a track record of awards and critical acclaim decide to do concert films or comedy specials. Because while I totally understand it's a completely unique kind of directing experience, I also feel like it's a project where the performer gets all the credit.

JY: I hadn't done a film like that. So that was exciting. Maria is also a friend. So I was very excited about working with her. Because conceptually, there was a stylistic through-line that was fun to riff off of. And just silly things like coming up with the merch that she would sell.... That for me was just like catnip. Oh, I get to order, you know, whoopee cushions with Maria slogans on them? And I also just love her material ... her fascination with how a joke plays in different environments, and the idea that "Hey, if you've got a big venue that is, you know, packed to the rafters with slightly tipsy fans, and they're just gonna laugh at anything and like but if you're telling this joke to a couple of friends in your living room, how does it feel then?"

There's also something really satisfying about watching one performer and getting a sense of how she works, her discipline, what it requires for her to perform. And she's a comedian and an actor and a writer. Watching her, it made me just, again, appreciate actors and the demands and the concentration that their work requires.

KS: Would you have been less interested if the project was just Maria Bamford saying, "Hey I'm playing three nights at The Wiltern and I need someone to direct it?"

JY: I would just wonder, "Are you sure you really need me?"

KS: Do you feel like the person who directed the Maria Bamford special and who makes documentaries and the person who directs episodic television are basically the same person? Or are they different versions of yourself?

JY: It's probably more a matter of exercising different muscles. In documentaries, you do have to guide the production, you have to be thinking about story.... But when you go in there, you need to be open to the reality of whatever it is that you're there to capture. And when working, say, on a show, your role is to be a bit of a cheerleader for the show. You're propelling the day forward, you're trying to get the work done and leave room for creative space. The other thing, too, is when you're coming into shows that have already gotten on their feet. I often liken it to being a foreign exchange student. You're there to figure out, "Oh, how do you do things in your country?" and you want to respect the rules and the laws and, but also, you know, hopefully, it's kind of a two-way exchange. In writing and editing, that's where you can be the most internal, where I think the hours just fly by. You are only thinking about the story. You're not thinking about "How do I elicit a certain emotion? How do I shape this performance?" You have the material there, and somewhere, somehow the story is in there. It's just almost like pure problem-solving.

KS: On a good day there's an inherent optimism to editing and postproduction. You know the movie is in there and it doesn't feel like a hopeless search for, you know, a needle in a haystack or something like that.

JY: And you end up realizing, like if there is a gap in the story or you're missing something, well, I only have myself to blame, right? You learn so much in the editing room. It's sort of unadorned evidence of what you have done, for better or for worse.

Sages **91**

Tamra Davis (b. 1962)

Films Mentioned
13 (2022)
The Punk Singer (2013) (producer)
Jean-Michel Basquiat: The Radiant Child (2010)
Crossroads (2002)
Half Baked (1998)
Billy Madison (1995)
No Alternative Girls (1994) (short)
CB4 (1993)
Guncrazy (1992)

Television Mentioned
Dead to Me (2020)
High School Musical: The Series (2019)
You're the Worst (2017)
Crazy Ex-Girlfriend (2015)
Grey's Anatomy (2007)

Music Videos Mentioned
Hanson, MMMBop (1997)
Sonic Youth, Kool Thing (1990)
Indigo Girls, Closer to Fine (1989)
Tone Loc, Wild Thing (1989)

Actors Launched
Dave Chappelle
Adam Sandler

Adam Sandler as a leading man, Hanson's *MMMBop* as a number one song in twelve countries, *Half Baked* as the best pot movie since Cheech & Chong, Britney Spears in *Crossroads*—they all come from the mind and eye of director Tamra Davis, who has signed her name to mileposts across decades of American pop culture. Does that put her ahead of her time or right on time? The Davis body of work blurs the divide between predicting the zeitgeist and creating it yourself. Maybe that means the divide is imaginary and the real definition of her filmmaking chops would be projects whose influence seems larger in retrospect.

A middle child and a Southern California native from a show business family [her grandfather was a comedy writer, grandmother an actress] Davis originally wanted to be an actress too. But after apprenticing at Francis Coppola's American Zoetrope production company and studying at Los Angeles City College, Davis started getting hired to direct videos for bands. Her slow-motion, black-and-white treatment of a raunchy cut called *Wild Thing* defined the MTV debut of gravel-voiced Los Angeles rapper named Tone Loc.

Davis would direct over 150 music videos for artists as disparate as Depeche Mode, MC Lyte, Bette Midler, and The Beastie Boys and moved into feature films with her 1992 remake

92 Break the Frame

of the 1950 crime classic *Gun Crazy* in 2010, Tamra Davis was nominated for the Grand Jury Prize in Documentary at Sundance.

I spoke to Tamra Davis in August 2018 and 2023 from her home in Malibu, California.

Kevin Smokler: Growing up in Southern California and having family in the industry, did you feel like there was anything fated about you becoming a filmmaker?

Tamra Davis: I feel like there was in my roots in the sense that my great-grandparents originally came to Hollywood, they were in vaudeville.... Then my grandfather was a comedy writer. But then my dad and my mom really didn't have anything to do with the industry. So it's kind of skipped a generation.

KS: And you being a middle child, were probably influenced culturally by your older sibling and probably exerted the same on your younger sibling, I assume?

TD: My older sister went to CalArts. But she was listening more to, like, Patti Smith music, and I was kind of a little bit more in between, 'cause my brother and I, we were listening more to punk music. But I was not in scenes. I'm usually more of an observer.

KS: You worked at Francis Coppola's American Zoetrope before going to film school.

TD: I was so grateful that, in my ambition to try to figure out what is my place in Hollywood, Coppola didn't say, "Oh, you're a girl, you shouldn't direct." ... And his wife was kind of a strong woman as well. He didn't even question it. He was just like, "Well if you want to be a director, you should go to film school."

KS: You started directing music videos while still in film school, the early days of the music video as a visual medium.

TD: As I saw it, you could film a music video and make it like a short film or make it like your film school short films. And so that's what I was doing, but I was doing them with Super 8 cameras and film school equipment.

I got a call from a record company executive who saw my videos.... I thought I was gonna get in trouble because I filmed these videos without any permission. And instead, they were like, "How did you do this?" I'd shot it with my film school equipment, and it was the first time record companies saw that grainy, edgy, handheld, shaky-camera look. [Early video directors] Mary Lambert and Russell [Mulcahy], they were making those slick, well-lit, studio-polished, big-budget videos. I came in with this handheld, standing in the pit, and that's why my camera was shaking, or on the side of the stage trying to hand-hold it.

KS: I watched about a dozen of your videos in preparation for our conversation, and I want to list off a few things I see in common for artists as different as *Sonic Youth [Kool Thing], Tone Loc [Wild Thing], and The Indigo Girls [Closer to Fine]* that you directed videos for.

There's a real reverence for black and white, and in switching between black and white and color, in slowing down and speeding up the camera, which creates a kind of dream-like, otherworldly quality.

TD: I love black-and-white movies, 'cause I grew up watching every single black-and-white film from my mom having me watch them. I loved slow motion, and the in-camera tricks that you could do I thought were really cool, like double exposures. And also, some of that feeling of what it feels like when you're watching a concert, and those low angles, that's what you see as the audience member. You're below, you're on the stage looking up. So it

is reverential a little bit, but it's also like that's the point of view if you finally made it to the front row and you're looking up at the musicians.

The *Kool Thing* video, it was like a production challenge, because we didn't have a place to shoot it. So I took from Andy Warhol, 'cause I knew also they were influenced by Warhol, and I covered the production office in aluminum to copy The Factory. So I feel like you're constantly calling out references while you're working on the concept that both you and the artist can say, "Yeah, yeah, we want it to look like that." Or like here's these images, so that you have some point of reference that you can agree upon before you start shooting.

KS: Can we talk about you directing the video for Hanson's *MMMBop*?

TD: When you first hear that song, imagine nobody had ever heard it, and so I heard it and it was catchy, but I was like, "What?" And then, the only photos they had of the band were their passport photos, these three kids in these little teeny squares. And I took one look at the middle kid, Taylor, and I was like, "If I was a fourteen-year-old girl, or like a twelve-year-old girl, this would be it." I was like, "He was the cutest thing I'd ever seen in my life." And when I did the video, I got to speak to Taylor all night long, as if I was like the little girl on the phone with him. And all those ideas are theirs. And so that's what I would do, I would work with the band and somehow get their ideas. And that's why it looks so fun and playful, is because that's what they wanted to do. They wanted to Rollerblade, which I thought was the dorkiest thing in the world. They wanted to pretend to drive. They wanted to be on the moon. Like all those ideas came from all of us on the phone together. People would always say, "Oh, we really love your videos. They have edge to them." It's just because it's the only way I know how to do things, 'cause I don't know how to do things that perfect right way. I just do them by any means necessary, which is like guerrilla filmmaking.

KS: Your movies often star artists not in their primary art form. I'm thinking specifically of *CB4*, *Crossroads*, and *Half Baked*, where your lead actors are comedians [Chris Rock and Dave Chappelle for *CB4* and *Half Baked*] and musicians [Britney Spears in *Crossroads*].

TD: When I made videos, it was extremely important to me to work very closely with that artist.... The person in front of the camera has to feel safe, that the director standing behind them, watching them, had their back, and wasn't going to lead them into a place where they didn't feel safe and protected, and made sure that they gave the work that's true to them. So I feel like when I worked with people like Chris Rock, Britney, Dave Chappelle, first of all I loved each and every one of them. They knew that when they hung out with me, that I was their true fan, and truly truly thought they were the funniest person ever, or thought they were the most amazing performer.

It also crossed over with Adam Sandler when we did *Billy Madison*. If I'm hanging out with you and I really love you and all the sudden I become your best friend, and now I know who you really are, that authentic voice, what you're like at dinner, what you're like hanging out in a hotel room, what you're like wherever. And I know when you're being real, and I know when you're acting. I always tried to create the situation on set to be light and easy so that whenever those actors walked onto that set, they felt like we were just hanging out again. And so I feel like that really translates.

KS: I look at your movies and they are almost all about young people. I have a hard time imagining a Tamra Davis movie about senior citizens.

TD: I think one, growing up, just that that's when I started was when I was a youth. And also, I saw how easily youth can be manipulated by adults. As a young girl, I saw that they try

94 Break the Frame

to manipulate your youth. So there's that aspect of trying to protect that innocence of youth and giving that ownership of that back to the person instead of being the person, as a director, that takes advantage of it. So I feel like there's that aspect of it that's very personal to me.

But then I also feel that I came up at a time, as most people do, just with this love of pop culture, With making music videos, or just that I felt that I had a hand in the development of pop culture for those decades. And so, I like being associated with that.

KS: For your documentary about Jean-Michel Basquiat, *The Radiant Child,* I read somewhere that you found him both beautiful up close, because you film him very tightly framed in that documentary, but you also mentioned in that same interview that he had a way of captivating a room when he walked into it.[16] This reminds me of a theme that you keep coming back to in your work, particularly with who you cast and work with, that beauty and charisma are two separate things.

TD: I feel like you see a lot of beautiful people, but they're not charismatic or they're not really that interesting. I have no real interest in models and stuff like that, like it doesn't just interest me to see a beautiful face on a guy or a girl. But a personality, a character, a charisma, that's something that they glow, and they can make you believe they're beautiful because they have something. And so I feel like recognizing that and praising somebody for that is more interesting to me than just praising somebody for growing up and having whatever, a good nose and high cheekbones or something. I had said no to Britney Spears, to doing a movie about her. But they were like, "Will you just meet her?" And I was like, "Hell yeah, I'll go meet her. Why wouldn't you want to go meet Britney Spears?" So when I first met Britney Spears, it was like at ten in the morning. She opened up a hotel room door in Las Vegas in like a T-shirt and shorts, and it was like, "What?" I immediately was captivated. I was like, "Who is this girl?" and I just fell madly in love with her. We spent the whole day together, and I was like, "If I could get this on camera, I'm in. I'm in, because this girl, she has it. She's so charismatic, and she's running this whole thing. And it's not because she's beautiful, and it's not because she even sings well. She has something." And I felt like there's a few times in my life that I've crossed paths with people that have that, whether it's Basquiat or Kurt Cobain, or Britney Spears, or Dave Chappelle, whatever. You run past these people that have this incredible charisma, and you love it. I don't know. And they don't have to be beautiful to have that.

KS: The Basquiat movie and Kathleen Hanna documentary *The Punk Singer* that you produced are both about artists who haven't figured everything out. Particularly with Kathleen Hanna, we see her in the middle of a career, after making music with the bands Bikini Kill, Le Tigre, and her own solo project The Julie Ruin and still only in her mid-forties, not at some kind of summit where the movie's going saying "job well done" for ninety minutes.

TD: [*The Punk Singer* Director] Sini [Anderson]'s got great interviews.... But when you do a documentary, it's not the interview that matters so much, it's what you choose from that interview to tell your story. That's where you realize as a documentary filmmaker that all those words in the dictionary exist, but they don't mean anything until you arrange them in a certain way to tell a story with them. And so the footage that Sini had shot, the interviews were there, it's just that I knew the story that needed to be told because of my closeness with Kathleen. I'm still close with her.

But like you said, her story isn't over.... Kathleen, look what she did, and she came from nothing, and that one strong little voice changed our world, and that's inspiring.

So if I could inspire the next young girl or the next young guy, that's what her story's about.

I feel that the innate difference between the two of them is Jean-Michel, when I met him in his early twenties, he said, "I am the next Picasso." ... And Kathleen never had that "I am the next person." ... She just wanted to not be silenced for her expressing her view and not be silenced for being a woman. And so her thing was more about equal rights for girls and for marginalized people, and it was more political than "I am coming on this scene to become the biggest rock star in the world and I want to play arenas," whereas Jean-Michel wanted to play arenas.

KS: Starting your career in music videos, making movies featuring musicians in acting roles, producing a documentary about a famous musician, and years later directing a musical on screen like *13* [about a teenage boy from New York City who moves to small-town Indiana in the months leading up to his bar mitzvah], does it feel, spiritually, like the completion of a circle?

TD: I think there is something really great that I started my career very music focused.

It was really such a pleasure making that, and I really felt like it was hugely challenging. And I felt like I had the skills I needed to pull something like that off. But I've had so many different aspects of my career, and a lot of the TV that I've been doing had musical elements in it, like *High School Musical*, the series. Even within my TV work it would constantly be, "Oh, hire Tamra Davis for this episode. There's a musical number in it." I still kept all that alive.

KS: *High School Musical* the movie is the obvious antecedent to *13*, but *High School Musical* has a classic Disney feel, even though it was made in 2006, where the characters are all perfect people until explicitly stated otherwise. The characters in *13*, on the other hand, wear their imperfections on the outside. And to me, that's what the whole movie is about, taking responsibility for oneself and one's actions.

TD: The original play, which I read, showed that at age thirteen, or anytime in our life, we make mistakes. It's just what happens, and we try to make sure that it's not the mistake that you made that defines you. It's how you responded to it. And I felt that the message that what the little boy went through in *13* was he made a mistake that got him ostracized and everybody hated him. And that happens, and it becomes bigger than life. And he could have lived his whole life with that mistake and been that kid. But instead, he took action. And he tried to figure out a way to solve it, to remedy that problem. And to say sorry, and to try to figure out how to be responsible for resolving those mistakes. And I felt like that was such a positive message.

I really tried to hire only thirteen-year-olds, so if you were over fifteen, you didn't even get an audition. Basically I felt that there was something that happened on a child's face, that you could tell when they hit maturity. I need the innocence on their faces to make this work. And so a lot of the kids have actually never even acted before. And so I was working with a lot of newcomers.

KS: I can tell that the person who directed *13* has seen a lot of movie musicals. But I'm also glad to report that *13* has what I call the *West Side Story* merit badge, which is that a musical adopted from stage to screen has to be a movie first and a musical second.

TD: When I made *13*, I watched only musicals while I made the film. And thank God, there's so many musicals from early times of filmmaking that my plate was full. I was really

96 Break the Frame

focused on *The Young Girls of Rochefort* [a 1967 French musical film written and directed by Jacques Demy]. I love that movie and the color palette and some of the camera movement. For sure, you know, there's some definite similarities. If you're a real big musical theater fan, you could go through almost every one of the numbers in *13* and be like, oh my God, she's referencing this or she's referencing this, because there's some pretty obvious ones. But you know, those moments also get filtered through my head, and then interpreted by a group of thirteen-year-olds, so it becomes its own piece. That's how I did music videos as well. You get influenced by something, it sparks something in you, you refer to it, but then in the end it gets interpreted through me.

KS: Do you do this level of research for every directing project?

TD: I try to get anything that I can put my hands on that refers to the topic that I'm working on. And it's also what I love about my job. I remember when I got to do *Grey's Anatomy*, I would exercise to a *Grey's Anatomy* episode and watch every single episode up until my season came.

If I'm doing a comedy, I will only watch comedies every single night and only read books that are comedic. I put all things on my walls around me that have to do with that topic, especially when I'm in a hotel room. I put visuals around me so I immerse myself in the world. If I'm there for two or three weeks, when I'm on a project for longer, ... my whole room starts to look like the world that I'm recreating. And if it's not in my hotel room, it's in the office that I'm working in, so that when I have meetings, and I meet with my actors, they're visually aware of ... the world that I'm creating and I can kind of walk them through it. So they also seem like they're actively involved in it themselves as well and kind of get an idea of what I'm trying to do.

But by the time I'm actually on set, it's become a new thing, because you can show a picture, show an inspiration to somebody, and now my choreographer is going to interpret that and then now my cameraman is going to interpret that and everybody kind of adds to it. And that's why it's so important to build a really great creative team, that if you bring in inspiration, everybody kind of adds their interpretation.

KS: It's so clear that, in all your years of making movies, you have never lost your enthusiasm for being a fan.

TD: It has to be authentic. To me, it's what I love, and I become kind of the audience or the biggest fan of what I'm working on, so that while I'm sitting there directing, I am experiencing it the way an audience member would in the way I want to connect with my audience. And so I tried to put myself in that. I have to be in a humorous mood to do a comedy because I have to really authentically laugh. I can't be worried about whether the plumber is going to come, you know what I mean? I've got to be in a comedic mood so that part of my brain is present while I'm working.

KS: You directed *13* after an incredible, almost ten-year run of directing for great television series [*You're the Worst, Dead to Me, Crazy Ex-Girlfriend*, to name only a few]. What was the switch like mentally and creatively?

TD: On *13* I was nice because my schedule was children, so we were only allowed to have eight hours with the kids, ten with the crew. But yeah, TV is faster, harder, because it's quicker. So you really have it together. It's not just running a marathon, it's running a marathon twice, as you know, with one leg or something that's really challenging. But I definitely bring my same toolkit with me. When I did my first feature after doing music videos, the thing I was the most scared about was, do I have the endurance and can I keep

up with that repetitive schedule like five days a week for four weeks at a time, whereas I was so used to just doing two days, and it's exhausting just those two days. And sometimes when you're on an indie film, they add Saturdays, too, so you don't even get a weekend off. Just finding how to manage your body so that you can function at a level like that—I think that was a challenge.

With television, when you do a pilot, it's kind of like doing a mini-feature, because you really are there from the beginning. And it's you hiring people. And it's your vision, you're really collaborative, you're really doing everything from the beginning. Whereas normally, when I'll come in and do an episodic show, I come in with only five days prep, and everything's all set up, everybody already knows their job. And then you shoot, and then depending on what you know, whether it's a half hour or an hour, you have five days to edit, or eight days to edit, and then you're gone. They don't want to talk to you, they're not interested in you, they don't want you for the sound mix, they don't need you for all these other things. And so you're kind of off and the producers do it all. So it's really important for you as an episodic director to deliver the elements that the producers will need to finish the show. So you need to give them lots of options, because you don't know all those different things that they may need. Then back on *13*, I was shocked again at how long a feature takes. It just made me realize like, man, you really have to love what you're doing because you're on it for a year at least.

KS: I want to return to the question of fandom. In 1994, you made a short film called *No Alternative Girls*[17] where you interviewed female musicians like the band Luscious Jackson, Kim Gordon from Sonic Youth, and Courtney Love about their own musical influences and experiences as professional artists. On the one hand, the musicians you interviewed all came from a similar genre of music. And yet when you asked what their influences were, they cited wildly different genres of music. And in 1994 when this short film was made, it was before streaming music services and iTunes, even Napster, where exposing oneself to different genres of music was a much tougher project than it is now. Even from 1994, *No Alternative Girls* feels like a look into the future where music is as often tied together by vibe and feeling rather than category.

TD: Hmm, yeah.

KS: And obviously you weren't an equal fan of every artist you directed music videos for, but in both this short film and the dozens of videos you directed, it's clear to me you were more interested in the emotion behind music rather than the genre. As opposed to you saying, Well, I do hip-hop videos, but not heavy-metal videos.

TD: It made me as a filmmaker realize that I didn't want to be categorized into only doing one thing, like because I did rap videos, but I didn't want to only do rap videos. So I wanted to do some college radio because I also listened to that or I wanted to do Cher or Bette Midler or Lou Reed because I also listened to that, and the fact when I started to do that, it made it so that I could open my myself up to different things so I could be up for a lot of different styles. And the same thing happened with television, that I could do a comedy, but I could also do something that's more drama or female-oriented so that I didn't just get stuck in only doing comedy The same with movies, and I just feel like as a filmmaker it's important to do that early on.

I went from *Guncrazy* to *CB4*. It gave me permission to do different genres. . . . I like that I don't want to be limited because in my life I'm not limited. I love listening to different things and reading different things and hanging out with different people.

KS: How did *No Alternative Girls* happen?

TD: I had just been on *Bad Girls* [a 1994 Western starring Drew Barrymore, Andie MacDowell, Madeleine Stowe, and Mary Stuart Masterson] ... and I think I shot on it for less than a week. And then I was taken off. I was fired, right? So I was at home crying and so upset. And then instead of doing that I said, "Fuck Hollywood." No kidding. And I got this opportunity to make this little, short film. And so I was like, all I need is a camera and myself and I could be a filmmaker. I don't need $50 million from Fox to do a movie. I can shoot this in my garage with people that inspire me. I directed, edited it, whatever. I was the filmmaker. And it brought back my confidence to show me that if I say no to myself as a filmmaker, then that's a valid no, but Hollywood can't say I'm not a filmmaker.

KS: We're just now celebrating the thirtieth anniversary of *CB4*, the twenty-fifth of *Half Baked*, the twentieth of *Crossroads*. What's it like for you as a filmmaker that we're now getting to the point where these movies you made are now mileposts not just for this generation or that one but, really, in the long story of pop culture itself.

TD: It's so nice. You see what an impact it had on culture at the time, but also the new fans that come and discover these films. When you make a film, the only thing you could do is make the best thing you can at that moment and feel really happy with the film that you made because you never know how it's going to be received. You don't know how it's going to be seen in historical context. And for sure, most of my films, when they came out, I would get trashed by the media, which I didn't care because I knew that I made the film that Adam and I wanted to make or I made the film that Shonda [Rhimes, screenwriter of *Crossroads*] and Britney and I wanted to make. Then the only thing that you can do is feel happy about it when you make it and finish it.

But yeah, I'm so happy people have just rediscovered these things. I mean, we knew it all along, you know, when we made it. We were like, yes, we love *Billy Madison*. We kind of knew it was there all along. And, you know, I'm never afraid to be ahead of my time.... But time catches up to you and you just have to stay current long enough to reap those benefits. You know?

KS: Your first film, *Guncrazy* was really one of the first movies to have the foresight to see Drew Barrymore as an adult actor and not as a kid who grew up too fast.

TD: Revitalizing her career or anything was not my thing. She wasn't even on my list, but she demanded to be seen.... She came in and she and I just bonded so intensely, from the first moment that I saw her, that I was like, I love this girl, I would do anything for her. And that was a true authentic bonding of a relationship. I just felt like she had so much to offer. And she came to me at that time and said, nobody takes me seriously. Nobody wants to work with me. Please take a chance on me. I was so moved by that because I started my career as an actress, and I wanted somebody to have that same passion that I would have brought into the role as an actress, and she showed me that and so I was really excited to work with her. So it wasn't like thinking of revitalizing her career, it was more like that little girl is amazing. And she has just the amount of ethos and humanity and vulnerability that I want for Anita. In taking that chance and believing in her, it formed a lifelong relationship, for sure. She's also just the most beautiful, loving person. I love her dearly.

KS: The in-person meeting seems a very important part of your creative process

TD: Yeah, you have to bond because you get really close with these people. What I love is that I've done that with a lot of young people.... If they do hit it big, they're about to go through a big change in their life dealing with fame and success. And it's really helpful for

them to have somebody that's in their court, that's been around, that's grounded, that's a calm voice, maternal, friend, that is there for them. I love these long relationships. Even if we don't see each other for years, that when we see each other, it goes right back to those relationships, because you go through a lot when you're doing those films. You have to get really deep with somebody and really to get those performances. They're very unique and personal, and you get really bonded.

I'm so proud of those relationships. Because how do you survive Hollywood? Without those, a lot of things that go wrong. We have to stick together.

KS: Your movies are always to some extent about the process of growing up. Do you see yourself making movies about young people, like, at the age of eighty? Is this subject the gift that will keep on giving for you as an artist?

TD: I don't know. 'Cause you never know. What project I'm attaching myself to next, I have no idea. . . . Who knows what my career would have been if I wasn't limited, especially at an early age, being a woman and getting the jobs that I got, because they didn't offer me the big jobs as a woman. So I feel like I'm looking forward to all the girls that are coming up now. For myself, you know, I'm just so excited that it's been at least three strong decades, almost four decades coming up, really working and being relevant. And that's the only thing that you have.

They used to say you're too young, and then when I was older, they would say you're too old. But when you make a hit, it doesn't matter how old you are. Now you're the person who made the hit. It doesn't matter what my age is, if I'm young or old, and that's inspiring. And I feel like now, the fact that I'm still getting tons of offers for TV and films . . . I don't know. I just keep doing it as long as they let me.

I was never in that position where somebody said to me, "What do you want to do? What do you want to make?" And I fucking want that position. I want to sit across the table, or be at the table, where a studio says to me, "You must have some films you want to make. What do you want to make?" Every single dude that is in the position where I am at in my career has that opportunity, and I as a woman do not have that, and I don't feel that's right.

I have that opportunity now. And I want to also help young women who or marginalized people who haven't had that opportunity because of the color of their skin or their sexuality to have a voice in this industry. So I constantly, on every show, have between two and three women or girls shadowing me, because I want to pave the way for that voice. This has been the first time in my career that I'm so in demand that I can turn stuff down and know that I'll work again, and that really came out of the MeToo movement, and there's a real push in Hollywood now to hire more women. It's the first time I have felt that things are changing, and I'm really happy that I stayed long enough and worked hard enough to see that happen.

Aline Brosh McKenna (b. 1967)

Films Mentioned
Your Place or Mine (2023)
We Bought a Zoo (2011)
Morning Glory (2010)
27 Dresses (2008)
The Devil Wears Prada (2006)
Three to Tango (1999)

Television Mentioned
Crazy Ex-Girlfriend (2015–2019)

Actor Launched
Rachel Bloom

Screenwriters you know by name, who weren't directors or actors first, are a rare thing. Immediately I can think of Charlie Kauffman, Aline Brosh McKenna, and … I'm all out of names. And Charlie Kauffman had the advantage of writing himself into a movie called *Adaptation* and having himself played by Nicholas Cage.

Like the movies her scripts clearly love, Brosh McKenna's methods were a bit more classical Hollywood—time writing for television, eight years before selling a first film script, beating out other writers for plum assignments, then nailing the dismount. That dismount was the adaptation of the bestselling novel *The Devil Wears Prada* (2006), a global box-office phenomenon, a multiple award winner, with nominations for BAFTA and Writers Guild of America Awards for Brosh McKenna, who was chosen over four other writers for the job.

The top line of the poster for her next movie, the romantic comedy *27 Dresses*, reads, "From the writer of *The Devil Wears Prada*." Not "from the director of *Step Up*," which had been a massive hit two years before. Not the name of star Katherine Heigl, fresh off an Emmy win for *Grey's Anatomy*. None of that. The writer. A 2011 *New York Times Magazine* profile of Brosh McKenna commented: "For screenwriters, that kind of credit is about as close to a Hollywood ending as it gets."[18]

Except in Brosh McKenna's case, it was only the start. The next act of her story is as co-creator of *Crazy Ex-Girlfriend*, already a modern classic of Peak TV, becoming a director herself (2023's *Your Place or Mine*) and then being chosen as the "brilliant, hilarious, and talented"[19] showrunner of an Amazon series starring and executive produced by an actor you may have passing familiarity with named Reese Witherspoon.

Crazy Ex-Girlfriends, *27 Dresses*, *The Devil Wears Prada*. Two projects starring an actor whose empire is named Hello Sunshine. Summary judgment might tell us that Aline Brosh McKenna is the queen of the romcom. But look closer and do the work because that's what her filmography is really telling us. Brosh McKenna's movies and TV projects are, first, about women and jobs, the workplace as the arena where we grow, learn, and demonstrate who we've become. Long after the main character understands herself as professional, maker, teammate, colleague, and adult does she get around to who she might be as one-half of a couple.

102 Break the Frame

Raised in New Jersey by immigrant parents from Israel and France, Brosh McKenna graduated from Harvard with a concentration in literature and wrote for the campus newspaper, *The Harvard Crimson*. A six-week course in screenwriting at New York University and the encouragement of her teacher led to a move west. By age twenty-six, she had sold both her first feature screenplay and a television pilot.

In addition to her nominations for BAFTA and WGA awards, Brosh McKenna won a 2016 Gotham Award for *Crazy Ex-Girlfriend*. In 2015, she established the Aline Brosh McKenna Creative Writing Fund, which will provide advising and mentoring support for aspiring writers at her alma mater.

I spoke to Aline Brosh McKenna in January 2023.

Kevin Smokler: You and I have *Broadcast News* [a 1987 Oscar-nominated workplace comedy starring William Hurt, Holly Hunter, and Albert Brooks] as a favorite movie in common.

Aline Brosh McKenna: One of my very favorites, yes.

KS: I was a teenager when I first saw that movie. And it was the first time I'd ever seen a movie where I witnessed adults being very intelligent and very professionally successful but also personally and emotionally lost. *Broadcast News* feels like a coming-of-age movie for grown-ups.

ABM: That's a great way to put it. I will borrow it.

KS: Please do. Because the reason I wanted to hear about your relationship to that movie is that the DNA of that movie is a lot of the same DNA in your movies—that we still are trying to find ourselves even after we grow up, and that often the workplace is where this happens.

ABM: *Broadcast News*, *Jerry Maguire*, *Tootsie* [a 1982 Academy Award–nominated comedy starring Dustin Hoffman], and *Four Weddings and a Funeral* are kind of the big ones that loom large for me in terms of comedy dramas. I describe them as dramas with jokes. And of those, *Four Weddings* is the only one that's not a workplace thing.

I think the workplace is a great venue for figuring out who you are, working on your issues. I did a speech at BAFTA,[20] and that's what I talked about, was why I like workplace stuff so much. And for me, it started with *His Girl Friday*, *It Happened One Night*, a lot of those thirties and forties movies which are about journalists. And I love journalist movies. And that's obviously what *Broadcast News* was, and then getting a chance to write *Prada*, which is about an aspiring journalist. That movie is often referred to as a romantic comedy. Which is hard, isn't it? It's hard because the love story is absolutely not the point. It's beside the point.... And so even though movies I've written are, strictly speaking, romantic comedies, I always try and explore the workplace. *Morning Glory* is also a workplace comedy. I used to call those things "... and a man comedy." So it's about a woman realizing her place in the world and her worth and her value ... and a man.

KS: I've seen *The Devil Wears Prada* six or seven times and I still do not understand how it could get called a romantic comedy other than mistakenly. What fuels the main character [Anne Hathaway] is ambition and professional respectability, not finding love. So where's the romance if this is a romantic comedy?

ABM: It isn't. She breaks up with a college boyfriend and then she has a roll in the hay with an older guy. That's about it.

KS: Is sexism the reason for that confusion?

ABM: You know, it's hard to speculate on the concrete motivations of the patriarchy.

KS: That's very well put.

ABM: I did *Crazy Ex-Girlfriend* with Rachel Bloom and we both have an allergy to being told our work is adorable or cute. And I get that a lot. I feel like if you work in a genre space that traditionally talks about women, at some point you're going to be minimized, where if you work in a genre that's more traditionally male, like an action movie or superhero movie, often those things are taken more seriously as cultural documents, even though they're also really dealing with the dictates of genre as much as any romantic comedy or ensemble comedy. And then there's just an undervaluing of comedy in general, as anyone who's written both drama and comedy will tell you. I think it's a combination of that comedies don't get their due and stories about, for, made by women tend to get grouped into "cute, adorable, funny."

I have a kind of a running thing where men will say, "God, my wife loves *Devil Wears Prada*, my daughter loves *Devil Wears Prada*." And I always think like, "It's okay if you like it. I won't tell anybody."

KS: I think *The Devil Wears Prada* is a great movie for anyone who's ever had a contentious relationship with a difficult boss.

ABM: Or a difficult parent, frankly.

KS: I think you make a very interesting point, though. I think some of your movies fell into the dictates of what we traditionally call the romantic comedy genre. But I also feel like the "rom" is usually in small letters and the "COM" is in big letters. Or maybe I just get the sense that being funny is a real artistic priority for you.

ABM: It depends. A movie like *27 Dresses* is a traditional romantic comedy, but I really did stress it has to be funny. Because otherwise you'll get into the romance and it'll start to feel like a Hallmark-y thing because this one and that one is preoccupied with love, and I think if you don't then inhabit it with a lot of humor. . . . A lot of great movies that are dealing primarily with love are riotously funny: *The Awful Truth* [a 1937 screwball comedy starring Cary Grant and Irene Dunne], *Bringing Up Baby* [a 1938 screwball comedy starring Grant and Katharine Hepburn], and then if you're supporting more of a dramatic burden, like *We Bought a Zoo* [a 2011 comedy-drama adapted for the screen by Brosh McKenna about a man grieving the loss of his wife who buys, eh, ya know] is less funny. I will say it the original draft that I wrote before Cameron [Crowe, the film's director and co-writer] came on was in many ways more conventional fish-out-of-water comedy and Cameron brought his kind of burnished emotional quality to the movie, and so it's a little bit different. I was sort of sending that guy up a little bit more. And he was really exploring that guy from the inside more. So I think it sort of depends also what your rubric is.

KS: *Crazy Ex-Girlfriend* is a romantic comedy. But it's also a deconstruction of a romantic comedies.

ABM: It stems from a personal belief that romantic love is not the be-all and the end-all. And we all know this, right? When someone gets divorced, we don't act like oh, you fucked up your life forever. We know that love comes and goes. And we don't have a lot of stories about people finding work that they love, which is likely to last a lot longer. And it doesn't have to be work, but it can be some sort of purpose that you find that will be with you your whole life.

Some of that comes from my father, who really loved his work. He was an engineer, and he worked until he was in his late eighties. And so I think I grew up around somebody who being an engineer was such a part of his identity. And he was a very devoted father

104 Break the Frame

and a very loving parent, but he also really had a thing in life that he loved. And I think it was one of the things that actually made him such a great parent was that he wasn't 100 percent dependent on his family, marriage, all those things to make him happy. He had something that was really fulfilling for him. That's something that I wish we can prioritize more for young women.

KS: What was your chief inspiration for getting into screenwriting?

ABM: Well, I never considered being a screenwriter until I saw those movies from the thirties and forties and the very biggest stars at that time were women, Joan [Crawford] and Bette [Davis] and Claudette [Colbert] and Kate [Hepburn] and Rosalind [Russell]. It was just, it was all women who were driving the box office. So that was my feeling of like, "Oh, that's interesting to me." And that's the type of writing that I can imagine myself doing and might, because my parents are not American. They have different views on certain things. My dad was comfortable with strong, opinionated women. He's from Israel and never reinforced those sorts of ideas about hiding your intelligence.

My mother is very fabulous. She grew up in France. Her parents are North African. She speaks six languages. She worked all over the world. She was a midwife. She had a very adventurous young life. And so she just doesn't subscribe to any notions about women apologizing to the furniture. My mother expects the furniture to move aside for her.

Going to Harvard, that's the fanciest thing I did. So I did know people worked in show business, because a lot of kids from Harvard go into show business, and a lot of those people we've all kind of gone into the business together. It's a combination of luck and skill and luck is a big deal. But I didn't have "Oh, my dad has a friend from college who is a CFO of a studio." I didn't have anything like that.

I joined the Writers Guild in 1991. So, like, I've been at it since I was twenty-three. And it was a different time. I can't say that being a very young woman in 1991 was so helpful.

KS: The word I keep coming back to with your screenplays is "atomic." There's something very elemental in them, where your pivotal moments happen because of a look or a gesture or chemistry between actors. It reminds me a little bit of what Robert Altman says about how he was more interested in behavior and how people act around one another than he was about ideas or themes.

ABM: I'm interested in both because I really write from a thematic place, and it's hard for me to watch a genre that I refer to as "shit happens" movies, where there's no plot, there's just shit happening. So I like a pretty propulsive plot with a thematic element to it, where the movie really knows what it has to say. But you're right in terms of what I'm interested in is human behavior, which is why heavy genre things which are more about the mechanics of the genre, and less about the individual, where the individual is sort of subsumed into the needs of the genre, don't interest me very much. I am very interested in those little, tiny . . . Like one of my favorite moments in *Prada* is when Andy is tucking her silly newspaper stories into her envelope, and she makes this little expression like, yeah, these are good. I'm gonna blow her away with these. It's so great and it's so funny because you can recognize that youthful smugness and you kind of know that she's about to get punched in the face.

Part of what attracted me to writing film and television is I do love stars. I love the idea that you know, for example, Meryl in *Prada*, like we know her, we associate her with a certain thing. We knows she's highly intelligent. We're used to feeling empathetic towards her, which is a really interesting thing to bring to a character like Miranda. And that's true

for my very first movie [*Three to Tango*, a 1999 comedy of errors starring Matthew Perry and Neve Campbell]. The movie is in a way about Matthew. I love Hollywood movies where the fabric of the star is part of the story. *Broadcast News* is partly about what we know and love about Holly Hunter and Albert Brooks and William Hurt and we bring those things to the movie, which is not to say they're not tremendous actors, they are, but there's some elements of their soul that we don't actually know but we feel like we know. That particular movie would be completely different without those actors, *Jerry Maguire* would be completely different without that kind of energy and focus and determination that Tom Cruise brings to the character. So I like the intersection of those things. And it was one of the things I loved about all movies is that, in a way, the Cary Grant movies are about being Cary Grant. And the Barbara Stanwyck movies are about being Barbara Stanwyck. And there's a certain sense of the audience's relationship to them informed the work, and it's something that makes movies and TV different from novels and short stories, where that person is more something you can project things onto, which is why it's hard when you make a novel into a book and you're asking, are the characters, are they the thing that you imagined, and what is the relationship to the thing you imagined?

KS: Part of fandom is acknowledging that the experience we have with the actor in the movie we are watching right now is shaped by what movies of theirs we've seen and loved before.

ABM: I wonder if that's retro now the culture is so much more niche-a-fied. But it still speaks to me. So *Your Place or Mine* [a 2023 romantic comedy starring Reese Witherspoon and Ashton Kutchner about best friends who swap houses for a week], with Reese and Ashton, we've grown up with them literally. The public have known Ashton since he was nineteen and Reese since she was maybe twelve. So watching them play their own age, dealing with trying to figure out who they are, and, as you said, coming of age in their forties, we bring to it a knowledge of her fierce intelligence and her energy and his laconic humor and all these things that we're kind of accustomed to from them. That's a privilege when you can do that. But also, *Crazy Ex-Girlfriend*, Rachel was an unknown, but that show was very much written with an interest in and an appreciation of who Rachel is. I only hired people whose first sentence was "I love Rachel," people who had seen her work and sought it out and were like "Rachel's brilliant." So I was only going to choose people who understood the power of Rachel's personal charisma.

KS: I had not seen the comedy videos Rachel Bloom made before I started watching *Crazy Ex-Girlfriend*, but I was probably three minutes into the first episode when I said, "That's a movie star."

ABM: She's a star. She's one of the most talented people I've ever met. And I always say to her, I can't wait for the Kennedy Center Honors where you're an old lady, and you're sitting there getting the award, and I'm an even older lady and they wheel me out to say great things about you.

KS: May we talk about *27 Dresses*, which I think is a misunderstood and underrated movie? Because I've walked away from that movie saying to myself, I get that it's structured like a traditional romantic comedy, and it very much has love as its subject. But that's plot, not meaning. When you step back, *27 Dresses* feels to me like a movie about being good at something that doesn't make you happy.

ABM: Yeah, it's specifically about people-pleasing. I am not that because again, if you're raised by an Israeli person and a French person, you are not going to become a people

pleaser. But so many of my girlfriends had that particular disease, one in particular, who kind of inspired the movie. But it really was to me about a woman figuring out that she shouldn't be as available to people as she is. My friend Kate, one time somebody emailed her and asked her to dog-sit for them. And she forwarded to me, and she said, "I don't know who this is from." But that's how comfortable people feel with her that they'll ask her to dog-sit, even though she doesn't know them very well. So I was interested in that.

The funny thing about that is that I didn't want her to end up with anyone. I thought all the character needed to do was take a step forward towards, like, going out on a date and us feeling like "Oh, that's a good spot. That's a good idea for her." But they wouldn't let me do that.

KS: That's too bad. I love a movie about romance where the thing that happens at the end is a baby step towards romance. Like in *Sleepless in Seattle* where they just look at each other and walk away holding hands and that's the end. I love a romance that implies what's going to happen next rather than telling you.

ABM: Everyone at the wedding wearing the old dresses was not my idea. And I think it's pretty glorious. And I think it works really well for that movie. But you're right, *27 Dresses* isn't about what it takes to find love. It's about what it takes to put yourself first.

KS: Both you and Ms. Bloom have talked extensively about the diversity of casting in *Crazy Ex-Girlfriend*. And upon watching the show after I had seen most of the movies you wrote, I really feel like, had casting it been up to *you*, which it isn't as the screenwriter, but had been up to you, that kind of diversity of casting would have been present in your movies ten or fifteen years ago.

ABM: I mean we have a character named White Josh [played by David Hull] that hilariously reminds us that amongst that group of friends, he's the minority. The whole business has changed. So when we went to them and said we're gonna make the demographics of this exactly what the demographics are of West Covina, California [where *Crazy Ex-Girlfriend* takes place], not just ethnic diversity, but body size and orientation and things like that. That was very welcome. And that's something that has developed over time.

On *Morning Glory* [a 2010 workplace comedy starring Rachel McAdams, Diane Keaton, and Harrison Ford about a young TV producer in charge of a morning show with cohosts who hate each other], I worked with J. J. Abrams [who produced *Morning Glory* between directing the 2009 reboot of *Star Trek* and his own screenplay, *Super 8*], and that's something that's always been very important to him. And so I think it's developed over time. Things that we look back on that seem like they've been white bread-ified would not be the case anymore. You can talk about how social movements have changed our culture for the better or for the worse, but you got to say that the conversation has changed around all kinds of diversity in a great way. That was the great gift of making a show in the late twenty-teens was that they only wanted more diversity. Like, yes, yes. The community of West Covina is minority White.

KS: My favorite reminder of that in *Crazy Ex-Girlfriend* is when you meet Heather's parents [Season 2, Episode 4] and Heather's father is Black and her mother is White and the show doesn't pause for a second to mention it. It just rolls right by. Reminds me of that moment in *Ladybird* when you learn the main character has a brother named Miguel who is not White and the movie doesn't stop to elaborate or explain.

ABM: Well, that's the world we all live in and have always lived in. So it's just being reflected more. Heather's parents were based partly on Vella's parents [actress Vella Lovell, who plays Heather, identifies as "mixed, black, Jewish, European"][21] and then partly on my assistant, Brittany Young's parents. And then the episode where Heather's dealing with the "Where are you from?" question. We had Vella come into the writers room and talk to us for a long time about those kinds of issues and how hurtful that can be.

KS: On the interview you and Ms. Bloom did on *The Partners Podcast*,[22] you talk about how societally women are often conditioned to agree, but you guys had a healthy amount of disagreement working together.

ABM: We're just both women who like to wear our opinions on our sleeves in different ways. When you're working privately, just the two of you, you have certain ways of working it out. But then when we started trying to translate that into larger group and writers' room production meetings, concept meetings on set, we had to find a way to air out our agreements and disagreements in a way that was different from what it's like when it's just the two of us privately. And basically what it was to step aside and have those conversations privately. And because when we were making the show, she was so busy, and we did seventy million things with her and she always had seventy million things to do. Anytime we ever got close to each other, we would be locked in a deep conversation right away. So the assistant directors started trying to keep us away from each other because I would slow her down and keep her from set. The biggest adjustment for us to make was definitely going from just the two of us writing to being in a show environment where all your artistic collaborator visions are done with an audience.

The way I describe that relationship is that two women, twenty years apart, who met in an office, started a conversation that continues to this day. And we work on our communication, we talk about it. But even as a person who's twenty years younger than me, she's always been very forthright with what she thinks and it's always been for the good. And as we still work together those pathways have gotten, you know, easier and smoother as they would with practice.

KS: Now that you're running your own production company, which part of you is the CEO? And which part of you is the director? The screenwriter? And if these three people met, would they recognize each other?

ABM: Oh, for sure. I have a high level of executive function. I'm not unlike the girl in the front row of *School of Rock*, as I think a lot of bright women are. It's so funny because I was on the phone with my agent and I was saying, hey, this company is incredible. They're moving so quickly. And these producers are so great. And they're so amazing and blah, blah, and my husband is shouting from the other room. "They're women! They're women!! They get it done!" So I don't feel a bifurcation there. What's great about getting older and having had success with the box office and on TV and stuff is that I don't feel like I need to pretend to be anything.

I need a lot of sleep. So I when I directed *Your Place or Mine*, I came home, ate dinner, went to sleep, and I slept until five or whatever. So I would go to bed at eight you know and that's—I didn't feel a need to stay up late or go out drinking or pretend that I could. That's not really a function of my age. I've always been like that, like, never pulled an all-nighter, never stayed late. It's just who I am and this is what I need. So you get more comfortable with that.

108 Break the Frame

KS: When did that transition happen? Or better put, professionally speaking for you, when did you realize you had sort of graduated into the mentor role?

ABM: That's a lifelong thing where there's been people I look up to and now people look up to me. I'm filled with advice. I'm very bossy. So I think I've been doling out mentorship that people didn't subscribe to or ask for a very long time. And then I had some really wonderful mentors who are not afraid to tell me what's what. So it's a critical part of being a creative person is having people to look up to and then when I have helped someone, and they try and say like, "Oh, do you want a bottle of wine? Do you want a box of chocolates or whatever?" My answer is just go help someone else who needs it. I don't need a box of chocolates. And so if I've helped you, go find someone else that can use your help.

KS: I've two more questions. One is substantive and one is very silly.

ABM: If you're asking everyone a silly question, I don't want to miss out.

KS: Okay, serious question first. Who are the women directors that inspired you?"

ABM: Nancy [Meyers, director of *Something's Gotta Give* and *It's Complicated*] and Nora [Ephron, director of *Sleepless in Seattle* and *You've Got Mail*] both started directing in their late forties, early fifties. And that was a huge inspiration to me, because I think people expect writers to start directing right away. And I just wasn't going to direct a movie with a six-month-old baby and a three-and-a-half-year-old. I know some people can do it, but I didn't think I would be able to. So knowing that Nancy and Nora had been these outstanding writers who transitioned into directing, you know, basically when their kids are grown up, was always a guiding light for me, and I'm tremendously grateful that those two women exist. And I met Nora once, I've met Nancy a few times and, yeah, they kick ass. They changed the game for everybody.

KS: Okay, the silly question is why your company is named Lean Machine?

ABM: Lean Machine is because people have a lot of trouble pronouncing my name ["Uh-lean," not "Eye-lean"]. So my husband when I met him used to say to me, "Just tell people 'a lean mean fighting machine.'" Oh, nice. So that's why it was between "lean machine" and "fighting machine." It doesn't say a lean mean machine production on *Your Place or Mine*. It says "Hello Sunshine Production" and "Aggregate Production." And then it says 'A Lean Machine."

Debra Granik (b. 1960)

Films Mentioned
Leave No Trace (2018)
Stray Dog (2014)
Winter's Bone (2010)
Down to the Bone (2004)

Actors Launched
Vera Farmiga
Jennifer Lawrence
Thomasin McKenzie

With their still majesty and deep gaze into the struggles of ordinary Americans, Debra Granik's four movies rarely scream box-office payday. Yet in spite of that or probably because of it, they've succeeded in every other way we ask movies to—seducing critics, winning awards, and launching acting careers. Oh, and her most famous, *Winter's Bone*, was a box-office success too.

It was *Winter's Bone*, her second movie, where the buzz around the quiet cinema of Debra Granik got loud. The southern gothic tale of Ree Dolly, a seventeen-year-old girl from an impoverished Ozark family searching for her father, who's gone missing while out on bail for meth dealing, *Winter's Bone* won the Grand Jury Prize at Sundance and received four Academy Award nominations, one for a Minnesota-born actor named John Hawkes, who would soon be winning fistfuls of awards for starring in movies like *The Sessions* and *Three Billboards Outside Ebbing, Missouri*, and the other for a nineteen-year-old actor from Louisville, Kentucky, named Jennifer Lawrence.

Raised in the suburbs of Washington, DC and a graduate of Brandeis University, Granik worked in educational media and long-form documentary making in Boston before attending NYU film school. Her graduate thesis, a seven-minute work of narrative fiction called *Snake Feed*, about a pair of recovering addicts, was accepted to the Sundance Institute's Lab program for screenwriting and directing and became her first feature film. That movie's protagonist was played by a New Jersey actress named Vera Farmiga, who would be cast two years later in Martin Scorsese's *The Departed* and in 2009 as the romantic lead opposite George Clooney in *Up in the Air*.

In addition to awards from Sundance, Granik's films have won Gotham and Independent Spirit Awards as well as prizes at the Berlin International Film Festival. In 2023, she received an honorary doctorate from the Massachusetts College of Art and Design.

I spoke to Debra Granik in October 2023.

Kevin Smokler: Do you still do ropes courses?[23]
Debra Granik: Oh, God, I do love them. I mean, after my kid got older, I didn't really, I haven't really had too many invitations to do them, but there have been very peak memories of enjoying them. I have some issues around height and other things, so the ascending feeling of getting past a couple things that I kind of thought weren't in my wheelhouse made me very happy. And I felt very high off of those things. And I loved when I was

112 Break the Frame

down on the ground, when I couldn't get past level 2, it was very fun to look really high up in the trees and see people.

I'd love to make a documentary about that, because really amazing moments happen in them. It's not something that I do with any frequency. But now that you raised it, I'm like, my God, I gotta get back into it, you know, because it is a form of extreme, exciting liberation.

KS: Ropes courses feel like a Debra Granik kind of sport. If you had to identify the athletic pursuit of the director who made *Winter's Bone* and *Leave No Trace*, I think it would be like ropes courses or mountain climbing or ultramarathons, something that really requires a kind of patience and quiet and listening to yourself.

DG: Kind of a "forced" condition in which one has to listen … I almost feel like taking the word "sport" out of it and say, like, "practice" or something, only because I'm not a particularly athletic person and I don't, I never could associate a sport with myself. But I like the idea of pushing myself. So the idea of the ropes courses is a thing I try or I learn from. Yes, I take it.

KS: I know, the word "quiet" is used way too often when describing your movies. But maybe "patient" is a better word, patience that goes into making your movies and the patience asked of us in watching them.

DG: I think something about quietness and allowing is the idea of not plugging up all the space, right? That means I the viewer, *we* the viewers, we get to ask some questions like, "I wonder what that made her feel? How would I feel? Or what's she going to do when someone says that? Or why are they saying that?" We—American filmmakers—live in a culture where the emphasis is on trying to plug up ambiguity. And so quiet is the time, it's the space, the fissure, the small chasm. It's a small space between events or clues being dropped, for the viewer to suture, to think, to collect, to refer back to. I love doing that when I watch someone else's work.

With documentary, there's a bigger challenge, right? Because we want to confirm if we're showing someone in a noble light, or we're showing something scary to have to face, we want to make sure that the viewer gets what we got. In narrative, there is even more space. So yeah, the idea of interpretation, decipherment, and staying. I love for my mind to be staying in the place where I can ask those questions.

KS: You can really see it in how much attention and care your movies pay to people's faces. Every one of your actors has something going on behind their eyes, even when they're not speaking.

DG: Of course I can't take credit for that. That's something that an actor comes with. But the fact is, I like to provide some experiences, some context, some really rich moments that they're going to be stepping into. Whether it's something to do with survival skills, if you're living in a nontraditional way off the grid, if it's being on location in southern Missouri, as in *Winter's Bone*, that there would be a way in which seeing and being in a real holler, and with a real family, that is the guide. Something gets behind the eyes because the person has really seen a whole lot. There are no sets there. It's very immersive. So what's behind the eyes is what that talented actor is bringing, in terms of their observation skills, what they're gleaning, what photographs they're taking with those eyes.

Thomasin, or Jen, John Hawkes, Ben, Vera Farmiga, they're taking pictures, so I have to be incredibly resourceful and making sure that they're seeing the real horse park, that they're seeing the real holler, that they're seeing the real Price Chopper, in a small town in

New York, where they're seeing the real dirty snow when you come out of rehab, where they're being in a real rehab. I can't always be that way. But as much as possible, I want an actor that has the eyes that reveal thinking and feeling to have a lot for them to photograph. And then that will be reflected back when we start to photograph them.

KS: Though all of your movies take in the vastness and the bigness of the American landscape, each is beautiful in its own unique way. But that landscape is not static. You may not move the camera a lot, but there's always a little bit of movement and restlessness in the frame.

DG: It's definitely an Eastern European tradition or maybe French neorealist. Something moved in every frame. The laundry moved, or smoke came out of the chimney of the small village house. For me, I love, I *love*, just straight-up photography, just working with a DP [Director of Photography] and making these frames, and making these tear books and image books and then screen-grabbing frames that I adore from other people's films. So I'm always looking for something that will maybe give you a clue about where we're situated, maybe the social context, or the sort of economic resources that somebody might have access to, or something lyrical, they've done to decorate their house. Yeah, so I like to put as many signs and symbols into the frame.

Someone used to ask me, "Oh, why do you always put an American flag in every film you make, you know, what is that?" ... My answer used to be I don't go searching for American flags. It's something as an American visual anthropologist I had there, that we are one of the only countries that needs to put our flag everywhere. I started filming a lot of documentary footage during the Gulf War. And the flag was being used in a very, super-intense way, you know, that was harkening back to other historic periods. And then when I got involved with photographing and trying to document a story within the veteran community, at a veteran funeral, there wouldn't be just the flag on the casket, but that maybe fifty flags, with maybe a thousand bikers are going to come in, and every one of them will have a flag on the back of their bike. So some themes—many filmmakers say this, right?—you don't go looking for the next picture. I don't ask myself, "Oh, how am I going to include a flag?" Instead I say, "I got there and there were flags." And that's important for me to note, you know?

KS: Your narrative films are three for three in discovering an actress who then goes on to much bigger and better things. And you are at least two for three in taking a couple of male actors and showing them as they have never been seen before and essentially changing the trajectory of their careers too.[24] Does it ever feel like, many years in the future, the first line of your obituary is going to be "Debra Granik, the filmmaker who discovered Jennifer Lawrence?"

DG: I, of course, don't want that to be because I try to stay very much practicing outside of any kind of star system. So it'd be a little bit devastating, because, you know, I'm trying to make a lot of space outside of the celebrity worship that we have in this culture.

I want to make space for newcomers, people who need second chances. I want to make space for people that have been, have had a hard first chance. There's so much talent coming out of prison, for example. So many talented vets that have so much life experience ... a certain kind of role would be amazing! I wish there was more space. I can't make it happen because our financing system doesn't allow for it. We don't have any First Amendment when it comes to financing. This country is the most censorious beatdown, punishing country in the world when it comes to how films get made. There's no other

country as harsh on stamping out ingenuity as our country on the filmmaking front. We can bring out big guns and atomic weapons and blast things and make them for $250 million, the size of the budget of a school system in most states and other countries. We know we can do all that. But we're not a zone of tolerance for the smaller story, the smaller life, the life's that's had raw Americans experience imprinted on it. So I joined the other filmmakers that are in this tradition called social realism. I want to be in that. In that position, I want to bring people in, versus looking at some price tag that someone's been assigned.

If you're telling stories about scrappy Americans that survive, that might be in a difficult financial straits, or maybe got jammed up somehow or trying to survive or you love them, you love them because you're attracted to them because of their survival chops. But they don't all have perfect teeth. They didn't all get them whitened. They don't all have perfect skin. Some have scars, you know? So I'm up against that, right, you know? I really want to include different kinds . . . I know that for a film to be watched for a long time, they have to be somehow pleasing. I just wanted to expand what pleasing is, you know?

KS: I think that's so well put. *Winter's Bone*, for example, is a movie where the purpose of each scene is very similar. Here's a teenage girl looking for her missing father. And yet it's never dull. Even if the very general lines of it are the same, the seeming ordinariness of it is what makes it interesting. Even when it is still, it is moving.

DG: Suspense is defined in very different ways, but I always think about that the end of the month is suspenseful for a very big portion of Americans, right? Am I making rent? Do I have enough? Am I okay this month? That is ordinary, and it's intense as well. Every end of the month is intense for a lot of people. I'm so inspired by filmmakers that show the ramifications of a small decision that goes in a direction we can't predict, where small things can lead to good. Someone drops something at a bus stop and then two people bend down and they say hello, and something good happens like that, you know, the tropes of microincidences that actually balloon in good ways. And, of course, they balloon in really difficult ways. You know someone thinks, "I don't have enough to pay for this, so just this one time I can just put it in my pocket. I'll just walk out. There's one time. I won't do it again." And a chain of events happens because that one time was that one time that led to something but that's an ordinary day in an ordinary life. No one woke up and said, "Oh my God, I'm gonna try my first shoplifting experience today!" It's more like they woke up and they said, "Oh shit, I don't have enough money. I could tell my kid I was gonna get them a costume. Oh my God, oh my God." So it's like it's an ordinary life and this intensity that's really high.

KS: As a filmmaker, you are comfortable leaving visible questions in your movies unanswered. In *Winter's Bone*, Ree's mother doesn't speak and is clearly not well, but we are never told why. We know the main character of *Leave No Trace* [*played by Ben Foster*] is a traumatized veteran, but what happened to him is never explained. We don't have a very obvious answer as to what happened to Ree's father, which is the engine of the entire plot of *Winter's Bone*.

DG: As you know, both of those are adaptations from novels [*Winter's Bone* from a 2006 novel of the same name by Daniel Woodrell, *Leave No Trace* from *My Abandonment*, a 2009 novel by Peter Rock], and I think every novel presents a set of *really* forceful challenges to the adaptation process. I had felt inspired that, in Danny Woodrell's book, there was some ambiguity as well. And I think one of the things that I found so hard about Ree's mother was that Daniel, the author, uses internal monologue as well, which is a beautiful tool of the author, right? And many filmmakers don't use it. There's some that, some very

famous films have used first-person narration, of course. But, to some extent, a lot of us are schooled—I certainly was—to go as far as you can, without narration.

There's not always a clear understanding of what makes someone not functioning, not feeling okay, not able to participate in daily life in a normative way. Ree's mom, I think, has a very, very severe kind of bipolar condition or something of that nature. And at the time, in the space of the story, she's not saying much, right, she's not saying anything. Normal people are not exempt from depression. But there's often not a diagnosis or name or support to understand how it's functioning or what it is. And so I left that in the story that this is completely undiagnosed.... Obviously, recognition for the daughter, a kindness there, a something, but a silence, you know, so I had to leave it open ended. I felt confident that people understood that somehow the debt Ree's father had transgressed somehow, right? Did he cross some line? And I didn't want to get to—I couldn't pinpoint it further than that.

And then *Leave No Trace*, again, very difficult to keep causality for what makes someone who's experienced combat, have their brain function altered to the point where their head is on a swivel, where they feel hyper-vigilant, where they can't sleep.... Even the person themselves, of course, wants to know the causality and how to how to pinpoint and understand it, and you rarely can. But the brain, the human nervous system, is not built to absorb that level of trauma. And therefore, someone will come home, they'll try to reenter society, and they find that they are not able to conduct themselves in a normative way that this society is expecting. And what was so touching in that story was that it was very historically accurate.

KS: It was?

DG: You know the scene of hanging that bag of food on the tree for that fellow that was hiding out in the woods? There was a huge precedent of that from the Vietnam era. And there's amazing films and incredible footage, even on YouTube, of veterans who had gone into the wilderness to live off the grid, undiscovered, undisclosed ... and those documentaries are outstanding, because Will [the name of Ben Foster's character], the young Wills are all there. Five, six, seven of them, you hear from them. You hear from their sisters, like "My brother can't, he can't re-enter, he doesn't feel okay." He can't go to the store like everybody else. He's hearing things. It's feeling things that cannot—that are *not* accommodated in normative society, and therefore he is extricating himself. Soldiers always had, throughout history, to take leaves. They couldn't always come back from war and then participate in normative society. It's a centuries-old story. And it is a mystery.

KS: I turned to my wife after we finished watching *Leave No Trace* a few days ago and I said, "I didn't realize how much of this movie is about fear." And she said, "Actually, I think it's about trust. I think it's about how trauma takes away your ability to trust."

DG: Wow, those are both very compelling ends of a spectrum. They kind of kiss each other, and then they fly away from each other in opposite directions.

KS: Your first movie, *Down to the Bone*, was based on a true story. I did not realize that the true story and the original student film was very much about a couple in the clutches of addiction. As a full length feature, *Down to the Bone* is about the woman played by Vera Farmiga and takes on this aspect of addiction we don't see a lot in movies about addiction, which is how addiction has centrifugal force that keeps sweeping people towards it. No matter how alone an addict is, their illness will somehow ensnare other people too.

DG: There's some amazing addiction films: *Man with the Golden Arm* [a 1955 drama directed by Otto Preminger and starring Frank Sinatra as an addict trying to stay clean upon his

release from prison] or *Best Years of Our Lives* [a 1946 drama directed by William Wyler about World War II veterans and their difficulty adjusting to civilian life], incredible films that really get to … the legacy of alcohol and families or class issues around addiction. It's not movie stars or old jazz musicians. It's like the American flag. You can't really get away from the fact that chemical dependency is threaded throughout human existence. And it's not like you go seeking it. It's more you realize that, on your journey, you will find many people that have recovered, who have battled it, who have dealt with it, who have confronted it, who are still working with it, who have lost people to it. It's one of those things, as it touches, like, almost every family in some way.

Our research [for *Down to the Bone*] was at a working-class rehab in New York State, a rehab for people in the uniformed services, you know, FDNY, NYPD, Con Edison.… And what made it different is there's no cushion. You don't have endless friends and family that can possibly help you out or your own resources where you could have very meaningful individualized therapy to help you work on everything. We were also interested in the whole idea of accountability, that this person was accountable to these two younger people. That the mother in this situation is attempting to walk away or put down their addiction, or get out from underneath the chemical dependency, has an extraordinarily high-stakes situation of accountability. Because two other people that you love, that care about you, that are depending on you or watching you do it, and they need you to succeed. And the stakes don't get higher than that usually in a person's life.

KS: Can you tell me about not only what you saw in Vera Farmiga as an actor, but what she added to the character of Irene Morrison once you guys began working on the film?

DG: Vera, to me, is a very rare example of a standard of the artistry that is so invaluable to making unusual films and being able to go into the field much more like the British tradition. Vera, she could have been one of those amazing people in Mike Leigh's stable.[25] Vera is someone that will go anywhere without doing stunts where you harm yourself by losing one hundred pounds or wearing tons of prosthetics or something.… She has working-class chops herself, meaning that she has observed in her own family of origin the steps it took to build her life with humble resources and a certain kind of required frugality … that when she goes and meets a cashier at Price Chopper and spent the day shadowing that person, and then hangs out in the staff room, and you know, she's there and she's understanding; she's not far away. She's not coming from a rarefied isolated bubble of stardom or a privilege. So that kind of boots on the ground, she marches in. And Vera is a people lover. Vera has an enormous, realistic, compassionate heart. So she meets people where they're at and that's a kind of spiritual anthropology. I think it's almost like an actor with Jesuit wisdom, learning, and understanding where someone's coming from, what they come into the room with, what their life has brought them, you know, what bags they're carrying as they enter. Vera does all that work. And, and she's got a crazy, wonderful sense of humor, too. Therefore, she can lighten up a set, she can bring a lot of joy. There's no whisking her away and putting her in isolation. She helps make things happen. If she needs to do something, drive her own car, in the snow, whatever it is, she's down.

KS: It's that theme I heard you come back to in all of your movies: "How are you coping?"

"How are you coping?" is a big-enough question in an ordinary life. You don't need to have the president of the United States and aliens bombing the White House in order to make something really interesting out of that question. "How are you coping?" Which is a question we all face.

DG: That was always the suspense with someone who's in recovery. If it's day 21, and you're getting a completely bad pang, think about that person, 3:00 to 4:00 p.m., that afternoon.

I remember someone said this incredible thing: They could take a left at that stoplight and go straight home, or, if the light doesn't turn green fast enough, you go instead towards where your dealer is or where you know where to cop, the bad place you shouldn't go. Corinne, the life model that Vera was listening to . . . she would be saying these mantras to herself all day. She'd be saying the mantras from NA [Narcotics Anonymous], or whatever it was, like hour by hour. Well, that's a very suspenseful, high-stakes situation: deciding to stay sober hour by hour in the first sixty days.

KS: Both *Stray Dog* [Granik's documentary about Vietnam veteran Ron Hall and the lingering effects of combat on his middle and old age] and *Leave No Trace* are also about how we cope, but in a very different way. Both movies are about military veterans and the very cruel paradox of American masculinity, that we ask these men to do these very dangerous, traumatic things and then we give them no tools on the other side as to how to cope with it. And both of these movies are, to some extent, about the nature of that trauma.

DG: So I told you that people say to me, "Oh, why do you always put flags in your movie?" right? So we went through that. I forgot to say people always say to me, "Oh, you're gonna have drugs in every film? Do you always have to put drugs in?" And that's when I said, "Hey, I don't look for them. They happen to touch a lot of lives." You know, for whatever reason, the United States is the largest drug market in the world, as well as other things we excel at. We have the most problems with chemical dependency. And then third would be like, "Do you always make films only about women, or you only care about women protagonists?" And, you know, that's where *Stray Dog* was very important, for me to say, "No, no, no, no! I care about how people construct their survival when the odds aren't always in their favor." I am interested in the act of building a life that you can keep going with that you don't get weary of, that you're either attempting to assure your survival or the people around you, or you have to be very resourceful how you're going to rebuild something that got fractured or harmed in the process of coming of age in America or living here. . . . And I am interested in seeing when people are building back from that. What does it look like? What does it feel like? What do you need? What do you need to make it happen? So "How you're coping?" is a question that I—you're right, that's the one I come back to, and being very attracted to the methods that people use, that are ones that I don't know about. I feel like there could be a really nice sector dedicated to films about "How are you coping?" and then the diversity of how people pull off that coping. Because that's the kind of anthropology that is magnificent to me. But there are many different ways. You know, it was so powerful for me to see when Stray Dog would say, "You need to know that we are a sector of the American landscape. We are hillbillies," right? And hillbillies have extremely different resources than city slickers and urban people and coastal people. There are tenents of our life and how we live it that you have not been exposed to. Since you're here, and since you're interested, I'm happy to set some of those down for you and let you know the resourcefulness of making do, using it up, making it last.

Stray Dog used to say a big thing in his community was that during the Depression "people are jumping off buildings in New York and Los Angeles. People are killing themselves. Their stocks are going down. They're upset, they're depressed. People are having a wretched, wretched time. And in the Ozarks, people were poor to begin, so they knew how to survive that. And they were poor during the Depression." Not that he's glorifying

118 Break the Frame

that. He's just saying they had resources to keep life in check and make it work without depending on the vicissitudes of an out-of-control stock market and have capitalism end their lives for them.

KS: Stray Dog, aka Ron Hall, appears in *Winter's Bone* too. Is that how you met?

DG: Yes, he helped on *Winter's Bone*. And he portrayed a sort of a variation of himself.[26] And I met him in the scouting for *Winter's Bone*. He was so helpful to us and then by choosing to meet him in his own context, after the filming, it was just a really great course. And it's, you know—he had really, I think, appreciated being involved in the project. Things were happening that would confound me and him, you know, and I'd have to call him and ask him. I'd say like, especially with mass shootings, given that he is in the heart of gun country, and has a deep, deep, deep web of connections to everything related to gun culture, as well, you know, I would have to call and confer and just how far we could get in our conversation, you know. And he would tell me everything he knew from his side, his neck of the woods, that I would try to tell him what I was seeing up here, and, it was pretty precious. I don't mean precious in the negative way. I mean invaluable to me.

The masculinity part. It was such a breath of fresh air in his life, to encounter a therapist through the VA that he could really talk to. It was such a beautiful proof of concept. Like, what you're talking about: tools and resources and what people are given, and just the sheer excruciating weight of masculinity at times. It was such a gift that this particular therapist who was a part of the VA system at the time. They really accomplished a lot together.

KS: The big challenge of returning to the theme of coping in all your movies is that coping is intertwined with ordinary life. If coping is a big theme, most of your movies are going to be about the small moments of the everyday. Your movies do that and are never dull.

DG: It's a little bit like the ropes course. Here's this dad, and you went climbing on a ropes course, and then all of a sudden you got on this platform and holy shit, you can't and your little kid's down on the ground saying, "Dad, it's okay. Just jump! Jump! The rope is there to hold you!"

That's like an ordinary life. Small moments that are ordinary but filled with intensity. This person decided to take his kids on a ropes course. And then you know, after eight hours, they have to actually call a rescue team because they can't get him down. Those are great stories.

Notes

1. Lindsay Zoladz, "Mimi Leder Is the Best Director on Television," *The Ringer*, April 12, 2017, https://www.theringer.com/2017/4/12/16045810/mimi-leder-director-the-leftovers-deep-impact-1725f67b26de.
2. Mimi Leder directed ten of the series' twenty-eight episodes.
3. The director of the original Rambo movie, *First Blood* (1982), Ted Kotcheff has been a director and executive producer of *Law and Order: Special Victims Unit* since 1999.
4. Boris Kachka, "Mimi Leder on Ruth Bader Ginsburg: 'We Both Know What It Means to Have Doors Slammed in Our Faces,'" *Vulture*, December 25, 2018, https://www.vulture.com/2018/12/mimi-leder-on-the-basis-of-sex-q-and-a.html.
5. Showrunner and television producer John Wells hired Mimi Leder to direct and ultimately produce on his series' *China Beach* (1988–1991) and *ER* (1994–2009).

6. Casey Mink, "How Mimi Leder Built the Feminist World of 'The Morning Show' from the Inside Out," *Backstage*, May 14, 2020, https://www.backstage.com/magazine/article/the-morning-show-mimi-leder-apple-tv-69692/.

7. Lesli Linka Glatter directed the 1995 coming-of-age classic *Now and Then* and was a regular director on the television series *Homeland* (2011–2020), *The Good Wife* (2009–2016), and *Mad Men* (2007–2015).

8. The walk-and-talk is a storytelling technique where two characters talk while moving, often shot without cuts and frequently used in workplace television to demonstrate the frenetic pace of the job.

9. A longtime collaborator of Aaron Sorkin, Thomas Schlamme was the primary director and executive producer of the Sorkin-created series *The West Wing* (1999–2006).

10. Steve Rose, "How Today's Female Directors Broke Out of 'Movie Jail,'" *The Guardian*, January 21, 2019, https://www.theguardian.com/film/2019/jan/31/female-directors-movie-industry-gender-discrimination.

11. *Vulture,* December 25, 2018, https://www.vulture.com/2018/12/mimi-leder-on-the-basis-of-sex-q-and-a.html.

12. Owen Gleiberman, "*But I'm a Cheerleader*," *Entertainment Weekly*, July 5, 2000, https://ew.com/article/2000/07/05/im-cheerleader/.

13. Lael Lowenstein, "Finding Her Way, " *DGA Quarterly Magazine*, Fall 2012, https://www.dga.org/craft/dgaq/all-articles/1204-fall-2012-close-up-jessica-yu.aspx.

14. Caroline Brew, "'Quiz Lady' Director on Why Awkwafina's Pooping Skit Is 'the Film in a Nutshell,' the 'Watermelon Sugar' Trip Scene and That Surprise Cameo," *Variety*, November 4, 2023.

15. Nick Dawson, "The Weight of Water: An Interview with Jessica Yu," April 17, 2012, https://filmmakermagazine.com/44028-water-under-the-bridge/.

16. Shepard, Julianne Escobedo. Shepard, "Q&A: Director Tamra Davis Talks Basquiat and Her New Documentary," *The Fader*, July 27, 2010, https://www.thefader.com/2010/07/27/qa-director-tamra-davis-talks-basquiat-and-her-new-documentary.

17. https://www.youtube.com/watch?v=YgZyti2nVCg&t=5s.

18. Susan Dominus, "If Cinderella Had a BlackBerry . . . ," *New York Times Magazine*, August 25, 2011.

19. BreAnna Bell, "Reese Witherspoon Cheerleading Comedy 'All Stars' Gets Two-Season Order at Amazon," *Variety*, December 14, 2022.

20. Aline Brosh McKenna, "Screenwriters' Lecture: Aline Brosh McKenna," British Academy of Film and Television Arts, London, September 21, 2010.

21. Dwayne Epstein, "It's All About Community. Even Though She Left New Mexico, Vella Lovell Took Its Sense of Community with Her," *Emmys.com*, February 14, 2019, https://www.emmys.com/news/online-originals/its-all-about-community.

22. Rachel Bloom and Aline Brosh McKenna, interview with Hrishikesh Hirway, *Partners,* podcast audio, March 4, 2020, https://partners.show/episodes/rachel-and-aline.

23. Kate Murphy, "Sunday Opinion: Debra Granik," *New York Times*, November 1, 2014, https://www.nytimes.com/2014/11/02/opinion/sunday/debra-granik.html.

24. In addition to Vera Farmiga and Jennifer Lawrence, the costar of her third movie, *Leave No Trace*, was Thomasin McKenzie before McKenzie went on to star in Oscar-nominated films like *JoJo Rabbit* and *Power of the Dog*. Both John Hawkes and Ben Foster had their careers reframed as dramatic leading men after starring in *Winter's Bone* and *Leave No Trace*, respectively.

25. Actors like Brenda Blethyn, Tim Roth, and Gary Oldman all had a career breakthrough after being cast in the films of legendary British director Mike Leigh.

26. In disposition if not fact. Ron Hall's character in *Winter's Bone* is a local crime boss. In real life, Ron Hall is a veterans activist and legitimate small businessman.

Section 3
Documentarians

Chris Hegedus, Dawn Porter, Tiffany Shlain, and Dream Hampton

The four interviews in Section 3, "Documentarians" are directors—Chris Hegedus, Dawn Porter, Tiffany Shlain, dream hampton—whose works are modern classics of several areas of documentary filmmaking: the fly-on-the-wall documentary about the famous (Hegedus's Oscar-nominated *The War Room*, about Bill Clinton's presidential election victory in 1992, and the *Depeche Mode: 101* concert documentary); the political biography (Porter's *Good Trouble: John Lewis*); film working with the power of the Internet (Shlain, founder of the Webby Awards); and the cinematic call for social justice (hampton's *Surviving R. Kelly*, credited with bringing the musician and sexual predator to justice).

Documentary film in America has historically been more open to women directors. The reasons for this are both noble (pioneers Albert and David Maysles hired women at all levels of production long before it was politically fashionable to do so) and crass (lower budgets, lower financial risk, and, until recently, lower visibility). But it is undeniable that the twenty-first-century documentary boom (theatrical releases of documentaries have tripled since 2000; add streaming platforms to that number too) has meant greater opportunities for women directors and also greater competition and difficulty making a living doing it. The world of documentary making, once an exceptional place for unheard voices, now resembles the loud, chaotic marketplace of most other kinds of filmed entertainment,

Several of the directors featured elsewhere in this book make both documentaries and fiction films. A dedicated section for "documentarians"—even if the four filmmakers here don't readily identify that way—honors the principles by which they work and the reality that documentary making is a different beast than its fiction sibling. Documentaries can be commissioned or funded through grants or nonprofit mechanisms and have no limit on how long they can take because there is no script to complete or actors to send home. The works of each documentary maker we spoke to here are very different from one other and time with their respective filmographies may feel like four visits to four separate countries. What bonds them is how their differences arrive at a common truth, that documentaries aren't about drawing conclusions but arming the audience so they may draw their own.

Chris Hegedus (b. 1952)

If music documentaries are your thing, it's likely you view 1967's *Don't Look Back*, directed by D. A. Pennebaker, as the granddaddy of them all. *Don't Look Back* perfected both the genre and identified the favorite subject (performers and the craziness of their job) of its director's half-century career. In filming Bob Dylan's 1965 tour of England, Pennebaker gave us a mostly backstage, handheld view of rock stardom, more Bob Dylan berating a journalist in his dressing room and managers haggling with agents than reverent footage of concerts and crowds. From here, the story goes, the music documentary became the visual equivalent of an all access pass. And Donn Alan Pennebaker would make a glorious career out of the genre he raised to such heights, in documentaries about the Monterey Pop Festival of 1967 and later, Alice Cooper, Little Richard, David Bowie, and the Plastic Ono Band.

It's a great story, if you love music documentaries. But what I've just told you is barely half of it. Because in the mid-1970s, "directed by D. A. Pennebaker" became "directed by D. A. Pennebaker and Chris Hegedus," launching one of the greatest partnerships in the history of documentary filmmaking. The presence and talents of Chris Hegedus would again raise the level of innovation in nonfiction cinema. The Pennebaker/Hegedus concert documentary *101* (with Depeche Mode) is as much about a van full of fans headed to the band's Rose Bowl concert as it is the concert itself, predicting MTV's *Real World*, which arrived four years later. Their era-defining pair of movies about triumph (1993's *The War Room*, about Bill Clinton's presidential campaign) and failure (2001's *Startup.com*, about the first wave of the digital economy) are legendary for both their access and their heart: The most private moments of a winning political campaign or a failing business are as much about the people involved and what they mean to each other as they are about whether the filmmakers had permission to capture those moments.

A Pennebaker/Hegedus movie has soul in a way earlier Pennebaker projects seemed reluctant to lead with. *Don't Look Back* is mostly about what we get to see. Pennebaker/Hegedus is about what we get to see and feel and, hopefully, learn from. Access for the directors is only as important as what emotions it gives the audience access to, taking giant happenings like rock concerts and court trials and giving them humanity as well as might.

Trained as an artist specializing in photography and experimental filmmaking, Chris Hegedus had been a cinematographer when she met and first collaborated with D. A. Pennebaker on the 1979 documentary *Town Bloody Hall*, about a public debate legendary in feminist history. The two married in 1982 and would collaborate on over a dozen films before Pennebaker's death in 2019, setting the high bar for a generation of spousal filmmaking teams to follow.

Chris Hegedus is the recipient of a Lifetime Achievement Award from the International Documentary Association and the winner of the DGA Award for Outstanding Directorial Achievement in Documentary. Her films have been nominated for Oscars, Emmys, and the Sundance Film Festival's Grand Jury Prize.

I spoke to Ms. Hegedus from her production office in November 2021.

124 Break the Frame

Films Mentioned
Unlocking the Cage (2016)
Kings of Pastry (2009)
Only the Strong Survive (2002)
Startup.com (2001)
The War Room (1993)
Depeche Mode: 101 (1989)
DeLorean (1981)
Town Bloody Hall (1979)

Kevin Smokler: You began your career in filmmaking as a cinematographer. From your point of view, how would your trajectory have been different if you'd first walked in a different door? If you'd began your career as an editor or a sound recordist or something?

Chris Hegedus: Well it really goes back to that I started as an artist.

KS: Your education is in photography and experimental film.

CH: I went to art school at a time when art was really deconstructing itself and becoming conceptual art and performance art. And I didn't really want to do that, even though it was an extremely interesting time to be involved in the art world, because a kind of a new trend was happening and it was exciting because of it. I got into experimental films at first.

In documentary, it's similar. Pennebaker also came out of experimental films. A lot of people did, because you didn't need to have sound equipment and stuff like that. But you also made it yourself, which was kind of like being an artist. You paint your own pictures and make your own sculpture. Because of that, you could use a camera and learn how to edit, vaguely. So I can't really say that I came at filmmaking as a cameraperson, but more as a filmmaker, as a true independent filmmaker, which a lot of us were back in the 1970s, when I began.

KS: As a young filmmaker, you were inspired both by the kinds of pioneering experimental film that Maya Deren was doing in the 1940s and 1950s [Deren is often cited as a key influence on the dreamlike filmmaking of David Lynch] and the beginning of direct cinema such as the documentaries of the Maysles Brothers [*Grey Gardens* and the Rolling Stones concert film *Gimme Shelter*, to name but two]. I find the two together really interesting because direct cinema seems resolutely nonfiction; i.e., we are simply filming real life as it happens. The experimental films of Maya Deren are an art piece and really say genre is beside the point and fiction-versus-nonfiction is not what we are doing here.

CH: My attraction to a lot of the experimental films is that they were so different from anything I saw in Hollywood at the time, which was pretty artificial, except for certain filmmakers or foreign films and things like that. For Maya Deren, it was because she was a woman. I mean, there were no women anywhere, you know, just stories about women in the back room with the white gloves on, gluing together pieces of film behind the scenes. And here was a woman filmmaker, and her work was very poetic. And I think that spoke to me in terms of my art background. How do the two intersect? I really wanted to tell stories and have something that was more about character and drama. And that was something that the experimental films didn't do for me.... I had no idea you could make a Hollywood film. I grew up a little bit in Michigan and then in Boston, and you know, I mean, it just seems so far away. And then these films by Bob Drew [called "the father of direct cinema"] and Pennebaker and the Maysles came to my attention, and it just

changed everything for me because they were, for me, like Hollywood films, even though they were only about real-life stories and real people. They follow the same trajectory as a feature film, where you had a character and a storyline and a dramatic resolution, all in this real story that I felt like I could do myself.

KS: You guys have made a lot of documentaries about people who perform for a living, which calls into question the idea of what is real and what is the performance. Were you ever worried that someone who is familiar with your work was going to perform in front of the camera for you instead of being themselves? Or does the question of realness not even interest you anymore?

CH: Not really. Our interest in performers came about because, for both Pennebaker and myself, one of our favorite books was *Act One* by Moss Hart [the 1959 autobiography of the great Broadway playwright and theater director]. It totally bonded us. Actors, they've always intrigued me, as well as musicians. Getting up in front of an audience, you're so vulnerable and exposed. If people in real life want to act in front of the camera, that's their personality, like if you take [Democratic political consultant] James Carville in *The War Room*. I mean, *The War Room* was the perfect setup for James Carville because he needed an audience. So a camera was also a great vehicle for him just because he needs something to play off of all the time.

A lot of times if you start filming people and they're really involved in what they're doing and concentrating, and after a while, they can't be thinking about you all the time, and they just forget and go on living their lives. So I would say that the largest percentage of people that we've filmed have said, you know, I forgot that they were even there. I didn't even know they were there. So it's not really something that we worry about.

KS: And was that also true with subjects who have requested you guys as the filmmakers on their project? Depeche Mode asked for your team to film them on their 1988 tour.[1] And because they asked for you, presumably because they had seen your films, you weren't concerned that they were going to say, "Okay, well, we have to we have to put on a certain kind of show because we know the kinds of movies Pennebaker/Hegedus make and they're here filming us."[2]

CH: They may have asked other people, and we didn't know who they asked. Basically, it was their management team that came to us and said, "You might be interested in this band because they have a really interesting following and are completely unique." But I don't know how they came up with our names, or if they really wanted us, or if they saw *Don't Look Back* or were suspicious or whatever. You still have to form a relationship in the beginning or you don't have anything. One of the things that we loved about the band is that they had all of their friends going on tour with them, working with them, doing lighting, building the sets. They were all their buddies from where they grew up in England and they protected them. So in the beginning, when we started filming, we got almost no access to the band. They would go on their bus and their friends would say to us, no, you're on that bus over there. And so it was a really difficult situation. We had to have a little bit of a stand-off between their friends and the band saying, we're here to make this film and we have to be on the bus with the band too. It was a developing relationship. As it should be.

KS: Does that mean you spent the first couple of weeks of filming *101* with Depeche Mode shooting lighting technicians and van drivers and guys who got the sodas for the band and that kind of thing?

126 Break the Frame

CH: It's not the same as it is today, because we were shooting on film and film is very expensive. Every roll is only ten minutes long. After that it runs out. Then you put another one in and you waste five minutes on something and then back shooting again. So we didn't waste a lot of film shooting other stuff. We just tried to get access in the beginning.

KS: I want to ask you about access. But first I want to ask about this idea of filming people that are on the periphery of the subject you're there to make the movie about. You guys are fascinated by many pieces making a whole, the different kinds of people that make a big thing happen. So when we watch a Pennebaker/Hegedus documentary, we are going to see the concert promoters arguing about ticket revenue in a trailer in the back parking lot while Depeche Mode is onstage at the Rose Bowl playing to thousands of people. We're going to see James Carville getting lost backstage at the Democratic National Convention until someone tells him he's wearing the wrong badge around his neck. How do you guys go about selecting those moments? Because we are talking about little, everyday moments, so there must be a lot to choose from.

CH: Much more now. *The War Room* was maybe forty hours of film. I mean, now, if somebody was going to film that type of thing, they'd shoot four hundred hours at least.

KS: Right. Because all your footage goes on a hard drive and who cares?

CH: Yeah, it's all really about access. For *The War Room*, our story was originally to film a man becoming president, and we wanted to follow Bill Clinton around. In the end, we were kind of reduced to the campaign staff.... But we went through the different areas of the campaign and stumbled across James Carville, who just seemed like somebody's drunk uncle at a party, but he was really by far one of the most interesting people there and brilliant. And him and [campaign director of communications] George Stephanopoulos, they were like a buddy story. So we continually tried to get in with Bill Clinton, but we were left with this wonderfully strange couple, James and George, which, in the end, was more interesting. We wanted Bill Clinton. Instead we got the making of a successful campaign. Ever since, every presidential campaign has to have a war room because of the type of strategy that they developed.

KS: What is your attraction as a filmmaker to events that kind of take over one's life and become all-encompassing, like a concert tour or a presidential campaign or starting a business?

CH: Most of our stories come to us and we don't think of them.... Even for Penny's film *Don't Look Back* on Bob Dylan, his manager came and said, "Would you like to make a film about my artist Bob Dylan?" And so that's what's happened in almost everything that we've tried to do. We're as simple as if you have money or access, we'll come along, and if you just have access, well, you know, we'll start on that. Our films are really totally subject driven. It's trying to find somebody that you think can withstand that type of pressure and somebody who is really passionate and going to take some kind of risk and going to let you along for the ride while you watch them jump off the bridge. You don't really know the scope of the situation a lot of times till afterwards. That was particularly the case of *Startup.com*, where we really thought we were following these two young entrepreneurs who were going to be millionaires at the end of the film. That was the projected storyline that we had in our head, and instead it turned out to be one of the examples of the whole boom-and-bust economy at the time.

KS: Were you guys ever in a situation where a story you had access to did not pan out? Like what if in *The War Room*, one of the losing presidential campaigns had given you the

most access? Would it have been a movie about an unsuccessful presidential campaign? What happens when your access is the wrong kind of access?

CH: We've definitely given up on stories. We shot some wonderful material with Al Sharpton when he ran for president [in 2004]. And at the same time he had a friend who was filming his National Action Network's work. And he had also this guy who had also gone to Africa, I think, with Reverend Sharpton, but he couldn't really tell this guy, "No, this other group is making the film about me, so you can't." And so we would both be trying to do the same thing, and it was three people trying to get in the car together and you can't all do it. We realized, and to his credit, Sharpton wasn't going to tell this guy that he can't film, so we just, you know, stepped out of it because of that.

KS: I've heard you describe your work before by saying, "We make home movies."[3] And I think it very accurately describes your documentaries, which seem to be saying that what is in front of the camera is the star of the show and not the people behind the camera. We're not going to wow you with a lot of fancy filmmaker tricks. But also there's an implication in that phrase that aesthetics are less interesting to you as filmmakers because home movies are typically emotionally important but not beautiful works of filmmaking. At the same time, a lot of your films are about the grit and dirtiness of life, those piles of empty coffee cups in *The War Room* or the unfurnished office in *Startup.com*, but you've also made quite a few films about things of beauty. Your movie *DeLorean*, about the ill-fated automobile, is one of them. Or the end of *Depeche Mode: 101*, where the band climbs aboard this magnificent silver airplane gleaming in the sun and your cameras circle around it the same way it did several minutes before, where it circles around Rose Bowl Stadium, getting this enormous crowd all waving their arms in unison. Stunningly beautiful images of beautiful things, both of them.

I've said way too much without really asking a question.

CH: I think the home movie aspect is that we film in a really small way. One is so we aren't the center of attention; the other is that we never have any money. A lot of times it's just the two of us, the ma-and-pa grocery store aspect of filmmaking where we do everything. We film them, we edit them. We can't really say we direct them because it's real life, but whatever. But we do really appreciate beautiful filmmaking too as well, and sometimes we get more of an opportunity to do that type of thing. *Depeche Mode: 101* has a lot of beautiful shots in it that I love. You can say the same of several of our other films or that we tried to make the beauty in the editing if we didn't have time to do it in the shooting.

KS: I know the type of filmmaking Pennebaker/Hegedus pioneered was premised on the invention of lightweight cameras that do synchronous sound so the camera and a sound person didn't have to be wired together and the camera could move as freely as the subject moved. But given how present you have to be as filmmakers for the subject, which is basically there all the time, how did you physically accomplish that without your body giving out on you?

CH: As heavy as the 16 millimeter cameras we started with were, they had a kind of balance to them in the way that they sat on the shoulder. Even so, my shoulder's not very good. It does take its toll on your body. For *Only the Strong Survive* [about a reunion concert of famous R&B and soul musicians from the 1960s and 1970s] we shot with those with pretty big video cameras. And they were heavy. I had to wear knee pads. Later when we got into using the smaller digital cameras, I would just wear a fanny pack. I mean you just find ways of being a tripod and getting through it, but it can get heavy. Being a

128 Break the Frame

cameraperson is really exciting to me. Just watching the action through the lens is really addicting. I think you run on that adrenaline.

KS: How did you both decide that *Depeche Mode: 101* was your most fun filmmaking experience?[4]

CH: That's something that Penny has always said. I kind of liked that he said it because everybody thinks it's scandalous that he doesn't love *Don't Look Back* more than *Depeche Mode* as a filming experience—the adrenaline that I was just speaking about, you know, for the person onstage, performing, the adrenaline of trying to shoot a concert together and capture and make sure you get it all. And, you know, we shot that on film and didn't have twelve cameras the way they might today. So there's a risk for us in the same way there's a risk for the people we're filming, and especially true in a concert like that. We became good friends with the band and really love them and their music and love what they were trying to do, throw away everything and the type of music that their parents were about and invent a whole new genre.

KS: There's no way anyone who was present for that tour and those last concerts could have known this at the time, but music journalists and historians now look at Depeche Mode's Rose Bowl concert in June 1988 as the moment where the popularity of a musician separates from how much their popularity was reflected on commercial radio and Top 40 charts. That Depeche Mode, who got very little radio play in America and had had exactly one top 40 hit up to that point, could fill a college football stadium was a predictor of the music world we live in now, where "pop music" no longer means "the thing everybody listens to." It feels like a generational turning of the corner the same way *Don't Look Back* had been twenty years before.

CH: Yeah, I think a lot of people have said that. At the time, I didn't know that that was happening, and a lot of times you don't when you're in the middle of something, but there was a cowboy aspect and kind of a bratty aspect of the band too. They were pretty much self-managed. I could relate to that. We were kind of a little bit of an outlaw band of filmmaker types ourselves.

KS: In retrospect, do you consider yourself and Mr. Pennebaker pioneers of the husband-and-wife equal filmmaking partnership? Do *American Splendor*'s Shari Springer Berman and Robert Pulcini or the *Free Solo* team of Elizabeth Chai Vasarhelyi and Jimmy Chin owe their working relationship to you two?

CH: To have a couple doing this together, whether it was sound and film or film and sound or switching back and forth, it was very common in that day, because sound and picture were separated. So you needed two people, you needed a partner. You needed the Maysles *brothers*. I think it works for a man and a woman couple because you get to share your life together in a very special way. And you know, although it may have a lot of stresses, especially during the editing process, where we usually get divorced (*laughs*), I think during the filming, especially filming real life, you need somebody there because you don't know what's happening, and that's somebody there to strategize with. A lot of times people don't love you when things are going bad and they don't want you there. And it's really nice to have a partner to share that with, as opposed to somebody else who doesn't know what your life is like when you go home to them.

We were not the only ones. Alan and Susan Raymond [the filmmaking team behind the seminal 1973 PBS television series *An American Family*] were doing it at the time.

Joan Churchill and Nick Broomfield [ex-spouses who made the 1998 documentary *Kurt and Courtney*] were doing it. So there were quite a few couples.

KS: Did you guys have the same responsibilities project to project, or did you alternate? Or did you switch them around based on the subject of the film you were working on?

CH: Penny takes awful sound. He makes all these rustling noises holding the microphone. So the majority of the time that we worked, just as two people, he would shoot and I would take sound, and occasionally we'd switch back and forth a little bit but not as much. If we shoot with multiple cameras, then I would shoot and have somebody else take sound because I really like to do that. On concert films, Penny really likes to film onstage.... I'm usually the front camera, trying to take beautiful close-ups. A lot of times I'll be on and off a tripod, so it can get really smooth panning shots, which are hard to do if you're in a stage as big as the Rose Bowl. But it also gave him the freedom to do those types of shots, because he knew somebody else was coming at the other stuff.

I made a lot of films without Penny recently. *Unlocking the Cage* [a 2016 documentary about a court case aiming to establish the legal personhood of animals], I did totally by myself where I took sound and shot, and nobody came with me. That's the amazing thing that you can do now with the equipment.

KS: And I would presume, for *Unlocking the Cage*, just you in the editing room?

CH: I edited it up to a certain point. Unfortunately, I didn't realize that films about legal cases can take a really long time. The law moves very slowly. Penny wasn't working much in the editing at all with me at that point. And so towards the end of the film, after I made a cut of it and had shot almost all of it, I started working with Pax Wasserman, and he was really the first editor I worked with whom I hadn't also shot the film with. I feel really lucky that I just met Pax and hit on somebody who had the same interest and understanding of how to make a film as me.

KS: We live in a very good time for interest in documentaries. How much of that is due to the films of Pennebaker/Hegedus?

CH: I don't know if it's our films, but definitely Penny and the Maysles and Bob Drew and [pioneering nature film producer] Hope Ryden, who was the one woman who worked with them and who was very instrumental for me—they really engineered and creatively forged a path for documentary filmmaking to be much more dramatically told stories, whereas before, they were much more journalistic stories. They were the innovators. Hopefully I brought something to it—if nothing else, being a woman out there as a presence.

KS: How do you divide your time between filmmaking and teaching?

CH: I do not teach anymore.... It was always hard in our office when we would go to Yale. I went for the beginning semester, Penny went for the second semester, for student filmmakers and their year-long thesis project. Frazer, who's been our producer forever, never liked for us to go. So we had a choice to either go to New Haven and teach or go to Paris and do a film about French pastry. Right. Let's go to Paris. And so we went and did *Kings of Pastry* [a 2009 documentary about a competition between chefs to receive France's highest honor for craftspeople, the Meilleur Ouvrier de France] and then we never went back to teaching.

I liked it. But you know, it's hard being an independent filmmaking company. We distribute the films as well as produce, direct, and edit them. And we have a huge archive. And that's, that's pretty much what I've been spending my time on recently, dealing with

130 Break the Frame

the archive and trying to preserve a lot of the films, especially the ones that we shot in 16 millimeter.

KS: Which part of your personality is a director and which part is the cinematographer or camera operator? The editor?

CH: I don't divide them at all because I've always seen making a film like painting a picture or creating a sculpture. For me, these were all the aspects that you have to do to make the whole, and I enjoy doing them all. I don't know how people can't do them. I'm sure I could, it's just, it's a little bit foreign to me, because I think of them all as being part of the creative process and the creative end product.

KS: Who are the filmmakers that have inspired you? Who are the ones you feel like you came up with? And who are the ones you're excited about for the future?

CH: I mentioned a few of the women who inspired me, like Hope Ryden and Maya Deren, but [Federico] Fellini [considered Italy's greatest director, whose use of extravagance and fantasy directly inspired filmmakers such as Wes Anderson and Tim Burton as well as musicians like Lana Del Ray] is one of my favorite filmmakers. When we were talking about having poetry in film, I was very attracted to a lot of the foreign films like Fellini's and [Jean-Luc] Godard [a leading director of French filmmaking in the 1960s who would directly inspire the revolution in Hollywood movies of the 1970s]. And then, of course, you know, there was a whole group of women filmmakers who were trailblazing in the 1970s, everybody from Julia Reichert [whose 2020 documentary *American Factory* won a Best Documentary Oscar] to Martha Coolidge [who became the first female president of the Director's Guild of America in 2002] to Barbara Kopple.

I remember seeing a rough cut of *Harlan County USA* [Barbara Kopple's documentary about coal mine strikes in Eastern Kentucky that won a Best Documentary Oscar in 1976] when she brought it to our office . . . She's always been a pioneer and a role model. I was also very attracted to the diary films [self-conscious documentaries either narrated by the director or about the director or both] at the time. I don't know if you know of Joel DeMott and Jeff Kreines [directors of the 1983 film *Seventeen* about a group of high school seniors in Muncie, Indiana, which won the 1985 documentary prize at Sundance and was an inspiration in the development of the public radio program *This American Life*]. . . . I mean, I don't feel like I'm brave enough to do that type of film. I love that they did it, and as it went through the years, it turned into Michael Moore, doing it in a much more political way. There's so many amazing filmmakers today, I don't even think I can name them all. But it is really a golden time for documentary films. I'm sad that I'm not filming in this digital age where everything looks so spectacularly beautiful, even shot on your phone. That was always one of the things that was most important to me, that the filmmaking tools could be put in the hands of the people that they're about. . . . And that stories could come from other people like women, because when I started making film, almost all the stories were done by men.

Dawn Porter (b. 1960)

Films Mentioned
Rise Again: Tulsa and the Red Summer (2021)
John Lewis: Good Trouble (2020)
The Way I See It (2020)
Trapped (2016)
Lone Star Nurse (2016) (short)
Gideon's Army (2013)

Television Mentioned
37 Words (2022)
The Me You Can't See (2021)
Bobby Kennedy for President (2018)

The documentary films of Dawn Porter are patriotic in the best way—proud and questioning, searching for promise instead of looking away from mistakes. Their uniquely American majesty comes from a level head and open heart unrolling in the spirit of what James Baldwin said of the nation that both birthed and persecuted him: "I love America more than any other country in the world and, exactly for this reason, I insist on the right to criticize her perpetually."[4]

You probably came to Dawn Porter's work via her breakthrough film *John Lewis: Good Trouble* (2020), released the month before the civil rights icon's death. Before that, she had already directed documentaries on abortion clinics in the Deep South, young public defenders, and a multipart series on the presidential campaign of Robert Kennedy for Netflix. Documentaries on White House photographer Pete Souza, the 1921 Tulsa race massacre, and the fiftieth anniversary of Title IX in sports followed in quick order, part of a five-movies-in-three-years-streak that continues to build in momentum.

Trained as an attorney, Dawn Porter now runs her company, Trilogy Films, out of her native New York City. Her movies have been honored at the Sundance and SXSW Film Festivals, with Emmy and Independent Spirit Award nominations, the 2014 Ridenhour Prize, presented by the Nation Institute, and a Peabody Award. Ms. Porter also holds honorary degrees from Swarthmore College and Simmons College.

I spoke to Dawn Porter from her home in Cape Cod, Massachusetts, in June 2022.

Kevin Smokler: The beginning of *37 Words* [a four-parter for ESPN commemorating the fiftieth anniversary of Title IX] is Billie Jean and Gloria Steinem sitting down together. It's like a microcosm of something I see in so many of your movies, that our emotional response to history is often inaccurate. Most of the people in *Gideon's Army* do not conform to our commonly held notions about what public defenders look like. Most of the people in *Trapped* do not conform to our emotional idea of who operates abortion clinics. And I think anybody would be forgiven for feeling like the second wave of feminism was one mighty roar, but Gloria Steinem did not understand how women athletes were important to the movement despite Billie Jean King practically having to scream at her to enlist them.

Dawn Porter: I grew up a big tennis fan. I love to play, I love to watch, Obviously I have watched Billie Jean my whole life. And so, as we were doing the research for *37 Words*, she just kept showing up … starting women's professional tennis, playing Bobby Riggs. But then she was there, at the start of women's professional basketball. She's a part owner of Angel City [women's pro soccer team]. She formed the Women's Sports Foundation. So I was really, really excited to meet her just as a fan and as a person but also as a feminist. And it almost happened by accident that we paired her with Gloria Steinem, because they were—we wanted to interview them both—And they're, you know, between schedules and restrictions and everything. And so I thought, "Why don't we do it together? Why don't we have them talk about that?" She was nervous about talking with Gloria. She was like, "I really admire her, but I really had to beg her to, you know, look to us as possible allies in this movement." And so that's how we started. She comes in and she's like, "Does Gloria know what we're gonna talk about that … is she okay?" She was nervous. And the one thing I've never seen Billie Jean King be in any interview—I've studied her, I've read her book—I've never seen her be nervous. I think we've all had that experience with someone we look up to, want to have a positive interaction with them. And she wasn't quite sure. And *that's* when she told me they had never done an interview together before. They certainly had never spoken about this. Since then they've become great allies, you know, and totally in sync. I love to see people in a different way than they expect. And seeing Billie Jean be a little bit nervous, and then seeing them just so easily settle into each other. They both have such a storied history, and such an important place in the women's movement, that I really liked the ease of them being together. And so that's how we started.

KS: Billie Jean King is really the sort of guiding spirit of all four parts of this story, isn't she?

DP: Yeah, she is! We started the research and she just was everywhere. And she was a pre–Title IX athlete. "My life is about so much more than tennis," she says. And you can really see how many ways she's just encircled her activism. And she's so, you know, energetic about it. I think even if people don't start out intending that that's going to be what happens for them. That part of being empowered physically. Also, this idea of teamwork, leadership, understanding your place in a group, you know, sports—participation in team sports—helps people develop all those skills. And they don't just stop in the field. They get carried over into school, into life into professional life, into marriage. So, you know, it's not that sports is the only vehicle for that, but where it is, it can be incredibly empowering for people who not only have not always felt their power.

KS: It is a particular kind of activism choice that Billie Jean King makes in her life, to sit down with her supposed adversaries and find common ground. It takes a certain kind of strength for Billie Jean King to be treated horribly in the public eye by Bobby Riggs, who was her tennis hero growing up, wallop him on the court [in the famous "Battle of the Sexes" match at the Houston Astrodome in 1973], and then become friends with Bobby Riggs for the next two decades of his life until he died.[5]

DP: I think what Billie Jean shows is there's a graceful way to recognize your power, that you don't always have to be antagonistic in order to be assertive. She's indisputably the winner, not just on the court, but in the court of public opinion. What she's doing by not being drawn into a pointless battle is she's freeing up her energy to do productive things.

KS: Your movies are universal while only telling a few stories about a few people. No one would see the athletes in *37 Words* or watch *Gideon's Army* or *Trapped* or *Rise Again* [about the Tulsa race massacre of 1921] and say, "This movie is only the story of female

athletics or these three public defenders or those abortion clinics or this one particular incident of racial violence a hundred years ago."

DP: People ask me why ... I haven't done fiction films. And I kind of give them that answer, which is because the truth is so much more interesting than things that I could make up. And I really, really think the need for allowing people to see for themselves and to make connections to their own lives has only increased. When I started, there wasn't TikTok, there weren't filters for your pictures.... So I often find that history is sanitized and made palatable. And I don't think that that does us a service. I would so much rather—first of all, I trust my audience. And I think people can take it, you know, and I think when you show what happened in the past, with all of its texture and reality, it allows people to say, "Things are messy. You know, I don't have to be a Marvel superhero in order to participate in making change." John Lewis was nineteen when he started leading civil rights marches. But he didn't wake up and say, "I am going to become the greatest civil rights leader ever." He said, 'I'm going to organize a group of people in a basement. And then tomorrow, we're gonna go across the street and protest. And then the next day, we're going to do this, the next day, we're going to do this." And over time, the consistency of his actions is what led to him becoming a great man. It was not some grandiose plan.

A lot of times in my work, I'm addressing my own bias.... I didn't know what a public defender did. They do this exercise for the public defenders the first day that they get there, and they have everybody tell their story. Why did you become a public defender? And as these kids—and they are kids—are telling their stories, person after person, like essentially, many of them came down to they felt powerless at some point in their lives. And they carried that, and they didn't want other people to feel powerless. They decided they didn't want anybody else to feel like that. So one kid said his he was the younger brother and his older brother was picked on all the time. So he was eight years old, his brother was twelve. And he couldn't protect his brother. And he just held onto that. Often it's rage. One young woman told me her mother was a probation officer, and she would bring food to her clients because they didn't have any food and they're not in jail. And she was like, "Why are you bringing them food?" and she's like, "Because they don't have any and they can't get jobs."

I really like making people slow down, and think for a moment, like, how do you put yourself in somebody else's shoes?

KS: You were a lawyer in the previous chapter of your professional life, a litigator, to be exact.

The American justice system is, by definition, adversarial. Your movies are not. How did you decide, growing up professionally in an adversarial system, not to make movies that way?

DP: I'm much more interested in "why" than in just fighting. Litigation, when it's a puzzle, when you're trying to figure out something, is really great. When it's just arguing over your date for your depositions, it's terrible and not enjoyable. And so what I tried to extract was the part that I really loved, which is the puzzle of something.

KS: If I may take your body of work as a whole, there is a civic quality to your filmmaking. The question of what it means to be an American is a big part of the work you do.

DP: Our house in New Jersey came with an American flag. And we never took the flag down, because we're American. And then a friend of mine was like, "What's with that flag? Only really conservative, crazy people fly the flag." And I was appalled by that. And I think being an American is very complicated if you're a woman or minority and if you're a

Black person, but I also think, "Why would I ever cede patriotism to people who are discriminators?" I love parades. I love the promise of equality. I love the idea that we've given people a chance, they can change their lives. I do love all of those things. And I definitely come from the school ... you criticize the things you love out of love to make them better. And I also tend to be an optimistic person, believe it or not—until recently. *The Way I See It* [about Obama White House photographer Pete Souza]—that's why I wanted to do that movie. I wanted to remember what it felt like to be proud of your president. I wanted to remember how hard that job is. And so how important it is to have the right person.

KS: It's also a movie about the power of image.

DP: My father was a photographer.... When I was little, like, he had a studio in New York City downtown, kind of over by the river and the East Side. And, you know, there are those old carriage houses because people used to have horses and carriages. I just always remember him talking about light, the light in that building was phenomenal, because it was frosted glass, really tall ceilings, and just gorgeous, gorgeous light. So I really have a deep respect for photography. I never thought I was gonna be a photographer, but I was fairly obsessed. And then when I got to ABC, I was like, "You can make the images talk!" And then I was like, "Oh, this is what it is!"

The opportunity to make the movie about Pete was such a gift ... because it was like the things I love. Both of them.

What does it mean to be an American? Pete was also the photographer of the Reagan White House. And you see Reagan, the great communicator, say, "Pete, over here. This would make a great picture." That just tells you so much about Reagan, right? He doesn't have to be evil to be a manipulator. He [Reagan] is very self-aware and aware of image, images of Reagan in stirrups on horseback, in those grand situations that would convey the image that he wanted. He's a strong Marlboro Man kind of leader.... There's a little bit of pretension and bravado. There's a little bit of paternalism. It means a lot of things, which is, you know, why there's a lot of movies to make.

KS: In both your documentary about John Lewis [*Good Trouble*] and in the series you did for Netflix about Robert Kennedy [*Bobby Kennedy for President*], you're dealing with a subject that, in many cases, has been elevated to sainthood. In both cases, how did you make a real documentary and not, say, a filmed encomium?

DP: That was a bigger danger with John Lewis because I was with him. And I did love him. I hadn't thought about this enough when I came to the movie, which was, don't meet somebody you really love because they could disappoint you. And the opposite happened. He was more. He was kinder, he was smarter. He was more generous than I thought. I'm not here to take down John Lewis. And there really wasn't that much to take down. That wasn't the point of that movie. The point was, how do you age as a civil rights hero? How do you watch the legislation that you helped to get passed in 1965? How do you have the stamina to reintroduce it in 2020? Which is what he did; he totally reintroduced the Voting Rights Act in 2020. With Bobby Kennedy, it was easier because I didn't know him personally ... What I quickly decided to do was only interview people who knew him. And so the footage details his flaws very easily. And then the people are there to support the footage, not the other way around. So the people are speaking. They're adding the texture of "How did he walk? How did he sound? What did he eat?" They also loved him. They knew him warts and all. And they knew what he was trying to do. And that is so very much, "What does it mean to be an American?" It means you can change, it means

you can evolve. And you don't have to be perfect by any means to do great things. You can be human.

KS: The Kennedy miniseries, the John Lewis film, and *The Me You Can't See* docuseries [about mental health, produced by Oprah Winfrey and Prince Harry] are the three projects of yours which deal most directly with famous people. And I've noticed in your movies that famous people are often photographed similarly to ordinary people.

DP: That is extremely intentional. We talked about that ad nauseum in *The Me You Can't See*. And Harry and Oprah, but really Harry, embraced that immediately. He got it. [Codirector] Asif [Kapadia] and I had that conversation with him: "You don't get special light. You don't get special anything." And then the same with Oprah. There were more cameras for her interview. But, you know, to the great consternation of her producer, I was like, "It's me and her in the room with sound. That's it." And Oprah was fine with that. And, you know, I think Harry's always wanted to be a regular person. So for him, it was a relief. I think they both saw the power of making sure what we were talking about happens to anybody, regardless of wealth or privilege, that they both really bought into that. And then it really helped with other famous people.[6] Lady Gaga? Me and her in the room, you know—everybody else I made them stay outside. DeMar DeRozan, NBA star, that one was the least set up of any of our interviews, and it's gorgeous. And he came by himself. No entourage, no wife, no friend, no manager, no nothing. I had to do that interview remotely because it was really in Covid. I said, "DeMar, close your eyes and tell me what depression feels like for you?" And that's how we open Episode 2. Because he's like, "To me depression feels like being at the bottom of the sea and you just can't swim up." And it's so perfect. And it's what so many people have felt and it's not contrived. It's the opposite of NBA clips. He was so generous. There were a couple times I think I asked him about his parents. And I said, "I've never heard you say that before. I read a lot of your interviews, blah, blah." And he said, "No one ever asked me. They never ask me about me. They just asked me how many points I just scored or this or that." I am still so moved by that interview.

KS: How were you selected as the director for that series?

DP: That series was produced by Radical Media and they were the producers on the Bobby Kennedy series. So they knew me. They put up a number of possible directors and then I had to go meet with Oprah. So the day I was supposed to meet with her, I was in New York City—I think I was still living in California at that point. It was May, and the weather had gone from really hot to really cold overnight. And I only had one dress that was appropriate for the weather. So I put it on; it's fine. I get in the cab and I'm heading over, early. I'm gonna meet Oprah Winfrey for the first time. And I looked at my dress, and it has all these spots all over it. I think a bottle of lotion had exploded in my bag.

KS: Oh, no!

DP: And so I start sweating. And I'm like, "It's nine o'clock. Should I be late and try to change? Or do I show up to Oprah with a spotty dress?" And so I go in like this and I'm like, "Hi!" And I lean in to her. So then she leaned into me. What I was doing was trying to make sure that she couldn't see that my dress was a mess. And I think she thought maybe I was being real engaging. And so anyway, I got the job.

KS: I would imagine assuring the privacy of your subjects was paramount in both *The Me You Can't See* and *Trapped* in particular. How did you and your crew accomplish that?

DP: For *The Me You Can't See*, we had unbelievable story producers. And they really are the heart and soul of that series. They would source the characters, they would find out their

stories, make the initial approach. ... And so by the time we got to do the interviews, the trust they had with our story producers transferred to us. We also had advisers who we then made available to the subjects, mental health professionals if they wanted that, because sometimes talking about your issues raises your issues for you. And we didn't want people to go back and have no resources once they opened up to us. You also have to have the right cinematographer and crew. In *Trapped* we had a sound person who was used to doing reality TV and we sent him home because he was looking bored, when people are telling their abortion stories. And I was like, "Nope, you gotta go home." I'd just camp out [at the abortion clinics]. And some days no one would talk to us and it was just like sitting in the room. And then some days we'd get three people who wanted to talk to us. So what I would do there is say who I was, that I'm here with the camera and they absolutely would not film even a person's foot if they didn't want it. If people were interested, they could send a note to the nurse. And they could talk to us. What really was effective, though, is when the clinic owner and the doctor would come out and say, they're doing this piece, if you're interested, either full face or they can obscure your identity, it would be really helpful. And a lot of times, this was the first time that the women heard about the political battle in Washington. They did not know that the laws were about to change. They didn't know what the doctors were going through. And then there was just one time when this man, a father there with his daughter. And so I went over and I was like, "Would you like to talk to us?" and he's like, "Oh, no, but I agree with everything you're doing!" No means no, you know. I didn't ask people twice in the abortion clinic. And in other circumstances, you do try and get people to talk to you. Not in a clinic; not on something that is a tough day for somebody.

You also have to follow instructions. In *Gideon's Army*, we're in Alabama, the reddest of the red states. And I'm looking to make a criminal justice movie. And so I actually filed a motion—it's good to be a lawyer. We had an open argument. The prosecutor opposed it, and the judge said, "I think for the administration of justice, it's important for people to see what happens here."

So that was good. And then he was like, "Here's all the rules. Only three of you: me, sound, camera. You have to stay in like a three-foot area right over there and 'If I say turn the camera off, turn the camera off.' And I was like, "Yep!" We were playing a long game. By the end of it, we had four cameras in that room, we had a microphone on his desk and a microphone on the defense table. It was because you don't have to be tricky with people to get what you want. You need to respect their circumstances.

Our job is about relationships, it's a relationship with your subject. And sometimes I put stuff in that people don't want. And I have to know that they're going to be mad at me after because the story that you write in your life about your life is not the story that everybody else sees. And so sometimes you don't like what I see. So that's part of the job, too.

KS: Many of the directors we have spoken to for this book primarily make movies about women but have teams and colleagues of many genders. You made documentaries about all kinds of people but your company, Trilogy Films, is entirely staffed by women.

DP: I do have a great team. And most of us have worked together for a really long time. And I'm not opposed to men. We work with all kinds of people who are here for one project then go away. It's just the people who stay have been female. I want to work with people that I really love and trust. And I want to know that anybody who's representing

me to anybody, that they are going to treat any subject with the same amount of respect that I would, and so those are the people who I would trust with anything. I would trust them with a person who feels suicidal. What we do, there's a big responsibility to it. We're not extractive filmmakers. We're not looking to take, take, take and leave you behind. You kind of have to be on board with that as your philosophy. And that has ended up being primarily women. We have a few men, but we don't have a lot.

KS: The crew for *Red Summer* [about the legacy of the 1921 Tulsa race massacre] was the biggest you'd ever had. What was that like for you as the hub at the center of that wheel?

DP: I think, at this point in my career, I'm very certain about what I want to do, and about who I want in the room. I know what I need to get what I need. But I actually do really like bossing people around now. I'll walk onto a set. Invariably, there's some White dude who walks by me until they realize I'm their boss. And it used to annoy me. And now I just think it's funny. I just wait for the like realization to kick in, and like how much nicer they are to me when they realize I could send them home. I don't worry about that stuff anymore. And that just comes with confidence and knowing what you're doing.

I tend to shoot with the same people over and over. And they are incredibly professional. I don't have enough women cinematographers. We're always looking for that. But even though they are men, I have some of the most caring and compassionate cinematographers who are also excellent. I did the short for *The New Yorker Presents* series based on a story by Katherine Boo called "Swamp Nurse." It's about this evangelical woman who's a nurse who works with pregnant teens and then stays with them for two years. I traveled with her when she does home visits. And some of these houses are really—there was one house with a lot of fleas.... There was no indoor plumbing in one place. And in one girl's house, and she was a girl, she had a two-year-old, and she had almost no furniture.... The first time her nurse went to her, she had no food in her refrigerator, and she was walking to work and she was six months pregnant. And if she didn't work, she didn't eat, because she didn't have enough money for food. So [our cinematographer] Keith is shooting this very emotional day. And then he gave me an envelope the next day and he was like, "Can you give this to her?" He was leaving; I was staying for another couple of days. And he'd given her, like, $100. But he had also given her a card that says, "Thank you for sharing your story. I believe that you can do this." To me that just says everything about him. He wanted her to know. He wasn't just observing. He was really listening. But he also wanted her to know he believed that she could do it. That's what you want. So I would send Keith anywhere because I know he always gets the goods, but you don't get that kind of great interview unless the subject feels like the person filming is a good person.

KS: One question I like to ask documentary filmmakers who I think are familiar with *Paris Is Burning* [a 1990 documentary about drag ballroom culture in New York that is now in the Library of Congress's National Film Registry] is that I like to believe that every documentary maker exists in a continuum of other filmmakers who came before and who will come after, or will come after. In that spirit, who are the mothers and fathers of the House of Porter?

DP: Oh, gosh. I mean, definitely Steve James [director of *Hoop Dreams*]. And Barbara Kopple same thing. I think just the way she just lives with her subjects really influenced me. And it's Madeline Anderson, who was the first Black woman to make these observational

140 Break the Frame

documentaries. I had the opportunity to be on a panel with her and see her work. And it was just so gratifying to know that she was there first, making her way in this very White world, this very male world [Madeline Anderson's 1960 documentary *Integration Report One* is recognized as the first American documentary feature directed by a Black woman. Her 1970 film *I Am Somebody* is a 2019 addition to the Library of Congress's National Film Registry].

KS: So much of your work, in addition to being about what it means to be an American, is particularly timely now because it's about reckoning, reckoning with our history and who we are, and who hopefully we can be. And it's not just *Red Summer* [which centers on a mass grave found in Tulsa just before the centennial of the 1921 race massacre that may contain some of its victims]. All of your movies are to some degree about being honest with our own history as Americans.

DP: To me, those are the most interesting stories, because I think we do live in community and we need community. And if we're going to have that, we have to have a strong foundation. And to have a strong foundation, you have to have honesty. And so I think a lot of what I'm trying to do is help us to get to a place of honesty and authenticity, and without being didactic. If you really want to talk to somebody, you can't shout at them. So I'm looking for those points of understanding, and a lot of that is trying to address my own limitations and biases. I just assume if I'm prejudiced in some way somebody else probably is too. So maybe I'm kind of more than thinking about fixing somebody else, I'm trying to fix myself. It's kind of like my reckoning with myself, like, "Where am I giving people a pass? And why am I doing that? What mythologies do I want to hold on to? And do I need them?" Sometimes you do. Sometimes you need your heroes to be perfect. But sometimes you can take them being flawed and still recognize the value they've put into the world. I think that's part of growing up.

KS: Is this why, in your films, there always seems to be one question for your interview subjects that's you speaking on camera?

DP: No! I fought against that so hard. But sometimes it's just the right thing to do. So I've kind of relaxed my rule about that. I really tried to avoid it. I'm not a person who wants to be in my movie. I'm much more interested in centering my protagonists. What am I connecting with in all of these people? What part of Bobby Kennedy is me? Did I need somebody to help me change? What would that feel like? What would I do if confronted with somebody who was vehemently disagreeing with me? Would I change?

KS: *Red Summer* comes about with the unearthing of those graves and also the one hundredth anniversary of the massacre in Tulsa. *37 Words* celebrates the fiftieth anniversary of Title IX. But on the whole you do not make documentaries to be newsy and buzzy. Your work has a longer arc of history and timelessness.

DP: I think there is a long arc to this story when the conversations that you're having today are underpinned by what happened before. *Trapped*, the abortion film, is probably the exception to that. That was unfolding in real time. And it's really hard to do that in a long-form documentary because you can't be everywhere. But the other thing is, you don't really have perspective. So, you know, when I made *Trapped*, we thought that was the

end of the story. And now I'm back filming with those same clinicians because clinics are closing.

KS: If you're cognizant of history, you can make a movie that doesn't have an obvious hook, seem present or contemporary.

DP: It's harder because it's about the deeper story—not, you know, what are the twists and turns of the surprise of tomorrow? You have to find that deeper story.

Tiffany Shlain (b. 1970)

Films Mentioned
Connected (2011)
The Tribe (2005) (short)
Life, Liberty and the Pursuit of Happiness (2003) (short)

Television Mentioned
The Future Starts Here (2013–2014)

Books Mentioned
24/6: The Power of Unplugging One Day a Week (2019)

Tiffany Shlain's documentary filmmaking and visual art lives at the intersection of technology and its mysterious relationship with our collective humanity. In 1996, she founded the Webby Awards, aka the Oscars of the Internet, at age twenty-six. In 1999, two young men arrived at the ceremony to receive their award wearing Rollerblades and metallic capes. They represented an even younger internet concern called Google.

Shlain returned to full-time filmmaking after selling the Webbys a decade later. She has since premiered four films at Sundance, including her 2011 feature *Connected: An Autobiography about Love, Death and Healing*, about the death of her father, the writer and surgeon Leonard Shlain, and the early moments of her own family. The US State Department selected *Connected* in 2012 to be shown at embassies around the world.

A combination of narration, animation, shot and found footage, a Shlain film is the multiparent child of nonfiction cinema, the video essay, the slide presentation, and the documentary genre of trying to tell a story where an idea, as opposed to a person, place, or thing, is your main character. Those ideas will often start long before we as humans do, but quickly catch up: Put another way, a Shlain movie usually begins with ideas bigger than us but always ends up at our progress as a species. Or at least our best efforts at something like progress.

The youngest of three children born and raised in the San Francisco Bay Area, Tiffany Shlain is a graduate of UC Berkeley, where she gave the 2010 Commencement Speech (included on NPR's list of the Best Commencement Speeches ever) and the author of the 2019 bestseller *24/6: The Power of Unplugging One Day a Week*. The centerpiece sculpture of her inaugural art exhibition *Human Nature, Dendrofemonology: A Feminist History Tree Ring*, presented by the National Women's History Museum, was installed on the National Mall in Washington, DC, in November 2023.

Emmy nominated for the AOL series she created and hosted, *The Future Starts Here* (2013–2014), Tiffany Shalin's documentaries have been honored at both the Tribeca Film Festival and Sundance.

I spoke to Tiffany Shlain at her home in July 2018 and her studio in December 2023.

Kevin Smokler: I hadn't realized until I was prepping for our conversation that you and I had *Baraka* [a 1992 nonverbal documentary featuring the world's great natural wonders and scenes of religious worship around the globe] in common as a favorite movie of all time.[7]

144 Break the Frame

Tiffany Shlain: That movie is so important to me because I think it was the first movie that told a story and kind of a visual rhythm without narration. And as someone with a background in experimental filmmaking, it was such a powerful language of these kind of image matches that were telling these larger stories of society and humanity and nature and I just loved it. Its visual metaphors and visual links just really had a profound influence on me.

KS: *Baraka* is technically a Sufi word meaning "the essence of life," but thematically, it's a movie about wonder and awe. And I see in so much of your work—and this is not just your movies, but this is your artwork too—awe and reverence for the sort of size and scope of our planet and our human experience. How does this fit with the idea that the human experience is also a very important one? And we're all kind of tied together. Because the big coffee table book of the works of Tiffany Shlain has one half that is about how small we are here on planet Earth and another about how important we are to each other.

TS: All my films really start from far out. Almost all my films start in space and move in. And then a lot of these sculpture timelines I am working on now, which I very much look at these timelines like films, it's like a film in a three-dimensional piece of wood [the centerpieces of Tiffany Shlain's first art exhibition were tree rings etched with a thousands-of-years timeline of the history of women's rights] because I'm into time and scale. I think it's about the importance of getting a different perspective. The last few months have been very hard but I do believe in humanity. The other thing that these timelines, when I go back very far in history and all of my documentaries do, too: If you go very far back on any issue, you will see that we're moving forward, whether it's women's rights, Jewish rights, LGBTQ, disabled, African American rights, one hundred years back on any one of those issues, we are moving forward even if it doesn't seem that way. And it's a lot of two steps forward, one step back and all that, but ultimately, in the big scheme of things, we are moving forward. So that gives me hope that we're evolving. That feeling of believing in humanity—I think that is a fundamental part of *all* of my work.

KS: You grew up, went to college and now live in the San Francisco Bay Area. Is there something about your story that entails not going far from home?

TS: I always imagined I would end up in New York, actually. And I love New York, but being in the Bay Area and both making films and then utilizing all of my work with the web and combining those two together to make social change feels like such a perfect sweet spot for me.

KS: It sounds like you consider part of being here as a filmmaker as occupying a spot on the timeline of history of Bay Area filmmakers. You've mentioned several of them as your heroes and inspiration.

TS: The Bay Area has a very strong documentary community . . . and the fact that technology is so integral into my films, both as a subject and a way that I use them, it's kind of a perfect place for me to be and create.

 We're Jewish, but culturally. My father was atheist agnostic, but the thing we did every week without fail was go to the movies and then go to Chinese food and ice cream afterwards and use the film we just saw to really discuss the meaning of life. That was like our scripture, our visual scripture, and if you think about the movies from that era, it was everything from Coppola, which I mentioned, to *Star Wars* to Woody Allen's *Annie Hall*. And then as I got older, I studied film theory at UC Berkeley, and I was exposed to the experimental filmmaker Maya Deren, who was a huge influence on me . . . just the way she went completely outside the system and would show movies in her Greenwich Village

apartment, and is considered the mother of independent cinema in America. And then as I'm older, Agnes Varda [the late French director whom Martin Scorsese called "one of the gods of cinema"[8] and the only female director to win an honorary Oscar] is a big hero of mine.... I also look at couples for inspiration since my husband, Ken Goldberg, who is an artist and professor at UCB and I have cowritten scripts and collaborated on art installations. So I look to everyone from Laurie Anderson and Lou Reed, artists that I admire for both what they create and how they live.

KS: When did you get your first computer?

TS: I got a Mac in 1984. My parents had just gotten divorced and I would escape into my computer to get out of my reality. I used to have a modem and all I could do was connect to the library, but it was still very exciting at the time. I cowrote a proposal in high school called UNITAS, which stood for United Nations in Telecommunications and Software, about how computers could unite the world and exchange ideas and all that stuff. I went to the Soviet Union as a student when I was eighteen, before I went to Cal, and no one had personal computers over there and then came back to Berkeley pretty deflated that it was gonna be a lot longer until the computers were gonna create an infrastructure to support that idea.

Graduated from school and while working on my first film, I would run into debt and then work in the CD-ROM industry to get out of debt. So I went back and forth and back and forth, and then I worked for Industrial Light and Magic [the special effects company founded by George Lucas during production of the original *Star Wars* in 1975] in Hong Kong and, again, getting out of debt. And then I was working on a CD-ROM for Sting, and someone said, "You have to see this thing called the web." I was like, "Oh my God, that was that thing I was talking about" and shortly after that I started the Webby Awards. I was twenty-six years old. Four years after college.

KS: Was there a moment when you were like, "Oh, wow, I'm onto something here?"

TS: Yes. When I started the Webbys, I also had just applied to CCA [California College of the Arts, in San Francisco] for graduate school as an art student.... Got in literally right as the Webbys started, and when the first Webbys happened in 1997, it was packed and there were TV crews from around the world. I was like, I'm gonna treat the Webbys like my art school. And the web is about to take off, and I want to help this nascent medium and kind of channel all my creative urges through the Webby Awards, and I made a lot of films for the Webbys.

The Webbys are now owned by an organization called Recognition Media, and they have many award shows, but the Webbys are their crown jewel. It's great. It's an interesting process of creating something and then letting somebody else run it 'cause I wanted to go back to filmmaking full time. The Webbys was this incredible decade-long journey, but my first love, what I wanted to do was filmmaking.

KS: How is your career as a filmmaker different if had you never founded the Webbys?

TS: Women that I know in Hollywood ... they're either fighting a system that was built for men or trying to recreate it, but I have always been outside of the system, which I love. That's what the Bay Area's about to me, create your own system. As Buckminster Fuller said, why fight systems, just create new ones, and I feel like my work with the web has allowed me to really experiment with the distribution and engagement and the global aspect of it, so I feel grateful.

KS: For someone who has always made movies about technology, I think we're at a moment of reckoning for what we've built and what it will become. What's that like for you?

TS: The disinformation spread on social media scares the shit out of me. But technology like Marshall McLuhan [the Canadian philosopher who coined the term "global village" and the slogan "the medium is the message"] said, it's an extension of us; it's not separate. And we are good and bad and everything in between. Even with ChatGPT, I actually do use it a lot. I brainstorm with it. It is an extension of us and we need to keep directing it for good because it is also going to be wielded for bad, and this is the struggle of human nature. It's not going to go away. And we as humans are driven to create and to keep creating new things. And that manifests in technology. I use it in a creative way. I love using it.

KS: Your movie *The Tribe* [2005], which you directed and you cowrote with your husband Ken begins with the true story that Barbie [the doll] was invented by a Jewish businesswoman named Ruth Handler. It was the first I had heard of that, but it also meant I was prepared for the appearance of Ruth Handler [played by Rhea Perlman] when she shows up in the movie *Barbie*. Take me through when *Barbie* becomes the biggest thing in pop culture. Do you and *The Tribe* enter that fray?

TS: I remember reading that that movie *Barbie* was going to come out and thinking I'll re-release *The Tribe* when it happens. But then it kind of snuck up on me. And then all these reporters started writing to me that had been very influenced by *The Tribe*. I did around three interviews right in a row that were asking me, "What do you think of this in relation to the Barbie film?" and I hadn't seen the film yet. And then I thought, "I'm going to re-release *The Tribe*." It was exciting. Many people wrote to me, "You were ahead of the times. You were playing with this idea so much earlier." And, then, I really enjoyed the movie. It had been so long, especially with Covid, that a film felt like an event and everyone was excited. And listen, if a film gets people talking about patriarchy and feminism, I'm all for it.

KS: In watching your films it really seems that *The Tribe* and *Life, Liberty and the Pursuit of Happiness* [a 2003 update of a fifties educational film about the erosion of reproductive rights in America] are kind of a pair, in that they are both a different narrative form inside a traditional documentary. *Life, Liberty* is a send-up of an educational film. And *The Tribe* feels to me almost like a legal argument. Maybe it's because in *The Tribe* the narrator is not you.

TS: Well, that was a really interesting term because with *Connected* [2011], it started where Peter Coyote [aka Julia Roberts's legal colleague Kurt Potter in *Erin Brockovich* and the narrative voice of both Olympic and Oscar ceremonies] was narrating it. And the movie was very intellectual about the history of civilization and connectedness, biologically, politically, technologically, scientifically. And then in the middle of the movie, my dad got really sick and I thought, how am I making a movie about connectedness and not dealing with emotional connection? And I remember, I'll never forget, I was just about to turn forty. Sitting in the editing room, the film totally didn't work.

KS: You were how far into shooting it at this point?

TS: I'd been working on it for around two years. And it wasn't working, and I was like, "I think I need to narrate part of this movie." Eventually, I narrated half of *Connected*. So the film is between me being the narrator and Peter being the voice of God, and then my narration being the emotional connection to the viewer. And now I can't imagine it any other way. First of all, I was a woman and as a feminist, why was I having a man narrate my thoughts?

KS: Even someone you knew and had collaborated with.

TS: Exactly, because in all these studies, people believe the male voice more. Well, fuck that. Why not give a strong authoritative woman's voice perspective on it? So that was a big awakening for me, literally finding my voice. Secondly, I realized the personal connectedness with the viewer at the beginning of the film was so important and powerful. If you watch my films, I will appear at the very beginning, somewhere in the middle for a little bit, and somewhere at the end. And it's like this connectivity that I really like. And also making documentaries, it removed me from having to act objective, which no documentary is even though you're supposed to pretend to be objective. It liberated me to be very clear, that this is my perspective.

KS: The long arc of time seems to be something you're very interested in. And you not being in every single minute of the film pays respect to the size of the subject being much bigger than any of us.

TS: Absolutely. I'm just giving you a reference point, like this is my perspective, my vantage point from where I sit. As a Jewish woman in the twenty-first century, and my films always go back in history. . . . And then, I usually show the wrestling and then hopefully at the end, what could this be? I end a lot of films with questions. I also end with space to "What can you do with this information? Or this idea?" I've always looked at the films like the appetizer and the discussion you have afterwards with your own friends and family as the main course. A discussion kit that goes with the whole movie, so it's like this full experience. The movie is your emotional journey, and then I'm gonna provide a whole bunch of materials to go even deeper on your own.

KS: Was there a recent moment where you were like, "And now it's time to make sculptures." Did the idea shake you awake in the middle of the night?

TS: I've always viewed my work as very much on the edge of the art side of things. The *Dear Human* show that I did at MoMA in New York I called "spoken cinema," or a live documentary experience, was a big bridge in terms of moving from the film world more into the art world. MoMA premiered it February 15, 2020.

KS: Uh oh.

TS: So then I thought, "This is going to be it. I'm going to travel and do these live spoken cinema performances." And then the whole world . . . stopped. And I thought it was really interesting that everyone at the same moment was asking these very profound questions that we usually only address when you think you're gonna die, things like "What am I doing with my life? What matters?" I grew up near Muir Woods and would go there a lot and was so impressed with the tree ring slice at the entrance, the idea of going back far back in time and what the trees had borne witness to. And on these walks I was bringing home pine cones and sticks, and then I started making sculptures from large pine cones and tiny figurines, and then I started photographing them and then turning them into photographs and light boxes, which feels very cinematic. And then blowing them up and making the scale really big. And to me they're—these are like frozen moments in cinema, like a portal into another world.

I remember when it hit me: I'm going to do a feminist history tree! And I'm gonna find the biggest piece of salvaged wood I can, and it was one of the most satisfying things that have made—I've made so many films on feminism, with all this research, and to try to distill it down into thirty points [on the tree ring], going back fifty thousand years and starting with when goddesses were worshiped in almost every ancient civilization because that's such a better place to start the story then where women normally started,

148 Break the Frame

which is like, we're behind, we're trying to get power, so let's start where we are most revered. That goes back to filmmaking. It matters where you start the story. So these tree rings in some way are, like, really using a lot of my filmmaking thinking, but just in a three-dimensional way. Next I'm going to embed a project a film onto a tree ring. And to further this idea of what trees have borne witness to, so I'm gonna do this kind of *Baraka*-inspired experimental film on it . . . with a feminist lens, and have that on the tree ring.

KS: Your work, to me, feels like this four-way mixture of documentary, video essay, art installation, and one-woman show.

TS: I love that! I mean . . . just knowing what you heard, that I applied to art school and that I'm doing spoken cinema and that I'm normally in the documentary world, but I've never made traditional documentaries. When people ask me what kind of films I make, I say documentaries. But they immediately think of talking head interviews. Creating the live theater experiences for the Webby Awards, films, sculptures, art installations, they are all very interesting different mediums for me. What I came to is that I'm an artist who has different mediums to communicate different things. All of the work is wrestling with ideas. And sometimes that comes out in a book or a film or a sculpture.

KS: *Connected* seems to be an earlier point on your own timeline as an artist where things change. May I ask you about that?

TS: *Connected* premieres at Sundance, and then it gets distributed. I think it was ten cities in theaters. And then after that it's on iTunes and all that, and then Netflix, but it's exhausting for me, the amount of work—every weekend I was away. I was flying to another city and I'm doing all this press to get people into a movie theater. So all my energy is going towards "Hopefully it'll be in this article leading someone to go to this particular movie theater." And that film, it was both emotionally exhausting to make the film because of the subject of losing my father, and then a huge amount of work for the launch of the iTunes and educational markets. And as I got older, it's like, what's my real goal here?

KS: It does raise the question of why one makes movies in the first place.

TS: When I get asked to do something I really like, how do I do this with the limitations of not interrupting my family life and my marriage? My relationship to Ken is so important to me as well as being a present mother to our daughters. I think what's so exciting about films is they are such an additive thing. You can collaborate with so many people that might have a skill that you don't have that everyone's bringing something powerful. Everyone on your team, they're bringing their creativity in. You have this one vision that you['re] focusing and then it shows on the screen and then everyone in the theater is bringing their own perspective and they're gonna be watching completely different movies based on what their own life experiences.

KS: How do you see yourself as a creative person, before the implementation of Tech Shabbat [the idea of turning off all technology from Friday sundown to Saturday sundown codified in Shlain's 2019 book, *24/6: The Power of Unplugging One Day a Week*] and after?

TS: Ken and I both started implementing Tech Shabbat, a day without screens, with our daughters in 2010. It gave me the perspective and clarity all the distractions from technology was taking away from me. I do my best thinking on Tech Shabbat. In a world that's so noisy, and everyone's online all the time, even me, that when I have that day off, I just feel like I think differently. I'm more creative and more grounded and more thoughtful. I hear an inner voice. I hear bigger thoughts. The work got so much better after Tech Shabbat. I think because I made this space to think deeper and broader. Because when

you detach from the network, you see things you can't see when you're constantly plugged into the network.

KS: The commencement speech you gave in 2010 at your alma mater, UC Berkeley, was named one of the best commencement speeches ever by NPR. I know it wasn't yesterday, but do you have any sense memory of May 16, 2010, or even a specific moment or two you can tell me about?

TS: I was so nervous for that speech. I had just lost my father. I had just had my daughter. I was being asked by my alma mater, "What have you learned so far?" And it felt so big, like, "What do you have to teach the next generation?!" I worked so hard on that speech, and I normally use visuals in my speech, and I wasn't able to here. I did a short film at the end, but the majority of the talk was me speaking without any visuals. So my normal visual component was not with me. And then right before I went onstage, I had something happen that's never happened to me before: I got dry mouth. All the moisture from my mouth went away. And I was in the front row in front of twelve thousand people. I was like, "I need some water. I need someone to help!" I didn't realize how much the lubrication in your mouth is critical for speaking. Thank God Ken was able to get me a bottle of water right before I went onstage. I just remember standing there and I felt like it was one of the most important things I've ever done. And I was just totally present and in the flow and had fun with it. And the response was so amazing. And it was just an incredible ... an incredible feeling. And I have so many people that come to me and say, "I was in that auditorium! I was graduating then! I was a parent of a graduate then!" I'm so glad I did it.

Who was it—Dorothy Parker?—who said, "I hate writing. I love having written." I love having done that speech! Being fifty-three, I'm so glad I've done so many different things. And some things I'm glad I did. And maybe I'll do them again. But maybe that won't happen again. Just like the same way I feel like there's so many places I still want to go. So part of me is, "I would love to go to Italy again. But I haven't been to India and who knows how much longer we've got?" I have a process I go through on any project, whether it's making a sculpture or having my artwork installed on the National Mall or creating the Webbys or a making a film. They are all creative mountains I both make and then climb. I really do like to both envision very complicated, creative mountains and then climb that mountain. And then once I climbed it and I looked around, and I was like, "This view is beautiful from the top."

KS: I think it was Toni Morrison who said something like picture yourself, successfully creating—what does it look like? And most people answer that by saying, "Oh, it feels like ecstasy" or "It feels like serenity." And then Toni Morrison clarifies and says something like, be more specific. What are you wearing? How tall is the table? Where does your chair feel like? What music is playing? It's an abstract question that Dr. Morrison correctly identified as needing a tangible answer. I am sure you get asked this, particularly by young people just starting out.

TS: I literally want to walk them through my process. This will be the subject of my next book. I do have a process of when I have an idea, then all the stages I take it through. Right now I'm in all my documentation phase from DC. You have to document what you just did. It's just as important. So there's always steps. And one of the first steps is how do you even create space for creativity. This studio, I think, represents that. Because I always have had film studios. And my film studios were always made for the many people I collaborate

with. We always had staff and teammates, and even the Webby Awards were very creative offices and fun. But what I love about this space is I feel like this is like a sacred space that is for just for me to create. It's actually not. I have enough space to bring people in on projects. But this to me feels like . . . I think that's why the studio means so much to me, as it's so inspiring. And it's so peaceful and it feels it creates space for being creative.

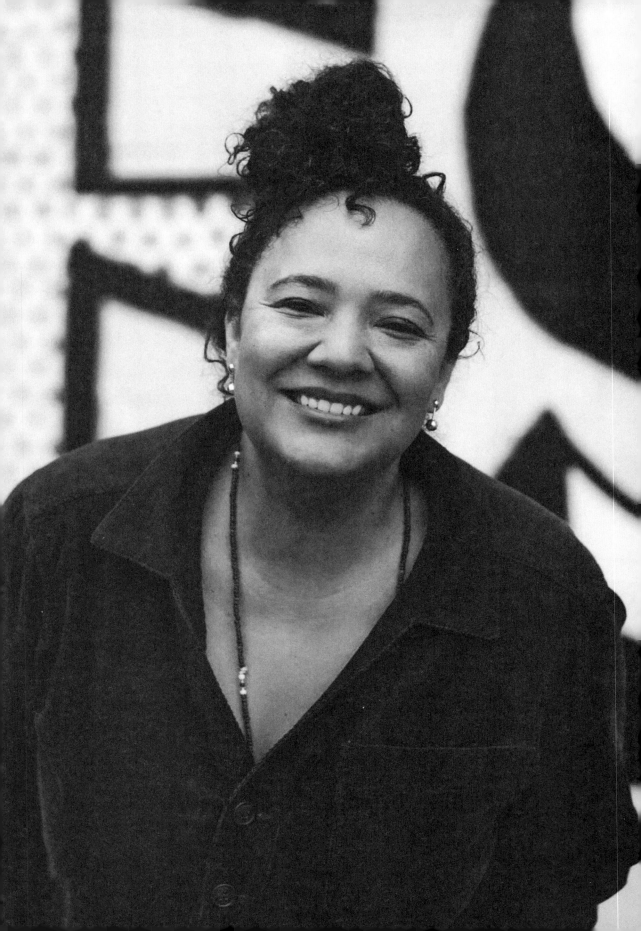

dream hampton (b. 1972)

Films Mentioned
Freshwater (2022) (short)
It's a Hard Truth Ain't It? (2018) (executive producer)
Treasure: From Tragedy to Trans Justice. Mapping a Detroit Story (2015)
An Oversimplification of Her Beauty (2012) (executive producer)
I Am Ali (2002) (short)

Television Mentioned
Finding Justice (2019)
Surviving R. Kelly (2019)

Books Mentioned
Decoded (2010)
The Black Book (2006)

Detroit's dream hampton (the all lowercase is in tribute to one of her chief influences, the late author and scholar bell hooks) is in her second career of greatness. A graduate of New York University, she became a pioneering music journalist in the early 1990s—writing for *Vibe*, *The Village Voice*, and *Essence*, and served as photo editor of *The Source*—as hip-hop was transforming from a regional to global cultural phenomenon. Hampton could write about hip-hop with the icy precision of Joan Didion and the linguistic flair of the music itself. She loved it, befriended it (her review of Jay-Z's first album led to a friendship and ultimately hampton cowriting his 2010 autobiography *Decoded*), and at the same time demanded it live up to the greatness it proclaimed by not leaning on misogyny and greed as a crutch. A 2023 profile in *The Atlantic* called her "hip-hop's fiercest critic."[9] The same week I read that profile, writer-director Felicia Pride during her interview for this book echoed a generation of artists raised on hampton's essays, reviews and profiles: "dream hampton is the GOAT (Greatest of All Time)."

As a director and producer, dream hampton would bring this standard of integrity to her filmmaking, which she has said repeatedly is her true home as an artist. Beginning with her 2002 Sundance short film debut *I Am Ali*, her body of work has looked unblinkingly at the America we have and said, "We didn't end up here by accident. We chose it and can choose differently." The 2019 Lifetime series *Surviving R. Kelly*, for which hampton served as executive producer and showrunner, is widely credited with bringing R. Kelly to justice after decades of sexually preying on underaged girls.

In 2019, *Surviving R. Kelly* received a Peabody Award, and dream hampton was both honored by the Ms. Foundation and named one of *Time* magazine's 100 Most Influential People in the World. Her films and television projects have also been nominated for Emmys and International Documentary Association Awards.

I spoke to dream hampton in July 2022.

154 Break the Frame

Kevin Smokler: You are the first filmmaker I have spoken to who is also a native Michigander. I feel a little neglectful that I am not sipping on a bottle of Vernors while we are having this conversation.

dream hampton: I love Vernors!

KS: Me too! I look at how many of your projects came out in 2019. I can only imagine what kind of a year that was for you.

dh: (*Laughs*) What kind of year 2018 was for me! You know the thing about the business is that only one of them hit. I got to go to great places like Cannes because of *Surviving R. Kelly* but it was a lot of energy. And then the pandemic happened! So I'm having all of these meetings with people that I've probably been wanting to meet with for fifteen years, and now they want to meet with me. But nothing is happening. And all of that made me say, "Well, what can you do? Like, what do you love about film? Can you gather a couple of friends together and make these two short films and just remind yourself of what you're doing?"

KS: Although *Surviving R. Kelly* had several producers, you are the public face of the filmmaking team behind the series and the one who has interacted most with the press.

dh: I think the publicist told me, "You did 113 interviews." I said, "Oh, it felt like 500, but I'm so glad that's over! I have nothing new to say!" I'm not a carceral feminist.... Police and the courts and jails harm women all the time. So to me this outcome, if the survivors feel some kind of ... if it feels a bit like justice to them, then that's a good thing, right? At the same time, I know, having talked to all of them, that had he really entered a restorative justice—I don't want to say negotiation—but had he entered a process of restorative justice, which first comes with an acknowledgment of harm, which he still hasn't done, and includes things like financial compensation—these women all need therapy, their lives are all destroyed by this man—that would have meant so much, to not just them, but to the culture at large. We have not really had someone accused of crimes at this level take responsibility, and I don't mean like taking your own life or doing a sentence, but like really taking responsibility and trying to heal the harm that he himself experienced.

The state harms women all of the time. It harmed the women and their families who tried to report R. Kelly for decades.... Police, prosecutors failed these women countless times. Sometimes it was nefarious; they moonlighted as security for him in Chicago. Sometimes it was ineptitude. Sometimes it was systemic. Well, all the time it was systemic. Jim DeRogatis's reporting begins at the very end of 2000 because a lawsuit had been filed by Tiffany Hawkins, who was sixteen.[10] An attorney in Chicago named Susan Loggans was the clearing house, basically, for settlements for R. Kelly. And the reason that these were ultimately being settled civilly wasn't because the women hadn't gone to the police. They absolutely had.

Back to *R. Kelly*. When Brie Bryant from Lifetime [told me] they were looking for an EP and a showrunner and I was on a shortlist of people at that point,[11] I said, "There's too much information out there for me to feel objective and neutral about this." I am approaching this like *Blackfish*, that [2013] documentary on SeaWorld, the way it stopped people from going to SeaWorld, or at least when they went to SeaWorld, they now had to understand the conditions.

I wanted there to be this moment that made it clear that the women who for thirty years have been accusing him of the same exact thing, themselves from different generations, so no opportunity to get their stories together, were not lying.

KS: I understand there may be a different answer to this question with you answering as a filmmaker versus answering as a person. But when the sentence was handed down, did you have a feeling of "This is the completion of a long arc of my work," or did you feel like "Some portion of some kind of my work is just beginning"?

dh: Neither. At one point, I remember one of the parents tweeted out kind of combatively that I hadn't been in the courtroom. I didn't consider that my job. You know, I had a job to tell these women's stories. A very important aspect of that was to make sure their stories made it to air in a possibly litigious situation. But no, neither of those feelings. This idea of the impact that documentary can have ... I'm still interested in hacking the production side that can make documentary so fraught.

When I did *Treasure* in Detroit, a feature documentary that premiered at the Los Angeles Film Festival, about a trans girl who was coerced into becoming an informant, on the spot, once she was arrested over a petty kind of drug—for smoking a blunt—and threatened with being put in a men's prison or giving up the drug dealer. Days later she was found hacked to pieces.... Her drug dealer and conspirator, a codefendant, were sentenced for that. And one of the reasons I didn't approach that project like a true crime was because even though these two men were in a Michigan prison for her murder, no one had held the Macomb County Police Department responsible for the role that they played in her death. Sarah Stillman wrote about it for *The New Yorker* even before I began filming.[12] When *Treasure* came out, it didn't have some big impact. If 13 million people saw *Surviving R. Kelly*, maybe 130 people or 1,330 saw *Treasure*. It still had this impact of a civil suit being settled—I don't say as a result of that documentary—but as a result of a kind of a relentlessness between Sarah Stillman, myself, her own family's self advocacy, a relentlessness around storytelling.[13] So this power of narrative I don't think can be undersold.

The same thing happened, by the way, with the BET project we did, *Finding Justice*. One of the episodes was about high school students in LA, Black and Brown, being made to feel like prisoners every time they went into school, all of this connected to a gun falling out of a student's backpack in 1992. Students in 2018 were having to undergo basically airport security and random searches. And so we filmed this meeting, this contentious meeting that the parents had with the school board president, and he failed! ... It was such a "gotcha" moment, the things that happened on that board.... We also we also captured Stacey Abrams having the gubernatorial election stolen from her. And we situated our police brutality episode in Minneapolis because of the murder of Philando Castile. This is 2018. George Floyd hadn't happened. No one saw this series *Finding Justice*. People beg for BET to have content like this, and it just didn't get seen.

KS: You've been making films for at least two decades now. When, in the arc of your career, did you have the realization, or the evolving realization, of the power of documentary filmmaking?

dh: I didn't set out to be a documentary filmmaker. I still wouldn't self-ID that way. I try to tell stories, period. I want to make feature films. It's incredibly hard to make films. If you're a painter, you can steal some canvases from somewhere and work to buy paint and find some quiet time. The same with being a writer. It doesn't require a lot of tools. My friend Greg Tate would always say you write with your ass.[14] Yeah, well, you make a film every time you just turn on a camera, but this idea that video is now good quality so that democratizes the process isn't true. You make films by raising thousands, tens,

156 Break the Frame

hundreds, you know, a million dollars right? Every time one turns on the camera, it costs thousands of dollars.

I was at the premiere of *Daughters of the Dust*.[15] I was a film student at NYU, and it was walking distance from my school and I was there as a friend of the cinematographer, Arthur Jafa, who has now established himself as a big-time artist.Julie Dash was outside, pacing. I told her that I knew AJ and introduced myself. At that point, I had a fledgling career as a journalist as someone who was writing basically profiles and essays for music magazines, in places like the *Village Voice*, and I said to her, "I feel like I'm derailed. I came to New York to make films. I'm in film school. I'd never taken a journalism class, for instance. But I find myself with this secondary career as a twenty-one-year-old writer." And she said, "That's not a bad thing. It takes so long to set up between projects." This was her big debut feature, and it's still kind of her hallmark film, and it's not like she's had a chance to make another. When I see people like Ava [DuVernay], and even Dawn Porter get into the game and then do that Spike Lee thing of like, "I'm just going to keep producing projects," I understand the importance of that. And when you can have the resources and find them and are doing the kinds of projects that people want to fund, then God bless you, you know?

Now this question that you're asking. For me, before there was film, before little French brothers figured out that they can refract light through this device, before we get, you know, the brilliant [Sergei] Eisenstein, before we get D. W. Griffith, we were telling stories. It's an ancient project. So I've always known.

The very first thing I wrote as a filmmaker was an article taking on Dr. Dre, the NWA producer, who's now a billionaire—everyone wears Beats headphones—who at six foot three had beat up a woman video show host, Dee Barnes, someone who was really important in the hip-hop world at that time. ... And he beat her up really badly in front of a lot of people in a nightclub. And I wrote about it, and I called him a bitch. And I took him on. And I knew then that there was power in telling a story and making a case.

KS: I look at your work in total and I do not see a filmmaker who is interested in calling attention to themselves as a filmmaker. I see a filmmaker who views themselves as kind of a node amongst other artists, and one who not only makes her own work but empowers others to do so too. I see you as the hub at the center of the wheel rather than the point of a pyramid.

dh: It's not always true. I've been both. When I did the Oscars, Steven Soderbergh was the point at the top of the pyramid.[16] He had a vision. ... It was fun to execute it for him. I was in service to him. Film sets are deeply hierarchical.

The reason that I have found myself doing documentaries is because I have cared about justice for a long time. As soon as I got to New York, I landed in one of the places where Black people were feeling a sharp and persistent and ceaseless amount of state and city terror, in the form of the NYPD, and so immediately began with my friends organizing against that state terror. So that began this three-decades-long activism, and one of the things that's been so innovative when I moved home to Detroit, around 2008, was to find this new generation of organizers and activists who were rethinking hierarchy and were rethinking what collaboration and allyship and all of these things could look like. And they were looking at emergent strategies. Met people like [writer and activist] adrienne maree brown and Grace Lee Boggs and all of these people were rethinking the actual ways that we work.[17] And I would love to say that I took what I learned from these organizers and decided, "Oh, I'm gonna try this in my art." But that's not true.

My set on *Treasure*, it was very top down. I may have had three people, whereas when you're on a production like the Oscars, you know, you're one of several hundred people. But the reason that the hierarchy works in those situations: I remember being in a night-club. We were shooting a ballroom scene for *Treasure*, and I needed someone on my crew to get [release] signatures. That was their only job, ... as we were filming people, to get a signature. They wanted to have a conversation with me about how disrespectful it was to be up in this space at four in the morning, asking people to sign, and while I under-stood that, truly and inherently—I was a straight person, my crew member wasn't—but to be there with this camera, you know, period, is invasive. It changes the room. So to ask people to sign these releases was a further disruption. At the same time, there's absolutely no reason to be there at four in the morning if we can't then use the footage because we didn't have releases signed. Either way, we weren't going to have a debate about it. I had to fire this person. So I have been both, to answer your question.

They made *Surviving R. Kelly* for almost nothing. It may have had a lot of view-ers. But it didn't air more than once on Lifetime. One or two of the episodes repeated. And that's because Always, who makes maxi pads, and Secret, who makes deodorant, they don't want to advertise with something around abuse of girls. So this wasn't some big hit for them. At the same time, they're a publicly traded company that doesn't deal with the DGA [Directors Guild of America]. So there's no director credit on this.

As to what role I played: I was hired as a showrunner and an EP. I think they never watched *I Am Ali*, they didn't watch *Treasure*, they didn't watch *Black August*. They hired me thinking I was a hip-hop journalist, something I hadn't been the whole twenty-first century. And they hired me in 2018; it's eighteen years since I had written about hip-hop. Anyway, long story long. That was its own learning curve. I had never made those kinds of concessions with the studio. I've never gotten reams of notes. I lost so many battles. Nothing about *Surviving R. Kelly* aesthetically feels like me. I now understand the wisdom in what Brie Bryant was trying to do. I would have forty women saying—no, that's an exaggeration—but I had fourteen women saying the same thing. And she wanted a fifteenth and sixteenth. And it was because of that repetition, this question about who gets believed was kind of essential. We needed to stack the deck for the viewer to combat their own inherent bias against Black women.

KS: I see a common thread between *Surviving R. Kelly* and *I Am Ali* and *Treasure*. Each of those three films seems to be saying that we need to take responsibility for the toxic ele-ments of Black masculinity.

dh: In *I Am Ali*, she decides not to let him off at the end. That was a more personal film, in some ways. I knew someone, two someones, who would have total breaks from who they were. . . . But both of the people that were in my life personally were hearing auditory com-mands. And I remember thinking that—I couldn't believe how rapidly they both degen-erated from being someone that we recognized as someone who was unrecognizable. It was literally a matter of months. And so much so that Black folks, their families, we have a huge learning curve around mental illness because they're denied those services and just healthcare in general. And then we are conditioned to bear a lot of pain in this country.

One of the things that became common in my research around schizophrenia and people who heard auditory commands, it was never the voice of their uncle or their land-lord or supervisor in their building or whatever. It was always like God or Jesus. And so I was playing with this idea of Muhammad Ali, this kind of undefeated Black man icon.

I was playing with that idea of, like you said, masculinity—thank you for noticing that. Well, for me, *I Am Ali* is about this girlfriend who has to witness the rapid deterioration in a short film. It all happens in seventeen minutes.

Arthur Jafa, by the way, who shot *Daughters of the Dust*, shot *I Am Ali*. So AJ and Aunjanue Ellis, of course, who's big time and there's some really great people in that film.[18] Ishmael Butler from *Digable Planets*. Anyway, it was deeply collaborative and it was fun to get those kinds of performances from those actors. Anyway, that's a long way of saying, yeah, there are times when I've been deeply collaborative. And there are times when it's been very top down. And I prefer a hybrid of the two. There has to be order on a set! (*Laughs*)

KS: In the work of dream hampton, the question I keep hearing is, "How do we hold ourselves accountable? How do we take responsibility?"

dh: I have a little pennant in my office that says, "It can be better." And it animates, I guess, everything. I'm a Virgo. So what gets read as criticism and perfectionism from Virgos is just this belief that things can be better than they are.

I think that Grace Lee Boggs helped me to understand some blind spots in my worldview, around constantly focusing on systems, like we do have to turn into ourselves, like we have become a part of the system, even if that part is to be the bomb throwers and the burn-it-down-ers. The people who are resisting the system, we still, by that very act, are still a part of it. And so we have to look at the ways that we are affected by the things that we're bumping up against and to be honest about where we fail and where we come up short. I'm not bragging of firing that person who was helping me on *Treasure*. I had a tiny crew and I wish that I was a better manager. I wish I had better communication skills in that moment.

KS: Amongst other women filmmakers, who do you see as your mentors and your peers?

dh: I look at Black art in a kind of total way. And then film, I've just always loved, in the way that I love travel and food. It's woven into the fabric of my life. There's not a day that goes by that I'm not watching a piece of filmmaking, which would include television, which got really good two decades ago! (*Laughs*)

As a documentarian, in film school I really studied [Frederick] Wiseman, like *Titicut Follies* is lodged in my brain.[19] I wrote the papers about "Can one really be a fly on the wall? No, of course not." You know, our very presence again changes the thing, right? When I look at the work of someone like Charles Burnett, to a certain extent they're doing a verité that borders on a Wiseman. You're never sure if what you're watching is real life. Did Burnett just go to South Central and cast some people? Or did he just turn his camera on and get people to play with him?[20] And so those people were on my mind when I was doing stuff like *I Am Ali*. And Terrence Malick, who has my heart. Spending two or three hours to set up a shot of a blade of grass is deeply important to me. I said Black art, but in general I'm thinking about people trying to build a world for you.

KS: What is it like being based as a filmmaker in the same place you spent your childhood?

dh: Making *Freshwater* [2022], which was about my memories of Detroit, was absolutely the most personal film I made. It was about flooded basements, which means both climate and this place where we store our memories. And when those two things happen, when your basement, which is a place where you throw things, you discard things, quite frankly, becomes flooded, and things kind of come to the surface. The log line is that it's about flooded basements, memory, and my disappearing Black city.

I have a home in Detroit. I left New York after almost three decades. And at that point, I had spent more time in New York, more years in New York, than I had in Detroit. I moved to New York at nineteen and didn't leave until I was almost forty. I had left Detroit at seventeen or eighteen. When I go home to Detroit, it's right before ... again, this systemic thing, which is the unbridled greed of real estate, which of course, shows up in Manhattan before the rest of the country. But this kind of national problem that we have, where people are spending 30 percent or more of their income on housing, was just a New York way of life, right? And so it was just Christopher Columbus kind of discovering Detroit by, you know, people who could no longer afford Brooklyn, who had already gentrified Brooklyn, [who] would have been kicked out of the Lower East Side. And so anyway, long story long ... you have these silly billboards that were showing up in Brooklyn, basically hiring waitstaff at a Thai restaurant in Detroit, and they were advertising in Brooklyn. Like it became the erasure and the kind of the same oldness of my whole life of being from a city that was surrounded by hostile suburbs that acted as if we were like a blank canvas, an example of a failed state—like all of the things. The reason that there are "Detroit vs. Everybody" shirts—and they [the suburbs] the only ones that should exist—is because we are shorthand for failure. We are reacting. We're defending ourselves. My whole life made us this scrappy.... So when I got to New York and I would meet people, and sometimes it'd be exhausting White people, and they'd be like, "I'm from Detroit too!" And I'd be like, "No, you aren't. Like, where are you from?" Because if we were home, you would never say that. You would absolutely be clear that you were from Birmingham, Bloomfield Hills, or Grosse Pointe, like you don't want to have shit to do with Detroit. Of course, you know, that's me getting to New York in 1990. Now, there's a whole new generation that was raised on Wu Tang, and they didn't listen to their parents who told them that if they went to Detroit, they'd die.

So that was the Detroit I was coming home to. People discovered what we've always known about Detroit, which is that it's like one of the richest cultural centers in the country.

KS: I did not grow up in Detroit, but as I mentioned, ... half my family did. And I know I would not be the person I am had I not grown up in the radius of influence of Detroit.

dh: As much as I'm on this Ms. Detroit rant ... our adoptees are quite important. They include Stevie Wonder, but they also include Marvin Gaye, who's from DC, George Clinton, who's from New Jersey. Grace Lee Boggs is from Chicago.

KS: And Prince!

dh: Thank you for saying Prince. Because Prince adopted us! A pre-religious Prince shaped for me what was—as much as Terrence Malick, as much as anyone—it shaped my idea of what was possible as an artist.

KS: Could we talk about the influence that bell hooks and her work had on your development and growth as an artist?

dh: For sure. I encountered her work at a store in Detroit called The Shrine of the Black Madonna, where I was getting the typical Black bookstore fare. And this is the eighties. Black women were writing some of the most important fiction in the country. And by that I mean Toni Morrison, I mean Alice Walker, Paula Marshall, Gloria Naylor, all of these women who I was reading. My appetite was bottomless. In that bookstore, where I was finding all these authors, I came across bell hooks. While there was something implicit about the feminism of Toni Morrison and certainly Alice Walker, ... bell hooks was

160 Break the Frame

being explicit. The first book I read was *Ain't I a Woman?* [1981] and it was all about Black feminism and defining it, and she too had been reading the same books that I had been reading. She was young and she was incredibly prolific. She died too soon but produced an outsized body of work.[21] It changed me because it was so plain. Her arguments were just undeniable. She was brilliant and had this logic. She could just take you down the chain of custody of her brain. They were arguments that I could implement in my real world I was negotiating being, regrettably, a cis hetero woman, you know what I mean? Like, if I could choose, it probably be anything but that, but here I am, like, dealing with fucking hetero men, you know, one of the like, least interesting species on the planet. And being in relationship with them, whether it was like romantically, intimately, in our talking back to something like hip-hop, all of that. Especially her work on film and her work on visual culture and visual art. It was extremely important, her reads on people like Lorna Simpson and Kara Walker and Ming Smith and the kind of people that she was looking at. She made it important for me to also look at them.

KS: Somewhere in the back of my mind, I knew that you were intimately involved in the writing of Jay-Z's 2010 memoir *Decoded*.

dh: I reviewed Jay-Z's first album at a time when no one was paying attention to him, but I thought that *Reasonable Doubt* [1996] was remarkable. I thought his sense of spatial awareness was remarkable. All of the kind of white space that he left on a record, his economy of phrasing. And all of that was deeply interesting to me. But Jay is someone who, when I wrote about him for *The Village Voice*, he called *The Village Voice*. I don't know that there were cell phones, people might have had pagers, there definitely wasn't—email wasn't common. It's 1997. He called *The Village Voice* and asked to speak to the guy who wrote the review. And so I got this message on like a pink piece of paper, whatever the secretary wrote it on. And I called up, but I was like, "Hey, I'm the guy that wrote the review." And he was like, "Oh, you're a woman!" And I was like, "Yeah, like, I'm from Detroit. So if there's one thing I understand, it's drug dealers." From then on—and I had criticized his hyper-materialism in this review. *The Village Voice* didn't think he was big enough to get his own review. So I had to write about him with Nas; there was a double review of Nas's second album and Jay's debut. And Jay felt seen was the bottom line, and that became a friendship. It was a friendship where we would think out loud with one another. And he was an intellectual intimate of mine for a couple of decades. And then when it came time to write his first book, *The Black Book* [2006], I wrote it, and then *Decoded* [2010].

It's not a secret. He thanks me in *Decoded*. All of the press about it identifies me as a writer. But he struck a deal with Bing, a search engine that Bill Gates was trying to roll out. And Bill Gates, it wouldn't have mattered if Norman Mailer or James Baldwin had cowrote it, he only wanted Jay-Z's name on there. And it was a last-minute thing. It's not a ghostwritten book. So if you think that was just Jay-Z writing, then you'll hear all the stuff that I'm talking about, himself in third person. He's not Trump; he doesn't do that in real life. It's just that there were weird things around production. I mean, we settled things as friends, and I was compensated for that removal. And he compensated me publicly. But in terms of, like, what it takes to negotiate a principle like that and get it done, maybe that'll come in useful for me as I make a feature film.

KS: You've done animation work—you've worked with animators on *Hard Truth* and on the *Oversimplification of Her Beauty* project. Is animation a mode of filmmaking that particularly speaks to you?

dh: Absolutely. I mean, I grew up in the seventies. The seventies was a heyday of animation. *Schoolhouse Rock*, *The Electric Company*. I think that we're in a post-literate moment, just to be awful about it. And visual culture is everything, and the simpler you can make it, the better. We were lucky to get the animator [Yoni Goodman] who had worked on *Waltz with Bashir* to work on *Hard Truth*.[22] We were dealing with really practical questions. We had access to the Pendleton prison in Indiana. But we wanted to tell their stories before then. And these were guys who were my age or a little younger, who grew up in the seventies or eighties. So they don't have cell phone footage of every moment of their lives. You were lucky if your parents had a video camera.

KS: I cannot tell you how much I appreciate talking to a filmmaker like you who is open about the economics and sheer practicalities of making films.

dh: I encourage you to try to get that out. I'm trying to do it with these girls. To be a filmmaker, you have to make very expensive mistakes again and again. You've got fully formed people—I think Kubrick and Malick are amongst them—but for the most part we're out here to make a bunch of mistakes, and that's why when there's someone like Jordan Peele is so exciting to me, like, I didn't love *Get Out*, but I thought that the next film, *US*, with Lupita Nyong'o was a little more interesting.

Anyway, one day we'll meet in Detroit and have Hummers, these six-hundred-calorie drinks, and we'll talk about all this stuff.

Notes

1. Kerry Doole, "The Class of 101," *Music Express* 13, no. 138 (July 1989): 40–44.
2. TIFF Originals, "Pennebaker & Hegedus | Kings of Pastry | Higher Learning," YouTube, December 13, 2012, 42:15, https://www.youtube.com/watch?v=oKQkAdMfplg.
3. Pennebaker/Hegedus Films website, https://phfilms.com/films/depeche-mode-101/.
4. Baldwin, James. *Notes of a Native Son* (Boston: Beacon, 1955), p. 9.
5. Billie Jean King, interview with Marc Maron, *WTF with Marc Maron*, podcast, August 30, 2021, https://www.wtfpod.com/podcast/episode-1257-billie-jean-king.
6. Caroline Hallemann, "*The Me You Can't* See: Director Dawn Porter on What Led Prince Harry to Go Through Therapy on Camera," *Town & Country*, May 21, 2021, https://www.townandcountrymag.com/leisure/arts-and-culture/a36453292/dawn-porter-prince-harry-therapy-the-me-you-cannot-see/.
7. Jenn Pries, "Tiffany Shlain," *SOMA*, Spring 2011, https://www.somamagazine.com/tiffany-shlain/.
8. Scott Feinberg, "Telluride: Martin Scorsese Calls Agnes Varda 'One of the Gods' at Fest Tribute," *Hollywood Reporter*, August 31, 2019, https://www.hollywoodreporter.com/news/general-news/telluride-martin-scorsese-calls-agnes-varda-one-gods-at-fest-tribute-1235935/.
9. Spencer Kornhaber, "Hip-Hop's Fiercest Critic," *The Atlantic*, September 6, 2023 https://www.theatlantic.com/magazine/archive/2023/10/dream-hampton-music-journalism-hip-hop-notorious-big/675115/.
10. Along with then *Chicago Sun-Times* staff writer Abdon Pallasch, former *Sun-Times* pop music critic Jim DeRogatis was among the first journalists to report on R. Kelly using his fame and power to have sex with underaged girls. DeRogatis's book on the case, *Soulless: The Case Against R. Kelly*, was published in 2019.

162 Break the Frame

11. As of this writing, Brie Bryant is the Senior Vice President, Unscripted Development and Programming at Lifetime Television.
12. Sarah Stillman, "The Throwaways," *New Yorker*, August 27, 2012, https://www.newyorker.com/magazine/2012/09/03/the-throwaways.
13. In the fall of 2017, Oakland County agreed to pay $1.07 million to the family of Shelly Hilliard.
14. Known as the "godfather of hip-hop journalism," the late Greg Tate (1957–2021) influenced a generation of cultural critics who followed. "We are all Tate's children," wrote *New York Times* pop critic Jon Caramanica in a Dec. 8, 2021 New York Times remembrance.
15. The 1991 film now regarded as a modern classic, written and directed by Julie Dash.
16. Activist Grace Lee Boggs (1915–2015) is an inductee of both the National Women's and Michigan Women's Hall of Fame. In a statement following her death, President Barak Obama praised her for her "passion for helping others and her work to rejuvenate communities that had fallen on hard times."
17. An inductee of both the National Women's and Michigan Women's Hall of Fame, the late Grace Lee Boggs (1915–2015) who, in a White House statement following her death, President Barak Obama praised for her "passion for helping others, and her work to rejuvenate communities that had fallen on hard times spanned her remarkable 100 years of life, and will continue to inspire generations to come."
18. As of this writing, Aunjanue L. Ellis-Taylor is the star of Ava DuVernay's 2024 movie *Origin*.
19. Since 1967, filmmaker Frederick Wiseman has been making documentaries about American institutions, including zoos, public parks, and city governments. His first film, *Titicut Follies*, about the patients at a hospital for the criminally insane in Massachusetts, was selected for the National Film Registry in 2022.
20. A contemporary of Julie Dash, filmmaker Charles Burnett's debut feature film, *Killer of Sheep*, about a working-class Black family in the Watts neighborhood of Los Angeles, was selected in 1990 for the National Film Registry.
21. bell hooks published nearly forty books of essays, memoir, poetry, and literature for children before her death from kidney failure at age sixty-nine in 2021.
22. A 2008 Oscar nominee for Best Foreign Language Film, *Waltz with Bashir* tells, via animation, the story of an Israeli soldier's search to uncover his own memories of participating in a wartime massacre of civilians.

Section 4
Directing in Partnership

*Shari Springer Berman (with Robert Pulcini), Betsy West
and Julie Cohen, Anna Boden (with Ryan Fleck),
and E. Chai Vasarhelyi (with Jimmy Chin)*

The four interviews in Section 4, "Directing in Partnership," highlight women filmmakers who work in partnership with a spouse (Shari Springer Berman, *American Splendor*, and E. Chai Vasarhelyi, *Free Solo, Nyad*), a longtime creative partner (Betsy West and Julie Cohen, *RGB*), or an old friend from film school (Anna Boden, *Captain Marvel*). The predominant theme of these interviews is teamwork, how we divide responsibilities with our creative partner, how we separate life and work if they are also our romantic partner, and how theses collaborations lead to the themes in each director's work.

Pairs of male directors are quite common, be they brothers (the Coens, the Hugheses, the Russos, the Zuckers) college buddies (Lord and Miller, the Daniels), or young industry professionals who decided to go out on their own and work together (the legendary documentary pair Joe Berliner and Bruce Sinofsky). Unsurprisingly, Hollywood has been about as open to sister directing pairs, literally and figuratively, as they have been to women directors in general, which is to say not very (female director pairs are more common in other countries). The loss of the kinds of movies those groups of artists could have made brings the same lingering sorrow as all cultural loss caused by bigotry: It falls on creator, audience, and history alike. May we cast some kind of loud wish into the near future that a Best Picture winner will soon be a movie with same ambition as *Everything, Everywhere All at Once* but directed by a pair called the Danielles?

The team behind this book and I considered this idea for a section more carefully than all the others. We did not want the idea of filmmaking partnerships to introduce male co-directors into a book about women directors, and we did not want our interviews about the gift of great moviemaking to become interviews about who should get credit for which piece of a great movie. But filmmaking is an inherently collaborative art form, so directing teams should really not be any more surprising than songwriting teams or comedy duos. And as I said in this book's introduction, the idea of a director as a lone artistic genius may have some merit when looking at themes a director returns to over a career. The idea that the director is the only one responsible for a great movie has no merit. Even if it it did, it's a prize we seem to have trouble giving to a woman director.

Shari Springer Berman (b. 1963)

Films Mentioned
Things Heard and Seen (2021)
Ten Thousand Saints (2015)
Cinema Verite (2011)
The Nanny Diaries (2007)
American Splendor (2003)
Off the Menu: The Last Days of Chasen's (1997)

Television Mentioned
Fleishman Is in Trouble (2022)
Succession (2019–2023)

On their first trip to Los Angeles after film school, writer-directors Shari Springer Berman and Robert Pulcini expected their big break to come from a meeting with a studio executive, not the inn where they stored their luggage during meetings. Their inn host, however, had a second job at the legendary Chasen's Restaurant in Beverly Hills, which was closing after fifty-nine years of serving generations of Hollywood stars, sitting presidents, and visiting royalty. The host entertained the young filmmakers with stories of Chasen's regulars and the indomitable staff that made the place special. The pair sensed a story, borrowed equipment from another cinema school, and got to work.

Their documentary *Off the Menu: The Last Days of Chasen's* (1997) won multiple film festival awards and put the Berman/Pulcini team on the map. Not long after, their first narrative feature, *American Splendor* (2003), about the life of the legendary underground comic book writer Harvey Pekar, won the Sundance Dramatic Prize and received an Oscar nomination for their adapted screenplay.

Shari Springer Berman and Robert Pulcini married in 1994 and continue to write and direct features, documentaries, and episodic television (recently the episodes "Safe Room" and "Tailgate Party" of *Succession* and half the episodes of the Hulu limited series *Fleishman Is in Trouble*). Their work has been honored with an Emmy nomination as well as a Gotham and awards from the Writers Guild of America and the Directors Guild of America.

I spoke to Shari Springer Berman from her office in New York in January 2023 and her home in the country in August 2023.

Kevin Smokler: I know you are a born and bred New Yorker. But at least three of your films are about young people who have a mythological, naive idea about what New York is and are brought down to earth by the end of the movie. What's your attraction to those kinds of stories as a native?

Shari Springer Berman: I come from such a New York family. My grandfather was born on the Lower East Side.... My dad was a New York City councilman, the year that New York went bankrupt: "Ford to City: Drop Dead!" [the banner headline in the *New York Daily News*, October 30, 1975]. So I feel like I was part of New York when it was at its darkest yet also most magical, because it was a time when apartments were cheap.

166 Break the Frame

Artists could live anywhere. So much was created, music was amazing. *Ten Thousand Saints* is set around that time. We're such through-and-through New Yorkers that "I am a New Yorker"—that is like my main identity as a human. So any story that connects to New York for some of the tangential issues of why New York is special or coming to New York as an outsider. I read somewhere that the problem with coming from New York is you don't have New York to run away to. And I always thought about that. I guess there's a part of me that always wondered what it would be like to be the person who comes to New York with all those dreams and instead of me, who grew up in New York during the lowest point. I am very much drawn to those stories.

KS: The films of Sidney Lumet or Spike Lee, those tell some very dark stories about New York. But there's also a tacit assumption in most of their movies that no other place on earth exists. New York is the stage where everything worthwhile happens. And your movies are very much about people's misplaced notions that New York can fulfill every dream you have. If their movies assume New York is everything, many of yours are about how it can't be. At least not to any one person.

SSB: I'm a huge fan of both Spike Lee and Sidney Lumet. I've also lived elsewhere on occasion and my husband and partner Bob, he was born in Queens, but his dad was in the military, and he wound up living all over the place. He is a New Yorker in spirit but actually lived in many places. So his influence on me could also explain that, seeing the world through his eyes.

We met at Columbia film school. He was moving into New York for the first time. And I was the old hat.

KS: You were falling in love with a New York rookie ...

SSB: And actually enjoying showing him seeing New York for the first time. That definitely was part of a part of our early relationship, introducing him to so many things about New York and about being, trying to be, an artist in New York.

KS: I love how much your movies are about the mythology places create, not just the three New York movies, but *Off the Menu*, the Chasen's documentary, is obviously that kind of movie too. And even *American Splendor* is a movie where Cleveland is a character, a nondescript everyplace that produces iconoclasts like Harvey Pekar. You seem to like places that have their own myth and aren't just backdrops to the movie happening in the foreground.

SSB: For years, you know, we would get scripts, and any script that people said, "Oh, it could take place anywhere!" I was generally not interested in.... I feel like where you live informs every aspect of your character unless you live nowhere and you're a nomad, in which case that's part of your character as well.

Talk about Cleveland as a place, the most amazing place to film when we shot [*American Splendor*] there. I remember sending the dailies to HBO, and they went crazy over the production design of the street, "How did you do that?" And we were like, the production designer was brilliant, but that's Cleveland, like, it's production designed already. It had such a personality, the buildings, the architecture, the way people dress, the way people walked, the way people gathered at the restaurants, the place where Harvey and Crumb go to meet. You can only find this in Cleveland. To me that's a really important part of any story.

Maybe it's because we started out making documentaries. So instead of trying to impose my vision on a place, I like to go to a place and allow it to tell me, oh, okay, here's the

Directing in Partnership **167**

beautiful detail of this city or this town, or here's what makes us so specific and so unique. I try to do that in every project.

KS: *Off the Menu* feels to me like the richest example of that. There are a dozen stories one could tell about the closing of a famous restaurant that served famous people. But the thing that was special about your movie was the focus on the staff. It was the people who worked there, not just the famous people who ate dinner there, that made Chasen's a special place.

SSB: That was the only reason why I wanted to tell that story, because I felt like if it was about the famous people, then it was about the end of the era, the end of the golden age of Hollywood. . . . But then it could have just been a little piece on an entertainment news show.

What was so engaging and so amazing to us was just the idea that these were waiters and busboys and captains and the woman who worked coat check and this was their career. They weren't like everybody else in Hollywood. They weren't part-time; doing this but going on auditions. They didn't want to be actors, they didn't want to be screenwriters. They were there because this was a good job. They took so much pride in what they did.

I felt like these were the unsung heroes of the golden age of Hollywood. So we, from the minute we thought about doing it, we were like these are the people. The stars are the waiters; the waitstaff and the crew. The movie stars are the supporting actors.

KS: Every time I see *Off the Menu* and the last twenty minutes comes around, I'm like, "I can't. I'll cry all over again." Not because a famous restaurant is shutting down but because the staff will all have to go elsewhere. It's really a movie about the band breaking up.

SSB: We were filming the last staff meeting and they just broke into "I'll Be Seeing You" [a 1938 song made famous first by Bing Crosby, then Billie Holliday]. We didn't ask for it. I would never have thought of asking for that. It just came from their hearts, and they all started singing it and it was just so perfect and beautiful and real.

KS: Your movies do a lot of this cross-pollinating of different kinds of artistic expression. You see it the way comics are represented in *American Splendor* [literally drawn on screen with the actors appearing as characters in a strip], the way paintings are represented in *Things Heard and Unseen* [a 2021 horror film where landscapes of the Hudson River school art movement are a recurring motif]. The new frontiers of television in *Cinema Verite*. Can you tell me about how you seem to view filmmaking as a kind of Silly Putty that can pick up influences from these other art forms?

SSB: I think we've kind of always had that kind of approach, which is like, what will make this interesting? Your approach can be straightforward if the material is very straightforward, but for something like *Cinema Verite*, it's about this landmark television show that was like the first reality show [PBS's *American Family* about a supposedly "typical" American family, released in 1973]. We kept looking at the great stock footage that they had of the family. And then we kept looking at *The Dick Cavett Show* from that time and we're like, this is just so great, why not find a way to incorporate it and make it seamless with the material?

With *American Splendor*, Harvey Pekar had been drawn by multiple artists over the life of the comic. And he looks really different depending on who drew. We felt like that gave us license to have handsome Harvey Pekar look different than sweating Harvey Pekar, to have so many different Harveys in our movie that were all still Harvey Pekar. Now, I might be too terrified to make that decision. To have the real Harvey Pekar narrate

168 Break the Frame

and not Paul Giamatti [who played Harvey Pekar]. But it came from this kind of can-do documentary making we did early on. That sounds like a cool way of doing it. And we didn't know better. So we did.

KS: You watch *American Splendor* and can almost hear pencil scribbles in every scene. You watch *Things Heard and Unseen* and hear the hush created in a museum around a painting in a gilded frame. Your movies show a lot of respect for the process of other kinds of artistic creation as if they are guests at the same Thanksgiving table alongside filmmaking.

SSB: We love art. We're such fans of animation and comics. We try not to do things that we don't feel personal connections to. I don't 100 percent of the time have that deep personal connection, but more often than not, I do, and anytime that we can expand our tools and bring anything from music ... Bob was a musician. Before he went to film school, he was in a band for a little bit. So ... music is incredibly important to us.... I love directing musical sequences, you know, and like, I just did an episodic of a new show for Amazon and I got really excited when I got the script because we had a big karaoke scene with live karaoke and a live band and I was like, oh, good, I love to film things with music.

KS: How does the success of *Off the Menu* beget the opportunity to direct *American Splendor*?

SSB: We have this very strange career. The success of *Off the Menu* meant we actually started to sell screenplays. And we made a documentary for HBO. But none of the scripts were getting greenlit. So we just kept at it, and one day I got a crazy phone call from [producer] Ted Hope. And he was like, "I have a project for you. It's very close to my heart. You have to say you'll do it, even if we get like $100,000. I want you to commit to doing it no matter how little money we get. Call me." It was like a dare. We called him. He said the project was about Harvey Pekar. And then he sent us a box of old *American Splendor* comics and a VHS of Harvey on the *Letterman Show*. And I have to say it was just like, "oh my God, we have to say yes to this. This is too crazy". But then Ted said, "Well, Harvey and his wife, Joyce, are very picky, and you have to meet them because they might not like you and you might not like them. So you have to go to Cleveland and meet them." Harvey told us to stay in this hotel, which he said was the best hotel in town: "It's the closest to where we live." But it was basically a place where people who were getting chemotherapy at the Cleveland Clinic stayed. It was barely a hotel. It was more like an outpatient clinic. Then we met Harvey, and he and Joyce, they had a huge fight and we were like, okay, we love you. And they loved us. And we committed crazily after that insane trip to Cleveland.

KS: *American Splendor* focuses on not only this very interesting iconoclastic person, but the creative solar system around him. Nearly all of your movies have a deep suspicion of this idea of a lone artistic genius.

SSB: Yeah, I mean the fact that we would direct in partnership means we don't buy into the lone, artistic genius myth, and believe that it's a process of a collection of many people. If either one of us had that vision, we wouldn't want to work with each other. So yes, I think we very much believe that especially film is such a group process that it's impossible for one person, regardless of how visionary they are, to pull it off without a lot of help.

KS: Your next movie was *The Nanny Diaries*, starring Scarlett Johansson, the first time you've worked with a lead actor who was kind of already famous.

SSB: The funny thing about it is we had a project that we were developing with Scarlett before *The Nanny Diaries*. *The Nanny Diaries* started and stopped a couple of times. But we had met Scarlett and just sort of hit it off with her. She was young, twenty-one, a baby.

But already post–*Lost in Translation*. And she had done a Michael Bay movie and had been working since she was a kid. I mean, she was such a pro. In the weirdest of ways, she was twenty-one, but she was like my mentor. Like she—there's so many things that Scarlett taught me about how to survive in the business. She was like this old soul with all this wisdom.

We were shooting part of *The Nanny Diaries* in the Hamptons. And so we were all out there, and it was around the midway of the shoot. And Scarlett was in this nice house and she decided to throw a party for the whole cast and crew and, like, personally went around and invited everybody: the Teamsters, the electrics, the grips, like just the whole cast and crew. So, you know, we had a great time. I felt there was no difference in the fact that she was sort of becoming a star. I didn't feel any difference between working with people who, you know, weren't as famous.

KS: *The Nanny Diaries* both as a book and as later the film adaptation you guys did, suffers from an unfair comparison to *The Devil Wears Prada* because they're both stories of ambitious young women working for awful aristocrats. But I think that's where the comparison stops. *The Devil Wears Prada* is a story about a villain that doesn't change, and *The Nanny Diaries* is a story about the redemption of the villain.

SSB: The funny thing about *The Nanny Diaries* is, although it was funny as a book, Bob and I both found that there was a lot of pathos in it.... A mother who doesn't know how to handle having a child and doesn't really know how to show love to the child is one of the saddest things. And then to be a mother and not to be able to find joy—I mean, there was something really tragic in Mrs. X's [played by Laura Linney] existence. She couldn't buy her husband's love. He was cold and absent and moving on to a younger mom—you know, a younger version of her. She tried desperately to find a way to hang on and in the process, ignore, you know, forgot about the greatest thing, which was her kid. We saw it as a tragic comedy, as opposed to a comedy with a little bit of sadness, whereas *The Devil Wears Prada* was really a satire, comedy. But in our story, we had an unloved child. There's no way that's not tragic.

KS: In order to care about the villain's story, you really have to have an actor who can work at the enormously high level that Laura Linney can. Otherwise you just want to scour Mrs. X off the screen.

SSB: That was the hardest role.... Laura is just such a brilliant actress and can give you all kinds of shades of, you know—she can be awful and yet you see underneath it as a character. Why she's in pain and why she's vulnerable.

KS: In almost all of your movies and television work, the villains are played by men and women who are routinely called the greatest actors of their generation, like Laura Linney, or Brian Cox in *Succession*, or Ethan Hawke in *10,000 Saints*.

SSB: Well, I think it's interesting because I don't see ... I was thinking about this the other day. I have no judgment of villains in any of my work. I don't see people as villains. I see them as flawed characters, Ethan Hawke in *10,000 Saints* to me is like a guy who is just trying his best to be a good person and fucking up along the way. He's flawed. He's a mess, but he wants to be better, and by the end, he kind of is better. And you know where he's doing his best, he'll probably screw up again. Harvey Pekar's a hot mess, but he's a good soul. Mrs. X is flawed. She was promised something as a young woman: If you're beautiful and young and you'll have this life, and she probably wasn't loved enough by her own parents, so she didn't know how to model that with her own kid.

170 Break the Frame

I always fall in love with all my characters in one way or another, so that I can understand what they're doing and why they're doing it, and then I don't see them as villains. I see them as flawed humans … as I try to find ways to love them and accept them and understand if they're flawed, and deeply flawed, why they are deeply flawed and try to find compassion for them.

KS: Also your villains are almost always people with a fake veneer of respectability.

SSB: *Cinema Verite* was also amazing in that way because the family that was selected, the Loud family to be the subject of *An American Family*, on the surface were the most respectable, right out of casting, you know, really good looking, wealthy. They lived in Santa Barbara. And then as they scratched the surface and started spending time, it all came undone. And all of their surface respectability led to a big hot mess. That was beautiful. I mean, they were real and they were beautiful. That's what made it so engaging. I'm always interested in getting at the truth. Maybe this again comes from documentaries, to get below the surface and see what's really what truth really lies. I feel like that is the operation of all documentary. I feel like we could do the same thing with narrative films as well.

KS: The mess of people and of life …

SSB: I love the mess. Harvey Pekar was one of the greatest people I've ever known and ever will know. He was brilliant. The most well read, didn't have a college diploma. Incredible, incredible people. But they're mad. One of my greatest moments that *American Splendor* was going into the Cannes Film Festival with Harvey walking around dressed in some rented tuxedo from some Cleveland tuxedo store and walking around the French Rivera where everybody was so fabulous, and people coming up and wanting his autograph. It was the greatest ever.

KS: I think this brings us in a very interesting way to *Succession*. Because your work always touches on power to some degree but for the most part is about people on the other end of power. What it was like to direct in a world that is all about people [or characters] with unimaginable power?

SSB: I have to completely credit the brilliance of the writing on *Succession*, which is [creator] Jesse Armstrong and his brilliant writing team, that they are so specific. They are so in control of every nuance of every character on that show that no line is thrown away. The Roys, on the surface, they're incredibly wealthy, and incredibly powerful. And underneath it, they're like, all of them—including Logan, at times—are like lost souls, little children who need their mommy or their daddy. It's part of why that show is so brilliant, because otherwise you couldn't watch it! You'd be like, "Oh, my God, they're also awful!" But they are awful, … they're so specifically awful, in a way that just feels so real. You can't help but say, "What happened?" You know, what happened to them? Obviously for the siblings, you see their father and you see their upbringing. But you've got to know, I mean, there's something that never got explained, which is another thing that I just love about *Succession* is that they don't feel like they have to explain things to you. But there were a few times in Season 1, and maybe once in Season 2, where you see scars on Logan's back. And I always think about that, and they never explained it. But the assumption is he was beaten, either by his family or he was sent to some boarding school or something happened where this guy was abused. There's a pain there so deep. You don't know what it is, but you know, it's there. *Succession* is brilliant at finding that balance. Nobody is saved or changed in any way. But they give you just enough of a human vulnerability to connect with them.

KS: Because you've directed episodes in Seasons 2, 3, and 4, which is 75 percent of the series, you got to witness *Succession* going from an overlooked gem to a massive hit to modern-day classic.

SSB: The first season, it wasn't a hit, like right out of the gate. It took a minute. But Bob and I loved it from the first episode. We were just ... loved it. And then it just got better and better and better. It went from being like, "Wow, I really love being in, working on the show. It's so good. The writing instead of the acting is so good that, you know, everything is so good" to, by the last season, it was like, "I hope you know I have to serve this show that's considered this masterpiece. I hope I don't disappoint!"

KS: You also directed four of the eight episodes of *Fleishman Is in Trouble*, essentially the back half of the series. And you were in the director's chair when the series makes that all-important pivot from being told from Fleishman's [Jesse Eisenberg] point of view to being told from Fleishman's best friend Libby Epstein's [Lizzy Caplan] point of view.

SSB: Taffy [Brodesser-Akner, showrunner and author of the novel on which the series was based] was with us constantly. It's easy to get lost in the episode that you're doing at the moment, not always see the big picture, or the four episodes you're doing but not see the whole meta of it. And Taffy was on top of it constantly. There was a scene where Jesse was telling the kids that their mom isn't coming, you know, "I don't think Mom's coming home." We were like, "God, he's been so harsh about it. Can [we] do a subtler version of it?" And I think we found a compromise where it wasn't quite as harsh. But she didn't want it to be too loving, too, because she was like, "Remember, we at this point, we're already starting to, we need to have signs that he's not exactly the guy that we thought he was in the first few episodes." And I was like, "Oh, yeah, you're right!" Like I got caught up in protecting the character. And Taffy was aware of these hints of subtle shifts that you needed to have. So you could start questioning, you know, well, is he really what we think he is, and so I think she had the big picture in mind in a way that sometimes we would get lost in it because we were just thinking about, like, the scene or the episode or the end, and not necessarily the whole picture.

KS: That shift in *Fleishman*, from who is the main character to even what the series is ultimately about, happens primarily in the episodes you directed. It starts as a show about a very specific group of people acting out very specific class and gender roles but ultimately becomes a story about time and all of us getting older.

SSB: First of all, 100 percent of it was on the page, and Taffy had it all mapped out beautifully in a way that guided all of us and how we did what we needed to do. ... But we had a limited shooting schedule. ... So we just had to find ways to shoot moments that we could shoot in existing locations or cheat locations that didn't look like the same location because we couldn't go to five [locations]. You know, would have been great if we could have gone all over the world and shot different locations, but that was not an option. And then we use a lot of photographs. We repurpose some moments from earlier scenes or different perspectives. Taffy would always write that in the script, to make sure that if we were shooting a scene, we might shoot it from two different perspectives, so that it can be used. Again, when we're in Toby [Fleishman's] perspective to when we're in Claire [Danes's, playing Rachel Fleishman] perspective or whatever, like, she would always ask us to try to shoot multiple perspectives on scenes.

Taffy would think about screen time. She would be like, "I need more Libby here because we're transitioning into Libby now." Like it would go down to something as simple

172 Break the Frame

as "I need her on screen more than she was in the prior episode." Some of that was just the reality of the shoot. But it also made a lot of sense for a series that is all about the passage of time.

KS: That ending monologue makes me want to watch *Fleishman* all over again.

KS and SSB in unison: And then. And then. And then.

KS: How do you guys divide up responsibilities as writing and directing team?

SSB: It really works well that Bob and I have things that we're specifically good at and like to do. When it comes to writing, Bob, he's really good at slamming through that first draft, and I like to take a really long time. I'm really detail oriented and much better at taking something, whatever it is, and whittling it into something. We never sit at the computer together ever. He'll do his draft, I'll do my draft, and we'll go back and forth. And sometimes we fight. That's where we fight the most. Writing and editing is when we fight. We do not fight in production. That would not work to fight in front of our crew.

Bob, he loves looking for locations. . . . He probably talks to the location manager more than anybody. I work with the actors a lot. . . . I'm really intimately involved in every aspect of casting and getting actors and rehearsing the actors. He's a little bit more with the cinematographer and the images, although none of this is set in stone when we're on set. It's not like he's standing with the cinematographer. It is fluid, but it's always like I'm the person who talks to the actors. Bob will give me notes or give me suggestions. Same thing with the cinematographer. He generally interacts with the cinematographer more than I do, but again, I will also on occasion.

And then in post, it's very interesting because on most of our movies, Bob edits, until recently he has not edited. He's decided that maybe it's good to have another set of eyes, but when Bob was the editor, then I was like, "Well, I'm the director and you're the editor." So, you know, I could say, "I don't like that." And then he'd get mad at me because I was acting like his boss and then we get into a fight. That's generally the way we split it up. But that being said, there's no rules, there's no "You have to do this" or "You have to do that." It's just where our interests and our strengths are.

KS: What part of you is the director and what part is the screenwriter? And would the two parts know each other if they met?

SSB: 100 percent know each other because I don't see any difference. You're constantly writing even when I'm directing for other writer, unless a writer is extremely word perfect and you can't change a word. I know there are some like that, but I haven't worked with anyone like that yet.

To me acting is just writing without paper or without a computer. It's creating backstory, it's creating specificity. What bag the person is carrying tells you a million little details about them, or what book they might be reading. So to me, they really are the same. The difference between the director and the writer is writing is such a solitary . . . I go into a different space when I'm writing. In my office, it's quiet. I'm really in my own head. And directing is social. You're on a set with one hundred-plus people. You're communicating. I always say that a screenplay is perfect. It's always perfect until you show it to somebody, and then it's suddenly starts to slowly get less and less perfect.

I feel like I'm always writing, and when we're directing stuff that we write, we're constantly rewriting for locations and for actors. You know, you could write something in mind for an actor, and then you get another actor and they—you got to lean into something a little bit different because they're not quite what you saw, but they bring another

Directing in Partnership **173**

gift and to it. And again, I think it all goes back to that documentary thing: You got to have your eyes open for things and be willing to change. And so I feel like we're, I'm always rewriting, and writing and rewriting, and in editing, you're writing and rewriting and in sound mixing, you're writing and adding your score, you're writing your rewrite. It's all part of the storytelling process, all the tools. So I see it as one and the same.

KS: As a filmmaker, who do you see as your teachers? Who do you see as your peers?

SSB: I have a weird mix of influences. David Lynch is one of my absolute favorite directors. Ernst Lubitsch. That's a good one. I love Lubitsch. Not that you could see direct influences in my work, but, films that I feel had a huge influence on me. I'm Coppola. I'm Sidney Lumet. Susan Seidelman. Like her early New York movies were some of the reasons why I wanted to make movies. Her and Jim Jarmusch. What do you mean by peers?

KS: I mean, I know directors don't all go to the directors clubhouse and hang out with one another, but like do you feel on the same path or mission with certain other directors?

SSB: Liz Garbus, like me, she comes from docs. And I'm a huge fan. But a female filmmaker that I love and really respect is Mary Harron. There's a friend and who I talk to and connect to, and we watch each other's work. And I went to film school with Greg Mattola [*Superbad*], who I love and I think is a real talent. And obviously, the directing teams.

Julie Cohen and Betsy West

Films Mentioned
Gabby Giffords Won't Back Down (2022)
My Name Is Pauli Murray (2021)
Julia (2021)
RBG (2018)

The filmmaking team of Julie Cohen and Betsy West didn't plan on releasing four biographical documentaries of notable American women in a five-year period, but when you begin with a sonic boom (2018's *RBG*, which won an Emmy and received two Oscar nominations), you also don't ignore its echoes. Their subsequent projects—on civil rights pioneer Pauli Murray, culinary trailblazer Julia Child, and Arizona congresswoman Gabby Giffords—are all American women you know or should know about. And yet a Cohen/West joint is not a retelling of how a famous woman got that way but how that woman answered the call of history: Justice Ginsburg, first as attorney Ginsburg, who changed gender equality under American law; Julia Child, who brought dignity and professionalism to cooking and not just beef bourguignon to public television. And if you're wondering why you don't know more about Pauli Murray (the namesake of the newest residential college at Yale University) or the activism of Gabby Giffords following the 2011 assassination attempt that nearly killed her, I've a pair of documentaries by a pair of directors to show you.

Unlike most of the directing duos in this books, Julie Cohen and Betsy West are not married, nor did they meet as aspiring filmmakers. Both had a first career in journalism, met on the set of a television project, and have, since 2009, run sets together. Their four documentary films have won an Emmy, a Peabody, and received two Oscar nominations.

I spoke to Julie Cohen and Betsy West in March and September 2023.

Kevin Smokler: Together, you two have made four biographical documentaries about notable American women. I know this was not your aim at the beginning, but can you tell me how it happened?

Julie Cohen: It's hard to talk about that evolution without explaining how we met.

Betsy West: Around 2009, I was teaching at Columbia Journalism School, and I was approached by a documentary company to be the executive producer of a project about the modern women's movement [PBS's *Makers: Women Who Make America*]. I have sort of lived through the modern women's movement, to some extent, certainly benefited by it. But I really didn't have a clue about the breadth of the struggle, and the history of all the women who contributed. It was totally eye opening. The project involved identifying and interviewing one hundred women who had been groundbreakers, trailblazers in politics and sports, art, literature, across the gamut. It was an amazing experience, but at a certain point, I was a little overwhelmed with it all. And I asked a friend if she knew a producer that I could work with. And she said, "Oh, you should meet Julie Cohen. She worked for many years at NBC. I know her there, she's fantastic." These are the two extremely lucky things that happened to me in my life, that somebody approached me about doing this project. And that I met Julie. So that was the beginning.

176 Break the Frame

KS: Well, you guys really planted some seeds that grew into redwoods. Because I went and I looked in the PBS's *Makers* archive,[1] and it's now like its own country.

JC: Ultimately a lot of corporate sponsorship came in, and they started doing conferences, and now there are younger women profiled too. The women we were profiling by design, for the most part, really were older women, because part of the idea was let's make sure that there's an archive of this as the women grow older, with, obviously, a great example being Justice Ginsburg.

KS: I love that the four documentaries you guys made together are, in a very general way, biographical. And yet at the same time, you can watch each one of them and say they are more than biographies. They aren't a forced march chronologically through a person's life. I'm not sure I have a question there other than to say I was wondering about your intentions.

JC: That's absolutely our intention. And it also has a lot to do with how we select people we're gonna make films about. It has to be someone whose life means something bigger than their own individual biography. That wasn't necessarily true, for instance, for the whole project—the one hundred different women in the *Makers* project—Because Ruth Bader Ginsburg was one of those women and Betsy had done that interview, that's really what gave us a very deep sense of the richness of Justice Ginsburg's experience going back to the 1970s, when she played such a huge role in securing equal rights for women under the law, under the Constitution. And when we made our decision to make the first full film together, [2018's *RBG*] that was basically as a result of young women drawing our attention to what emerged in 2013–14 as memes, as an obsession with Justice Ginsburg, and we were like, well, that's amazing. There's like this really rich story that tells you not only RBG's life and all the obstacles she overcame, what she achieved, but also tells you a lot through one person's story about how women evolved in twentieth-century America. And so it just seemed like a natural subject matter to make a larger film about, although maybe not that natural, because unlike a singer, or someone … RBG isn't a performer. Her specialty was deep intellectual pursuits and the Constitution, and plus, she's soft spoken and a little bit reticent.

BW: It actually took about a year to get the funding for this. There were people that we approached who didn't really see how we were going to be able to make a documentary about someone who was elderly, intellectual, retiring, all those things. But we were extremely lucky to connect with the people at CNN Films, women, by the way, who got it pretty quickly, as soon as they heard that we had some limited, at that point, participation from Justice Ginsburg.

It's not as if she was just opening up her life and her home to us. But she had indicated that she would not object to us starting. And when CNN Films heard that, they thought, okay, let's go for it. Let's try. And that was the beginning of that project. From that point it took about two years, once we got our producers and backers.

KS: I feel like *RGB* is equal parts, without minimizing Justice Ginsburg's legal or political accomplishments, about the making of a Supreme Court justice and the making of a pop culture icon.

BW: Just to jump in there, Ruth Bader Ginsburg, as a litigator, changed the world for American women. That's at the heart of it. That's what we knew was going to be the core of the story. To answer your question, also about how we construct these things, we very much wanted *this* Justice Ginsburg to be front and center and not to have it be a simple

chronology: oh, she was born in 1933, in Brooklyn, and then, you know ... We wanted to find a way to weave the story to go back and forth in time. And we're very lucky that our editor, the brilliant Carla Gutierrez, had the brilliant idea to help us structure the film using RBG's testimony before the Senate Judiciary Committee when she was nominated to be a Supreme Court justice, because she was talking about her history and talking about her beliefs, and it allowed us to just go in different directions and really bring her to life.

KS: I have two questions based on that: How do you make what is deservedly a heroic story about someone who (1) is soft spoken, retiring, and also (2) as a lawyer and as later a judge has an abiding faith in not only in the legal system, but also the slow, incremental, cumulative progress of the law. I would imagine it's easier to make a documentary about a lawyer who believes the law is a sword designed to slash through the brambles of injustice.

JC: Our philosophy throughout all the films we make is to not try to gloss over what could be the problems but lean into them. Like the fact of RBG being an introvert, a little shy, a little awkward at times, is a character specificity that makes her a really interesting person. And the contrast between the person who is not going to be, like, chatting away at a party and really is incapable of small talk, as we discovered when we spent a fair amount of time with her, the contrast between that and her incredibly buoyant, outgoing, helping-to-push-her-career-forth husband Marty was, like, it to us. That's not something to ignore. That's a story beat. We expected some of the responses that we got to *RBG*. We certainly understood that women were going to find this an empowering women's rights story. But we were really pleased by some of the unexpected responses. And one category of that was the response from introverts saying, like, you know, "I've never seen an introvert portrayed that there's like, actually something powerful and beautiful, and cool about being an introvert." And that's part of *RBG*. Of course, with the little twist that towards the end of her career, like in her eighties, once her husband had passed, she picked up the torch of being a little cheekier and being a little more comfortable with the spotlight.

KS: After Martin Ginsburg passes away, that's when we get the Ruth Bader Ginsburg who was willing to have a guest-starring role in the National Opera Company or gets asked on-stage who Biggie Smalls is and plays right along.[2]

BW: Or who allowed us to follow her into her gym and just see her amazing workout routine.

KS: The gym scene is my favorite part of the movie. This probably seems like a ridiculous question but what was Justice Ginsburg's trainer like?

JC: Oh my gosh, Bryant Johnson, her trainer, is one of those people who just immediately connects with everyone. So much humor, so much fun. He seemed personally a little bit shocked that RBG had agreed to let us in the gym because she understood that it was going to really add some fun to the film and also kind of show how tough she was. We emailed him. He immediately called her and said, "Justice, did you really say that they could bring cameras to our workout?!" And she said yes!

BW: He had been working with a couple of other judges and was recommended to Justice Ginsburg, following her cancer, because she had lost so much weight. She was extremely fond of him and grateful. I don't know if you saw that very moving scene when her casket was lying in state and he went down on the ground and did a plank. That was one of the more moving moments when she passed away.

JC: When you go into these projects, you're really worried about all the access that you don't have. I think we were pretty pleased and surprised about how much access we did get,

including the two scenes at RBG's home with her granddaughter Clara [now an anti-discrimination litigator in New York]. That was something she allowed us to do towards the very end of our process. We started with much more public events and got to the more personal later.

KS: I love the last shot of *RBG* where she's kind of sitting in the chair. It looks, on the one hand, like [it] could be her portrait in the National Gallery. And on the other hand, it could be like, if I had a Ruth Bader Ginsburg trading card, it would look like that.

JC: Yeah, well, that credit goes to our director of photography, Claudia Raschke, who did really an amazing job with that film, given very, very tight structures. We didn't have that much time with Justice Ginsburg. We filmed a number of events that she was doing and, in those cases, we did have some latitude because if she was at an event that she was allowing us to film, we would film the whole thing. But as far as the time that we were taking up to get some footage of our own, whether it was in the gym with her granddaughter or working in her office, all those things were—including the interviews—were all extremely time limited.

KS: *RBG* comes out in 2018. Your next three documentaries come in just five years' time. Do you guys have robot duplicates? Are there only two of you?

JC: I think the short answer to that is that Betsy and I both come from the long-form news world where working really quickly is paramount. But because there are two of us, we're able to divide up some of the work. We also bring in teams that aren't the same people. Like we don't have the same editor working on two films at a time and if we have two films that are going, they have separate editors and separate producers so that we can sort of save our own selves and brainpower for the real substance of the film, rather than like all the logistical stuff.

The thing that takes a long time is the developing and fundraising stage. And because we had the great good fortune to make *RBG*, a film that had some commercial success for its distributors, that made the funding of especially the two that immediately followed a shorter than usual process. Because people were willing to take a chance that we could make a good film about amazing feminist stories.

KS: Pauli Murray is the least-known subject of your four films, undeservedly so. How did you first encounter her story?

BW: From RBG.... As a lawyer, writing the first brief before the Supreme Court for gender equality, Ruth Bader Ginsburg very deliberately put Pauli Murray's name on the cover of that brief to indicate that the fundamental idea that the Fourteenth Amendment should apply not just to African Americans, but that equal protection under the law should apply to women. That was an idea that Pauli Murray had put forward with a coauthor in the mid-sixties, at a time when people really weren't saying that. So Justice Ginsburg remained an admirer of Pauli Murray.

It was really after *RBG* came out, Julie did a little googling and discovered that in the 1970s, Pauli had been interviewed mostly on audiotape because of Pauli's role in the women's movement, as one of the early founders of the National Organization for Women, and also because Pauli had become the first female-identified Episcopal priest.... And we just started thinking, "Oh, my God, you know, why don't we know about this person?"

Often, someone's lack of notoriety is an impediment to getting a film made, because why do we want to make a film about this person no one's ever heard of? But I think in this case, it was an advantage because the fundamental question is, "Why haven't we heard

about Pauli Murray?" And the other thing is, we were extremely lucky that academics had studied Pauli Murray.... So even though there wasn't a popular understanding of Pauli's place in history, others had done work in this area and there were several wonderful biographies, a lot more rich material there than we thought. And then we had some lucky discoveries in the course of making the film that helped us really bring Pauli to life. Julie can tell you about those.

JC: The potential for a Pauli Murray documentary was really set in motion by Pauli Murray herself, who had collected boxes and boxes of documents and tapes of a very nomadic life, living in two or three different homes a year—the thought that this might later be of interest to historians, writers, or filmmakers, which is something that probably we learned from one of our consulting producers, Patricia Bell Scott, who had known Pauli towards the end of Pauli's life in the eighties. And Pauli Murray had a dream that there would be a film made someday and so that was incredible.

KS: Pauli Murray has been gone the longest of anybody in your four movies together [She died of pancreatic cancer in 1985, at age seventy-four], and I love that you ground her story in the present. Most of the interviewees in *My Name Is Pauli Murray* are young people.

BW: Because obviously many of Pauli's contemporaries were no longer around, right? We were very, very lucky that Pauli had become an educator and had really connected with young people. And it was [producer] Talleah Bridges McMahon who tracked down the two former Brandeis students who had such amazing memories of Pauli and classroom clashes over approaches to African American identity and, and then had become real friends with Pauli. Interviewing them was extremely moving. I mean, they were so happy to kind of reflect on their younger selves and how their appreciation for Pauli Murray developed.

JC: As far as bringing in the perspective of later generations of trans activists, finding trans people who are out [as] trans doing interviews, is actually not a huge challenge among younger generations. But, like, if you were looking for the people that were octogenarians and nonagenarians that we interviewed and other aspects of the film who were trans, I think that would be a much bigger challenge. You just don't have as many to draw from.

KS: The premise of *RBG* seems to [be] "Look at the effect this person had on America at so many stages of her life and ours as a nation." The premise of *My Name Is Pauli Murray* seems to be "Why don't we know this person who had such an effect on the America we live in now?"

Pauli Murray had so many careers and lived so many lives.

JC: Yeah. And we didn't even get into all of them in the movie because there are a lot.

KS: I look at your Julia Child movie [2021's *Julia*] and I sit and it feels very much to me like a post–*Julie and Julia* movie. This is not a movie told from the point of view of a fan but from people who actually knew Julia Child. It reminds me that as filmmakers, you guys do not do hagiography. You clearly admire each of the women you have made movies about. And yet there are always moments, in particular, the Julia Child movie, where the people who knew her speak about her mistakes and how she learned from those mistakes.

JC: Right? Again, something that seems like it might be a stumbling block is actually what makes a more interesting character study and ultimately a better film. Julia, like so many in her generation, was homophobic. I think that's the only way to say it. The positive side of that is events transpired in her life in such a way that she changed. I mean, she

180 Break the Frame

went [about] using not nice words to describe gay people and had this overt denial that her longtime lawyer and friend who everyone around her understood was a gay man. And she just would pretend like, oh, "Where's his girlfriend?" like she just didn't want to know. And then once he ... he was dying of AIDS, it led to sort of an awakening for her, not only on a need to be more sensitive and open but also realizing, 'Oh my God, AIDS is terrible.' Well, how come nobody's talking about it and raising money for research? Like that's what we should be doing! And then all of a sudden, she's doing AIDS benefits. It's a pretty stunning turn. In big-picture wording, the story of *Julia* is the story of someone who is still quite famous. People know who Julia Child is. But we were really trying to make you think of this person as someone who had a major impact on American culture.

KS: I was really moved by the interviews in *Julia* with chefs on the cutting edge of American cuisine a few generations removed from Julia Child. Because it was very clear when you talked to Marcus Samuelsson [the youngest chef ever to receive a three-star rating from *The New York Times* and a great admirer of Julia Child] that Julia Child has been kind of unfairly pigeonholed as this great leap forward for American cuisine that happened seventy years ago and her love of French cuisine is clearly part of our past, not our future. I was very moved by how important she remains to generations of culinary innovators after her. I'm not sure we would have the bounty of food options we have now if not for Julia Child giving cooking professional respectability. And Anthony Bourdain giving it sex appeal. And the children and grandchildren of those two is America's food culture now.

BW: After the film came out, we were invited to be on podcasts with chefs all over the country. Everybody was brandishing their very worn Julia Child book, because a lot of people did learn from Julia Child and just respected what she did. And I think also—as [James Beard Award winner] Jose Andres said—Julia gave a kind of dignity to chefs and made people understand what a creative and important profession it is. And I think there's an amount of pride also in their appreciation of what she did for ... the way we eat and how we all cook in our own kitchens and the level of professionalism and joy that you can find in restaurants all over the country.

KS: Your Julia Child movie makes time for the later parts of her career where she is no longer a television star, where she is considered an elder stateswoman of the culinary profession.

JC: I don't think it's coincidental that we've been drawn to women whose big success in life has come in later years. And as part of that, it's important for us ... to really get into women's lives in the decades where people are less interested in hearing about women and what they're up to.

It's so funny, I was just reading something today about women feeling kind of invisible once they pass—you can pick the year and it kind of changes at—what, fifty? Forty? Letting our protagonists have their visibility into old age is important to us. We had set out as a plan in the editing, and even filming of *RBG*, that while we appreciated that she had—obviously we're making a big point in the film of the great career that she had in the seventies, and while there was quite a bit of her confirmation hearings, at which point she was age sixty, in the film telling the story—we also wanted to make sure to always keep the octogenarian RBG in the fore[ground], because who she was as an older person was part of our story, and was a lot of what was so amazing about her.

Julia Child didn't become famous until she was in middle age either, and that's a cool fact. It was actually one of the facts that attracted us to that story. But we didn't want to

Directing in Partnership **181**

just be like, "Oh, look at this. She's, like, in her fifties. And she's a TV star!" Actually her career continued. She played a big role, she continued to play a big role, in the culinary world and even kind of like helping elevate younger chefs. She's revered by people in the food profession even now. And certainly, that was true when she was in her eighties, and we wanted our audience to sort of see and feel her in her eighties. And also, both with the decline of her husband, who had dementia, and then even after his death, she's still trucking along. We were so happy when we found that footage of her walking around Cambridge, and that bright red shirt in her eighties. You know, she was a tough cookie. And the fact that she was still out there playing a role in her world seemed like an important part of her character.

KS: Let's talk about [Former Arizona congresswoman] Gabby Giffords. I saw *Gabby Giffords Won't Back Down* [2022] last, and in seeing the four movies you've made together in succession, it's very clear that that the supportive partner is the unsung hero of all of them. [Gabby Giffords's husband] Mark Kelly feels like a first cousin of Paul Child, of [Pauli Murray's life partner] Irene Barlow, and of Martin Ginsburg.

JC: I think that's right. We see the supportive partners and we want them to be sung. In the case of those that are men, the idea of a male playing a really important supporting role we sort of love. Although we do kind of admit that like our Feminist Love Story brand and the heroic husband dude, we almost have to retire that whole plan after Mark Kelly, because you really can't, like, you ... really can't be the epic, heroic role that Mark Kelly plays in the Gabby Giffords story.

I guess you'd call us hopeless romantics. The love story gets us every time. Every single film that we've made, all four of them, we've ended up expanding the love story from where it was. We think we see our documentaries as movies. We want them to be enjoyable to watch. It's great if you learn something and if your assumptions are challenged, and blappity blappity, but like the real, deep goal is to engage and entertain people. Romance is pretty good for that.

BW: In a way, it's a kind of reconsideration of a feminist marriage. The stereotype was that feminists had no sense of humor. And they really hated men, or the men they married were wimps or browbeaten or whatever. And you look at these incredible relationships and you know, how much they enjoy each other. The Gabby film was different because we got to see a love story in the present, because Mark and Gabby really enjoy each other, they kid around, they support each other, they're just fun to be with. We were really lucky that in all four cases there was a love story to tell.

KS: Most of *Gabby Giffords Won't Back Down* is about what Congresswoman Giffords does after leaving Congress and how she recovers from the assassination attempt on her life and the activist she becomes because of it, the work she is known for now as opposed to what made her famous first. As a society, we are frankly terrible at caring about the work of people who are once in the spotlight and must step out of it for whatever reason. And even worse when talking about women. It is so much easier to say, "Where did she go?" than "Why did she go?"

JC: Adding to that ... if a lot of our daily life has to do with a struggle of overcoming physical injury, like in Gabby's case, that somehow that makes us less interesting or less than or to be discarded or dismissed or, like, "You do whatever you need to do," but do it quietly. That's just not Gabby Gifford's way.... Her whole life has been the optimistic sunshine positive extrovert. She had something happen in her life which one would have

182 Break the Frame

expected to change that worldview. Amazingly, it only sharpened and strengthened it. Some around her, including members of her own family, found it a little irritating, like, "Why are you so damn sunny all the time?" It has ended up being her greatest salvation. It was beautiful to watch and seemed like it would be great fodder for a documentary.

KS: How did you guys physically position yourselves as filmmakers when you are filming someone's lengthy medical recovery?

JC: No, no, we weren't—that footage was all shot by Mark Kelly. I mean, part of what made us—one of the things that made us pursue that film was the fact that he had documented so much of her early recovery and had about forty hours worth of videotape that he had shot himself

KS: That probably would have been a very large hole in the story if that footage didn't exist.

JC: I actually don't think we would have done the film if that didn't exist. But we just started watching it and it was so moving and incredible, but he had set up cameras and done it himself.

KS: How do you two divide up responsibilities when working together?

BW: We often divide and conquer, but on the major decisions, we always do those in consultation. And luckily, we have a very similar approach to storytelling, so we have rarely had major disagreements. We have discussions, bounce ideas off of each other: "Oh, should we do this? Or should we do that?" And then we have a discussion, and then we move on.

Once having made the big plans, then we will divide and conquer to some extent. So I might have a relationship with some of the characters and then ultimately develop the [interview] questions. Julie will look at the questions, I'll do the interview, she'll probably be there. She'll lob in some questions afterward. And then, similarly, she does that.

JC: You might have noticed that a lot of our films have a fair number of people in them, ten to twenty participants or characters, depending on how you say that these days. We tend to pretty much divide those down the middle. So there's a lot of back-and-forth dealings with each of those people. And then, one or the other of us is the point person for every person that we're dealing with. And that actually does end up saving a lot of work. And then what scenes each of us starts out working on, we divide the scenes up, and each of us is working on the scenes with the editor. And then once we get it to a place where we kind of like it, then we show the other.

BW: We will give our usual shout out to Google Docs, because we work very collaboratively on Google Docs. We have a whole system, a color code system that I am green and Julie is purple. If we can very quickly go through a script and see the suggested changes or the questions if we agree, ... we turn it yellow and then we tell our editor to go ahead.

KS: You two did not grow up riding tricycles together. You met as seasoned professionals. What's it like to work so intimately with someone creatively and professionally when you also know they've had a whole lifetime before you ever knew them?

BW: It's pretty fascinating, because you keep learning new things about somebody. Julie and I are not the same age. I'm a decade older, so I have different musical references (I'm kind of stuck in the sixties and seventies and eighties) ... and we had different upbringings. But we're both trained as journalists. And as Julie said, we understand and appreciate deadlines, and we kind of rise to the occasion of deadlines. That really helps. But I appreciate the fact that we're not the same person.

Anna Boden (b. 1979)

Films Mentioned
Captain Marvel (2019)
Mississippi Grind (2015)
It's Kind of a Funny Story (2010)
Sugar (2008)
Half Nelson (2006)

Actor Launched
Ryan Gosling

Ask ten Marvel movie fans, "Who directed Brie Larson in *Captain Marvel*?" and see how many of them answer, "The same directors who earned Ryan Gosling his first Oscar nomination playing a middle-school teacher addicted to crack!"—even if it's the truth and nothing but. Then step back, line up all five movies written and directed by Anna Boden and Ryan Fleck and the connection seems less fragile. Even with superpowers, a Boden/Fleck hero (typically singular; thus far, the duo have stayed away from movies about squads/gangs/families/Avengers; if they made an *Oceans* movie, it would be called *Oceans Only One*) is often the source of their own trouble, a person weighed down by what they cannot quite do in order to make their life better. Addiction plays a prominent role in their movies, unsurprisingly, as does simply being too young and not ready to handle big things life hurls toward you. A Boden/Fleck flick can therefore be big or small, about legendary comic book characters or a season of major league baseball but can also happen largely within a school classroom or a hospital ward. Overall, though, they are quiet affairs that require the actors to do as much with silence as with speech, as the camera remains tightly focused on their face. A look or a stare in a Boden/Fleck movie conveys as much as a scream.

Originally from suburban Boston, Anna Boden met Ryan Fleck (originally from Oakland, California) when the two were film school students at NYU and bonded over a shared love of the movies of Robert Altman. The 2004 short film they made together, *Gowanus, Brooklyn*, won a prize at that year's Sundance Film Festival and was subsequently expanded into *Half Nelson*, their first feature film, from a screenplay they also developed at Sundance. Boden and Fleck began dating as students, broke up just before beginning their third film, *It's Kind of a Funny Story*, and have continued to work together since.

The films of Anna Boden and Ryan Fleck have won Independent Spirit Awards, Gotham Independent Film Awards, and MTV Movie Awards and have been nominated for Hugo, Nebula, Saturn, and Academy Awards. Until 2023's *Barbie*, *Captain Marvel* was the highest-grossing film in history directed by a woman.

I spoke to Anna Boden from her home in New York in June 2023.

Kevin Smokler: You guys are making a movie called *Freaky Tales*, a series of interlocking stories set in Oakland in the 1980s, where Mr. Fleck grew up [*Freaky Tales* premiered at Sundance in January 2024]. In the name of equal creative partnership, do you get to spearhead the next project set in Boston in the 1980s? And is it called *Wicked Tales* or something like that?

186 Break the Frame

Anna Boden: That's very funny. We joke about it all the time. I grew up in Newton, Massachusetts. The culturally not so diverse landscape of the suburb that I grew up in wouldn't quite have the same stories to tell. But you know, if I spread it out to Boston, I'm sure we could find something.

KS: I first became acquainted with your and Mr. Fleck's work through *Half Nelson*, I'm sure as a lot of people did. That movie takes place in New York. And I've noticed in watching all of your films in a row, that even though your work is very character based, where it happens is really important. How do you guys make those choices and balance those two creative agendas?

AB: It's really important to us, and I've never thought about it specifically in that way. Because I think usually our ideas start with the characters, but I don't know if that's 100 percent true. Or it might be part of our research before we've even started writing, is so much about spending time in a place. *Half Nelson*, little known fact, was written for Oakland because that's where Ryan grew up. . . . And he was the one who came to me with the idea for that first script that we worked on together. And we went out there, and we walked around different neighborhoods and took pictures and, like, started imagining it there. But we lived in Brooklyn and, ultimately, didn't have very much money. And everybody we knew was in Brooklyn. And when we picked up a camera to make *Gowanus, Brooklyn*, which was the short film that we made kind of based on that feature-length script, that's when the character started to come alive for us. Even though we had this idea for a story that was set in Oakland, it wasn't until we started really exploring our neighborhood, where we were living and also kind of around us, and made that short film, and met Shareeka Epps [who played Drey, the co-protagonist, along with Ryan Gosling] . . . who was a Brooklyn kid, that story those characters really came alive to us.

After that, with *Sugar* [the story of a gifted yet immature baseball pitcher headed to the major leagues], before we started writing, we went down to the Dominican Republic and not just like any place in the Dominican Republic, but we felt like we had to find the specific town that our character was from, a place that felt right. And then with *Mississippi Grind*, we actually got the idea for *Mississippi Grind* when we were shooting *Sugar* in Iowa. And we went to one of those riverboat casinos. And it was the place that felt so interesting and just kind of grabbed us and made us want to spend time there. I think that in some ways, yeah, our characters do kind of come out of that process.

KS: You guys are really okay with an actor standing still and not saying or telling us anything, while the camera holds tight on their face. And as you are doing that, you also manage to convey a very specific sense of time and place in your movies. You convey a very specific sense of place without spending a lot screen time on backgrounds, without resorting to things like passing by a sign that says, "Dubuque, Iowa" or without a long, reverent pan shot of cornfields or something like that.

AB: We did a little of that too, though.

KS: Fair enough. I bring that up as a way of talking about sort of your faith in actors. I know you've said that Robert Altman is an influence of yours. And Robert Altman was famous for casting movies the way Allison Jones [responsible for the ensembles of *Freaks and Geeks* and the American version of *The Office*] would later be famous for casting on television,[3] which is you go after people that look and seem interesting. You don't cast by resume. And I've noticed you kind of like to discover people. Emma Roberts and Ben

Directing in Partnership 187

Mendelsohn and Zoë Kravitz can all claim to be actors who went on to bigger things but appeared in your movies before they were household names.

AB: I feel like I saw all of them do special things before they were in our movies. So we only cast people who we feel extremely confident about, who we trust their instincts a lot and who we enjoy watching. So we never feel like we're taking a risk. For Ben Mendelsohn [who plays Gerry, the protagonist of *Mississippi Grind*], we'd seen him do amazing things in his Australian movies [born in Melbourne, Mendelsohn had been acting professionally in his native country since the mid-1980s] before we cast him, but then also, like, sat down with him at lunch and just immediately knew that this was Gerry.

I love working with actors, like I love seeing how they embody the words and change them. There's nothing more exciting than having somebody say things or do things that are completely unexpected. You have an idea in your head, you're writing it in a voice, and then all of a sudden, they say it with completely different cadence that kind of changes the meaning of it but is still brilliant. That's the most exciting stuff. I always think about that moment in *Mississippi Grind* when Ryan Reynolds's character asks Ben Mendelsohn who he owes money to, and he just looks around, and says, "Everyone." Being on set for that performance was super special.

KS: Was that not as the line was written?

AB: It was the words. But we didn't expect him to take this big, long pause. . . . He's such a special actor because he's so unplanned, and some might say unprepared when it comes to that. But I love the spontaneity.

KS: Jerry [a compulsive gambler] in *Mississippi Grind*, Ryan Gosling [an eighth-grade teacher / crack addict] in *Half Nelson*, and to a certain extent, the entire cast of *It's Kind of a Funny Story* and definitely a little bit of Carol Danvers as *Captain Marvel* . . . You guys are often interested in main characters whose minds are often their own worst enemies. The plot is fueled by the problems they create for themselves, not those the world of the movie foists upon them.

AB: I'm very interested in people who want to be good but are just failing all the time. Some of our characters act very badly and certainly do not live up to the ideals that they have for themselves or for the world around them. Craig in *It's Kind of a Funny Story* [the movie's protagonist, a high school senior with suicidal thoughts who spends a week on a hospital's psychiatric floor] is a little bit different. I feel for him and relate to him, but he's not our character . . . that is Ned Vizzini's [author of the original novel] character and written so beautifully. We felt very honored to have the opportunity to adapt that book and that character, but in some ways he's much more innocent than the characters that come directly from us. But I appreciated that and it was kind of fun to explore that as well. I mean, I love that character, Craig, but I don't think I could have invented that character.

KS: It seems like this interest starts with *Half Nelson* and the brilliant way the Ryan Gosling character is both written and performed. He does a lot of morally dubious things, but you also don't feel like the guy is ill-intentioned. *Half Nelson* is a movie about addiction, but as opposed to other movies about addiction, like *The Days of Wine and Roses* or *Leaving Las Vegas*, it isn't about the hell and trap of addiction itself but the character's weakness in the face of its temptations. *Half Nelson* was not Ryan Gosling's debut as an actor but is the movie that kind of made him as an actor [Gosling received his first ever Oscar nomination for the role]. So you two were not the filmmakers who picked him out of an audition of four hundred other actors but were sort of responsible for throwing his debutante ball.

AB: Right, gosh, to be perfectly honest, we tend not to think of it like that. It's more like we worked together on this thing. And we all provided each other with something that was really special. And we were both very young, like, very young, and he was way more experienced than we were at the time [Gosling was in his mid-twenties during the filming of *Half Nelson* but has been acting professionally since age twelve]. I think in some ways all three of us were still learning how we like to work.... And then throw Anthony Mackie [aka Falcon in the Marvel Cinematic Universe,] into the mix, who's also a brilliant actor. And then Shareeka Epps who'd never acted before, but also has this brilliant natural talent.

I think it was very special because I think it was a very special way to work because there was nobody who was like, "This is how I make a movie, you've come on my set" or an actor who's like, "This is how I need to work!" It was very much, like, a situation where Ryan was trying to help Shareeka learn her language for how to be an actor, and we were trying to figure out how Ryan works very differently from Anthony Mackie, and how can we create a set that allowed them both feel comfortable and feel vulnerable and be their best selves.

We had no money to make that movie. Half the movie's out of focus and we didn't give a shit, as long as the camera eventually finds focus. We walked into a room, we said, the actors can walk anywhere, light the room. It was a very special way of working. One of the things we learned from Ryan Gosling on that movie was, well, we wrote that script for years and years before we're able to get it made, the first script that you write out of college and you don't have, you don't know anybody to make it. So you make a short film, then you rewrite it. And then when we find an actor, you have all these ideas in your head about exactly how exactly the character is going to be. And then like somebody else comes into it with their own ideas. And that can be very jarring. It can feel like you want to hold onto this thing that had been only yours for so long. We were talking to Ryan about the facial hair that he was going to wear in the movie, and we had some idea and he had a different idea. And then he says, "You know, when I look in the mirror, and I have my facial hair like this, I feel like the character." And we're like, "Shit, man, well, there's no answer to that." Half of our job is just making, providing a space where the actor can really feel like the character and embody the character. And if that means having that facial hair, then great. I love his facial hair in that movie.

KS: Your movies always seem to start with people, even in *Sugar*, which is a baseball movie, and baseball is something people have a lot of preexisting ideas and opinions about. I think *Sugar* is one of the great baseball movies because it seems to understand that great baseball movies are always about something else and baseball is just how you get there. *Bull Durham* [1988] is about middle age. *A League of Their Own* [1992], it's about being a pioneer and not knowing you're a pioneer until later. And *Sugar* is a coming-of-age movie that happens to be set in the world of Major League Baseball.

AB: I did not grow up a baseball fan. I fell in love with the sport over the process of making *Sugar*. But I'm not a team person. I didn't grow up rooting for a team. So for me, it was the idea of a coming-of-age story, somebody who has this dream, and they've never really had the opportunity to really question that dream. So they've had this dream, that's been their dream, because it has to be their dream. And they're running after it and then something happens, that makes them start to question whether that's really their dream.

Directing in Partnership **189**

I'm very interested in characters who don't live up to their own expectations of themselves ... have, maybe have, the best intentions but don't always act so well. But I also am very interested in stories that are hopeful and so even though Dan Dunne [Ryan Gosling's character in *Half Nelson*] or *Sugar*, they might fail themselves in certain ways. But I also want to tell stories about people then [who] find other ways to come out the other side of that. It's a different ideal that they have for themselves at the end of the movie, not a loss, not a total failure.

KS: I thought about that personal struggle you're talking about here a lot when I watched *Captain Marvel*. I said to myself several times during that movie, "This is about a superhero finding her humanity," similar to the film that Patty Jenkins made about Wonder Woman. And I think it's interesting that those are movies about female superheroes with female directors and finding their humanity is kind of the thread that goes through the whole movie, but it's not performative the way it would be with a male superhero, like how we have to sit through movie after movie of *Batman* finding his humanity.

AB: In our early conversations with Brie [Larson, who played Captain Marvel], we talked a lot about how you make a movie about a superhero and also make their power something that's not the same kind of, like, masculine power that we've seen in so many movies. How can the power feel real and human and derived from a side of yourself? That's not like pushing aside the feminine part, not pushing aside the emotive part, and not pushing aside the human part?

You're right. It is very different from somebody who's, like, wearing a mask the whole movie and not just like a physical mask and then pulling it off.

KS: I am completely projecting here, but did you first see Brie Larson on screen in *Short Term 12* [Larson's 2013 breakthrough leading role, where she played the supervisor of a home for troubled teenagers]?—projecting because that was the first performance of hers I saw, and I love that movie so much.

AB: Yep. We actually were paired with Destin [Destin Daniel Cretton, *Short Term 12* writer-director who went on to direct Marvel's *Shang-Chi and the Legend of the Ten Rings* in 2021] at like a Hamptons Writers Lab or something. We read that script. And we're like, "Oh, shit, this is good. This is a good filmmaker" and then saw *Short Term 12*.

KS: I've heard you both say in interviews you were inspired by the [Eisner Award–winning comics writer] Kelly Sue DeConnick adaptation of *Captain Marvel* [2012–2013].[4] How did it feed into your interpretation of the character?

AB: She made this amazing series of comics on Captain Marvel that, to me, rebirthed Captain Marvel as the character we really fell in love with. And part of that was having Captain Marvel re-own her own origin story, which was really cool and really influential in terms of how we went about thinking about this story of this woman who was told that her power came from something else. but then she realizes by the end of the movie that it came from her—it's hers.

The other thing that I just really responded to in her comics were these female relationships that were competitive but weren't catty.... They're supportive of each other, but they also really want to beat each other. And I feel like, in so many stories, that's reserved for men, those kinds of relationships, this brotherhood where you're allowed to just kick the shit out of each other, you know? And I really just loved that about her comics as well. And thus was born the relationship between Brie and Lashana Lynch, who plays her best friend, who she reconnects with in the past.

190 Break the Frame

KS: I didn't really see it until *Captain Marvel*, but all of your movies, including *Captain Marvel*, are about how our bodies are our fragile things and will betray us. Or can betray us, I should say.

AB: My body is a fragile thing. It cannot do anything very spectacular. So, yes, it would make sense that I would make those kinds of movies.

KS: As filmmakers you two have historically done everything: You write, then direct, then edit. In the case of *Captain Marvel* and *It's Kind of a Funny Story*, both of which are adaptations of preexisting material, what was it like for you to meet the child in preschool, as opposed to in the nursery?

AB: Definitely a different experience. But you just can't help getting so invested that the baby starts to look like you even though it wasn't born from you. Also there's a certain purity of love that can come for something that doesn't come from you. I'm not sure if you have kids?

KS: I don't.

AB: I have kids and I fucking love the shit out of them. But every time they remind me of myself, I'm like, "Oh, you're my mirror!" And so there is something very pure about being able to appreciate all the good things about somebody else's work, that doesn't reflect you. And that's not your mirror. I just really did love that part of it. There's still the responsibility of doing right by the authors, and both Ned Vizzini and Kelly Sue were very involved. Both of them came to set.... It was important to me just that they were happy with how we took their babies and helped them along towards growing into something different and new.

KS: What parts of yourself, as a person, are the screenwriter, and what parts of yourself are the director, the editor?

AB: Both Ryan and I together think about the directing so much while we're writing it. And those parts are much more fused than, like, on set. We're changing words. It's constantly flowing between writing and directing. But then when I take off my writer/director hat and put on my editing hat, I am brutal. Nothing is sacred. I want to try everything.

Ryan is not like this, and it drives him a little bit crazy and it's why we have all of our fights in the edit room. I am ruthless. Maybe this movie's better if I take out the scene that we really love. I doesn't mean that I land there, but I want to go through all of the options and like really allow myself to explore the different ways that editing can impact the movie. And it's good that I have Ryan because it's good to have someone be like, "Okay, okay, okay. ..." Yeah, maybe it's a little bit slow in this part of the movie. But we need that, like eat your broccoli now in order to have the better experience of dessert later. You need to kind of maybe go through this slow part where you're getting to know your characters, so that the emotional impact later is greater

The director part of me would feel about the editor part like, "Who's, like, slicing up all my beautiful shots?!" ... Yeah, I do kind of rip things apart and post and then put them back together. It's just my nature.

KS: I keep a short list, continuously updated, of bands that were either started or came into their own, by people who used to be in romantic relationships. The Eurythmics and the White Stripes and Rilo Kiley are all bands that were either started by exes or contained exes for most of their history. And I do this because it gives me faith in adult relationships. I really appreciate that people who used to be romantically involved continue to work together, because creatively and professionally they work so well together.

Directing in Partnership **191**

So you and Mr. Fleck were dating when you started making movies together and stopped being romantic partners on *It's Kind of a Funny Story* but have continued working together. How is the division of labor between the two of you set up, and has it changed over time?

AB: It has changed over time. The landscape has changed so much in terms of directing duos. I mean, the Coen brothers didn't even take a co-directing credit early on. One of them directed and one of them produced. So we didn't have a lot of models to look at for co-directing. And then, while we were making *Half Nelson*, it felt so clear that we were being the creative brain together, even though there was more of a division of labor on that one. He would talk to the actors and do more of the directing, but we both came up with all the shots together and worked with the DP [Director of Photography] together. On *Sugar*, since I spoke more fluent Spanish than he did, I ended up doing a lot more direct communication with the actors. That was the biggest thing that started to move us into kind of figuring out what our relationship was going to be more on set. But everything's pretty much been the same from the beginning in both prep and post. I gotta be honest, we prep the shit out of things together. We just love talking about it. We do all the location scouts, we shot-list, we go through everything and talk about all the details. We really like to get an idea in our heads about what we want and don't leave a lot up to spontaneity on the day. We may end up doing something else, but it doesn't mean that we didn't plan it first.

On most of our movies, I've edited it. I've done a pass and then get in the edit room and fight it out together. And on set, I think as time has gone on, what we've learned is we kind of just speak better with different actors, like, we just have different vibes with different actors, and one of us will just get magnetized towards one, and one of us will get magnetized towards the other. And it happens very naturally over the process of rehearsing or auditioning.

Before *It's Kind of a Funny Story*, we just lived in all of it, always together. There was a constant kind of creative back and forth that was always happening because we just spent so much time together, even outside of making movies. And now we live on opposite coasts, believe it or not. So it's like our time working together is much less fluid, but also so much more productive and sane. Because we have times when we stop working. It's amazing to have a time when you stop working and you go hang out with your family and your kids and then you get some weird idea that comes from just being. And then you come together and have stuff to talk about because you've both gone off in your separate lives and come back together, and it creates this other dynamic and this new thing that synthesizes from these two separate lives. And I gotta say, there's something really nice about that.

KS: Who are the other women filmmakers you admire from your own generation and also the generation that came before? I asked this because it helps me in the course of the project to see the ecosystem as very big. I would like to finish this book and feel like there's three more like it I can do.

AB: In terms of like filmmakers that I admire, who came before me, Amy Heckerling, for sure. And *Point Break*, you know what I mean? Seeing that movie as a kid and being like, "Holy shit, this badass woman made this movie." That was so huge for me. And she [*Point Break* director Kathryn Bigelow] just continues to blow my mind. And then I remember seeing a movie by [legendary French writer/director] Claire Denis and thinking it was a man, because I was just so used to seeing male filmmakers' names. And I was like, you

know, "Claire," like some, you know, a foreign name. And then realizing, my God, you know, this is like an amazing female filmmaker.

Working today, it's insane. My husband is a DP and I feel like he only works for female directors. He has introduced me to so many awesome women directors, and it's been fun to talk to them and, like, see the amazing work, everyone from like Gillian Robespierre [whose 2014 debut film *Obvious Child* was comedian Jenny Slate's first starring movie role] and then Eliza Hittman [writer-director of the 2020 Sundance Special Jury Prize winner *Never Rarely Sometimes Always*], who I have known for a long time and has been doing amazing work that I so admire. Issa Rae is such a genius writer and creator. I couldn't possibly name all the female filmmakers who I think are amazing.

In terms of like other filmmaking duos, we were doing the festival circuit with a short film at the same time as *American Splendor* [directed by the husband/wife filmmaking team of Shari Springer Berman and Robert Pulcini], and I loved that movie. That was such an impactful movie for us because of the way that it kind of blended documentary and fiction and played in a really special sandbox.

KS: We had always planned to have a section in this book about filmmaking pairs, not just men and women or romantic partners, but we also have directors who met later in their careers and started working together and teams, like you guys. It's just a working and creative relationship that's totally unique and special and fascinating. Do you and Mr. Fleck feel like always explaining the terms of your working relationship to people who aren't familiar with it? Like in the documentary about the band Sparks that begins with them reading the questions people always ask them: "Are you brothers? Yes. Do you live in the same house? No."

AB: Yeah, a little bit. But I think that I feel like that's probably what everybody has to do. It's like, even to the AD [assistant director] we have to say, "This is how I like to work. It's a little bit different because we're two people. Try not to corner one of us in the men's bathroom and ask them a bunch of questions. Because the other one can't go into the men's bathroom."

E. Chai Vasarhelyi (b. 1978)

Films Mentioned
Nyad (2023)
The Rescue (2021)
Free Solo (2018)
Meru (2015)
Touba (2013)
Youssou N'Dour: I Bring What I Love (2008)
A Normal Life (2003)

Starting with her 2018 Best Documentary Oscar win for *Free Solo* and reeling off a list of topics addressed in her filmography (unclimbed mountains, religious pilgrimages of millions, hundred-mile swims across raging oceans), you'd think the work of director Elizabeth Chai Vasarhelyi held stories of impossible tasks closest to its wild heart. But that would mean beginning her story midway up the rock face rather than at base camp. So let's begin where we should, where the filmmaker began, rather than when she made the movies we now know best.

New York City–born Elizabeth Chai Vasarhelyi, daughter of two academics, was three documentaries filmed across several nations in when she married and began directing with the Minnesota-born son of two librarians Jimmy Chin, a professional mountain athlete and photographer. It's Chin we see on camera in *Free Solo* hanging from ropes and filming Alex Honnold's 2017 unassisted climb of El Capitan in Yosemite National Park. It's Vasarhelyi behind the camera, as she had been for their first collaboration, *Meru* (2015), about Chin's first ascent of a mountain in the Indian Himalayas.

Before the two began working together, Vasarhelyi had won the Best Documentary Award at the Tribeca Film Festival for her debut, *A Normal Life*, about seven friends coming into adulthood in war-torn Kosovo, and filmed legendary Senegalese musician Youssou N'Dour during the most trying moments of his career—on a world tour for an album in praise of his Muslim faith in the months immediately following 9/11—for her second documentary, *Youssou N'Dour: I Bring What I Love* (2008). Her third, *Touba* (2013), gets its title from Senegal's holiest city for the county's Sufi Muslim population where millions make annual pilgrimage. These first two projects had main characters facing death threats and crises of faith under circumstances they didn't ask for and could only react to rather than control. What connects them to the later documentaries and the first narrative feature of Vasarhelyi's filmography (movies instead about challenges willingly undertaken) are a collective feeling—awe, wonder, anticipation, rapture—each movie holds onto despite what events unfurl on screen. The world in a film by Vasarhelyi is always bigger than the characters and includes us, the audience, wide-eyed or holding our breaths, rapt in silence or crying out, together.

In addition to an Oscar, Elizabeth Chai Vasarhelyi has won the 2015 Sundance Audience Award for *Meru* (which was also an Independent Spirit Award and DGA Award nominee), a BAFTA and two Emmy Awards.

I spoke to Elizabeth Chai Vasarhelyi from her production offices in January and December 2023.

196 Break the Frame

Kevin Smokler: Your career has a really interesting dynamic. At what now seems like the midpoint, you became part of a filmmaking pair. So I'm wondering when you are asked to discuss your career in total, do you feel like you have to spend a disproportionate amount of time explaining which movies were made by you and which movies were made by you and Jimmy?

Elizabeth Chai Vasarhelyi: I think it probably was more of an issue in the beginning, when Jimmy and I first started working together. Jimmy is a public personality. I'm not. People would assume that I didn't direct these films. But I think now the people who know, know, and that's kind of fine by me.

KS: Your first film, *A Normal Life*, was a collaboration between you and Hugh Blakely, a Princeton classmate. Since the beginning of your career, have you viewed filmmaking as a team sport?

ECV: I think making a film is really difficult. And so it's really nice when there are two people. Also, I like to break my films in some way. I've really, really liked screening films that we're working on. And I value other voices in the process.

KS: You are the first director I've spoken to who used the phrase "I like to break my films," which is a fantastic phrase. Can you tell me more about that?

ECV: Life is short. I love my kids. There's so much I want to do with my time. So if you're going to make a film, you really have to make the film and give all of yourself to it, pour yourself into it. And my process and now our process, it's very much about stretching the material and trying to see different options. That's what I call breaking it. Because inevitably it doesn't work, but you've learned something. Or it does work and takes on a new shape.

We do pretty fast, radical things to our films. There was a version of *Free Solo* that was a love story. Our docs generally have a lot of footage, so you have lots of options to play with. And that's why it takes so long. I insist on at least sixteen months of editing, which is a really long time. So we have more opportunities to break the films.

KS: It sounds like iteration is really an important part of your directing process.

ECV: Iteration is, but I have to say I think it also comes from a certain confidence that comes with experience. I'm very clear on if I like people's feedback or not. I need other people to help me see just so I could feel their bodies in the room. But also I only show it to people who swear to watch the final draft.

KS: If you come in for an early screening, you're committed to watching it later on ...

ECV: Yeah.

KS: I appreciate that quality of your movies. There's a meticulousness to them, and it's clear they take a long time to make and are made under some degree of physical and logistical difficulty. But that isn't what your movies are about. They're not bragging to the audience "Hey, look at this impossible thing we had to do or remote place where we had to go. Look at how hard our movie was to make!"

ECV: That's the work of it, right? To be present in those moments and just be fully committed. I always say the director's also the janitor. You're all in. Jimmy appears in some of our films and people sometimes are like, "You don't? ..." But you don't want to see me in the meadow of Yosemite. I'm wearing a huge hat, tons of sunscreen, yelling at everybody, wearing a leather jacket. ... My job is to observe and to feel. The questions we are exploring are questions that are very personal to me. The gaze is very important. So you don't

Directing in Partnership 197

physically see me, but I do believe these films come out of one's heart with other people's contributions, and then land.

KS: I heard an interview with you right after *I Bring What I Love* came out where you said, "I'm a very passionate person, and I'm very sincere."[5] Those are qualities that any publicist or image maker would say are difficult to hold onto when you become a more public person.

ECV: With experience, I just feel more comfortable in my own skin. It's interesting to be understood and accepted on your own terms. And I feel like I've hit a place in my career that the people who know know, and they know that I'll be super candid. I'm very passionate about what we do and that I'm our hardest critic.

 We have to live these lives with intention. And I'm sure it has hurt my opportunities, being as passionate and candid as I am, but I don't mind that. I'd rather the world change, not me.

KS: When I speak to a director, I have the advantage of watching all their movies in a row over a relatively short span of time. So I can see the things different movies have in common. And what I hear from the filmmaker is often "Oh, that's interesting, you know, that film I made fifteen years before I made this one. So in my mind I never really connected the two." So take this with a grain of salt, but one of the things that I see occurring again and again in your movies is that they are often about people who accept an impossible challenge. That line in *The Rescue*, "Mission Impossible became Mission Possible," could be the title of the box set of your movies. Where does that interest come from?

ECV: I mean, they're good stories, right? And I think there are moments of change for most of the participants in our films, and being able to witness that change and see someone evolve, that is really special, but it's also that every movie that I make, or we make, has to leave the world a little bit better. *The Rescue*, sure, an impossible rescue, but they did it, and it reminds you that people can give themselves to total strangers and the world can cooperate. *Free Solo*, where, you know, it was really a meditation on how we live our lives and the intentionality that we bring to it, being able to show the strength that is innately human. I think those impossible moments are fundamentally very unique to being a human and reminding us, or me, of the good that you can do, that we're all responsible, we can effect change.

KS: Your first narrative movie, *Nyad* [based on the true story of Diana Nyad's attempted open-water swims from Cuba to Florida] is very much a story of a person chasing an impossible dream. How did you first become aware of it?

ECV: I was eight months pregnant with our first child when Diana achieved her swim in 2013. And it always stuck with me. Jimmy and I had always been interested, are always interested, in these stories about individuals who pushed the limits of what's possible. But we'd explored that very much in the male experience. And we were committed to look at that experience in a woman. And when we got the script, we understood immediately that Diana Nyad is just that person. She's not afraid to want something desperately. She's not afraid to have these audacious dreams. And then it also presented a very unique opportunity, two very rich roles for two older female actors.

KS: Yeah. You really cannot tell the Diana Nyad [played by Annette Benning] story without telling the Bonnie Stoll [Diana Nyad's best friend and coach, played by Jodi Foster] story too.

ECV: I'm sure someone could, but we weren't interested in doing it.... One, because I think we were really interested in exploring that idea of chosen family, in terms of women of a certain age—you can even include Jodie Foster in that too—that maybe your family didn't support your life choices. And you ended up choosing your family and how honoring a friendship that goes beyond the physical. And the friendship shared between Bonnie and Diana in the film is really the beating heart of the film. It's where you learn how to love Diana for who she is.

KS: As filmmakers, how did you tell a story about a person who is exasperatingly self-centered at times, and also make a convincing story about the value of teamwork?

ECV: That's the real joy in the film. I think it's rare that you get the opportunity to tell stories about a 360 [degree] woman, a complicated real woman and who's not always likable. And I think that's a real testament to Annette Benning's craft, that she's unafraid of playing an "unlikable character," a woman.... We all thought it was incredibly important to allow this character to be really complicated. And it's the friendship and it's Bonnie and this idea of a team and learning to love Diana's through their eyes is what I think brings it to life and allows this idea of teamwork to shine through.

It's too often that women are asked to apologize for their ambitions, apologize for their courage, apologize for not kind of living in their femininity, or like conventional femininity. And so I think that is the intrinsic part of the story. Like that is the essence of the story. It's where I found great joy making this film, it's where Annette and Jodie found great joy in making the film. But it's their means of connecting and dramatizing that connection and friendship and love shared by these two individuals that kind of allows you to access the more nuanced parts of Diana's character.

KS: *Nyad* ends with a statement on the value of teamwork, and, looking at all your movies, starting way back, from *I Bring What I Love*, taking us all the way forward to Nyad, I just get the sense that one of the most important human relationships to you is friendship. Maybe *Meru* [about a two-person first ascent of Meru Peak in the Indian Himalayas] is the first zenith of that. But it seems to be a relationship that you will never get tired of making movies about.

ECV: There's a meta way to go with that. With *Meru* it's, "If we only could be so lucky to have those types of friends in our lives," and I think it's the same thing with *Nyad*. Our ability to love one another—it's kind of the single most fundamental human, innately human, quality and the one thing that protects us against the abyss of loneliness. I feel like every one of these films as I'm looking at this question of "Why do you do this?" And maybe this was my trajectory, my path was to explore that through movies and to try to understand how friendship or love can coexist with ambitions as outrageous as these.

KS: My favorite moment in *Meru* is when Conrad Anker [Jimmy Chin's climbing partner] says something like, "I would give someone my climbing route. It's not my mountain. It doesn't belong to me." That's a feeling I walk away from *Meru* with, something I see in a lot of your movies, which is this combination of awe and humility in the face of things that are larger than us.

ECV: I'm so happy you get that from the film. I think that's Jimmy. I mean, that was one of the reasons we fell in love, just looking at the world through his lens, like literally, and understanding the humility and the awe he brought. And you see this in every photograph he takes. There's a real respect for the environment in those photographs. And the same thing in the filmmaking.

KS: I have noticed, in being a documentary fan, that there are certain subjects that recur again and again in documentary filmmaking, and one of them is mountain climbing. And I think part of that is because climbing to me, as someone who doesn't do it, feels inherently narrative. There's a beginning and a middle and an end and there's a plan and you know where you are at each stage of that plan.

ECV: But *Meru* is not about mountain climbing, right? It's about friendship and legacy.

KS: Yes, absolutely.

ECV: *Meru* was a real turning point where I suddenly understood how much I had learned in those years prior. I cut my teeth making foreign-language films, really tricky films no one wanted to watch, you know? And then if you do that with something people do want to watch, it works out.

KS: I totally get why lots of us would want to watch movies about people doing impossible things. There's an inherent human drama to those stories. And yet your movies, they're not about triumphalism. They're not about, "Oh, Alex Honnold was able to free-solo El Capitan, because, well duh, he's the best climber in the world." Instead your movies are as much about the enormity of the task and our humbleness in the face of that task as human beings. *Free Solo* especially is about confronting one's vulnerability.

ECV: Well, in nonfiction, it's hard because you're at the whims of your participants, right? I'll never forget when Alex said, "I met a girl, and she's gonna move into the van." I have this line I tell participants in our films: "A girlfriend in a movie is a girlfriend for life." You will forever be with this person. And the idea that he was willing to do that was really special because suddenly Alex was evolving emotionally in front of us. It's through his eyes, like you just—just looking at him, you see, understand how vulnerable he is. And I mean, the act of free soloing is vulnerable, like you potentially could die. And so I'm happy you saw that in the film.

KS: The emotional core of *Free Solo* seems to be, "What if the thing you have counted on to be great at does not serve you in every aspect of life?"

ECV: Alex has said it's scarier for him to socialize than it is for him to free-solo. And so that's what was so remarkable about Sanni is that she has a particular emotional language, that she could self-advocate, and teach him how to support her. And I think she's astonishing. She comes from a background where she can say, "I need this, and this is how you can do it. I understand it's difficult for you." And it really helped him bloom and come out, you know?

KS: This may be a question that can't be answered: If Alex never meets Sanni, is *Free Solo* a movie about something else? Is it a movie more like *Meru*, which is about a climb and an impossible task?

ECV: Sure, yes. But that's why I thank God for Sanni. I said that onstage at the Oscars.

I mean, they're married and have a baby now. Alex is fascinating, but I think that Sanni allows my mom to get involved in the movie emotionally, allows our kids to get involved in the movie emotionally because there's an access point, because otherwise you've got that scene where Alex's brain scan suggests he's just totally an alien. So thank God for Sanni.

KS: You ran the ground crew while Jimmy ran the crew suspended from cables filming Alex during the stages of the climb.

ECV: The wall stuff is like a ballet. It's very careful. They have to plan where they are. But we had a verité team on the ground, and I was on the radio with Jimmy.... I would never do that again. It was terrifying.

200 Break the Frame

KS: You mean watching a friend climb the face of—

ECV: There will never be a *Free Solo 2* … I think we all aged, like, quite a bit during that. When we finally got to Telluride and watched the movie, our entire crew was sobbing because we never let it out, like, released that breath you've been holding for three years. And yeah, it's kind of one of the regrets I have. It was a lot to put us all, this whole team, through that, because it was hard, just living with that risk. Even though we all trusted Alex so much.

KS: If we go from *I Bring What I Love* to *Meru*, you reach the summit with *Free Solo* where, the thing you walk away with, the big theme in capital letters, is an emotion. And the ideas behind the film come from that feeling. The feeling I get from *I Bring What I Love* is ecstasy, and it can be ecstasy in performing or listening to music, but ecstasy is also dangerously close to religious fanaticism, which is the antagonist of *I Bring What I Love*. In *Meru*, that feeling is humility in the face of fear. In *Free Solo*, it's vulnerability. *The Rescue* is saying teamwork is not just a method by which we get things done. It's a connectedness of the spirit.

ECV: I think *The Rescue* is the best film I've ever made.

KS: Say more …

ECV: It was the impossible film to make. The Thai Navy SEALS had this footage from inside the cave that no one knew about, getting it, going to Thailand during my two weeks of quarantine, in a hotel room, convincing them. So when we finally could have an in-person screening [*The Rescue* was released in October 2021, the second year of the Covid-19 pandemic], it was incredible, because people understood the movie in its guts, you know, understood the spirituality behind it, understood the complexity of it, even though it's part in Thai and some of the footage looks terrible, and X, Y, and Z, but the movie itself has such a large heart. I think it's our best or truly our best-constructed film.

KS: I have a quick logistical question. Obviously, *The Rescue* is not like *Touba*, which is an event that happens on a set schedule every year. So for *The Rescue,* do you guys get a phone call from National Geographic that says, "Be in Thailand in two days?"

ECV: That was also part of the challenge. National Geographic was already filming *The Rescue* and the previous director left the project. And I asked them because I'd been tracking this story forever, both as a mom and also in terms of the Asian representations at play. And also those divers are exactly the type of characters I'm interested in. So I asked them if we could have it. And they gave it to us. Then the pandemic hit. There was nothing shot on the ground. Everything is found, archival. That's hard. We didn't have cameras there and had to kind of paste it all together.

KS: I was fortunate to interview Chris Hegedus for this project about her work with D. A. Pennebaker. *Touba* to me feels like a Pennebaker/Hegedus film in that it is about a special event, but the specialness of that event is captured in the mundane, everyday moments.

I remember saying to Chris Hegedus, "In the Depeche Mode concert film you made, why did you intercut their last song with the guys settling up the ticket money in a mobile trailer out in the parking lot?" And she said, "Well, you can't just tell a concert story with the concert. That's not interesting. All these other things are happening too." One of my favorite moments in *Touba* is the thousands of people lining up the giant pots of food and saying, "Okay, this Quranic school lines up to eat at pot number 61"—the logistics of it all.

ECV: I grew up with their films. I'm very strongly influenced by Chris and Penny. It's hard with *Touba*. Not only were the conditions really difficult to film in, but … I think I went

on a pilgrimage six times, seven times? So it was a longitudinal project. And it was hard to follow the same people because life changes fast in West Africa and people move and leave, so we couldn't follow the same people the whole time. So it was just about the present as well as being eternal, if that makes sense.

KS: The annual pilgrimage weekend we see in *Touba* is composed of several annual pilgrimage weekends?

ECV: Yes, it is. Over several years.

KS: You've said more than once that, to be a friend or associate of yours means, eventually, you have to fall in love with Senegal. It's clear to me, after seeing both movies you filmed there, the whole country is one of those places like Jerusalem or Rio or New Orleans, one of those places you can just tell there's a special kind of earthly energy to it. In your own words, what is so special about the place?

ECV: Once you go, like, it's like part of your blood. It's just one of the most beautiful places and really, it's the people and the idea of *teranga* ["hospitality"; the BBC called it "the word that defines Senegal"], the type of Sufiism they practice. There's a welcomingness to it.

It also feels like it's still one of those places that's wholly itself. The differences are socioeconomic, not race, if that makes any sense. Like there's a certain blending that feels very comfortable in Dakar, maybe because of the colonial influence. But it's just a spectacular place. The people are amazing, the food is good. But it's really the light, you know, those images. I'm really proud of those images in *I Bring What I Love* and *Touba* because it's astonishingly beautiful.

KS: I know you've said with *I Bring What I Love* that you were not interested in making a music documentary. And in the way it's filmed, there's footage of really incredible intimacy, the use of handheld cameras during performances and concerts where you just see someone's chin or their chest or an arm holding a microphone. I would love to hear about the desire to have intimacy in that movie, but not have it be a biography. You do not talk to Youssou N'Dour's wife, you do not talk about Peter Gabriel's "In Your Eyes," the song that made Youssou N'Dour famous in the West. There's a lot of sort of obvious biographical details that are intentionally not in *I Bring What I Love*.

ECV: I'm happy you appreciate the camerawork, but it's just because we had one camera and no tripods and I was still influenced by Penny and Chris … One of the problems with never having gone to film school, you know? After 9/11, I was pretty obsessed with Islam and disturbed by the kind of images we would see and how we would understand Islam. That's what Youssou was trying to do that really spoke to me. These films shouldn't be about what you think they're about, right? They should look at other questions that are interesting and personal.

KS: And your movies seem to leave a lot of room for fate to intervene. Like if there's no 9/11, *I Bring What I Love* is a completely different movie.

ECV: That's the serendipity of documentary filmmaking, right? Those are the real moments of insight into a character.

KS: What was your relationship with the music of Youssou N'Dour before you took on the project, and then how, as the filmmaker, do you go about the challenge of saying, "Okay, this is probably the most famous musician on the African continent since Fela Kuti or maybe since Hugh Masekela or Miriam Makeba. And yet the West seems to know him as a guest star on a Peter Gabriel song. How do I introduce the audience to the impact of this man and his music?"

202 Break the Frame

ECV: I don't know if we ever did except by allowing people to come to love him and get to know him. I grew up in a mixed-race family where English was a second language to both my parents. So I grew up with tons of world music around me. It feels good to listen to music in other languages. Youssou, I mean he's a remarkable musician. But it's really the griot [a West African oral historian and storyteller] tradition that I found really special. It's kind of what we do with our films, to reflect historically on your own events and history through an entertaining experience.

KS: What is your division of responsibilities, you and Jimmy, on set and while developing material?

ECV: In terms of developing material, it's a Venn diagram. Because when our interests overlap, that means there's something special, and, honestly, when that works, it's like one plus one equals three. There's a synergy in that I bring a different point of view to the subject matter.

Primarily I do the interviews. He will get in the helicopter and do those, you know, aerial shots. Jimmy still has a full-time day job as a professional athlete, which supports our family.

Our films are not our biggest project; our kids are and our marriage is. And I trust him absolutely in his judgment, and he trusts me too. And that's why *Free Solo* is possible.

"The boulder problem" [the most difficult moment of Alex Honnold's solo climb of El Capitan] is a great example where Jimmy was like, "I can't film the boulder problem," and I was like, "You don't have a film without the boulder problem. Please figure it out." And he knew that I was asking for a reason. It was true: We wouldn't have a movie without the boulder problem. But, you know, he also didn't want to distract Alex at the most difficult move in the whole climb.

We had a three-year-old and a six-month-old during *Free Solo*. It's like a moving circus, a traveling circus, because all of these things are important. I'm really interested in kind of normalizing and showing people that, you can do both.

KS: This probably sounds like a very self-evident thing to say, but *Normal Life* feels like a film made by a younger person. Maybe because it was a about a group of young people who were all about the same age?

ECV: The thing about *Normal Life* is we were all the same age, exactly the same age, and just separated by nationality, ethnicity, and that was a crazy thing for me. I actually regret that we never let them interview us. Because I think it'd be really interesting to go back now and look at it. I was very interested, probably because I'm biracial, like, how do you define something that has never been created? And so Kosovo was a new country and they had to figure out what happens when you wait your whole life for war. Then it happens. Then it's done? It's a rebirth. They all went on to do extraordinary things, and they are still really good friends. I've filmed them over the years, like at their weddings.

KS: But it also feels to me like a film made by someone who has spent a lot of time watching movies. Because it feels like a coming-of-age documentary about a group of young people but also the maturing of a nation. It seems to be directed by someone who is familiar with coming-of-age movies as a genre, even when applied to documentary making.

ECV: *My Life as a Dog* is a really important movie to me.

KS: Me too. And *The Year My Voice Broke* and *Flirting* [a pair of Australian teen movies in the late 1980s that launched the careers of Thandiwe Newton and Nichole Kidman]. I love all the coming-of-age movies from that time.

ECV: *La Boum* [a 1980 French teenage romantic comedy that launched the career of Sophie Marceau] is one of those.

KS: Those are all such special movies. And I love to put those next to American coming-of-age movies and see how we view youth in different places around the world.

ECV: I grew up loving movies. But also I guess my deep dark secret is I'm a very good audience. I'm so open hearted when I watch a movie. I really enjoy it. I cried at *National Treasure*. I was on an airplane, but I was like, "How is this possible? I'm crying during *National Treasure!*"

Notes

1. At both https://www.pbs.org/show/makers-women-who-make-america/ and Makers.com.
2. Charlie Rose, "Ruth Bader Ginsburg 'Yes, I've Heard of the Notorious B.I.G,'" YouTube, September 27, 2017, https://www.youtube.com/watch?v=tQKebo5gewI.
3. The *New Yorker* profile of Alison Jones called "The Nerd Hunter" (Stephen Roderick, March 30, 2015) explains Jones's methods in detail.https://www.newyorker.com/magazine/2015/04/06/the-nerd-hunter.
4. ScreenSlam, "Captain Marvel: Directors Anna Boden & Ryan Fleck Behind the Scenes Interview," YouTube, February 28, 2019, https://www.youtube.com/watch?v=fF10LxoPedY&t=12s.
5. E. Chai Vasarhelyi, interview by Elvis Mitchell, KCRW's *The Treatment*, podcast, July 8, 2009, https://www.kcrw.com/culture/shows/the-treatment/chai-vasarhelyi.

Section 5
The Female Future

Felicia Pride, Jessica Sharzer, Tanya Saracho, Alice Wu, and Erin Lee Carr

The five interviews in Section 5, "The Female Future," are either younger filmmakers or directors earlier in their directing careers. Their movies, Jessica Sharzer's *A Simple Favor* screenplay, Erin Lee Carr's *Britney vs Spears* documentary, Alice Wu's *The Half of It*, and Felicia Pride's mini-studio Honey Chile—point to a female future for American moviemaking and television. If the directors here and throughout this book have turned so many great stories stories into cinema under less-than-great conditions, imagine what is possible when we give them and the generations to follow the support that has historically been given to male filmmakers? Imagine a Stephanie Spielberg, Christina Nolan, or a Quintara Tarantino?

In truth, any of the twenty-five directors interviewed here could have been placed under the section name "The Female Future." From the beginning of this project, I have chosen to speak with filmmakers who not only have an impressive filmography but who I know have great work to come. Every artist in this book, from Barbara Kopple, born the summer after World War II, to Erin Lee Carr, born forty-two years later at the end of Ronald Reagan's presidency is far from done. And we are all the luckier for it.

We will not run out of great things to watch made by women directors. But for them and for us to have a future, consuming will not be enough. I hope our collective future means not only watching the work of the women you read about here, but enjoying it with your people, and shouting out that joy to ensure the female future onscreen belongs to everyone.

Felicia Pride (b. 1979)

Films Mentioned
Look Back at It (2023) (short)
Really Love (2020) (cowriter, executive producer)
Tender (2020) (short)
The End Again (2014) (short, writer/producer)

Television Mentioned
Bel-Air (2023–present)
Grey's Anatomy (2020–2022)
Queen Sugar (2019–2021)

Felicia Pride had already had a long career in the arts and storytelling when she pivoted to filmmaking in her mid-thirties. The Baltimore-born writer, director, and entrepreneur began as a music journalist in 2000, had written six books, run small businesses, and had an active public speaking career before arriving in Hollywood in 2015. But instead of leaving the first era of her career behind, it ultimately came with her too, because after less than a decade in the business, Felicia Pride is writing, directing, producing, teaching, and leading under the umbrella of her production company, Honey Chile Entertainment, aimed at developing and producing for an audience of Black women over age forty. If there is a theme to her career, it may be summed up as always thinking bigger than she is doing right now. And then making bigger happen.

A Film Independent Screenwriting Lab Fellow and a graduate of NBC's *Writers on the Verge* comedy program, Felicia Pride has written three short films, directed two, and served as co-screenwriter and executive producer on the 2020 Netflix feature *Really Love*, a romantic drama about a young painter, Isiah, and a young lawyer, Stevie, in Washington, DC. In television, she had been on the writing staffs of *Queen Sugar*, *Grey's Anatomy*, and currently *Bel-Air*. She founded The Create Daily, a resource and online community for underrepresented voices in 2012.

A 2023 nominee of the Humanitas Prize, Felicia Pride spoke with me in July 2020 and January 2023.

Kevin Smokler: With a last name like "Pride," did you feel like you had to do something magnificent with your life?

Felicia Pride: People always ask me, "Is that your real name?" I do feel a lot of pressure to just live up to my potential and my talent, but the name is a bonus.

KS: Growing up, who were the cinematic influences that set you on a filmmaking and storytelling trajectory?

FP: I didn't have cinematic influences; I had storytellers.... What got me on the path to tell stories was hip-hop. I was enthralled by Big Daddy Kane, Slick Rick, Queen Latifah. They just had this way with words, this way to tell stories in an economical way within one song. That's what got me on the path to—and also not just telling stories, but inserting myself in those stories, and asserting my perspective, my point of view, my voice, my aesthetic. So I definitely feel like even as my relationship to hip-hop has changed over the years, it still is a part of my storytelling aesthetic, whether that be written or visual, for

208 Break the Frame

sure. This very clear voice, "Here I am," has definitely—also, again, like if you know, you know ... we're not gonna explain ourselves to people. We're just gonna be. It's definitely part of the aesthetic as well.

KS: When did the choice come about to tell stories visually? Did you have any moments growing up where you said, "My goal is to be a musician or a DJ or a producer"?

FP: I had so many goals. I have no idea what I was gonna do. It wasn't until high school and college when I had teachers who were like, "You can write. There's something here. You should really think about writing as a path for you." And I didn't know any writers, I didn't know how you got paid as a writer, so I did not pursue that when they told me to. But then I found myself circling back to it for sure. In terms of directing, honestly, it wasn't until after *Really Love* when ... You know, the relationship with writers in film-making is very different because films are a director's medium. TV's a writer's medium. I went through the experience of *Really Love* and I was like, "Oh, there are certain things that I write, that I need to really be a part of the project from start to finish." And there's two ways I can do that: through directing or through producing, in addition to writing. I didn't think I could see like a director. It was actually funny. Lulu Wang [writer/director of the Golden Globe and Independent Spirit Award—winning 2019 film *The Farewell*], who was a friend of Angel's [Angel Kristi Williams, the director of *Really Love*] told me, "You can develop your eye. You can train your eye," which was very encouraging. So I was like, "Well, let me just try it. I don't know. But let me try it." But I just went down taking a bunch of classes and focusing more on working with actors for my classes initially. And then finally, "Let me try it, but when I try it, let me not be doing too much out of the gate." So that's when I wrote *Tender*, because it was meant to be a simple way in—two actors, on location, one day, but still a project that would show my sensibilities as a story-teller, as a director.

KS: Your production company, Honey Chile Entertainment, has Black women over forty as its core audience. Where did this focus come from?

FP: That's how I'm looking to differentiate myself in the landscape.... Someone's whose career I really admire is Reese Witherspoon in terms of what she's done with Hello Sunshine. It's clearly a company that is for Gen X women, particularly aspirational, Gen X, White women, and she's been so smart with how she's connected with her audience directly. She's doing podcasts. She's doing books. She's doing digital. She's doing TV and film. I would probably substitute acting for directing, but I just like how she's very much zeroed in on—if you look at all the main characters in her projects, they're always Gen X, White women. I feel like there's such great Black millennial content and more Black millennial content coming.... I want to carve out a niche for myself because, in honesty, as Gen X, my friends and I just have different conversations. We talk about different things.

KS: I'm assuming that running Honey Chile involves many different skills that you developed with the ones you already had being a writer and director. What are those muscles and different skills? And where do you think you are with them?

FP: Oh, it's hard. Running a production company is really challenging. I mean, I've been an entrepreneur for a really long time. But this is definitely flexing different muscles. Everything from hiring and managing folks, onboarding—one thing that we're really focused on going into this year is operationalizing things, like we are working with the operations consultant to help us with systems and all that stuff. Marketing and sales is also a big one. That's a skill that, you know, I need to flex, and I'm strengthening partnership

The Female Future **209**

development. And then that's just the business part, that's not even the creative, right? Because I still write! I have a job. I'm on *Bel-Air* right now. That's where I'm headed to right now, to go work. So I think also just balancing being an artist, being the head of a company, creating my own work, working in the Hollywood system, balancing all those things at once, is a lot.

KS: Do you feel like you don't do a lot of sleeping or eating?

FP: Oh, no, I sleep more than enough! Sleep is very important to me. I think that one of the things I am thinking about more and more is I do want to have more leisure time. I love leisure. I joke on our *Chile, Please* podcast for Honey Chile that you're supposed to dress for the role that you want. So I started wearing mumus because the role that I want is a life of leisure!

There's a lot of truth to that. I'm going to be a storyteller and creating for the rest of my life. But how do I build this thing? Because one of our ambitions, our mission, for Honey Chile that is very broad and arrogant is helping others, helping Black women, get free, right? But you don't want to just talk the talk. We want to get free ourselves. So how do we build this thing in a way that isn't all-consuming but is still impactful, is something that we also talk a lot about?

KS: Tell me more about the first Honey Chile Fest.

FP: Yeah we filmed *Look Back at It* in Baltimore, and they didn't have the Maryland Film Festival that year, so we wanted to have a screening, and wanted to make it special. And so we connected with Nia Hampton, who runs the Black Femme Supremacy Film Festival from Baltimore. They had screened *Tender*. We're like, "Let's get together!" She's like, "Yeah, let's do it. But let's do it bigger!" It was really Nia encouraging us to be like, well, we're gonna have a venue, we were at the Enoch Pratt Free [Central] Library. So we're like, "let's just do it bigger!" So we had the Baltimore premiere of *Look Back at It* and a Q&A with the cast and crew, who were all from Baltimore. And then we had our first-ever live edition of *Chile, Please* podcast—which is our NAACP Image Award–nominated podcast—and then we had a special guest who's from Baltimore, [bestselling author and podcaster] Ty Alexander. And then we screened films from local Baltimore filmmakers. And it was . . . a lot of fucking work!

It was during the strike. It was a lot of work, but it was amazing! Honeys traveled from Tennessee to come to Honey Chile Fest. The response . . . I was quite overwhelmed by it. It was nothing short of amazing, to be honest. And we had an after party that was DJ by Ty Alexander, who became a DJ when she was a Honey. So just very on theme.

KS: *Look Back at It* does something that also happens in *Tender*, and it happens in *Really Love* too. You put several Black women in a room together and see what happens. And the scenes are always written and acted to make clear that these are very different people.

FP: That's how I grew up, like, that's family. As different as Black people are, and we're not a monolith and blah blah blah blah blah, there is a familial thread for us. And that's why I think we argue like family, we celebrate like family; we don't have to know you to be family, which is a family thing. It's funny because I say that I write about Black love, and I write about Black love very expansively: love of self, romantic love, spiritual love, familial love, love of art, and love of community. That's a thread that is part of what you're talking about.

KS: As a screenwriter, do you start with a moment and then say, "Where can this moment take us?" *Tender* is "two women have just had a one-night stand." *The End Again* is "Exes

210 Break the Frame

meeting up in the loft they used to share." Do you start with the iris zoomed all the way in as a writer and then start to zoom out?

FP: I think there's a truth to it in my short-form work for sure. Because I am like, "How do I make this story contain and make it a full story in a short time frame?" So I definitely think that there's something there with *Tender* and with *Look Back at It*. What I'm doing too is how we use sexuality as a proxy, a proxy to help women understand themselves better. You don't see it necessarily in *Look Back at It*, but in the feature, that's exactly what's happening. And then we see that kind of in *Tender*. People think it's about one-night stand but it's not. People think *Look Back at It* is about an escort, but it's not. So I've definitely used certain proxies, because I'm always interested in how this scenario, situation will help the characters learn more about themselves or get free.

KS: You're turning *Look Back at It* into a feature film, and I know you're making *Tender* into a feature film too.

FP: Yeah, that had to be put on the back burner. I cannot figure out that film. And what's crazy is I wrote a full feature-length version of *Look Back at It* before *Tender* the short, but I cannot figure out that film. So I was like, "You know what? I'm not ready. Let me go back to it. Let me get back to it."

KS: I want to talk about your two short films *Tender* and *The End Again* as kind of siblings. I'm not sure I have an actual question here. I might just stop talking and let you take over.

FP: That's cool.

KS: Both *Tender* and *The End Again* are about aftermaths. At the same time, they're both about intimacy and vulnerability, even though one is about the potential beginning of a relationship and one is about the definitive end of a relationship.

FP: I think that I am definitely drawn to stories about intimacy because I feel like intimacy is the stripped-down thing that we actually really want. I think sometimes there's a lot of things that are put on top of it … relationship, all of that stuff, sex, all that stuff. … But at the end of the day, I'm really just struck by that intimacy is the stripped-down core need. I think, also, I'm exploring it because I want to see, again, typically I want to see more of it in my life or I want to see more of it on screen, so that also has something to do with it. I have to be able to tap into my vulnerable self in order to get to the work, in order to create the work, in order to put out the work. It's all vulnerability. I think the more vulnerable I can be, the better my work is.

KS: On that topic, and I'm going to apologize up front because this is a completely self-interested question, but how much was *love jones* an inspiration for *Really Love*?[1] Because *love jones* happens to be one of my favorite movies of all time.

FP: It's one of my favorite movies of all time. It was a huge inspiration. When I first met Angel—we actually met at a cookout here in LA—and she wanted to direct more. And I asked, "What kind of stuff?" and she was like, "A romantic, you know, romance." And I said, "Well, I have a romance!" And I described it to her as *love jones* meets *Blue Valentine*.[2] And she was like, "Oh, I gotta read that!" So that's how we connected. I attached her to the project in that way over shared love of wanting to see this sort of Black romantic drama that would pull at the heartstrings, but also feel like real life.

KS: When you say "*love jones* meets *Blue Valentine*," the idea was that this was going to be a movie about a relationship *not* working?

FP: Yeah, we know that this is a movie about a breakup, essentially. This is a movie about two people who cannot make it work. Yes. From the jump. Because the original title of the movie was *Open Ended*.

KS: In a chronology of the plots of Black romantic dramas, *love jones* is on one side because the characters are just out of college, and *The Photograph* is on the other because the characters are very professionally accomplished.[3] *Really Love* is right in the middle of that because it's concerned with people on the way up.

FP: Yes. Which was very much based on my experience as an artist in DC. I feel like I'm both characters: Stevie in terms of the challenges of dating an artist, and then being an artist myself and being obsessed and consumed with your career and feeling so misunderstood, but then also being in a place like DC that has some Black wealth, and a lot of Black "excellence"—and feeling the pressure of that and those two experiences together.

KS: So much of your work is about love and intimacy, but the unique thing about *Really Love* is how it is also about timing. Really the key line of this movie is when Stevie's mother says, "Some people are only supposed to be in our lives for a season."

FP: I love that scene! I think timing is also crucial to the artist, right? And our relationship with timing can benefit us, fuck with us, be a part of our creative process. So I think looking at timing, both in its relationship to being an artist, and then timing in terms of, like, your expectation for how your life would go then timing in terms of the peaks of love. Love is one thing. But you have to add relationships on there, you have to add aligned ambitions, you have to add background and family; all these things to make a relationship work that has nothing to do with love and timing is one of those things. So we were really interested in exploring "they don't break up because someone cheated." They break up literally, because it's not the right time.

KS: I really appreciated that. The way the scenes unfold, that they take their own time to happen and you realize that these are both people who keep a lot inside and need a lot of time to open up to someone else, underlines the theme of the movie. I really think this is a movie about patience.

As the screenwriter and executive producer, did you have any conversations with the director where you were like, "Listen, this is not rapid-fire dialogue—this is not thirty seconds and then we cut to the next scene"?

FP: Angel and I had a really collaborative relationship starting out on this project. It was really nice, because we had time to collaborate before a lot of cooks got into the kitchen, which happens with productions. So we were able to talk about everything from music, to feeling, to our own experiences, as we were further developing the script. I feel like she took a lot of that into the production of it. And I was on set for most of the production as well. But I think that we were, at the forefront, clear on what we wanted. Now, of course, it can be tough in execution to get everything that you want, and you got budgets and things have to be cut. But I think we had a nice amount of time from our writer/director relationship in the beginning to really think about what we wanted.

KS: The movie opens with a montage of Washington, DC, set to a Meshell Ndegeocello song. I have a feeling you feel the same kinda way about her music as I do.

FP: Oh, you know, I do! I actually had—I will say I had nothing to do with that. That is an original song by Meshell that I was able to secure through a friend, and how fucking perfect? That's all I can say! Perfect, perfect. Meshell, you know, being from DC and coming up through Go-Go and really saw the film and wrote to it. Come on, that's priceless!

212 **Break the Frame**

When we talked about music, our goal was to bring the Black film soundtrack back. Like very arrogant, right? But we wanted to have a movie that had a soundtrack people wanted to buy, and download, and listen to for sure. That was one of our goals. And I feel like Angel, and the music supervisor, and our composer, Khari Mateen, really put their foot in it for sure.

KS: There is an aesthetic that I associate with your work and *love jones* and with Meshell Ndegeocello's music, and here's my stupid term, so feel free to correct this, but which I call the Black bliss aesthetic, which is this idea that there's a certain amount of glory and beauty and calm and stillness in Blackness, a certain amount of luxuriating in Blackness. Feel free to do whatever you like with that.

FP: I love that. Because I'm very clear that my ministry is not to prove Black humanity to White folks. My ministry is to illuminate the fullness of Blackness: Black people, our interior lives, our exterior lives, to ourselves. So I feel that connection with what you're saying in terms of the stillness and blackness and sitting in it, and not being afraid of it and not turning away. I definitely feel that. Tremendously.

KS: What kind of set do you like to run?

FP: A sense of calm. Some sets are really tense. Even though we had to shoot *Tender* in a day because that's all we had, I'm like, "This is not the end of the world. This is a joy."

I also want there to be a lot of feminine energy on set.... I think that was also really important to me is that I create a space, and help to create space, where everyone can feel like they can do their best work. That means, also, not getting in their way.

KS: You have been very forthcoming about the steps taken to get you where you are now. What are the takeaways you want to make sure, say, a young person reading this, gets?

FP: My fatal mistake, which was that I stopped writing.... There are ups and downs financially, and you may have to get a job. There's nothing wrong with that, but don't stop the creative practice because it's going to be so difficult to try to get it back. The biggest other thing is having a healthy relationship with the work and making it all about the work because the business is a separate entity and the business can take all types of things away from you ... credit, money, all of that. But the work is the most important thing. The work is what you can control and the work is where from which everything springs ... joy, freedom, all of that. I had a conversation with my mentor. She's like, "Well, what is it that you want to do?" I was like, "I want to write and create." And I was like, "And I want to do that for other mediums, like film and TV." She was like, "Well, you should move to the biggest market. What do you have to lose?" This was the day before Thanksgiving 2014. Move to LA. I had always brushed it aside because it just seemed impossible for me, seemed too far away. But in that moment, I made the decision because I knew if I didn't try it one last time I was going to have to end up getting a job and probably just being in that job and not actually going for becoming a writer again. I was thirty-five years old. That was a reckoning. That was a big one. I would say the second one was when I got laid off working out here.... I was devastated, but it was also that moment where I was like, "Well, Felicia, you came out here to write, create, but you're on this track to be an executive, to be a VP next. Is that what you really came out here for?" So that was the next sort of reckoning where I was like, "Okay, I need to be focused on why I came out here and really, really get back to my goal and my mission."

KS: How have TV writer's rooms changed for you, given that you are an experienced professional now and not a rookie?

FP: Luckily, my first writer's room experience was on *Queen Sugar*, a show created by Ava DuVernay, a Black woman, a show run by Anthony Sparks, a Black man. Anthony has been in horrible rooms, has been in wonderful rooms. When he got his chance to run a room, he really wanted to create a space, and he did this successfully, where people could be their full self in the room. I think that is always where I always did my best work, when I can be my full self, my full Black female self with bringing experiences to the table, the life experiences, life lessons, all of that, bringing my whole self to the table. I've been very blessed. You hear friends that have been in incredibly toxic rooms. I have not experienced that, thank goodness.

KS: So much of your work seems to be asking of its characters, "What do we need as people to move forward?" Are you a naturally forward-looking person?

FP: I'm not very nostalgic. I think also because I have "reinvented" myself a lot that sometimes the past feels very fuzzy to me. So I don't lean on the past that much, which I think has also helped me move in fact quickly in this business. Because I have found colleagues who have done amazing things in the past and lean on that, and Hollywood doesn't give a fuck.

One thing that I notice about my work is that most of my characters are trying to get back to themselves. And they're moving forward, really, though, to get back to themselves. So in my work now, that hit me recently: "Oh, that's kind of what I write about."

KS: Who are your mentors? Who are your peers?

FP: My mentor's definitely Anthony Sparks, who was my showrunner on *Queen Sugar*. He has been an incredible mentor to me about this business, but also craft, like just getting better at our craft because he's such an incredible writer. I love Dee Rees; *Pariah* is one of my favorite films. There's a restraint that Dee has in her work that I really, really like. And Lulu Wang? Exquisite! I studied *The Farewell* and she did not let anything go to waste in the frame. And I loved that about her work. She's a beast. In terms of peers, I have a fantastic writers group, so I'm just going to shout them out. Rochée Jeffrey, who's an amazing writer, director, filmer. April Shih, amazing TV writer. And we are all kind of coming up together.

KS: Your name comes up a lot when I speak to other directors as someone who is really doing right by themselves and by others in this game. I really get the sense you place a priority on having good relations with your fellows.

FP: I think that it's this business. "Hollywood" is fucking nuts, right? And I didn't grow up in this business, so a lot of things that happen in this business do not make sense to me. I think they're toxic. I think they're odd. I think they're weird. But integrity has always been something important to me, and when you move with integrity, and you also have a spirit of service, which has been part of the fabric of my career for as long as I can remember. That has been my two guides: have some integrity and be of service. It's not as common as you think out here. So I think that good people find each other. Not "good" in that way, but people who have similar purposes and see the world in similar ways find each other and look to support each other.

I moved to LA at thirty-five. I had a very strong sense of self. And as I continued to do the work, my self-work—the therapy, the journaling, the shadow work, all that stuff—I have a strong sense of like, "I'm not in competition with anybody." ... I have my lane, I have my thing. There's more than enough for everyone to go around.

KS: You were not twenty-one when you came to Hollywood. You had a significant amount of professional experience behind you when you arrived.

FP: I think that there are some people who think I came out of nowhere because what I get is, "Wow. It happened so fast." And I'm like, "I've been writing for nearly twenty years." I do think there may be some truth to that, but I was able to do it fast because of the twenty years behind me. Because I know how to deal with people, which a lot of this industry, the people … Because I'm comfortable in my skin, so I didn't shy away from my age. I leaned into it. Because I've run a business, there is some savvy in there in terms of how I think about my career. Because I came from different places, I have an incredible network that goes beyond Hollywood, which I think is important.

I was like, "I don't have the time to do it how y'all say it's supposed to be done because I just don't have the time." I think those things helped me with moving the way that I have. One of my charges in life is to protect my Black joy, and that is a full-time job. There are certain things that I don't do because my Black joy is more important. Also, I think age has helped me to be like, "I don't have time for a lot of dumb shit." So, for instance, I had this woman who works in the business. She sat down with me, and she came from journalism. She says, "You should consider working at one of the big agencies for a year to gain contacts." She's like, "It'll be soul-crushing, but it'll be worth it." I said, "I have no time to have my soul crushed. I'm sorry. I just don't." … The armor has helped me to be very deliberate about what I will do and what I want to do, what I have time for, what I don't have time for. It has helped me tremendously.

Jessica Sharzer (b. 1972)

Films Mentioned
A Simple Favor (2018) (writer)
Dirty Dancing (2017) (writer)
Nerve (2016) (writer)
Speak (2004)
The Wormhole (2002) (short)

Television Mentioned
American Horror Story (2011–2015) (writer/producer)

Actor Launched
Kristin Stewart

We often don't know it as movie lovers, but one of the things we ask our favorite writers and directors to do is show us our favorite actors as we've never seen them before. A walk through the work of veteran screenwriter-producer Jessica Sharzer shows an artist particularly skilled at this: Did we have any conception of Blake Lively as a villain before Sharzer's screenplay for *A Simple Favor* gave her that delicious villain dialogue? *Speak*, her 2004 debut film about a teenage girl who stops talking after surviving an act of sexual violence, had a retiring wallflower type as its main character in the original novel. In adapting it for the screen, Sharzer chose a thirteen-year-old up-and-coming actress with a bit more screen presence that you may have heard of named Kristin Stewart.

Raised in New York City, Jessica Sharzer planned for a career in academia before leaving a graduate program in Slavic languages and literature at UC Berkeley and, soon after, enrolling at NYU film school. Her graduate thesis short film, *Wormhole*, won the Wasserman Award, the program's top honor, which led to signing with her first agent and moving to Los Angeles. Sharzer received three Primetime Emmy nominations for her work on *American Horror Story* and nominations from both the Directors Guild and Writers Guild of America for *Speak*. As of this writing, her screenplay to the sequel to *A Simple Favor* is currently in production.

I spoke to Jessica Sharzer from her home in Los Angeles in November 2022.

Kevin Smokler: You're not the filmmaker who always dreamed of having this job, right?

Jessica Sharzer: It just didn't cross my mind. I was a theater kid, so I was sort of on the path without knowing it. I did summer stock in the summers. I was in all the school plays. I worked on the crew behind the scenes. I went to the theater a lot. So for me it was all about theater, which you know, is a natural segue to filmmaking. I just didn't know I was headed that way.

KS: And yet in your work I see a palpable love of movies, where a Jessica Sharzer screenplay seems to be talking to other movies like it.

JS: I was one of those pretentious, geeky kids who loved the Merchant-Ivory films [aka the forty-four movies made between 1961 and 2005 by the directing/producing team of the late Ismail Merchant and James Ivory, including *Room with a View* and *Howard's*

218 Break the Frame

End]. I was a huge fan of those when I was twelve and thirteen. So it wasn't just mainstream movies, although I love those too. Certainly the John Hughes movies had a huge impact on me growing up, and I must have seen *The Breakfast Club* fifty times. But I also really liked foreign films. I liked art-house films, I loved indie films, and I felt inspired by them again, even before I knew I was headed into this field. I just really liked that movies took me to another place and into a point of view that I didn't share and gave me an escape and an experience and a window, often into cultures I didn't know, so it felt my love of travel was sort of answered by movies because I could go to different countries and different time periods in history. And I just had a lot of curiosity about learning about those things, but not in a kind of dry, textbook way. So for me, movies were a way of thinking differently and learning about people in places without it feeling academic.

KS: Growing up in New York City, were you a take-the-subway-downtown-to-the-Angelica-Film-Center kind of kid?

JS: I went to the Angelica a lot. I went to the Film Forum a lot, the Quad, you know, all the art-house cinemas, and I was very independent. When I think about it now, having kids, it's a little bit horrifying, but I took the subway everywhere.

KS: You were born in Iowa City but really spent your formative years in New York. But I sense in your work an interest in the American Midwest. Do we have John Hughes to thank for that or a longtime collaboration with a Detroiter named Paul Feig [director of *A Simple Favor*]? Or something else entirely?

JS: It's funny because I don't have any conscious memories of living in the Midwest or of living in a small town. I basically grew up in New York City starting at age five. That said, I am drawn to stories about small towns and especially coming-of-age stories ... the sense of being an outsider in a culture. I grew up in a pretty diverse city and neighborhood, so it wasn't my direct experience. But I think I was fascinated by what it means to feel like an outsider in your hometown.

KS: Your debut film, *Speak* [2004], is all about that and, as I see it, some of the kinds of movies you mentioned watching growing up. It has the kind of hazy afternoon light that both John Hughes and Cameron Crowe movies and *ABC Afterschool Specials* [TV movies the network ran from 1972 to 1997, usually about young people and a socially relevant issue like teen pregnancy or suicide] had, as well as long, quiet, flat shots in, say, the original *Halloween* horror movie.

JS: The thing about *Speak*—and I'm not trying to disown that movie at all—is that it was made so fast for so little money that I wish I could have controlled the look of the movie more. *Speak* was shot in just twenty-one days, with a lot of nonunion crew because that's what we could afford. And we had actual children, which meant we had nine hours a day to shoot from the time that the kids left the hotel to the time they got back. We had a lot of constraints. I still love the movie and I still believe in it. But it's hard to talk about the look of it because we just had so many limitations that it was really hard to control each shot. I love it, but I would love to try again with a little bit more room to get the shots that I want.

KS: There's a jagged line from your award-winning student film *Wormhole* to *A Simple Favor* [about two women, played Anna Kendrick and Blake Lively, who each discover the other is hiding a violent past] and, metaphorically I guess, *Speak* in that they are all about women hiding in plain sight or vanishing.

JS: I've always been drawn to thrillers and I love genre storytelling. I love peak, intense experiences. And a missing person is such a ticking clock. I get offered a lot of projects where there's like a dead woman or a dead child at the center of it. And those actually interest me less, because, yes, there's a mystery, but there's no ticking clock because the person's already dead, whereas a missing person, you have a sense of at least a shred of hope, where you might be able to locate that person. You might be able to find them in time.

KS: On the topic of genre storytelling, have you ever put out an APB to your representatives for a bank robbery movie or a heist project?

JS: It's so funny. Because I am literally writing a bank robbery movie right now. I generally don't like heist movies. Heist movies are problematic because it's hard to root for people stealing money. You have to have some kind of deeper motivation.

KS: There's also a real emphasis on the clockwork of the plot in heist movies more than the people, and at some point, you're like, well, I'm just watching the inside of my watch go round and round for two hours.

JS: I can count my favorite heist movies on one hand. I mean *Dog Day Afternoon* [1975, starring Al Pacino, directed by Sidney Lumet, nominated for six Academy Awards] is one of my all time favorite movies, but I would hardly classify it as a heist movie. It's a character drama.

KS: Can you be from New York and not have a special relationship with *Dog Day Afternoon*?

JS: Well, Sidney Lumet is one of my favorite directors. My other favorites, Hal Ashby, Bob Fosse; they all have something in common. But grounded, historically relevant films [are favorites], often true stories that often have a really sad ending. I mean *Dog Day Afternoon's* one, *Coming Home* [a 1978 drama directed by Hal Ashby about the trauma of the Vietnam War on both soldiers and their spouses and families starring Jane Fonda and Jon Voight] is another. These are really heartbreaking movies. I don't know why they stay with me longer, but I just love a good down-ending movie.

KS: *Speak* has a bittersweet ending too. Kristen Stewart doesn't seem to make too many movies with happy endings. Do you ever see Kristen Stewart out there being fabulous and think to yourself, I saw something in her before anybody else did?

JS: Well, I can't really claim that credit, because before she had done my movie, she had done *Panic Room* with David Fincher.

KS: Except she was a child in that movie.

JS: I hadn't seen *Panic Room*—to be fair—and when she came into the audition, it was very, very clear that she was going to be a huge star. And the truth is, she wasn't actually physically the type described in the book. . . . But she was such a star that if, you know, all I could think was, How can I not cast her in this role? I want to watch her, other people will want to watch her. And she was dying to do it. She came to the first meeting with me and she had a dog-eared script with notes on every single page. And this was just the first meeting. And she was thirteen. And she had read the book and had dog-eared notes and all of the book. And she just was so smart. She was so intense about the work. I really admired that about her. She was going to have a huge career whether or not I had anything to do with it.

KS: May we discuss *A Simple Favor*, which I have about a zillion questions about?

JS: Sure.

KS: On the *A Simple Favor* director's commentary,[1] you mentioned the two big changes you made in writing the screenplay were to stick with one character's point of view instead of a switch in the middle [which happens in the original novel], in order to avoid comparisons

220 Break the Frame

to *Gone Girl* [which had been released five years before *A Simple Favor*], and the Henry Golding [who plays Blake Lively's husband] character not be part of the scheme at the movie's center so the primary relationship would be between the two women. How did you decide these were the changes you wanted to make?

JS: I took a big risk when I went into the interview. I just said, you know, *Gone Girl* came out first. And it wasn't like a small movie nobody saw. And I just felt that we were going to suffer by comparison. If we stuck to the book, to me the book almost felt like fan fiction of *Gone Girl*. There had already been a bunch of books that had this unreliable female narrator who gets involved in a situation that then they can't get out of. So there was a trend, let's say, and we were trying to figure out how to stand apart from that trend, as opposed to feeling like an also-ran.

Ultimately, standing apart was about comedy. That was the thing that the other movies weren't and the other books weren't doing. They were basically very self-serious. And we had certain elements from the book that were inherently funny. A mom blogger just felt like a funny character. So we leaned into that. The other thing I came into the interview with was that this is really a story about modern motherhood. And it's a conversation I have with my female friends all the time, where the stay-at-home moms are self-conscious about not having careers and not making money. And the working moms feel guilty about not spending enough time with their kids and not being hands-on enough. It's a grass is greener on the other side situation where both sides are looking at each other with judgment and envy. And I thought that was interesting. And I hadn't really seen that in a movie, or at least not in a genre movie. And I was really interested in that. And it was very relevant to my life and the conversations I was having. So I figured other people must be having these same conversations.

KS: A lot of the plot of *A Simple Favor* happens in the past. I look at the other adaptations you've done … and I get the sense you look at the original texts, and what speaks to you is often what is implied but not explored. I'm thinking about the remake of *Dirty Dancing* you did, which says, "Well, there's probably a whole story to Baby's mother that isn't in the original." Tell me if what I said speaks to you. Or do I just think the great Kelly Bishop, playing Baby's mother in the original, got done wrong by not having her character be big enough?

JS: Well, it wasn't so much a correction because honestly, the original movie I think is a perfect movie. And it meant so much to me growing up. I didn't take the job to try to fix something that was broken. And in fact, what I learned the hard way through doing that movie is that there are just some movies that are untouchable. People absolutely hated the *Dirty Dancing* remake, almost across the board. It got panned by audiences and by critics. And the thing that was painful about that was I'm such a fan of *Dirty Dancing*. And I loved writing that project. And I wanted to actually honor the original rather than try to fix it. I never approached it from the point of view of fixing it. You can't control the outcome of how movies are received. It's one of the painful things about being in this business, but I just really enjoyed the writing part of it.

KS: I really enjoyed your version of *Dirty Dancing*. I've seen the original a bunch, but I think it's top heavy with great actors like Kelly Bishop and Jerry Orbach [playing the main character's parents] who don't get enough to do.

JS: It's funny. Bruce Greenwood, who plays the dad in the remake, and I had a really interesting interaction with him on set. It actually gets me a little emotional talking about it.

I walked up to him, and I told him that I was inspired to write the character, like my father, because my father was a Jewish doctor, and I was his daughter, and I felt a real strong connection to that dynamic, that Baby adores her father. And she thinks that he walks on water, and that they both have a mutual, you know, fall from grace in each other's eyes in the movie, and it's painful for both of them. And I wrote the voice of that character as my father, and I was telling Bruce Greenwood that, and I got all choked up and I had to walk away.

KS: To get back to *A Simple Favor*: This is gonna sound insulting to the book, which I like very much, but the plot of *A Simple Favor* is complete nonsense but in a self-conscious way, like it's almost telling you as the reader not to quite believe it. So you as the screenwriter have had this very difficult task of what do you do with nonsense that knows it's nonsense and still make a believable story for the audience.

JS: Mostly I want stories to psychologically make sense, why the characters are doing what they do next. Can't just be because the plot requires it. For me, one of the biggest hurdles in adopting that book was that Emily's plot to get the insurance payout involved her twin sister, from whom she had been estranged for many years, but it required her to use her twin sister and to murder her. And I thought, well, well, that's a lot to lean on. For a plan, it's not a very solid plan, because how does she know the sister is going to comply with this plan, even on the most basic level? So one of the big changes I made was she doesn't have a plan when she goes to meet with her sister, and it's the sister's death that actually produces the new plan, which is I can stage my own death, and I can collect an insurance payout. This is going to be great. And that was not the way it was in the book. But for me, what's really important, even in something as absurd and stylized as *A Simple Favor* is, it still has to make sense from the character's point of view. And that's really important to me because the actors at the very least on set are going to say, "Why am I doing this?" And if you don't have an answer to that, and again, I'm not necessarily going to be on set answering that question, but I would never want to put a director in a position where there's no answer to why. There has to be a good answer to why.

KS: I think *A Simple Favor* and *Nerve* [a 2016 film starring Emma Roberts about an online Truth or Dare game that goes terribly wrong] are both movies that are self-conscious about the time in history where they take place. And yet I appreciate the fact that your movies don't lean heavily on contemporary slang and therefore feel dated quickly. In the case of *A Simple Favor*, how did you take a movie that, set in the present, clearly references past eras [sixties French music, forties film noir plots] almost for fun. But your dialogue doesn't make you groan, "Uh, how 2019!" when watching it.

JS: I really love movies that are timeless. And it's hard to do that because technology is very of the moment, pop culture references are very of the moment. Sometimes that's fun. But for me, I always have a goal of trying to make a movie timeless in whatever ways that I can. To me, the perfect movie has a modern sensibility without being stuck in a particular moment where it's irrelevant six months later.

KS: Thematically, a lot of *A Simple Favor* is about secrets and hiding from one's past. Those are quiet themes often defined by silence. Is it difficult to convey them out loud with dialogue?

JS: The idea that both of these women have dark and dirty secrets that define them was always there from the beginning. And frankly, it was in the book. So it was me taking what was in the book and leaning into it. But I loved the idea that these two women who seemingly

222 Break the Frame

have nothing in common are going to share their deepest, darkest secrets with each other. And that creates a bond because essentially, you hand someone your kryptonite, and they can use it against you.

All of our secrets are weapons. And I thought that was very interesting. And this was something I actually discussed with the first executive I worked with on the project, that Stephanie [Anna Kendrick] is desperate to be friends with Emily [Blake Lively], and her offering is to bare her soul and to tell her deepest, darkest secret because she needs to prove she's not a square. She needs to prove she's as dirty as Emily. She's just as dark, and she has as many skeletons in the closet. And, half drunk, she throws that out, and it is the thing that actually seduces Emily into the friendship. And I just thought that was really truthful and really interesting that that is how we pull each other closer, is through our secrets.

KS: *Nerve* is a movie to me that feels very contemporary and looks very . . . eighties neon noir to me. The movie is shot in gaudy, bright colors set against the deep blacks of night.

JS: I envisioned *Nerve*, much like the *Catfish* documentary [2010] that the directors had done, where I thought it was all going to be very gritty and handheld and feel like it was all shot on an iPhone—and is totally not the look of the movie, as you know from having seen it, which is fine. But this is where it's interesting to see how movies on the page get, you know, translated to film, and obviously any director who would have done it would have taken it in their own direction. So, you know, it's much glossier and more neon and more cool than how I envisioned it. I really wanted it to be a cautionary tale for teenagers that felt like a nightmare and more than a fantasy. I wanted the first half to feel aspirational, and the second half to feel like a total nightmare. And my script was actually much, much darker than what ended up on the screen. But that's the process. You know that's how movies come together, and they don't always follow what the writer had in their head.

KS: Can I ask you about writing for an anthology TV series? You did a big chunk of writing and producing for *American Horror Story*, and, frankly, I cannot imagine a bigger challenge for a screenwriter than an anthology television series. Not only do you have to create original stories for that particular season of the show, but you're dealing with actors who are playing different characters and yet are part of the series at the same time. So you have the episode you're writing, how it fits into that season, the memory of characters those actors have previously played in other seasons, and, finally, whatever assumptions we have about those actors as performers or famous people that already exists. You as the writer and producer have to work on four levels at the same time.

JS: I mean, it was so wonderful. And [showrunner] Ryan Murphy, obviously, is a huge magnet for actors. So he can literally pick up the phone and call Jessica Lange or Lady Gaga and, typically, he can convince them to come do the show. Most people in Hollywood can't do that. So we had the most amazing actors, I think, ever assembled on TV. It was absolutely incredible. And they enjoyed having new characters to play every season, and Ryan's approach was always what did they do last season? How can we make it as different as possible from that to the next season? So it gave the actors something really fun to do. I think the nightmare for a lot of actors about doing TV at all is that you get stuck in the same role for years and years, and it gets boring. And we never had that. I mean, you didn't have time to get bored, you got one season to play that role. And that was it. And you were done. And so I thought the structure of that show was genius because each season was

new but also familiar because the faces were familiar. But those actors got to play something new every season. It was a very smart engine for a show.

I was with the show from the first season. So the truth is that no one knew what the show was when we started writing, including us.... I got to see it be born as both a show on the page but then a show that the world really reacted to in such a strong way. I mean, it was a giant hit out of the gate. And that happens so rarely. And it was a really magical thing to be part of.... The first season we were at the Golden Globes and at the Emmys, and that just almost never happens. So I was really lucky to be part of it at all. And we found the show, you know, along the way. Ryan Murphy certainly comes in with a tremendous amount of ideas. And he's very confident in his ideas. And he's very good at communicating them to a writers' room. But there were also ideas that were born in that room. And that was super exciting to be part of.

KS: Tell me about the professional work of being a screenwriter from how a day or a week breaks down from a business point of view versus when the sort of creative work gets done.

JS: What I love about the work is that it's varied, depending on what stage you're at with a project. I'll take general meetings just to get to know different companies or producers or executives around town. So that's one version of, you know, what I might be doing. I might be preparing a pitch where I'm writing a presentation and putting together images to try to get a job. I might be breaking a story, which means, you know, I've already got the job, and now I'm breaking it down. And usually that involves index cards for a while before I will let myself start writing. I might be taking notes and getting notes on a project. And typically I'm doing all four or five of those things at the same time.

I get bored very easily. Every day is very filled with lots of different stuff. And then a lot of times on the weekends, when I don't have my kids, my favorite thing to do is just shut off my phone and write for ten hours because I end up needing blocks of uninterrupted time. And during the week, it's almost impossible between kids and meetings and calls and all of that. But when I know what I have to do, I love to just blast through it and have a long writing session on a Sunday.

KS: So it's a little juggling over here and cartwheels over there and then jumping jacks ...

JS: I do like that—also really like the focused time with writing. What I've started doing, which I had never done before in my career, is canceling meetings so that I can have a stretch of writing time. And I never used to have the confidence to cancel anything. But now if I really know that I need a six- or eight-hour block to write, I'll just clear my schedule to do that. But I like to go back and forth between super-serious, focused writing time. And then the juggle keeps it interesting.

KS: We've spoken before about other filmmakers and screenwriters you've worked with and whom you admire. What role do these kind of both professional and personal relationships have in your life as a screenwriter and director?

JS: It's funny. Angela Robinson, who's a big writer-director in her own right [*The L Word, True Blood, How to Get Away with Murder*], we've been friends for, we figured it out, like twenty-four years since film school. And we finally worked together on a project last year. And I say that because the relationships you have in entertainment really do lead to work. We've known each other twenty-four years, and that was the first time we worked together. So it's not like an automatic thing. It doesn't always happen the next day. But you meet people at dinner parties or you meet people at the playground, at school. And over

224 Break the Frame

the course of talking to them and getting to know them, projects actually come together from that.

People ask me all the time, do I need to move to LA to be a Hollywood writer or producer or something? And I try to say, you know, answer in a diplomatic way. And obviously Covid and Zoom have changed some of that answer. But the truth is, you do need to be in LA because of the chance meetings and because of those bonds. And I really believe it's incredibly important to treat everyone well, partly because it's the morally right thing to do. But also equally, it's the professionally wise thing to do. Because I know that my students at USC are going to be running studios in the next ten years. And I'm going to be working for them. And all of the assistants that I met when I got to Hollywood are now very high-level producers and executives that I'm now working for. So you want to really be treating everyone well and also interested in who is that person who just answers the phone when I call my agent. That's a person with a future career ahead of them that you're going to want to know about. So get to know that person.

KS: Your career is tilting more and more towards directing. How does that work sit alongside all the work you've done as a screenwriter?

JS: When I put something on the page, I'm always picturing how I would shoot it. And I'm trying to translate the shots into words. Now I might hand that script to Paul Feig. And he may shoot it in a totally different way than what I thought I put on the page and how I would have shot it. But that doesn't make it wrong and it doesn't mean I failed, it just means that we're two different people. And we have different senses of humor and different perspectives and different senses of what's cinematic. And so, to me, you know, with *A Simple Favor*, in particular, the collaboration was wonderful when we both obviously felt great about it enough to do it again, because he brought things to it I never could have imagined. And so the sum of the parts was just greater. I thought that our sensibilities really meshed well together. And so in a perfect world, the director is enhancing what the writer is doing, even if the director and the writer are the same person.

The other thing that happens when you're on set is that sometimes you get lucky and magic happens, and it takes your story in a slightly different direction. And the important thing about directing is staying open. You want to be very prepared. But you then want to stay open to what's actually present in front of you. And are you open to it enough to be able to take advantage of it and capture it on film? Because you can get some magic moments that you know you couldn't have anticipated when you were writing it.

KS: The stray cat wandering onto the set of *The Godfather* crawling into Marlon Brando's lap.

JS: And then that becomes you know, an immortal moment in movie history, right?

Tanya Saracho (b. 1977)

Television Mentioned
Vida (2018–2020)
How to Get Away with Murder (2015–2016)
Looking (2015)

Theater Mentioned
Fade (2016)
Mala Hierba (2014)
Our Lady of the Underpass (2009)
Enfrascada (2008)

Actor Launched
Melissa Barrera

Mexico born, Texas raised, Boston educated, and a veteran of the Chicago theater scene, Tanya Saracho may be best known as the creator and showrunner of the beloved but gone-too-soon television series *Vida*, the first prime-time cable show with an all Latine writers' room and all female department-headed crew. *Vida*, the story of two sisters inheriting a bar in the Boyle Heights neighborhood of Los Angeles from their deceased mother, asked hard questions of its cast and of us: about colorism in nonwhite communities and who a neighborhood really belongs to, then offered no easy answers. It dared to venture to places where even premium cable hadn't before and did it while still being funny, sexy, beautiful, and with a soundtrack almost entirely in the Spanish language. *Vida* received the 2019 GLAAD Media Award for Outstanding Comedy Series. In October 2023, *The Hollywood Reporter* included *Vida* on its list of "The 50 Best Television Shows of the 21st Century."[2]

Vida may mark the point at which television audiences recognized Ms. Saracho's talent, but there's a lot of "before *Vida*" to spend time with and, it would seem, plenty of "after." In Chicago, Ms. Saracho cofounded the Teatro Luna theater group and the Alliance of Latina Theater Artists. Her twenty plays have been awarded an NEA Distinguished New Play Development Grant and continue to be staged nationally. In 2010, She was named "Best New Playwright" by *Chicago* magazine. In 2020, she signed an overall deal with Universal Content Productions to develop original projects for Latine audiences and administer a television writing lab for Latine talent. The deal was re-upped in early 2024, and as of this writing, Saracho is at work on *Brujas*, a television adaptation of her 2008 play *Enfrascada*, about four Afro-Caribbean women in Chicago, a feature film adaptation of her 2014 play *Mala Hierba*, about a Texas trophy wife and the reappearance of her first love that Saracho will direct, and a television series about Annie Oakley and Spanish-Mexican trick-rider Señorita Rosalie, both stars of the Buffalo Bill Wild West Show.

I spoke to Ms. Saracho in May and June 2020 and January 2024 from her home in Los Angeles.

Kevin Smokler: When we first spoke a few years back, I asked you if the next step in your career was building an empire like Lena Waithe or Ava DuVernay. You said, "That's

228 Break the Frame

where I'm headed. I got this vision board that I'm putting things on!" Now that you have renewed your deal with UCP, how much of the vision board has come to fruition and how much is left?

Tanya Saracho: So there ... was a strike that happened, and we were talking during a pandemic, right? And because I'm a "Latina" in Hollywood, you have to sort of take that into consideration. Because I had all the tools from UCP to make this dream happen, but the industry is resistant to a lot of the stories that I want to tell or the way I want to tell them and my Latinidad ... we're still going for it. So like everything we've taken out we've sold, and then we set it up, and then after the strike, I lost a lot of the stuff. Right now, it's sort of about picking up the pieces. I think UCP has faith in me enough to be like, "Let's keep going!" I mean, as far as our part, it's a good track record, you know, getting multiple bids, all that stuff. And then it's getting stuff on the air or streaming.

I'm looking at it anthropologically too, like, "Look at how many of us are not doing it! And look at how many of our shows are gone." And so I have to question that because for the past four years, it's been like, "Wait a minute, we had everything, and I think the stories were good, and access, and we sold them, and then ... what happened?" But we're still gonna keep going with the same dream but with more Band-aids because, you know, those months of the strike. And then also, for me, people weren't pulling the trigger the same way through the pandemic on "Latina" things, if I'm watching the landscape. So I'm just trying to be an individual in this and take responsibility, *and* my flowers, *and* all the stuff for the good stuff that's happened, and the bad. *Vida* gave me access to a lot because of the work. But then the industry is resistant to the story. So it's a really weird place. But it's the same dream, just more grounded ... and a little bit broken.

KS: I would assume that the renewal of your deal with UCP is contingent upon your well of ideas being very deep.

TS: Yeah, and then we have these projects that we're already working on. The ideas and the projects are always there. It's more like I said, this industry—to be truthful, queer content right now—there's like a backlash! I'm in this thread called the Rainbow Menace (*laughs*), and we talk about this. This is before the strike. We go to sell something—like, one of the most famous trans creators goes to sell something centering trans characters, and they're like, "Oh, it's not the moment for 'trans content' right now." Wait, what?! It's something ... the pendulum has shifted. Same thing with the queer stuff that I'm [working on]. I was told, "Well, if you want to do this queer stuff, you have to Trojan-horse it." Wait, what?! And a queer person, a *Brown* queer person is telling me this! And I'm being told, "You could never do Vida right now." There's some back-stepping when it comes to our stories. It's not just Latinas that are [affected]. I was told, at this one giant streamer, "We're not programming for the coasts anymore."

KS: What does that mean?

TS: That the only thing they know about Mexicans is Taco Bell? I have no idea. But "Trojan-horse the queerness" and "We're not programming for the coasts" is a really scary moment. And everyone is programming with fear right now. And that started before the strike. But now? Poof! That's the moment you're talking to me in. But I mean, we're still going. We're still moving ... So I have to be grateful, too, and be like, "Okay, we're still committed to each other." I need a home a lot. And I need partnerships.

KS: I've heard you speak often about how much you like to work with your friends.

TS: I have this "framily," friends that are family. There's a few of us, my best friends, and they all ended up on *Vida*, not because of nepotism but because they were the best thing for the show or maybe sometimes I was writing a character for them. It's customized. Adrian Gonzalez, who plays [City Councilmen] Rudy Marquez in Season 3, is my best friend. Raul Castillo, who plays Baco in Season 2, I've known since I was fourteen years old. This is the theater-maker in me. I've always tried to create an ensemble, a troupe, any time I make something. I think it does change the stakes of what you're making, and I found that out in the theater because people have more skin in the game. They have accountability to you as a friend too, not just a peer.

KS: I've seen interviews with a large percentage of the *Vida* cast and it's so clear how much you all enjoy each other's company.[3]

TS: It's real. It was so good. Sometimes some cast members would come when they weren't called because we—I always made sure that we had delicious pupusas, empanadas, or whatever. But also just for the camaraderie. There's something about it, you know? I didn't know Meli [Melissa Barrera] or Mish [Mishel Prada] [who play sisters Lyn and Emma] before the show. Roberta [Colindrez] and Ser [Anzoategui] [who play bar employees Nico and Eddy] I did know before. I've worked with Roberta since 2011. She did a play for me for Sundance Lab and then she did a play off-Broadway for me in 2015. She came later, but the rest of the cast, it just formed. Carlos [Miranda who plays Lyn's ex-boyfriend Johnny] and I are going to be friends for life. He's a dear, dear guy to me now. I didn't know him before. Work is socializing. The work, it's socializing with a purpose, with a goal in mind. I can't believe it's been four years—four years since 2020—since we went off the air! I still advocate for it. The reason why I put so much meaning into it, that's because I really loved this project. It's not just a first project. It was like my first child. I know you're going to have other loves. I don't know what I will have, but I know that this was my love.

KS: For a show that was only on the air three seasons and twenty-three episodes, the doors *Vida* opened, not just for future television about queer Latine people, but for the entire group of actors and creative professionals involved with it . . .

TS: So this is me not taking credit for it. It's just creating the space for that. I'm not saying I opened everything, but when I see Melissa Barrera rising the way she is and having access to bigger stories, stories with bigger budgets in film and stuff, that's amazing [shortly after *Vida*, Barrera was cast in both the screen adaptation of *In the Heights* in 2021 and the reboot of the *Scream* franchise in 2022]. Also, my writers. Somebody who was at Netflix was like, "Oh, by the way, we look at your writers to lead stuff." Those writers, I do think that it had something to do with not having to explain, like in other places they worked in, their ethnicity, their culture all the time. It was about ideas and defending ideas, and it gave them a boldness. Because I look at those writers like, "These are some the best Latine writers!" you know? But I think it was what they got from [it], the access they sort of took from it. I included them all the time.

When we were the marshals of the [2019] Pride Parade in San Francisco, like it wasn't just the actors. We had a car of writers; like I was in the car with writers because that's important. My three female editors were as important and not just that, the directors, so the directors. I think only one director—so it was mostly Latina directors. The first season we directed so fast! It was not all Latina. I mean, it was all Latino, and one amazing Asian woman [So Yong Kim], and I loved working with all of them.

Vida was their first shot at directing, including mine. We understood how to hold the hand ... and now I could not get these people because they're amazing! I mean that, like they're so busy, and blessed and booked, you know, booked and blessed. And same thing with my cinematographer. That was, I think, one of the biggest wins. She had never run a camera department. She'd never done American [TV/film]. And she's so talented, had a vision. She just needed a shot, you know? Carmen Cabana. And then she did. And she set the look, the gorgeous look for the show, and now—again, I wonder if she'll take my phone call? I'm just kidding (*laughs*). But you know what I mean? Like everyone is thriving in this way. That's amazing, and I just want to keep doing that, providing this, the space for that. Because it's never like, "Oh, she opened the doors!" No, it's like, we were in a space and the doors were open, because we were sharing that space, you know? I just, I wanna be on set with, like, a really inclusive crew. I miss it.

KS: We've spoken to so many directors for this project who talk about being hired at the right time, and being able to show what they can do as artists changed everything for them and their careers.

TS: Women do that, you know? It's amazing.

KS: It's so true. Patricia Cardoso, whom we spoke to, said that. So did Cheryl Dunye.

TS: An OG. Both of them. Definitely.

KS: How did *Vida* happen?

TS: There was an article in the *LA Times* about "gentefication" and "chipsters" and then there was this world-building document the production company had by a writer named Richard Villegas [who had written the short story "Pour Vida," on which the series is based].[4] I think there were two sisters in there. The queer stuff wasn't in there. The character of Mari [a young neighborhood activist played by Chelsea Rendon] wasn't.

Some writers write in themes, like, "I want to explore this." I don't think in themes. I feel like writing is alchemy and that stuff just comes.... I knew that if I was just writing a show about the two sisters, if they're embodying it in action, I don't need to worry about it. They will just keep the theme alive by being themselves.

When I used to write my plays, I used to just light a candle, light incense, and just let the muse come. But for the *Vida* pilot, I had just had surgery, two back surgeries actually, and I couldn't walk for six months, and I would have a lot of opiates when I did this. I just remember writing like Frida Kahlo, on my back. Then I had a pilot when I didn't do the opiates anymore. I was like, "Oh, man. Okay." There's a lot of haziness, but I'm glad for it.

KS: Language and how we use it, different terms for race and cultural and sexual identity from different places or for different generations, is a thread that runs through the whole series.

TS: Where Eddy [Ser Anzoategui] grew up in the show, the word "queer" used to be a fighting word.... That shows you she's a neighborhood lesbian that has never left the neighborhood with those values. [She's] as progressive as they can come, but also traditional because of her generation. In Season 2, when we did the baby queer tourist thing ... In our community I get called a tourist all the time because I have dated cis men. I was like, "We have to do the tourist conversation. We have to do it." I really wanted to get generational about terminology.

I think identity is about being seen or wanting to be seen. We are an invisible people in this country, and you have to fight a little harder when you're us.

KS: Your writing gives your characters a lot of great monologues. How much of this comes from your time as a playwright?

TS: I considered myself a monologist for the longest time. Monologues were the easiest thing to travel with, you know? When we wanted our plays to travel, to start casting them with other actresses, it was really easy to sub somebody in or have me do the monologue, you know? As a producer of *Teatro Luna*, it was a great model, these monologues. But *Our Lady of the Underpass* [Saracho's twelfth play], it was an actual play about a moment in time, in 2005, the apparition of the Virgin of Fullerton. Or a salt stain.[5] I went and interviewed people, a bunch of people, and then wrote the thing. And I think it's the thing I'm proudest of. But I peaked in 2006. That's sad, but it was the first time I realized that monologues weren't for me. I thought I was going to be a monologist like [Eric] Bogosian.[6] But then I became a playwright, and now I'm this.

KS: How did your work directing theater influence your work directing television?

TS: Even as a creator of a show, they're like, "Here, you're going to have this man from the dominant culture babysit you. Here." *Vida* they let me staff it how I want. Marta [Fernandez, executive vice president of *Starz*] fought for that. Then I am absolutely at the helm on every creative decision, and it works just like it did in Teatro Luna. I can go back and draw from Teatro Luna, where I thrived creatively and didn't have any money. But shit, if you look at some of those pictures of the shows I directed, they're gorgeous with painting tarp. That's the script, but it was like forty bucks, you know? By the time I got to direct on *Vida*, oh my God, it was like love at first sight. I love the directing of cameras and the editing. The editing process is like theater directing, I realized, because theater directing is about setting rhythm, tone, when the lights go down, when they come up, where people move, where we see them from. Well that's . . . I mean it's just like an analog form of editing. You know? But directing on set is nothing like I had ever done, so that I had to learn. Theater's my first love. She's my ex-wife. But we were married, you know?

KS: Your play *Fade* was first produced in 2016 but premiered off-Broadway in 2022. What was it like to be off and running on all of these television and film projects and have *Fade*, that "ex-wife," come back around?

TS: She's still my ex. Look, I'm trying to book a trip to New York right now to see my friend Jonathan Groff in his musical and to see my friend Branden Jacobs Jenkins's Broadway debut [*Appropriate*], and the tickets for *Merrily We Roll Along* are 550 bucks for *one* ticket and for a play, a straight play? 435 bucks for Branden's play? Who is that theater for? I left because it didn't seem accessible again. . . . They would invite me. Like they would give me a commission for, you know, the Latine Commission or the BIPOC—whatever otherized term that they use. But it was not for *us*. It was for the dominant culture who could pay that money. They wanted that subject matter but filtered through them. So I didn't like how I was visiting these regional theaters as a visiting artist, because that's what you are as a playwright. You show up, you build it for them, you rehearse, and you have very little say in how your community has access, to how much they have to pay. Also you're fighting for the one slot for the marginalized people, the one on the main stage. That's why I left. Now, my love for the craft as a consumer, it's still church to me like to go, to see a good play. There's nothing better, you know, nothing!

I'm not telling stories like that with a beginning, middle, and end, you know, for it to be consumed live. But do I still adore them. I mean, that's the biggest treat, right? To get to

232 Break the Frame

be in community while experiencing the story. The American theater disappointed me in that way. I just can't.

KS: *Brujas* will be a TV show based on a play. As a proud midwesterner, I can't tell you how excited I am for a show by you set in Chicago.

TS: I can't wait. An Afro-Latina reality ... also, you know, witches? I'm sure we talked about this before. The image, the iconography, all of it is so Eurocentric, and what we know is like the witch trials in Europe. Everything we know, even the images, even the craft, even the stuff that's modern. It's based on that, you know, that imagery. My witches look like this [points at image on wall], you know, like that bruja's smoking weed. That's Sabina, Maria Sabina, who was the first one who said, "Hey, this is medicine. I mean, not the first one, but the [first one] that came into the consciousness, you know? I want also the imagery, like start seeing *us*, not just the, you know, the pointy [hat] and then the Victorian corset and the black, and the hat ... you know, the Halloween witch. No.

KS: I send out that *Hollywood Reporter* "Top 50 Television Shows of the 21st Century" list with checkmarks next to certain shows, like once a week. I'm a complete nuisance about it, too. Have you seen *The Wire*? *Homicide*? *Rectify*? *Vida*? Checkmark, checkmark, checkmark.

TS: I was beside myself when I saw that. It was like, "Oh my God, our little show!" Because in lots of ways it did feel like it had a niche audience of very loyal, but niche, audience because, you know, however it came to be cable, whatever, we are in the moment for cable, dah dah dah. But it's so funny, I've spent a lot of time in the UK now, the past four years. I just came back for Christmas—where people recognize me. *Me?* Because I'm not in the show. They were like, "I love *Vida*!" And I'm like, "Wait, I don't even know how you get *Vida* here?! It happened with Andrew Haigh's show *Looking* too. But it's like Brown queers just find [shows] wherever.... And I was like, "Wow! Well, we need more content, people, but Trojan-horse it!"

KS: Before *Vida*, you were on the writing staff of *Looking* and *How to Get Away with Murder*. How did that shape you creatively as a showrunner?

TS: There's so much of *Looking* in *Vida* that I was able to learn from Andrew Haigh. He doesn't even know how much he influenced ... It was really beautiful. And the way he shot those walk-and-talks, those exterior scenes, and he really included San Francisco as a character, that's very much how I include Boyle Heights, like a filmmaker. And the thing is that I wasn't a filmmaker. I'm still not a filmmaker, but I had sort of a little look under that rock, and I really liked it.

And then *Murder*, ooh, *Murder* was murder for me. I love Peter Nowalk, the showrunner. I just never knew how to give him what he wanted. I thought that ... because I was here pitching character shit, and you have to go through five acts of ... one act would have been a whole episode in another show. I'm not good at structure. I only write ninety-minute plays, so it's just one sit-down. I don't have ... I never wrote an act. I don't split shit.

When I went in to quit, I know they tell you, don't cry, and don't share your feelings and all that stuff, and I did not listen to any of that. I cried because right away I was like, "I love you, Pete, and I thank you for ..." Whatever, you know? It was like, I really did love him. "But I don't get your show." And he was like, "What are you talking about? You're doing really well in there." And I was like, "What are you talking about? I don't lend anything." And he goes, "Okay." He got up from around his desk and he hugged me, and he goes, "Just promise me you'll have your own show." I never forgot that.

The Female Future **233**

KS: If Tanya Saracho the writer, Tanya Saracho the showrunner, and Tanya Saracho the director all met each other, would they recognize each other? Are they different parts of you or parts of the same whole?

TS: By the third season of *Vida* the showrunner was writing the show and the showrunner was directing the show. It's kind of important but also that our budget got cut. We didn't have as many days to shoot all this stuff. So the showrunner got us through. I think the director especially does like the showrunner. I think the writer is the one who just resents everybody. "Let me do what I want! Let me write my story!" She's an asshole.

KS: How about the person who ran a lab for screenwriters?

TS: I don't have very motherly instincts, you know, because I don't have children. But I do during the lab. So it was like every Tuesday, we met for twenty-six weeks. I was there. But it's defending them, defending their [work], because I wanted it to be like … I wanted us to be able to have something tangible that we could sell to the studio, and to also say, "Write whatever you want! Because they don't let us do that!" We are always listening to mandates and stuff. So I got like a little bit *Mother Courage and Her Children* (*laughs*) [Bertolt Brecht's play about a woman's struggle to protect her children in wartime]. They can do whatever, even if it's flawed. Sometimes I would defend the flaws. And that's not good. I was defending them the way I wanted to be defended a long time ago, which I think I would do some stuff differently. Like I would … listen more and be a little bit more business savvy. I just wanted it to be an artistic space.

I need a balance, you know? I get really defensive, defensive, especially of voices, voices that are strong or that you could tell could be strong. You're like, "How do we protect and nurture?" And like, "How do I put my body in front of it?" Like, I don't know, because when I supervise a writer, too, and we're trying to take that out to sell that, I do the same. "No, that's how she wants to tell it. That's how we should tell it!" And I'm blocking the notes, and I shouldn't be sometimes.

KS: Who are your teachers? Who are your peers? Who are your heirs?

TS: [Playwright and MacArthur genius grant winner] Luis Alfaro. Right away. I mean that's obvious, and without him knowing, because I only met him a little later. [Oscar-nominated screenwriter] Jose Rivera. [Playwright] Migdalia Cruz. [Playwright] Milcha Sanchez-Scott was so formative to me, and I never got to meet her. And my literal teacher was [playwright and Pulitzer Prize finalist] María Irene Fornés. Contemporaries? Younger than me but creatively and when we came up: [Playwright and MacArthur fellow] Branden Jacob-Jenkins and [playwright] Karen Zacarías. [Playwright and Pulitzer Prize winner] Annie Baker. For heirs, [playwright and screenwriter] Isaac Gomez is someone I'm so invested in, since he was an intern at the Goodman [Theater in Chicago] and had not written a play except at school. And now Isaac is now a fucking superstar, you know,[7] and my dear friend who lives two blocks from me in LA.

KS: You have an incredible work ritual I read about in this article "Tanya Saracho 'Yes, and'-ed Her Way into Hollywood."[8] How did that ritual develop over time?

TS: It started because I was an actor first. Because acting is an interpretive art form, you're interpreting a story. But the actual creation happens with writing, you know? So [with] that, you needed more help. I needed more help. So I'm always like, "Look, you don't even know all this shit. So whatever help I can get from the ancestors too. I've been going to brujas since I was eleven years old. My mom took me to my first one, because I was having migraines as a kid, as a eleven-year-old, and the doctors couldn't figure it out.

234 Break the Frame

She took me to this señora who saw her at a party, grabbed her by the arm, and she was like, "I know why your daughter's having headaches. Bring her to me." And my mother [was like], "What? We're Catholic, we're not ..." But she brought me because it was bad. I don't know what she gave me to drink. I don't know what she did to me. The thing, I looked in the water ... gone! When I started creating, I needed extra, extra help. In fact, today at 3:00 p.m., I have a session with my bruja. I'm gonna ask what's gonna happen with *Brujas*!

Ritual is important. Writing is a ritual. I'm looking at my altars right now. It's so funny, because today, I made myself coffee, and I was like, "Oh, I remember that you do this. This is a ritual!" When I made myself a coffee, I write with the kind of markers you can wipe. I write on the carafe; I write the things I want to focus [on] today. So that's like a spell too.... Because to me—especially when you're creating from scratch or in this stage—when you're going as a [writer] in a writers' room, the spell's already been cast. But when you're like this, there's so much ritual I need to make because I do think a divine spark is involved. That kind of alchemy is involved in what we do, you know? It *has* to be! It's drawn from somewhere, from spirit. I totally believe in all that.

KS: How do you see *Vida*'s legacy?

TS: I do think of the legacy for *Vida* a lot. I do. I wrote those women with agency. They're ugly and flawed but also good. We don't see Latinas at the helm like that in television, and I hope that it engenders a lot more depictions like that. I really do. In lots of ways we couldn't find the audience in this lifetime, but hopefully there's a lifetime that the show is measured in. We need to have our stories out there. I get mad every time I think about how we've been left out of the fricking narrative. For so long, we'd get one thing and then years pass and then another thing, and I just hope it is not like that. I hope that it heralds something else, multiple something elses, just because I am so invested in these people and I want them to work and eat. I just love us. And I want to keep somehow working with us.

Alice Wu (b. 1970)

Films Mentioned
The Half of It (2020)
Saving Face (2004)

With only two films directed thus far, Alice Wu's work has been both ahead of its time and also a modern classic of one of Hollywood's most beloved and serviceable genres. Her 2004 debut, *Saving Face*, centers both a Chinese American lesbian romance and a mother / adult daughter relationship and has comedians Ali Wong and Awkwafina among its admirers. Its follow-up, 2020's *The Half of It* (featuring *Nancy Drew*'s Leah Lewis in her first starring role), an adolescent *Cyrano de Bergerac* where the two of the three characters are young women who also fall for each other, is already regarded as a twenty-first-century teen movie classic alongside *The Perks of Being a Wallflower*, *Booksmart*, and *Lady Bird*.

 Saving Face, set in pre-gentrification Flushing, Queens, has the night air of the movies of Jim Jarmusch and the working people's soul of the cinema of Ken Loach. In line with both the difference in story and the time between them, *The Half of It* is a descendant of John Hughes (if John Hughes ever left the northern suburbs of Chicago and landed in a Pacific Northwest railroad town) and the philosophical old-for-your-age soul of Richard Linklater. "I decided I was going to set this thing in a small rural town. I was hoping that someone in these red states would watch this, and it would make them think about that one immigrant family, or that one kid who's a little different. Or maybe they're thinking of coming out themselves," Wu said in a 2020 *New York Times* profile of her shortly after *The Half of It*'s release on Netflix.[9] Of that release strategy? "That person's not going to the Landmark theater to watch this movie."

 Between her two movies, Alice Wu worked as a program manager for Microsoft (where she had also been a software engineer before taking up filmmaking) and cared for her mother, who had fallen ill. During this interim, Asian American women directors became an increasingly common presence as television showrunners (*Nancy Drew*'s Melissa Hsu Taylor), on streaming services (*The Mandalorian*'s Deborah Chow) and feature films (*Always Be My Maybe*'s Nahnatchka Khan), in movie theaters (*The Farewell*'s Lulu Wang), and on award show stages (*Nomadland*'s Oscar-winning director Chloé Zhao). "They're like my family," Wu said of these comrades in that same *New York Times* profile. "I don't take credit for any of that, but I love that I was somehow part of their journey of storytelling in some way."

 Saving Face premiered at the Toronto International Film Festival in 2004 and would go on to earn Wu a Breakthrough Directors nomination at the Gotham Independent Film Awards. Her screenplay for *The Half of It* (which, after Wu's mother had fully recovered, a friend had held the director to a personal challenge to complete in five weeks) was nominated for an Independent Spirit Award. *The Half of It* would go on to win the Founders Award for Best Narrative Feature at the 2020 Tribeca Film Festival. The year before, the *Los Angeles Times* named *Saving Face* one of the twenty best Asian American films of the last twenty years, and in the fall of 2024, Criterion announced the film would become part of their collection.

 A Bay Area native, Alice Wu grew up in San Jose and received both her bachelors and masters degrees in computer science from Stanford.

I spoke to her in February 2023 from her home in San Francisco.

238 Break the Frame

Alice Wu: You're in San Francisco too?

Kevin Smokler: Yes! We could both lean out the window and wave.

AW: Everyone I talk to is usually in LA, sometimes in New York. They always assume I'm in LA.

KS: I hope you'll indulge me with this random first question because it is actually based on something I noticed watching your movies and getting ready for us to speak but I have a feeling you and I are both enormous fans of [Kazuo Ishiguro's 1989 novel] *Remains of the Day*.

AW: Oh my God, of course. When I was writing this [*The Half of It*], I just thought, "Well, this thing will never get made." So I just literally put in everything I love. Like I genuinely do love sausages. I also have my keys clipped to my bag. I'm just gonna write, "I love *Remains of the Day*" and I just was like, "Why not?" I'm a huge fan of the book. And actually, that was one of the few movies that took an amazing book and actually was a good adaptation [by the team of Ismail Merchant and James Ivory in 1993 and starring Anthony Hopkins and Emma Thompson], mainly because I think they understood that they were just going to have to take a thin slice of it and dramatize that.

KS: I noticed that not just in *The Half of It*, but in *Saving Face*, you seem to like to smuggle in things you like to your movies. Both contain scenes of people watching movies.

AW: My parents were very new immigrants, and I didn't speak English until I was five. My mom watched a lot of Chinese and Taiwanese soap operas, so I grew up watching that with her, but then she didn't allow me to watch regular TV, but I could watch classic movies. For me, I think watching anything that could show up on TV helped me understand how to interact with the world. I suspect it's very common amongst people who maybe don't have enough social currency in their actual world. They gain real-life experience by studying it in movies.

KS: It reminds me of Martin Scorsese saying that being a sickly, nonathletic child in 1950s America, he was drawn to the movies because he felt like he could participate in and learn about what was happening around him even though physically his body would not let him. The big thing I wanted to ask you, which I see as a thread between *Saving Face* and *The Half of It* and, really, *Remains of the Day* too is that these are all stories about someone who is afraid to act, even though in both of your movies the protagonist does end up acting. I see both your movies as an endorsement of courage.

AW: I come from a line of very repressed people. And that doesn't mean I come from a line of people who don't feel incredibly deeply, however.... it seemed like we lived in a world where in fact it could be dangerous to express certain things. So the safest thing to do is to keep one's feelings and thoughts to themselves. I was so repressed about being gay I didn't come out to myself until my senior year of college. And it was not like I was having these deep debates with myself when I was younger—like, if you have crushes on girls, which I do, but I was so repressed that I in fact had deep crushes on girls that I could track as early as the third grade. But the repression was such that I must have somehow split my inner life with my outer life. I somewhere probably felt that there was something deeply wrong with me. But since I was also a very awkward, nerdy immigrant kid anyway, there's another part of me that's like, no, no, there is something else, but I best not look too deeply or it's going to destroy life as I know it. Because I understood that there would be a deep, deep shame that would occur for my parents, and given how they had sacrificed so much to give me a good life, that I was like, I can absolutely not go there. Emotionally, I must

have hit some breaking point somewhere, like a banging on the door getting louder, and then finally, my senior year of college, it just came crashing out.

I do believe that the truth will set you free and that self-knowledge is a good thing even though it's extremely or can be extremely painful. So I'm making an argument for trying to be as true to one's nature, to tell one's truth as honestly as possible. Your truth is literally "This is what I stand for. This is who I love."

Saving Face—I mean, who the hell thought that movie would get made? And when it did, it took a long time for me to even fully understand how much it changed my life. One thing, it forced me to immediately be out in the world. I think it made my life bigger in so many ways I can only see now.

KS: When I look at the distance between your two movies, I so appreciate how you speak about that sort of interim between your two movies publicly, with a sense of deliberation, like this was a choice you made because it was right for you and your mom [who was ill and needed care]. And it wasn't how patriarchy often compels women artists to tell the story of their careers as a series of chance encounters and pratfalls and fairy-tale miracles, what critic Lili Loofbourow calls "chance, accidents and the passive construction of female artistry."[10]

AW: It was a deliberate choice only from the standpoint of it wasn't like I said, I'm leaving the industry to leave the industry. It was more like, oh, this major life thing happened. And to be totally honest, I don't think I was very good at chasing a career in film. So it's not exactly, oh my God, studios are banging down my door to be like, 'We really want you to write the next Alice Wu film!'" It was more "Will you rewrite this thing?" Or "Oh, we want to do something in China, but it's got to be like this!" Or, you know, we think you're good at romantic comedy. Can you do this?" I was probably there for hiring because I was cheap. So did I want to keep doing that and eke out an existence and actually make more money I could have, and maybe that would have gone okay. I can promise you [it] would not have gone *well* because, ultimately, I was deeply unhappy. And given that when you're kind of in that, "Well, this is fine." Mode When something really important happens in your life, you know, like my mom—I happen to just be very, very close to her—and I just thought, well that's not even a question. It wasn't a difficult choice. I don't know if I deserve that much praise because it's not like I just had an unbelievable career I was giving up. It was more, yeah, I had some opportunities, but they were not the opportunities I wanted. And now I see this very clearly. I am someone who will always choose my family. My life drives my work, not the other way around.

I think that's so important for storytellers, because what the hell are you going to write about otherwise? I didn't know I'd ever be back. But first and foremost, I think probably living my life gave me a perspective on things. One of them being about love, where I totally bought the whole romantic notion of finding one soulmate. And it wasn't until I got to my mid to late forties. I was like, "Not that that doesn't sound great. But there are other forms of love." And then that's where *The Half of It* was born out of, because I really only try to make things when there's a question I'm trying to answer. And I think at that point, I was trying to answer something about what happens if you meet someone who basically feels like your soulmate but no one wants to have sex with anyone else.

By the time I started my second movie, it was much easier for me to understand that, like, "Okay, this is the thing I want to make. And I'm not going to make compromises." ... This is who I am. And I now understand that I'm not for everyone.

240 Break the Frame

Somewhere in there, I really sat down and thought about what is the purpose, like my life cannot only be about trying to be like this great daughter or being a great girlfriend, so what else is it? I think that's when it made it a lot easier for me to figure out how I picked my work projects.

KS: I feel no compunction about saying that *The Half of It* is simply the best teen movie of the twenty-first century.

AW: My God. That means a lot. Wow. Thank you.

KS: Were there other teen movies that inspired it?

AW: I love teen movies. I don't know that I always think of *The Half of It* as a teen movie as much as I think of it as a movie with teenagers in it. Like people would say to me, like, "Oh my God, you got teens so right, that is how they talk." And I'm like, wow, I just wrote them like humans. You know, like, that's just like how I thought humans speak. They're actually secret homages throughout that entire movie to some of my favorite movies . . . in terms of composition, *The Graduate* [1967]. *My Life as a Dog* [1985] is one of my favorite movies of all time. In fact, you can even say that last train scene, the framing, right? And then old-fashioned romantic comedies like *The Philadelphia Story* [1940]. I grew up on John Hughes, but I realize I don't really have a John Hughes aesthetic, even though I loved *Pretty in Pink*. But I have to admit I didn't do much studying of teen movies. I just like them wholly.

KS: I think teen movies often focus on a love triangle. And I think all too often whether it's a woman in the director's chair or a man, there's this idea that if you have a teen movie with a female main character, the only plot that's interesting is a love triangle. Is she deciding between Ducky or Blaine? Team Jacob or Team Edward? And I think your movie does a really interesting sort of inversion of the love triangle where there is a triangle, but the character who's at the vertex of the triangle doesn't know she's at the vertex. And the main character sort of is over here and moves towards the center of the triangle.

AW: Someone who's in the margins, who doesn't actually think she could ever be the lead character in a story and in fact, arguably, would not be, except ironically she inadvertently has become the lead character. And at the end, she accepts that finally she's going to be the lead character in her life.

I get this question all the time. "When are you gonna do a sequel?" And I mean, honestly, I'm incredibly honored that they would ask that and I also hate that question. Because I know it'll be so disappointing when I say, "Honestly, I just don't like sequels unless you planned the sequel because I write to an ending. It does not take off until suddenly there's some moment in the middle that I wake up and ending has crystallized so intensely in my head, and then I just write like hell toward that thing. And if I've done my job right, hopefully you feel something and you don't need a sequel to have a strong sort of emotional satisfaction. But what I understand when people are saying that, I hope, is what they're saying is they love these characters, and you love the actors to play the characters. You want to spend more time with them.

KS: Every character in *The Half of It* seems destined to have a really full life, which kinda negates the need for a sequel. It isn't like we finish watching the movie and feel, "And then what happens? Tell me!" John Hughes famously said about the three main characters of *Ferris Bueller's Day Off*, Ferris and Sloane probably broke up freshman year of college. Ferris, Cameron, and Sloane probably stayed friends the rest of their lives.

AW: Exactly. Who gets the girl is not the important thing, and actually, honestly, at the end, we don't know. Maybe their lives don't go well. But as a result of this happening, each of them gets the piece they need to now begin the life that they were meant to live, and I think that's sort of the happiest ending you can have. If it's like Ellie and Aster get together, what is that like—that they're stuck in this town? Because that's *not* a happy ending! Because of their interaction, all three of them now have bigger lives to look forward to.

KS: It makes me choke up really to just think about it that the message of *The Half of It* is not that we are halves of wholes, but we are the vertex at the center of lines that makes up who we are.

AW: I love that.

KS: I don't want a pumpkin sticker for this or anything, but it's very clear in the raw filmmaking of *The Half of It* that you've done a lot of dividing the frame in two and making characters symmetrical and to indicate that halves make up more than a whole.

AW: No, I did a lot of that like, "There's a water fountain to make sure there's two of that." I'd like as much twinning as possible. And then triangles: "I need triangles everywhere. Anytime there's like some random sign, make it a triangle!" This notion that we all have a subtle connection to everyone we've ever met, some things stronger, some things less. And that helps us as we move through life, but we're also all connected to this whole. Two people can be like, "We're gonna decide to make us the strongest bond," and that's cool. But that doesn't mean someone else over here who doesn't have that is somehow less whole.

KS: In your own words (instead of mine!), what did you need to say in *The Half of It*? What did you have to say in *Saving Face*?

AW: If I may slightly amend that, because I think for me it's actually more, "What are you dying to figure out?" Usually when I'm trying to write something, I don't yet fully know. With *The Half of It* I was trying to figure out something about this friendship heartbreak I'd had so many years ago. I was trying to figure out something about the nature of love. With *Saving Face*, I was twenty-seven when I wrote that. And I just remembered, you know, at that point, my mom technically knew I was gay, but it was like something that we could not really talk about. She had met girlfriends. She was always totally nice to them. But we wouldn't really be able to talk without it being extremely uncomfortable. And she would always tell me about, "I went to the fortune teller. They said, You will be married someday to a man and you'll have two kids." And I was like, "Mom, that's probably not it." When I wrote that, she actually was going through something very intense in her life. And I was trying to help her because she was going through a deep heartbreak. I just felt so helpless. So I basically wrote what would happen if, you know, you take this daughter who's trying to be the perfect Chinese daughter but she's gay. And then her perfect Chinese mother ... who has also been the perfect Chinese daughter does something catastrophic—like, just totally fucks up. What happens if those two, after having compartmentalized their lives, are forced to be together? I actually wasn't finished shooting it when I was like, "Oh, I see. I wrote this for my mom. I want her know that I love her even though I'm flawed. And I want her to know I love her even though she's flawed. And I want her to know not to give up hope." But underneath it, it was a wish fulfillment of wanting to believe that one can have both your family and deep romantic love and have them coexist in a peaceful way. And at that point as an Asian American lesbian, it did not seem possible.

KS: Both *Saving Face* and *The Half of It* are in the romantic comedy genre. And I love romantic comedies. But my least favorite thing about them is where you feel like the characters exist in some kind of airless void where the only thing that's important is the romance in the story. No actor is charismatic enough to compensate for when it feels like their character is not a real person and we in the audience are just supposed to be content with watching them fall in and out of love for 93 minutes.

I cannot tell you how happy I was watching *Saving Face* when the main character is going to catch the train. And you realize she's friends with someone who works for the MTA. These are real people inhabiting the real world, and the story is happening to real lives. And in *The Half of It*, the second you see Ellie Chu, like, riding her bike to school, passing out the term papers, working at the train station—all of these people inhabit worlds that are larger than them.

Is that a priority to you as a filmmaker? Or just my hangup as a fan of romantic comedies?

AW: I guess it must be a priority to me, because I noticed that as somebody who is a romantic and has loved romantic comedies and then has been disappointed by a bunch of the ones that feel utterly like fantasy and fluff. I really love it when I believe that character exists. And so I think that's just an aesthetic choice I make. It's just very hard for me to want to spend time with characters that ... don't feel like people. Every now and then they'll be like an ancillary character they might seem a little bit broad. But I usually choose to do that when I'm trying to emphasize. In *The Half of It*, I'm trying to emphasize that's what high school feels like. It feels like you are the only actual person and everybody else is leading some fantastic life in a music video that you don't know the song to. You're the only one actually trying to figure out all these things. I want to be able to turn off that movie and believe those characters are still living their lives. And I think the only way to do that is what you just said, which is nobody *only* exists just to be romantic unless they are a flat character. They're like an AI chatbot or something. Actual people get hungry, they get sleepy and cranky. You have to address those things.

KS: In 2019, the *Los Angeles Times* put *Saving Face* on a list with *Chan Is Missing* [1982], and *Better Luck Tomorrow* [2002] and *The Joy Luck Club* [1993] of the twenty best Asian American films of the last twenty years."[11] And it has also been cited as an inspiration for Ali Wong and Aquafina and Lulu Wang, director of *The Farewell*. What's that like for you?

AW: It's surreal. I live in San Francisco, I don't live in LA. Most of my friends are not in the industry. And so while my friends are incredibly supportive, they're not impressed with me. So it was a little shocking when *The Half of It* came out. And all these people came out of the woodwork to be like, "This was so—you know, *Saving Face* was such an inspiration for me, and I can't wait for this next movie!" And I'm like, "What is happening?" It's hard not to get sucked into the external validation game. When I get it, I start to crave more of it, you know, and so I would be lying if I said, "Yes, I don't let that stuff ... " Like, no, I totally love it. But maybe I'm old enough now to be like, "Okay, that cannot be where your highest value is placed." I suppose there are two thoughts that come to mind. One is I try really hard to remember that your life purpose is, if you might help say something about the human condition, then keep working on those things. I finally wrote my third movie. Who the hell knows if I'll ever get it made. But meanwhile, I always say I don't think the world owes me a film. And the God's honest truth is if I never made another thing, the world would be fine. And I would be fine. There's so many good storytellers

The Female Future 243

and filmmakers out there. The second piece of it is, yeah, I'm not going to pretend I don't feel really good to think that maybe I could have been some small part of, you know, that person's journey that is now allowing them to do something wonderful. You know, it's like a very easy, effortless way to feel like you somehow did good, so why not? I take it.

KS: Do you want the audience to know what movie they are watching? Like to be watching and recognize what they are seeing as an Alice Wu movie?

AW: This is where it gets really weird for me, because I'll be honest, when I made *The Half of It*, it wasn't like I thought, "Well, as an Alice Wu movie, this is what happens." I think I disappear into that movie. And then it's super funny to me, where after the fact someone will be like, "Oh, I can really tell this is your movie." Because I'm like, "Oh, you can?"

I think I serve the movie.... If it's any good, it should be bigger than me. That said, all of my collaborators said that I'm very specific. I've heard that it's very clear to someone who knows me: "Oh, this is obviously you." But I don't know what that is, kind of the way I think we don't know who we are. Also, just be clear, we have two data points. It's not like I've made ten movies.

KS: You do not seem to be a show-offy director. The camera does not call a lot of attention to itself, and the score, for example, does not direct us as the audience as to how we are supposed to react.

AW: Not utterly across the board. But I mean, I think when I want you to notice it, I want you to notice it. Mostly I don't. A swell [of music] doesn't make any sense if you're swelling all the time, right? There are a couple of times when I go for it. Maybe we do a camera move and people notice it. But it's because that camera move, I think, emotionally that's the experience we should be having right now, right? It shouldn't be an intellectual, "Ooh, cool camera move. It should get [*gasps*]." Similarly, the music. You should be feeling it, not thinking, "Oh, look at this. Listen to this nice score." It should ideally be your feelings that are leading.

KS: There really don't seem to be villains in your movies. Will there ever be?

AW: In my ideal world, there will be a moment where you discover their humanity. And we understand. Those are the most interesting villains to me. I would never say never. The thing I can't say is that it's highly unlikely to me that I'm ever going to make something where at the end there's no hope whatsoever, because I'm not really sure what the purpose, for me, of making that movie is. My hope is always that people leave the theater and it makes them want to reach out towards others. And it's also highly unlikely to me I'll ever make a movie that doesn't have some layer of humor to it. Even if it's subtle, because it's my primary coping strategy in life.

KS: You were born in San Jose, went to Stanford, and now as an adult are living in San Francisco. I wonder if you feel you are close to or far from home? Close to or far from where you started?

AW: You know, it's weird. I, we moved a lot when I was growing up, even within the Bay Area. When I was very young, we moved to Detroit, Michigan, and then after a few years, we're back, and then, like, I feel like every few years we moved somewhere else. So I often don't feel that sense of home that I imagined other people feel. So maybe home is a phantom idea I have in my head. I have friends who lived in the same place all [their lives] until they went to college. And they're still friends with people from kindergarten. I don't remember a single name of anyone I went to kindergarten with because that was like fifteen moves ago. I often feel a sense of melancholy about it. But at some point, I think I figured, "Well, I think I'm just a traveler and my home is just going to be within me." And the

people that I have deep friendships with at this point, they're scattered all over the world. I would say New York felt the most like home of anywhere I'd ever lived. Like the moment I moved there, "Oh, this is where I was always supposed to live." I still go back. But most of my friends who I knew there for many years have all moved, right? It still feels like a home, but it doesn't feel like it did when I was there. Taiwan feels like home when I go there. Anywhere my mom is feels like home. The truth is, it's something I'm still trying to figure out. And it might be elusive forever. Maybe that'll happen when I can no longer travel. Like musical chairs, this is when the music stopped. This is now home. I don't know, but I'm not there yet.

Erin Lee Carr (b. 1988)

Films Mentioned
Undercurrent: The Disappearance of Kim Wall (2022)
I Love You, Now Die: The Commonwealth v. Michelle Carter (2019)
Britney vs Spears (2021)
At the Heart of Gold: Inside the USA Gymnastics Scandal (2019)
Mommy Dead and Dearest (2017)
Thought Crimes: The Case of the Cannibal Cop (2015)

Books Mentioned
All That You Leave Behind: A Memoir (2020)

Erin Lee Carr's documentaries have three overlapping concerns—gender, technology, and crime. Often you blink, and the three-sided room of an Erin Lee Carr film just looks different. Sometimes you feel her sliding the walls further away so the room is bigger. Sometimes they are closing in. The Erin Lee Carr filmography (seven films in as many years; the movies come at you like bullet trains) seems to be three concerns adding up to limitless possibility. And this is a filmmaker who is not yet forty. Not for a while.

Born in Minneapolis an identical twin, Erin Lee Carr was a video producer at VICE media upon graduation from the University of Wisconsin. Her 2013 VICE documentary *Click, Print, Gun* won a Webby Award. Her debut documentary feature, *Thought Crimes: The Case of the Cannibal Cop* (2015), premiered at the Tribeca Film Festival and began a long relationship with HBO Documentary Films. Her breakout second picture, *Mommy Dead and Dearest* (2017), landed the director on the 2018 Forbes 30-under-30 in Media list.

When do you know you're in a world built by Erin Lee Carr? It's as much feeling as topic: The director's unbreaking stare, a mystery taking its time but coming together one sure piece at a time. The goal is an exploration of why.

The filmmaking of Erin Lee Carr has been nominated twice for Emmys and awards at the South by Southwest Film Festival. As of this writing, she has first-look deals with HBO for her documentary work and Universal Content Productions for scripted projects, and runs her company, Carr Lot Productions, in New York City.

I spoke to Erin Lee Carr in March and June 2022.

Kevin Smokler: In *Undercurrent*, the murder of journalist Kim Wall does not end with a trial or the conviction of entrepreneur Peter Madsen. Instead, he's shuffled off screen at about sixty minutes in and the rest of the film is about Kim Wall herself. What was behind this choice?

Erin Lee Carr: When it came to telling this story, it felt like Kim had been left out of the conversation. And it was incredibly important for people to realize that this was somebody that we lost, who's going to do great things. And I'm a journalist, I was raised by a journalist. Journalism is one of the most important things in my entire universe and value system. And to think that a female journalist got on the submarine, like any other person would have if they were on assignment, and lost her life because of it.

KS: Your movies are often about a crime but rarely about a single perpetrator. Instead, they ask us in the audience to see villainy as something bigger. *At the Heart of Gold* [about the pervasive sexual abuse of minors in US Gymnastics] is the failure of a system. *Undercurrent* is the collective failure of our global acceptance of women in the workplace equal to that of men.

ELC: I think that one of the reasons why I'm so lucky to work with HBO is that I grew up watching their true crime. And I think from *Paradise Lost* to *The Iceman Tapes*, I never felt talked down to as an audience member.[12] And I was always given the right to think what I thought about the criminal case. And so it was basically one of my objectives as a filmmaker to, if I'm doing something about crime, it has to say something else. With *Mommy Dead and Dearest* [about the murder of a woman by the daughter she abused through false hospitalizations] it's about, what does it mean to feel sick? What does it mean to look disabled? *I Love You, Now Die,* [about a teenager's suicide and whether his girlfriend encouraged him to kill himself] mental health and loneliness, being a teenager and making bad decisions. *At the Heart of Gold*? How do you get through some of the most traumatic experiences of your life and come out on the other side?

One of my all time favorite reviews was *Mommy Dead and Dearest* where somebody called it "a Russian nesting doll of horror." ... I pick projects where you can just go deeper and deeper and deeper.... It's not just particular to this part of these two people, but it's really about our society and how we treat these issues.

KS: I'm so glad you brought up *Paradise Lost*, which is a favorite movie of mine, too. That's a documentary whose genius is that you spend six hours on what seems like a wrongful conviction case, and yet it leaves open the possibility of seeing it from several points of view.

ELC: Everyone believes that the simplest explanation is the explanation. I grew up with my father, [late *New York Times* columnist] David Carr, who had *The Night of the Gun* [his 2008 memoir about addiction and recovery], which is about being the most evil you can be as a man and him trying to have a redemption arc. So from a very early age, I found that we're not equal to our best or worst actions. The thing I think is special to the way that I treat subjects is that there is no absolution for murder or for evil. But there is why. And I think we can learn from the why.

KS: When you go into a story about crime, is your first challenge the inherently tabloid quality of most crime stories?

ELC: No, I never worry about it. For me, these are people that are in incredibly traumatic places in their lives. And I am trying to make sure that I'm doing outreach that feels ethical. I realized that part of my role as a director is really that communication with the subjects and making sure they feel heard and listened to. It's just so much more complicated than people realize, like, oh, you get a camera and you do it? People are always like, "So when are you going to make a real movie?" I'm like, "What are you talking about?"

KS: What an insulting question.

ELC: Yeah, imagine how many times I've been asked that.

KS: So much of what you are saying is reflected in the tone of your movies, which is very evenly paced, almost slow and methodical. *Britney vs Spears* opens with about sixteen newsworthy events that happened within about a seven-day period of time. And I think in lesser hands, this movie would feel hyper and cranked up.

ELC: Documentaries are about a person sitting here and I'm giving them the puzzle pieces and they're putting it together. And I love to carefully hand the pieces to them. And then it really reflects my relationship with the making of it. I had all of these expectations and thoughts at the beginning and then in putting these things together. And so the audience is often just a reflection of what it was like to make the film and I'm a proxy for them.

KS: *Britney vs Spears* also feels like a sibling of dream hampton's *Surviving R. Kelly* documentary series in that both are music documentaries that ultimately righted a terrible wrong perpetrated against young women.

ELC: From your lips to God's ears, my friend.

I want to bring up one thing before I forget. I am always thinking about, what does the audience want to watch? When I'm on a Tuesday night, what am I going to click on to watch? And so I've always been reverse-engineering, from Twitter, from Reddit, from talking to people, this type of stuff. And I was having a conversation with my point person at HBO. And I was like, I'm always thinking about the audience. How am I going to do it, how I'm going to translate, and she was like, you would be surprised so many people do not think about that. And so I think that . . . I haven't been inside the documentary awards, [which] are like the really inner circle of documentary, because I'm seen as a commercial filmmaker. Anybody who's reading this: [I'm] doing something that the people are talking about reverse engineering, getting access to that, and making it feel special. When you look at all these movies, what I tried to do is reporting these huge, larger conversations, and that's how you're going to keep going and keep working. I think there's more room now than ever for novices to really own a story and get it and actually be able to make it.

KS: I think *Britney vs Spears* has a lot to say as a film about access. Because whom you don't have access to is completely tied into the story you're telling. Britney Spears's conservatorship is not only keeping her from you and your crew but from the outside world.

ELC: Yeah, I mean, I specialize in having no access, which I despise. . . . That is really tough filmmaking and specifically because Britney has been exploited her entire life. And so when you're making something for a big company, you have to be really incredibly careful that you're not further exploiting. . . . There were sure critics that said it was that. I respectfully completely disagree. When I was making this, I thought about Britney all the time. I listened to her music all the time. I watched hundreds of hours of archive. I dreamt about Britney Spears. She just was part of my whole being as a person, and she never even knows I'm alive. It was such a tough one, because I would have given literally anything in the world for ten minutes with her. I tried so many times, obviously.

KS: The unspoken, bigger question in your movies we talked about a moment ago is often related to gender. I found myself watching *At the Heart of Gold* saying, "Why are male gymnasts in their early twenties? And female gymnasts are fourteen?" Or during *Britney vs Spears* saying, "Why can I not think of a single male celebrity who has been placed under a conservatorship by their parents?"

ELC: There's this interesting backstory about why my films are about women. My first film [2015's *Thought Crimes: The Case of the Cannibal Cop*] was about Gil Valle, who was a man who conspired to kidnap, rape, and torture women, as a former New York police officer.

He and I developed an uncomfortable relationship where he really believed that we were supposed to be together because I was incredibly understanding and I saw all the

darkness in him and I didn't flinch, I didn't turn away. And so he started to indicate romantic and sexual attraction. I felt really nervous because I needed to continue making this film. And I felt really powerless as a young woman. . . . And I was never able to talk to him about that because I was afraid that something would happen. And I was like, I don't ever want to feel this way. I don't want to feel like I'm afraid of my subject matter. I don't want to. I don't want to be afraid that I can't be honest with somebody. And so if you look at *Mommy Dead and Dearest, I Love You, Now Die, At the Heart of Gold, Undercurrent, Britney vs Spears*, it's all about women. Because it's a crazy thing that a man in my life changed the trajectory of my career based on pushing boundaries. And so I think that it ultimately led me to what I want to do with my life, which is to make stories about women. But it was born out of male violence, which I've always thought was incredibly unusual.

KS: I think it is such to your credit, both as an artist and as a person, that *Thought Crimes*, being your first movie, [was] made under those awful circumstances. You look at *Thought Crimes* as part of your body of work, and not only is it in dialogue with all your other movies but even though it came first, in retrospect, it looks like the one that ties it all together. It looks like the films that were the themes and the interests that would fill your body of work were being established, even though *Thought Crimes* was made under terrible conditions.

ELC: It's the only film you'll get that opens with talk of de-breasting a woman. I recently watched it, and I was like, "What the fuck? This is wild!" I don't think anyone but Sheila Nevins [legendary and longtime former president of HBO Documentary Films] would have let me do that. They all would have been like "No! This is disgusting!" So props to Sheila for actually letting me do that.

KS: If your films are about these three things—crime and gender and technology—with different ratios of each of those three things for each project, tell me, what is it about those three things that speaks to you both as an artist and as a person?

ELC: Technology is the way that people communicate, communicate about the crime, and women's stories and people of color are underrepresented. And so creating, finding the story that fits inside these worlds is something that is the spine of a project. And then it's about figuring out the twists and the turns and how to make the audience have different conclusions at different periods of time. What happens in the courtroom are some of the most compelling material in our whole universe, because a human being is being judged for actions that they did. And we lay in judgment of them just like we the audience does for a documentary.

I've seen people think of the people in my documentaries as characters on television shows. And I've seen horrific comments online about Gypsy Rose [the protagonist/accused of *Mommy Dead and Dearest*], about Britney. These are still people who have vulnerabilities that they're trying to communicate. But it's been a little disturbing how people basically rationalized picking apart people online. And I always feel a little nervous about putting work into the world for women to be judged by their body, by their actions. But that's what the internet will do.

Technology is one of the big things that I make films about besides women and how we communicate. And I think that there's an advantage to being a director then in my twenties, now in my thirties. I'm never speaking down about kids or young adults. There's a translation effect that's going on. What if texts were really a manifestation of your inner psyche? I think it's just the way I see the world and goes back to that audience

The Female Future **251**

question. One of my favorite things in the entire universe is when a film comes out is watching Twitter and seeing what people say.... Being a documentary filmmaker right now is one of the coolest jobs in the entire world because you're tapped into the zeitgeist.

KS: As a filmmaker, you've been called "the patron saint of complicated women."[13]

ELC: There are an incredible amount of filmmakers who can make films about men, and I choose not to. And that's not to say that like I won't ever, but I do think there are enough female-centric stories, where people literally email me and say, this is an Erin Lee Carr film. And so how could I turn away from it? It's where I feel like I can have the most creative version of my art, because I deal with ambiguity and how people feel about women, and how people feel really strongly about women ... and I do not get bored. I've been really grateful that people have called my films empathic, always searching for a greater point of humanity. So when I go out to people that I feel have been wronged by society or mistreated or did things that they're being held accountable for, but the coverage of them felt sexist, I have this incredible thing to go with them. I am the person to do this. I have to do this. And I convince people because I say, this is my calling in my life, to make a film about somebody like you. And I think it's sometimes a little hard to walk away from that, if you're a subject. My dad told me early in my twenties, get a beat and stick to it. So you're known for it. And here we are, and I just love it.

KS: You have a section on your website called "20 Things I Wish Someone Would Have Told Me About Being a Documentary Filmmaker." I'm particularly taken with Things number 8 and number 11. Number 8: "Be true to your own voice." And number 11: "Do NOT Be Hard to Work With." I feel like that same list written by a man, number 11 would be, "Screw it, if you're hard to work with, like, it doesn't matter. It's all about you! Stick to your guns!" As if being a jerk is the same thing as having integrity.

ELC: It has something to do with being a woman and sometimes having to overproduce and be so careful and be easy to work with. But I would say for me personally, it has helped a tremendous amount. Easy to deal with, under budget, on schedule, and someone hopefully will work with you again. I don't come from intergenerational wealth. And so it was very much when I was making my first film, I had to be really careful about doing anything to get the job because I really needed the money. But then when it came to the contracts, I signed everything.

Get the movie made, sign away, you'll have years later in your life to be finicky about contracts. Get the stuff. I signed terrible contracts in the first part of my career.

I'm just now starting to executive produce projects. I think had I had been a dude, I think around *Mommy Dead and Dearest*, which is my second film, I would have started EP-ing. And you'd be surprised. People say, "I want you to direct this thing." And I say, "You know what, I'm not available. I only am doing my stuff right now. I'm happy to have a conversation about executive producing." And people are like, no, no, we really want you to direct and I was like, no.

I think that I have been hit with I only can be a director versus helping usher in these projects, which has been confusing.

KS: What kind of set do you like to run versus what kind of small business do you like to run?

ELC: I love to come on set and I know everybody's name, I'm goofing around.... It's not so serious until the interview. I make sure I talk to almost everybody. And then while things are getting set up, I make sure that I go with the person that's being interviewed, we lock eyes, we get some coffee, I talk about sort of what's going to happen. And when

it comes to me actually doing the interview, I need everybody to be silent, I need everybody to be off their phones, and for people to be bearing witness to this person giving us their time. I ask very specifically that everyone pay this person the respect that they deserve. Afterward, it's turning on music and packing the stuff up and eating dinner, and I would say that I'm now on the road 50, 60 percent of the time, it's like camp. It's easy, cuz I'm the camp leader. But it feels so genuinely, like, such an incredible way to live life.

In terms of a small business, I started working with an executive coach who taught me that being a director is also being a manager, and that we devise all these systems, basically, to how do you let somebody on your team own what they're doing and succeed with it? How do I give them trust? How do I push them to the next position? How do I get more money for them?

For example, if somebody pitches me something that sells, they get a big financial bonus. And somebody—if somebody on my team were like, "Why are you doing that? You're paying them to develop stuff." And I was like, "This is going to make people bring their best ideas."

That's what the last five years have been centered around. If work is my life, then how can I be good to the people around me? It's not the Erin Carr show. Films are the work of all these people put together. And whenever a film comes out, this is the thirty people that made this happen. I did not do this alone. So I have enormous respect and joy for the people that I work with. And in terms of, like, personal life, I think that I have a really strong sober circle, but we aren't able to see each other as much we used to see each other every single week. So that's been a little bit painful.

KS: I finished your memoir about two weeks ago, and I finished your dad's last week. I feel like his book is very much about the accuracy of memory and the attempts to verify memory. And your book is very much about the emotional process of letting go and letting memory be a thing that fades.

ELC: My father wrote one of the most celebrated addiction memoirs of the entire genre. It's over four hundred pages, it was meticulously researched using his investigative skills from the *New York Times*. And it was an epic, right? So when you get to me, it was like, I don't have anything to say, this is terrible. And the real reason that I wrote the book is that it's an elongation of this sort of David Carr memory. It's really sort of an ode to a second life as a father and what that meant.... The book was an effort to continue listening to him, continue hearing him.... And when it came to memory, I knew by reading his book, now I've read it probably ten times, that memory is sort of a series of falsehoods that we tell ourselves.

KS: Addiction is also an enormous presence in both of your memoirs. Anybody who has ever achieved great things knows that work has an addictive quality the same way that substances or anything we get addicted to does.

ELC: I mean, it's completely addictive, right? I was modeled workaholism. You get up, you have breakfast, you talk to the dog, and then you work until 11:00 p.m. You have fifteen cups of coffee. My dad was somebody that relied on four to five hours of sleep.

I don't get to be drunk anymore. I'm six and a half years in recovery ... but I feel like the thing that is most akin to drunkenness, to me, is the exhaustion that you feel after a shoot day, and you did everything that you were supposed to do and it worked. It is the most intoxicating feeling in the world besides love.

The Female Future 253

I had a really intense experience with *Britney vs Spears*. It was during the pandemic and I spent every single day, almost every hour, working on it. And when it came out, it was this huge thing, but critics were mixed on it. I had a very intense reaction, mental health-wise, because I thought the work was me. And when somebody was saying something about it, I felt incredibly attacked. And it was this emotional bottom where I had to be like, you're gonna end up in the nuthouse, man. And so I said, okay, this is a project that I worked really hard on, that I'm really proud of, but it's not who I am. And not having the expectation that it's going to be the most giant thing in the world because it was, but it's also a documentary. And so I think that I've had a big sea change because I only talk about documentary, only talk about I'm working on, and I was like, oh, I'm becoming just like the person I don't want to be. I have made about ten projects in nine years because I'm a workaholic. And I'm also sober. I also prioritize that. I prioritize family, but it's addictive, to be brutally honest. I think my alcohol and drug addiction moved to workaholism, and it's rewarded by society, and there are consequences for it. But as a young filmmaker who does not have children, I can likely work more than most other people do. And that's why I've been so prolific.

KS: Do you feel like you can maintain this pace and still appreciate the movies you are making?

ELC: No! (*laughs*). I'm recently engaged to an incredible journalist ... and I'm now trying to shift a little bit where I don't have my claws in every single decision. I feel that I'm kind of being given more opportunities than ever before because I'm finally solidified in my name and space. And I also want to help other people direct. The pace is not sustainable, but I feel like I will figure out a way to continue to make good work and not tip over the edge. But we'll see.

KS: In your 2019 *Fresh Air* interview. you talk about how your dad raised you and your sister to be loud feminists.[14] How did learning feminism from a male parent shaped your sense of feminism itself?

ELC: It's really complicated, because I always feel like I have to bring this up, but I do it with an enormous delicacy. My father was not a friend to women for a good section of his life. In fact, he was somebody that terrorized women, and so I think that it's always been really painful for me to realize. He believed in feminism once he had daughters. It was not that we were girls, but that we were his, and he believed that we could do literally anything. And he loved being a girl dad and all that kind of stuff. But really it was anybody who was going to come as a child of his was going to be ferocious in many ways or incredibly brilliant. Either one suited him.

Now that I'm sitting here at thirty-four, I don't know if it was feminism, but strength of self. You are who you are. You will own who you are in the world. Is it feminism because we're women? Or is it just that he raised us to be strong?

KS: We are now at the point in history where 90 percent of your body of work happened after your father's passing.

ELC: When I made *Mommy Dead and Dearest*, which was my second film, my breakout film, he had been gone. And there were the series of inflection points where people involved in the process weren't sure that it was the next film for me. And I knew in my gut that that was the movie, and I was going to do it, I was going to get access. I said, "I'm just gonna have faith because I know what I'm doing. I know what I believe in." And to see that in its

own small, little documentary way, it just blew up and for me to feel so vindicated by my own internal voice, I almost never looked back.

Had he been alive, I think that could have happened, but it'd be a very different thing. And then people would have sort of continued to sort of see me only through him. And one of the reasons why I work so much is that I never want people to think that, "Oh, she made one good film, and then she kind of fell off." Like it was a stroke of good luck or something. A lot of people are like, "How can you have quality control if you make that many projects?" Look at my projects. Are they lacking quality control? I have devoted years of my life to making sure everything has quality. And some people may like some films more than others, but each of them are my little babies.

I've worked now the last ten years of my life not to be weirdly, not to be known as David Carr's daughter, but to be known as Erin Lee Carr, while owning the fact that I love this guy so much. One day, my dad asked me, "Do you think that you'll surpass me?" And I said, "Of course I will." And he said, "I don't know whether to be frightened or really happy," or something like that. I will want to surpass my dad in what he has done. And it's not rude to him, but like, he set upon this life and got sober so we can have this bigger sort of bolder life, and that's why I got sober at a young age. Okay, I got a certain amount of time on this earth, let's go.

KS: Who are your documentary compatriots that you admire?

ELC: I've watched every Liz Garbus film.[15] She has a level of prolific quality to which I sort of only aspire to. And she has dealt a lot with true crime and elevating it. In terms of documentary, we all come from Sheila Nevins, and attention must be paid. Because she basically invented the television form of documentary and sought to bring it to the public through HBO, and not just do one type of documentary but to leave space for commercial, for tabloid, for celebrity, for everything. I will always, always, always look up to Laura Poitras.[16] Alex Gibney and Andrew Rossi, they're making things right now. So they are my contemporaries.[17] I'm very close friends with Brian McGinn.[18] He's my creative consigliere. I recommend this for all directors that you have somebody who's your pacesetter where you can say, is this the right budget? Is this what's going on? I'm always asking different filmmakers questions about who they are and what they do and how they think. I will forever be searching for the answers to things, especially with female filmmakers that have come before me. Part of my work is paying homage, homage to the work that they've done.

KS: You've got the twenty things list on your website and another list at the back of your memoir. Are lists a key part of how you work?

ELC: I have probably forty-one notebooks ... since I was twenty years old. My handwriting has changed, my goals have changed, but I will randomly, when I'm trying to figure out a puzzle or something to do with work, I'll go and I'll look in one of the notebooks and recognize how far a human has come from then, but having so much gratitude towards that young person trying to figure it out. I had notes from the talk where my father died right after and one page is his notes from the talks—I always took notes when he spoke—and then it was his funeral preparations. And so I keep that, an analogy of what life is, any moment where your life can change dramatically. I write a list every day. This is in development, this is in production, this is in post, these are the ideas that I'm developing. I have that everywhere I go. And I put stuff on the wall where I say "You are living the life of your wildest dreams" or "I will take in the feedback of others with gratitude." So it's a

little woo-woo kind of stuff, but things that I need reminding of. The goals have gotten so much bigger, and sometimes they don't happen. But I believe when you are trying to figure it out ... What are the goals? What am I working for?

I have my daily list on the left. That's what I'm doing today. And then I have my year-long goals that I'm working for ... I need to have my ambition spelled out in front of me. And I love lists. I love handwriting. I love stickers. Like, everybody has some weird shit in the drawer next to their bed. I have stickers. I have rainbow heart stickers and dogs. "Where's the cocaine?" "Get a grip, lady. I got some new dog stickers." This is who I am.

KS: Just from our conversations, I really get the sense that being a good mentor is as important to you as it was to your father.

ELC: My family has this thing called "I put my nickel on you." I put my bet on you. It's my last nickel I have. And I've been very careful to put my nickel on very specific people, but when I know that they will succeed.

I take my job as a role model incredibly seriously. I joke about drugs and alcohol. But that's who I once was. It's important to own it. I mentor as much as I can and make sure that when I'm talking to someone, I am seeing them. I'm seeing what questions they have. I'm seeing how I grow you. I would say that loyalty, mentorship, and work ethic are the triumvirate of the things that I was modeled and taught about. And so I have a lot of mentees.

In the next five to ten years, that narrow definition of director is not going to look that way. And it's about not referring to directors just as female directors or things like that. But I think that I'm optimistic. I might be in the minority about being optimistic. But I specifically feel that I have been given more opportunities because I am a woman. And I get those errant pitches: "Oh, we need a lady to do this. We thought of you." And I'm like, "Get out of here. No thanks."

I'm just excited about all the work being done and very psyched about what's to come.

Notes

1. Jessica Sharzer, "Commentary" *A Simple Favor*, directed by Paul Feig (Santa Monica, CA: New Line Cinema, 2018), Blu-ray, disc 1.
2. Daniel Fienberg, Angie Han, and Robyn Bahr, "Hollywood Reporter Critics Pick the 50 Best TV Shows of the 21st Century (So Far)," *The Hollywood Reporter*, October 4, 2023, https://www.hollywoodreporter.com/lists/best-tv-shows-21st-century/sex-and-the-city-hbo-1998-2004/.
3. BUILD Series, "The Cast & Creator of 'Vida' Discuss Season 2 of the STARZ Series," YouTube, May 3, 2019, 30:56, https://www.youtube.com/watch?v=eC7SfAbeVjk.
4. Brittny Mejia, "Great Read: Two Bars—One Mexicano, One 'Chipster'—Show How an L.A. Neighborhood Is Changing", *Los Angeles Times*, April 7, 2015, https://www.latimes.com/local/great-reads/la-me-c1-boyle-heights-bars-20150407-story.html.
5. "Our Lady of the Underpass" was a salt stain that resembled the Virgin Mary beneath Kennedy Expressway in Chicago and became a pilgrimage site and local curiosity.
6. Best known on television as Captain Danny Ross on *Law & Order: Criminal Intent*, Eric Bogosian has also written the award-winning solo stage shows *Talk Radio, Sex, Drugs, Rock n' Roll*, and *Wake Up and Smell the Coffee*.
7. Isaac Gomez is an award-winning playwright and screenwriter whose work has been commissioned by Steppenwolf Theater Company and the Oregon Shakespeare Festival and has written for the television series *Narcos: Mexico* and *The Last Thing He Told Me*.

256 Break the Frame

8. Katya Vujic, "Tanya Saracho 'Yes, and'-ed Her Way into Hollywood," *The Cut*, October 2, 2023, https://www.thecut.com/2023/10/how-tanya-saracho-gets-it-done.html.

9. Robert Ito, "Alice Wu's Lesbian Rom-Com Was Influential, but Her Follow-Up Wasn't Easy," *New York Times*, April 29, 2020, https://www.nytimes.com/2020/04/29/movies/the-half-of-it-alice-wu.html.

10. Lil Loofbourow, "The Male Glance," *Virginia Quarterly Review*, Spring 2018, https://www.vqronline.org/essays-articles/2018/03/male-glance.

11. Brian Hu, "The 20 Best Asian American Films of the Last 20 Years," *Los Angeles Times*, October 4, 2019, https://www.latimes.com/entertainment-arts/movies/story/2019-10-04/asian-american-films-canon.

12. *Paradise Lost: The Child Murders at Robin Hood Hills*, a 1996 documentary directed by Joel Berliner and Bruce Sinofsky about three teenagers accused of murdering three elementary school students, is widely seen as the reason the three accused were seen to have suffered a miscarriage of justice and in 2011 were sentenced to time served and released from prison. *The Iceman Tapes* is a 1992 documentary directed by Arthur Ginsberg and Tom Spain about contract killer Richard Kuklinski.

13. Morgan Baila, "'I Love You, Now Die' Is the Most Relevant & Shocking True Crime Story of 2019," *Refinery 29*, January 23, 2020, https://www.refinery29.com/en-us/2019/03/226972/michelle-carter-i-love-you-now-die-erin-lee-carr-hbo-documentary.

14. Erin Lee Carr, interview with Terry Gross, *Fresh Air*, April 30, 2019, https://www.npr.org/2019/04/30/718666405/erin-lee-carr-daughter-of-david-carr.

15. Director of over a dozen feature documentaries, Liz Garbus received an Oscar nomination for Best Documentary for her 2015 film *What Happened Ms. Simone?*

16. Winner of the 2014 Best Documentary Oscar for her film *Citizenfour* about Edward Snowden. Director Laura Poitras is also a MacArthur genius grant recipient.

17. Alex Gibney has directed nearly fifty documentary films since 1980. Andrew Rossi is an Emmy-nominated documentary director and producer of twenty films since 2002.

18. Brian McGinn is the Emmy-nominated director of the 2016 Netflix documentary *Amanda Knox* and co-showrunner of the Netflix series *Chef's Table*.

Epilogue: A Practical Guide

Movies are not real life. They will not end wars, feed the hungry, topple fascism, or halt ecological calamity. But if all that happens when we watch movies is that we see things as we have not seen them before, then movies have boundless potential to make our thinking electric, our worldview bigger, our hearts larger.

We live in a lonely, broken time. It's fair to say we get a better life out of assembling rather than grinding down, of running towards what is left to be learned, of having broad minds rather than narrow ones.

I also understand that movies and their directors should work equally as teachers and entertainers. So I would hate for anyone to walk away from this book feeling like I had turned the leisure of watching films directed by women into homework and boiled spinach. From the beginning, I intended this project to be fun, for myself, for the directors I interviewed, and most importantly, for you.

The labor of filmmaking can take years for an experience that, for us, is over in an afternoon and forgotten the next day. A filmmaker's hours are long, progress unpredictable, rejections quick and cruel. Many of the artists I spoke to gave their time to me when they didn't have any to give. Yet it also took almost nothing for them to surge like wires when speaking of the labor of filmmaking, of the path they had chosen with odds resembling a wall of granite, and the art they made that leaped over that wall or barreled right through it.

I remain in awe of how these women do so in an industry with a century-long history of making it impossible for women directors to succeed and then crowing, "See?" like kindergarteners when they don't. But the themes the directors here kept returning to show us a way of enjoying filmed entertainment beyond this toxic state. I hear their commitment to stories bigger than their own and to a healthy, safe process for everyone doing the work of making them. I hear them saying making movies and television is hard labor with very little chance of success. And then I hear them saying, let us do it still, in a way that can be true to the vision of the filmmaker but also grants a respectful, fulfilling workplace to cast and crew and treats the audience as thinking, feeling, whole people instead of suckers to be mugged in broad daylight.

I hear them saying we will get better movies and television series this way. The work of every director in this book proves they are right.

Our job then, as their admirers and fans, is to vote with our time and attention, which is hard from the jump because watching filmed entertainment has an inherent drawback. Unlike a book, which can be read fast or slow, or a sculpture, which may be gazed upon for a moment or a week, you cannot shrink how long it takes to watch something. A 117-minute film is 117 minutes of your life. And most of the living, working grown up people I know don't have 117-minute blocks of time lying around.

How then? If you're excited about what you've read here, how do we make space for movies and television series directed by women when free time is a rare good and the contemporary

258 Epilogue

watching experience does not help us be mindful about what we watch?—as anyone who has ever been excited about something on a streaming service they don't currently pay for or balked at the price tag—tickets, parking, refreshments, babysitters—of an evening at the movies will tell you?

I have a few suggestions. I hope they are helpful.

Reasonable Goals

This book is meant to both give praise and thanks to women directors whose work gets overlooked too often and to offer you an invitation to watch more of that work, at whatever speed works best for you. It is not meant as coursework or a competition, unless it helps you to see it that way.

Begin, then, with goals you can imagine putting a check mark next to. Maybe, while reading this book, you've circled a few directors or movies or TV series that sounded particularly great. Start there Did you enjoy how a particular movie looked or what its director clearly thought was important? Perhaps your next move is more by that director.

Do you particularly vibe with what a director interviewed here said about the women directors who inspired them? Are you a person very much into where beautiful movies come from and what they inspired? Maybe then your initial viewing is work by one director showcased here, a movie or two by their creative mothers and a few more by their cinematic nieces and daughters?

In all cases, the goal is yours alone. Listen to the feeling any single watching experience gives you. Let them tell you what movies and what women movie directors should come next.

Remove Silly Obstacles

The current methods of watching movies and television exist for the benefit of streaming providers and how they collect data from us, their customers. Things are not set up this way for our ease or enjoyment. At all.

That's why, right now, the excitement of hearing about a new movie or TV series almost always gets water thrown over it by a bunch of silly logistical matters. Do I subscribe to the streamer that thing is on? If not, do I know someone who does? Whom can I convince to watch it with me? Whom can I "borrow" a password from? Failing that, can I check out a DVD of the thing from the library? When is my local library branch open today? Do I still own a DVD player or is it buried under boxes of Halloween decorations in the garage?

All that for a little leisure time viewing? No wonder it's easier to say forget it. Turn on that one streaming service we watched last night and press Play. I have laundry to fold.

An activity this much fun should not have this many small defeats build in. Therefore, our reasonable goals from Step 1 should come paired with painless methods to achieve them. From that short list of movies or television shows where you'd like to start, jot down where those offerings are available to be seen. Simple web browsing should give you the answer.

If you don't currently pay for the relevant streaming service, find someone in your life who does, invite yourself over to watch the entertainment in question and bring pizza and ice cream. Otherwise, I would advise either paying for a day's rental via iTunes or Amazon or wherever you can for the movie in question or acquiring a DVD from the public library. Or purchasing it used online, which will cost next to nothing. And if owning a DVD player and physical media at this moment in history feels like the behavior of a hoarder, a top-flight DVD player can be currently purchased for about $75 and will sit quietly under your TV set minding its own business. DVDs are not family heirlooms and should be donated or resold if you don't feel like you will be rewatching that movie or series regularly. It is a waste of space and money to keep piles of anything you have neither the room for in your home nor the time to enjoy.

A collecting habit is not a requirement of supporting the work of women directors. Cheap DVDs and digital rentals in the end cost way less than subscriptions to streaming services you rarely use and forget you are still paying for.

Above all, do not let *how* to watch the work of female filmmakers determine *if* we watch the work of female directors. Determine the quickest, cheapest path to seeing the thing you want to see and do it. Anything technical or logistical between you and that joy is a pointless obstacle to be dealt with and forgotten as quickly as possible.

Remember "Directed By"

People over the age of forty reading this probably remember a time when it just seemed easier to know what movies were coming out and what television shows could be seen where and when. They are correct. It wasn't because either movies or television were better thirty years ago. There were just fewer avenues to learn about new movies and television, a giant apparatus of commercials and billboards and subway posters to tell you about them, and very few ways to avoid and block all that advertising the way there is now.

Here in the present, this means that engaging with work by women directors is an active rather than passive hobby. But it's not a complicated one. I have Google Alerts ("directed by Mary Harron," "directed by Felicia Pride") set up so I know when directors I admire are working on something. I follow a good few of them on whatever social media channels they use most, where they will frequently post trailers and announcements of current projects. And I pay close attention when actors I respect (Jessica Chastain, David Olyelowo) speak of their commitment to working with female directors because most likely their next project has the double benefit of seeing actors I admire and a female director I admire as well.

The sexism of the entertainment business often means women directors have more roadblocks in developing projects and, consequently, end up with longer stretches of time between those projects. For us, their supporters, that will mean a willingness to watch movies and television series that are not brand new. It is human nature to want to see what is brand new and know what friends, family, and colleagues are talking about. But that method of watching means pretending institutionalized sexism doesn't exist rather than our film and television watching being a vision of things as they could be. Also, our lists of all-time favorite movies and TV series usually have movies and TV shows that are old, new, very new, and kinda old, don't they?

Recommend

This project I am suggesting has no future if we go at it alone. So when you see a great movie or TV series directed by a woman, say so. Loudly. Tell anyone you think would like it, particularly when they ask, "Seen anything good lately?" And tell them why. A recommendation is platinum instead of pewter when we (a) tell someone why we think *they* would like this movie, not just that *we* like this movie and (b) we identify *to* them why it is *for* them. Your friend who just graduated from law school will want to know about the Ruth Bader Ginsberg biopic *On the Basis of Sex* and will be even more tickled that its director was also hand-selected by Steven Spielberg to make George Clooney into a movie star, if you make those connections plain. Or try it with your loved one who loved *Captain Marvel* and *Barbie* but probably hasn't seen the man who played Ken be more than Ken-enough in his first Oscar-nominated role, in a movie made by the director of *Captain Marvel*.

How much fun can this be? As much as we know and then share.

Rejoice Together

Movies are rare among the arts as an experience that can be isolating or communal in equal measures. You can lose a whole lifetime of companionship by hiding away in the dark watching movies. Or you can attend movie nights and film festivals, and you can cupid your friends and loved ones with movies and television series that will change their lives as they have already changed yours. And we all can model how our time and attention should represent our values, in vocal support of labor and artistry we find important and necessary, rather than "watching" being a way to avoid "living."

I don't think we should settle for anything less.

We can all have a different experience with movies and television than the one that feels inevitable in this cruel, lonely time. It will require a bit of labor that will at times feel like too much. But it is possible, it is real, and, because I have been there, can report back that it is amazing.

Reasonable goals
Remove silly obstacles
Remember "directed by"
Recommend
Rejoice

As of this writing, the youngest director I spoke to for this book, Erin Lee Carr, is thirty-six and has directed roughly a documentary a year for the last decade. In the midst of that superhuman achievement, she told me of "the exhaustion that you feel after a shoot day, and you did everything that you were supposed to do and it worked. It is the most intoxicating feeling in the world besides love."

Every movie director was first a movie fan with that feeling. That feeling where you've seen a movie where everything about it worked. It made you feel great not just because it was funny or romantic or thoughtful or heartwarming. It made you feel great because it showed you something else was possible. And someone had made it real.